Graphic design

Reproduction and representation since 1800

already published in the series

National style and nation-state: design in Poland from the vernacular revival to the international style
David Crowley

Eighteenth-century furniture
Clive D. Edwards

Victorian furniture: technology and design
Clive D. Edwards

Twentieth-century furniture: materials, manufacture and markets
Clive D. Edwards

The Edwardian house: the middle-class home in Britain 1880–1914
Helen C. Long

Manufactured pleasures: psychological responses to design
Ray Crozier

Quotations and sources on design and the decorative arts
Paul Greenhalgh

Chicago's great world fairs
John E. Findling

The culture of fashion: a new history of fashionable dress
Christopher Breward

Henry Ford: mass production, modernism and design
Ray Batchelor

STUDIES IN
DESIGN
AND
MATERIAL
CULTURE

general editor
Paul Greenhalgh

Graphic design

Reproduction and representation since 1800

Paul Jobling and David Crowley

distributed exclusively
in the USA by
St. Martin's Press

Manchester University Press
Manchester and New York

Copyright © Paul Jobling and David Crowley, 1996

Published by Manchester University Press
Oxford Road, Manchester M13 9NR, UK
and Room 400, 175 Fifth Avenue, New York, NY10010, USA

Distributed exclusively in the USA
by St. Martin's Press, Inc., 175 Fifth Avenue, New York, NY10010, USA

British Library Cataloguing-in-Publication Data

A catalogue record for this book is available from the British Library

Library of Congress Cataloging-in-Publication Data
Jobling, Paul.
 Graphic Design: reproduction and representation since 1800 / Paul
Jobling and David Crowley.
 p. cm.—(Studies in design and material culture)
 ISBN 0-7190-4466-9. — ISBN 0-7190-4467-7
 1. Graphic arts—England. 2. Popular culture in art. 3. Magazine
illustration—England. I. Crowley, David. 1966-. II. Title. III. Series
NC978. J63 1996
741.6′0942—dc20 95-43365

ISBN 0-7190-4466-9 hardback
ISBN 0-7190-4467-7 paperback

First published 1996

00 99 98 97 96 10 9 8 7 6 5 4 3 2 1

Typeset in Stone Serif with Sans display
by Carnegie Publishing, Preston
Printed in Great Britain
by Redwood Books, Trowbridge

Contents

Figures

Tables

General editor's foreword

The books in this series are principally about objects. They elucidate histories of material things and assess their effect on the cultures that made and consumed them. The wide range of genres which have filled people's lives, the furnishings, utensils, adornments, decoration, clothing, vessels, electrical and mechanical products are made here into the central historical evidence. The present volume is very much at home in this company.

The period covered by this book was one in which the means of visual communication were transformed. Millions of Europeans were increasingly made to consume printed words and images, which advised them on every aspect of their waking lives. The effect of this on what *Punch* magazine referred to as 'the legions of dull-witted toilers' cannot be underestimated. In the twentieth century, graphic communication has changed the way people think and act.

There have been earlier attempts to outline the history of graphic design in the modern period. These have tended to concentrate on the classic movements and individual designers, dealing with them much in the manner of parallel volumes on the history of painting and sculpture. In its recognition of graphic design as a discipline that must answer to a different set of criteria from the artist working for a limited patronage, this volume goes much further than most before it.

This account of graphic design includes the social, political and economic forces which shaped the age. It reveals the nature of the industry that produced the posters, prints and pamphlets and explores the ways in which the design idiom developed in order to deal with a mass audience. The book also exposes the inherent tensions between the urge to persuade, the wish to please and the desire to profit.

Paul Greenhalgh

Acknowledgements

We would like to thank the following people for their invaluable support and involvement in preparing this book: Mike Berry, Derek Berwin, Lesley Bisseker, Bob Harris, Michael Horsham, David Landau, Marsha Meskimmon, Mike Moody, Robert Jobling, Kevan Rose, David Steen, Caroline Windsor, Catherine McLean, Rachel Worth, and the library staff at the University of Brighton. We would like to thank the series editors, Paul Greenhalgh and Katharine Reeve, for commissioning this study, and Albert Bowyer and Barbara McCarthy at Staffordshire University for all their kind help in preparing the photographs.

This book emanates from our own research interests in graphic design as well as from the courses that we have taught. We would therefore also like to thank the many students who have helped us to question and refine our approach to the subject area.

A note on quotations

All translations are our own unless stated otherwise.

Copyright

Abbreviations

AIA	Artists' International Association
AIZ	*Arbeiter Illustrierte Zeitung*
BIZ	*Berliner Illustrirte Zeitung*
CCA	Container Corporation of America
CCCS	Centre for Contemporary Cultural Studies, The University of Birmingham
EMB	Empire Marketing Board
FSA	Farm Securities Administration
ILN	*Illustrated London News*
MIP	*Münchner Illustrierte Presse*
NWAC	National War Aims Committee
PP	*Picture Post*
PPA	Periodical Press Association
PRC	Parliamentary Recruiting Committee
SDUK	Society for the Diffusion of Useful Knowledge
UCAD	Union Centrale des Arts Decoratifs
VALS	Values and Lifestyles System
WVS	Women's Voluntary Service for Civil Defence

This book is dedicated to our respective parents

Introduction

> Because graphic design, in the end, deals with the spectator, and
> because it is the goal of the designer to be persuasive or at least
> informative, it follows that the designer's problems are twofold: to
> anticipate the spectator's reactions and to meet his own aesthetic
> needs (Paul Rand, *A Designer's Art*, 1985).

More than any other form of visual culture, graphic design is in-
escapable. In the course of any day, we negotiate a huge quantity
of graphic images, sometimes consciously and sometimes not – in
public, from the plethora of periodicals and newspapers on sale at
the local newsagents to the overwhelming number of enticingly
packaged products on sale at the supermarket; from the more
mundane train or bus timetable to the eye-catching advertising
hoardings which beckon us as we walk along any high street; and
in the space of our own home, in the form of personal possessions
such as books and records which come wrapped in seductive
graphic and photographic images, or in the form of the opening
credits of the television programmes we watch. In this daily en-
counter with so much visual material, more often than not our
experience of graphic design appears seamless and the myriad of
images we confront so impenetrable that we scarcely take time to
consider the ways in which they can signify the meaning of our
own existence. Indeed, the very ubiquity and often ephemerality
of graphic design militates against most of us actually reflecting on
its presence in our lives. Somehow, graphic design just *is*. Yet even
though we do not need to visit a gallery or museum to see works
by graphic designers (indeed, today most producers of graphic
design remain anonymous – how many contemporary advertise-
ments or posters, for example, carry the name(s) of their creator(s)?),
this does not mean that magazines and advertisements take less
thought, time and creativity to produce than paintings, or that as
spectators and consumers we should not take them seriously.
Instead, the task before us is to examine what graphic design is both
in terms of what it reproduces and what it represents.

The term graphic design itself first came into currency in the
twentieth century, although its origins are open to dispute and
confusion. In 1922, for example, we find it being used in America
to refer to certain areas of practice such as advertising, although
the term 'commercial art' was more widely used during the 1920s

to connote much, if not all, of what would be described these days as graphic design.[1] More than thirty years later the use of both terms was still open to despute and Masaru Katsumie, writing in the Japanese magazine *Graphic Design* in 1959, underscored the distinction between graphic design, which he regarded as an industrial process, and commercial art, which he associated with hand-drawn illustration.[2] Questions of attribution and attempts to trace the definition of the term 'graphic design' to an exact source or date, however, often tend to state the conclusion without admitting the argument: that is, graphic design is a complex matrix of different sign systems and media, embracing both high and low or popular cultural artefacts, which existed long before either it or the appellation 'graphic designer' were identified as such. This, for example, is how the designer and art director behind Benetton's *Colors*, Tibor Kalman, sums up the nature and scope of the subject:

> Graphic design isn't so easily defined or limited. (At least, it shouldn't be.) Graphic design is the use of words and images on more or less everything, more or less everywhere. Japanese erotic engravings from the fourteenth century are graphic design, as are twentieth-century American publications like *Hooters* and *Wild Vixens* ... Graphic design isn't so rarefied or special. It's not a profession, but a medium, a mode of address, a means of communication.[3]

As much as for the historian of graphic design as for the graphic designer, the issue at stake, therefore, is one more of how to make sense of so much visual and verbal information. Clearly, given that the subject area incorporates such a disparate and complex range of processes and imagery, in constructing a cohesive and meaningful history of graphic design issues concerning periodisation, place and nationality, representation, style and technologies must be addressed. It is hardly surprising, therefore, that a standard or definitive history of so much activity does not exist, or that it ever could. This is not to say, however, that there have not been any serious attempts to investigate the history of graphic design or that there is not any serious literature on the subject. In fact, broken down into areas of specialisation such as photography, advertising, printmaking or typography, there are many scholarly texts which have investigated the field from different perspectives, and graphic design has consequently been the province of design and art history, cultural and media studies alike.

In addition, there have been several worthwhile attempts to synthesise a wider range of areas and practices such as Michael Twyman's *Printing 1770-1970*, Philip Meggs's *A History of Graphic Design*, and more recently, Richard Hollis's *Graphic Design – A Concise History*. Each of these authors, however, has his own distinctive approach to the subject. Whilst both Meggs and Hollis, for example,

share a similar methodology with regard to biography and issues of style, they write within different temporal and geographical parameters. The former begins his survey in prehistoric times and concludes with the impact of computer technologies in the late twentieth century, taking in Egyptian, Chinese, Japanese, European and American material in the course of his discussion; the latter similarly terminates his study with an assessment of electronically generated graphics but begins with the Art Nouveau period and concentrates on American and European practices. As both of these approaches demonstrate, there is huge latitude not just in what can be legitimately categorised as graphic design but also how far back in time the subject can be traced.

Although it is not our intention to dismiss the contribution of such authors, the methodology we have taken in constructing this evaluation of graphic design emanates from more particular historical guidelines and different ideological and aesthetic concerns. In order to attain a sense of focus and depth of analysis in this book, we decided at the outset to concentrate on European material which is the primary area of our research interests and through which we could argue our points more cogently. We appreciate that this overlooks the important traditions and practices of graphic design in other countries, however, not least American graphic design in the twentieth century (there is, nonetheless, an assessment of the latter whenever it impinges on Europe). Furthermore, whilst we would not wish to be overly prescriptive in determining what does and does not constitute graphic design, in general terms we would regard the three following interdependent factors as quintessential in circumscribing the field - namely, that all images are mass-reproduced; that they are affordable and/or made accessible to a wide audience; and that graphic design is not just a question of presenting pictures in isolation but more a means of conveying ideas through the juxtaposition or integration of word and image into a holistic entity. It follows, therefore, that chronologically we take our starting-point in the period after the Industrial Revolution and more particularly the early nineteenth century, when patterns of both production and consumption were greatly altered by the shift towards a mass, commercial culture. As we argue, by this time graphic techniques such as wood engraving and lithography had a significant part to play in generating cheap and widely circulated media such as catchpenny prints and illustrated weeklies, and market demand for them had also been greatly bolstered by a burgeoning urban population and improvements in literacy and earnings that applied to all strata of society including, albeit on a limited basis, the working classes. In turn, this approach helped us to alight upon

which designers and which areas of graphic design we should include in this study. Goya's series of prints *Los Caprichos* (1799) or the book production of the Arts and Crafts Movement in the late nineteenth century, for instance, whilst qualifying in terms of reproducibility and the intertextuality of word/image have been excluded, since they were both issued in limited editions and cannot be seen as directly contributing to the development of a more democratic and commercial identity for graphic design. In contrast, the caricatures of Daumier have been included in so far as they were more widely circulated in the context of periodicals like *Le Charivari*, *La Caricature* and *Le Journal Amusant*, and as such can be seen to satisfy all three criteria mentioned above.

Nonetheless, this study encompasses a diverse range of processes (printmaking, photography, photomontage, typography, digital technologies) and media (advertising, posters, periodicals, propaganda, record sleeves), but we have tried to look at both in fresh ways by incorporating much new visual material alongside more familiar images and by placing them into a more discursive framework around thematic contexts. It is not our intention to present a neat and hermetic narrative history of graphic design from the nineteenth century to the present time, based exclusively on a succession of period styles or a series of technical innovations, nor to prioritise the careers of individual, well-known designers, although there is history, discussion of style and technique, and biographical detail to be found in each of the respective chapters. Toulouse-Lautrec, for example, appears in the chapter discussing the codification of pleasure and gender in *fin-de-siècle* poster design, and Herbert Bayer in the chapter on modernist graphic design. Moreover, the inclusion of so many male practitioners in the text would appear both to suggest a paucity of female designers within the field and to relegate whatever contribution women have had to make to graphic design as second rate. There are, indeed, only a handful of female designers discussed in the following chapters – Clémentine-Hélène Dufau with regard to *fin-de-siècle* poster production, for example, or Fiona Adams in the context of commercial photography during the 1960s – but it would be myopic to dismiss the role of female practitioners in graphic design purely on the basis of head-counting and, as we argue, the contribution of these women was every bit as significant as their male counterparts. In terms of representation, the situation is clearly reversed and the objectification of women in all forms of graphic imagery is hard to overlook. Thus gender is one of the central issues addressed in this book and it fits well with our general aim to explore graphic design on an ideological level by placing it into its artistic, social and political contexts - a methodology which we feel is

crucial to a full and richer understanding of the field. Other important issues which are discussed in the following chapters include the representation of pleasure, class, generation and ethnicity; period style and taste; the censorship and official policing of graphic texts; the impact of new consumers and readers on the production and circulation of graphic images and symbols; and the role of new technologies in the evolution of graphic languages or what William Ivins jun. refers to in *Prints And Visual Communication* as 'nets of rationality'.

Perhaps the most persistent and overarching theme to emerge in this book is the way in which meaning is constructed through an analysis of word and image relationships, and it is worth underlining this point since the more one explores different areas of graphic design from posters to photojournalism, advertising to record sleeves, and corporate identity to cartoons, the more they seem to be predicated on such a formal symbiosis. Hence, in the following chapters we are clearly not involved in discussing type-forms and illustrations as distinct from each other, but instead have expressed the interplay of visual and verbal elements in any given piece or area of graphic design. This is a point which many graphic designers have also sought to emphasise; Tibor Kalman as quoted above, for instance, and the poster artist A. M. Cassandre, who argued before him that: 'The design must revolve around the text and not the other way around.'[4] Of course, the intertextuality of word and image is not always such a straightforward or harmoniously balanced concept, and whereas many designers have been consciously involved in integrating the two elements, many critics since the middle of the nineteenth century onwards have commented on the insidious nature of the image in taking control of the spectator's understanding of events: Charles Knight, the founder of *Penny Magazine* discussed in chapter 1, remarked in his memoirs that pictures were 'true eye-knowledge' which were also 'sometimes more instructive than words', while Guy Debord contested more critically in *The Society of the Spectacle* (1967) that: 'For one to whom the real world becomes images, mere images are transformed into real beings'.[5] At the same time, the mass circulation of graphic images has often been viewed with suspicion and the moral implications of some forms of representation and spectatorship, namely those dealing with murders, sex and sensational events, have been regularly impugned. In the wake of the murders perpetrated in the East End of London by Jack the Ripper in 1888, for example, *Punch* struck a more cautionary note, printing a satirical cartoon entitled *Horrible London: Or, The Pandemonium Of Posters*, accompanied with the following rhyming doggerel:

These mural monstrosities, reeking of crime,
Flaring horridly forth amidst squalor and grime,
Must have an effect which will tell in good time,
Upon legions of dull-witted toilers.[6]

In organising the material included in the book, the chapters have been arranged both chronologically and thematically as distinct critical essays, starting with a discussion of wood engraving and the evolution of the popular illustrated weekly in the nineteenth century, and closing with an evaluation of postmodern practice and the implications of the new digital technologies on the nature of graphic design and the role of the graphic designer. Thus respective chapters may be read either out of sequence and in isolation or adductively and *in toto*. In each case, we have treated the material paradigmatically and it is in this sense that we make no claim to have written a definitive history of graphic design. The chief aim of our project has been to interrogate a subject area which is, both in terms of form and content, in constant flux. Consequently, this book has been conceived and written in the spirit of what sociologist Karl Mannheim would call a hermeneutic circle – not only to stimulate the reader into his/her own fields of further enquiry, both through the line of argument pursued in and the suggested reading cited at the end of each chapter, but also to encourage the idea that graphic design has unlimited potential for study with regard to methods of reproduction and codes of representation.

Notes

1 W. A. Dwiggins, writing in the *Boston Transcript* (29 August 1922), stated, 'Advertising design is the only form of graphic design that gets home to everybody.' See P. Rand, *A Designer's Art* (New Haven and London, 1985), p. xi.

2 For Katsumie see R. Hollis, *Graphic Design, A Concise History* (London, 1994), p. 136.

3 T. Kalman, 'Good history, bad history', *Design Review* (Spring 1991), p. 51.

4 A. M. Cassandre, cited in H. Mouron, *Cassandre* (London, 1985), p. 19.

5 C. Knight, *Passages of a Working Life* (London, 1864), vol. 2, pp. 262 and 284; and vol. 3, p. 82; G. Debord, *The Society of the Spectacle* (1967), translated by D. Nicholson-Smith (Massachusetts and London, 1994), thesis 18, p. 17.

6 *Punch* (13 October 1888), pp. 170–1.

Suggestions for further general reading

C. Ashwin, *History of Graphic Design and Communication - A Source Book* (London, Pembridge, 1983).

R. Barthes, *Camera Lucida* (London, Jonathan Cape, 1982).

INTRODUCTION
———

L. Blackwell, *Twentieth-Century Type* (London, Laurence King, 1992).

E. Booth-Clibborn and D. Baroni, *The Language of Graphics* (London, Thames and Hudson, 1980).

R. Hollis, *Graphic Design – A Concise History* (London, Thames and Hudson, 1994).

Interbrand, *Brands: An International Review* (London, Mercury, 1990).

W. M. Ivins, Jun., *Prints And Visual Communication* (New York, Da Capo, 1969).

R. Lister, *Prints and Printmaking* (London, Methuen, 1984).

A. and I. Livingstone, *Graphic Design and Designers* (London, Thames and Hudson, 1992).

K. McCoy, 'Graphic design: sources of meaning in word and image', in *Word and Image* (January–March 1988).

P. Meggs, *A History of Graphic Design* (London, Allen Lane, 1983).

J. Moran, *Printing Presses* (London, Faber & Faber, 1973).

J. Müller-Brockman, *A History of Visual Communication* (Teufen and New York, 1971).

B. Newhall, *The History of Photography* (New York, Museum of Modern Art, 1972).

W. Olins, *Corporate Identity* (London, Thames and Hudson, 1989).

W. Owen, *Magazine Design* (London, Laurence King, 1991).

R. Philippe, *Political Graphics: Art As Weapon* (Oxford, Phaidon, 1984).

P. Rand, *A Designer's Art* (New Haven, Yale University Press, 1985).

A. Solomon-Godeau, *Photography At The Dock – Essays on Photographic History, Institutions, and Practices* (University of Minnesota Press, 1991);

S. H. Steinberg, *500 Years of Printing* (Harmondsworth, Pelican, 1979).

M. Twyman, *Printing 1770–1970* (London, Eyre & Spottiswoode, 1970).

Victoria and Albert Museum, London, *The Poster Collection to 1988* (on microfiche).

A Weill, *The Poster: A Worldwide History and Survey* (London, G. K. Hall, 1985).

J. Winship, *Inside Women's Magazines* (London, Pandora, 1988).

1

A medium for the masses I: the popular illustrated weekly and the new reading public in France and England during the nineteenth century

> Mass circulation journals became as central a feature of the industrialisation and urbanisation of Britain as did its coal, iron and textile industries (Scott Bennett, 'Revolutions in thought – serial publication and the mass market for reading', in *The Victorian Press: Samplings and Soundings*, 1982).

The evolution of popular illustrated journalism during the nineteenth century constitutes one of the largest markets within a nascent leisure industry for the production of graphic design at that time. By 1900 there were 2,328 magazines and reviews in circulation across the British Isles and it is likely that the majority of these would have been illustrated in one way or another.[1] In France, a similar situation prevailed and there were over 1,300 illustrated periodicals produced in Paris between 1800 and 1899 (see table 1.1).[2] These catered for all tastes and included magazines for women and children; fashion and arts periodicals; satirical and political journals (these are discussed more fully in Chapter 2); magazines for illustrated news and entertainment; literary reviews and numerous types of specialist periodicals. In England the best known and longest-surviving titles were the *Illustrated London News* (*ILN*; 1842-present), *Punch* (1841-1992), *London Journal* (1845-1906), *Cassell's Illustrated Family Paper* (1853-1932), *English Illustrated Magazine* (1883-1913), *Art Union* – later the *Art Journal* – (1839-1912) and the *Graphic* (1869-1932) and in France titles such as *Le Magasin Pittoresque* (1833-1938), *L'Artiste* (1831-1907), *L'Illustration* (1843-1943), *Le Journal Illustré* (1864-1900?) and *Le Charivari* (1832-1937).

Clearly, with such an abundance of journals swelling the market the need to attain a regular and healthy circulation was paramount. Tables 1.2 and 1.3 enumerate the numbers of titles which folded and those which survived in France between 1800 and 1899 (similar figures for Britain can be found in Alan J. Lee's *The Origins*

of the Popular Press 1855–1914)[3] and it is interesting to note that by the turn of the century just over 20 per cent of all the titles published were still available. From the very outset, it was realised that

Starting date					Category					
	A	C	CP	E	F	M	D	G	S	Total
1800-04	1	0	0	0	0	0	0	0	0	1
1805-09	0	0	0	0	0	0	0	0	0	0
1810-14	0	0	1	0	0	0	0	0	0	1
1815-19	0	0	4	0	0	0	0	0	0	4
1820-24	0	3	0	0	0	1	1	6	0	11
1825-29	0	2	0	0	0	5	0	3	2	10
1830-34	1	4	2	0	1	9	0	3	2	22
1835-39	1	7	0	2	0	16	2	1	1	30
1840-44	4	4	0	2	0	14	3	5	3	35
1845-49	2	4	21	7	1	3	4	10	11	63
1850-54	3	6	0	4	2	4	7	7	7	40
1855-59	5	11	0	4	8	13	6	18	20	85
1860-64	8	12	1	8	4	13	2	23	24	95
1865-69	5	41	6	6	4	13	2	13	23	113
1870-74	4	12	36	4	4	18	1	13	14	106
1875-79	11	23	14	2	3	12	6	7	21	98
1880-84	15	64	13	7	7	17	2	30	32	184
1885-89	19	28	10	3	7	16	1	30	33	147
1890-94	18	13	1	5	7	21	5	25	45	140
1895-99	29	10	2	5	4	14	2	26	44	136
Totals	126	242	110	59	52	188	45	220	280	1,322

Source: see table 1.3

Table 1.1] Number of illustrated weeklies which started in France, 1800–99

Folding date					Category					
	A	C	CP	E	F	M	D	G	S	Total
1800-04	1	0	0	0	0	0	0	0	0	1
1805-09	0	0	0	0	0	0	0	0	0	0
1810-14	0	0	0	0	0	0	0	0	0	0
1815-19	0	0	5	0	0	0	0	0	0	5
1820-24	0	3	0	0	0	1	0	3	0	7
1825-29	0	1	0	0	0	1	0	4	0	6
1830-34	0	5	0	0	0	6	0	0	1	12
1835-39	0	2	1	1	0	10	1	3	1	19
1840-44	3	6	0	0	0	8	1	3	1	22
1845-49	3	2	19	6	0	4	2	9	11	56
1850-54	1	7	1	3	1	1	2	6	4	26
1855-59	1	7	1	4	5	2	9	9	14	52
1860-64	6	6	0	2	1	11	1	20	14	61
1865-69	5	29	6	9	3	9	4	12	23	100
1870-74	1	16	35	6	5	10	3	10	14	100
1875-79	8	20	8	2	3	13	2	8	7	71
1880-84	13	58	11	5	8	18	3	18	24	158
1885-89	9	36	10	0	3	16	1	27	27	128
1890-94	16	13	5	2	6	16	5	23	35	121
1895-99	24	12	2	4	6	17	4	23	39	131
Totals	91	220	105	45	41	147	38	178	213	1,078

Source: see table 1.3

Table 1.2] Number of illustrated weeklies which folded in France, 1800–99

Exist date	Category									
	A	C	CP	E	F	M	D	G	S	Total
1800	1	0	0	0	0	0	0	0	0	1
1805	0	0	0	0	0	0	0	0	0	0
1810	0	0	0	0	0	0	0	0	0	0
1815	0	0	1	0	0	0	0	0	0	1
1820	0	0	0	0	0	0	0	0	0	0
1825	0	0	0	0	0	0	1	4	0	5
1830	0	1	1	0	0	7	1	2	0	12
1835	1	0	1	1	1	8	3	6	1	22
1840	3	3	1	1	1	13	4	3	1	30
1845	3	3	1	1	1	19	7	6	5	46
1850	2	3	3	4	3	18	8	6	5	52
1855	4	3	1	7	4	19	12	9	7	66
1860	7	9	1	5	6	33	10	20	14	105
1865	10	13	3	10	10	35	9	15	25	130
1870	10	17	3	6	7	38	6	18	16	120
1875	17	20	3	5	10	43	6	25	24	148
1880	15	37	9	8	9	48	9	29	43	206
1885	20	33	12	8	8	40	9	36	45	210
1890	31	25	8	13	12	38	8	35	56	223
1895	36	24	5	14	14	44	9	37	66	249
1899	35	23	5	14	11	42	7	42	65	244

Source: P. J. Jobling, *The Evolution of the Popular Illustrated Press in Nineteenth-Century France*, unpublished MA thesis, Royal College of Art, London (1983), Appendix II, pp. 287-96. The same text also contains a fuller citation of each of the titles associated with a particular category - See Appendix I, pp. 234-86.

Codes used for periodicals are as follows:
A - fine and applied arts; C - caricature (non-political); CP - caricature with a political bias;* E - children's periodicals; F - family periodicals; M - fashion periodicals; D - women's periodicals; G - general interest and magazines for illustrated news; S - specialist periodicals, including literary and scientific reviews.

(* The distinction has been made between categories C and CP since in France until 1870 all literature concerned with politics was subject to stamp duty and until 1881 caution money. Both measures were instrumental in curbing the growth of the illustrated press, as indicated by the above figures which show that the largest number of CP magazines were published when these measures were relaxed between 1848-49 and 1870-71 and after 1881.)

Table 1.3] Number of illustrated weeklies which existed in France, 1800-99

the popularity of no periodical could be taken for granted and that its visual appeal and selling price were fundamental factors determining success or failure; witness Duranty writing in 1870:

> To set up a journal is the most risky of speculations; whatever kind of journal it may be.
> Often the best ideas run aground and the ridiculous schemes succeed. At the same time it is axiomatic to have lots of money or nothing to create a magazine.[4]

It is the intention of this chapter, therefore, to account for the production and consumption of the illustrated press during the nineteenth century and to assess the technological, aesthetic and socio-economic factors which were strategic in forming a market

for it. We will examine the role and function of the widespread reproducible image with regard to wood engraving and photomechanisation and the ways in which popular illustrated weeklies were imputed to transcend class barriers by encouraging the democratisation of visual culture and the spread of literacy.

The discussion which follows is based largely on the iconography of *ILN* and *The Illustrated Police News* in England and *Le Magasin Pittoresque* and *L'Illustration* in France. All of these titles were long-runners and widely-circulated and as such they constitute a typological paradigm of the new kind of mass weeklies available during the period. At the same time, several other periodicals have been included in this argument for the purpose of comparison.

Wood engraving and illustrated journalism

During the late eighteenth and early nineteenth centuries it can be claimed with some certainty that those illustrated magazines which existed, did so as the exclusive reserve of the upper and middle classes, being sold on subscription for a minimum of one month or more likely for three. These consisted mostly of women's magazines and fashion reviews such as *Le Cabinet des Modes* (1785-92) and *La Belle Assemblée* (1806-36), which had expensively reproduced copperplate etchings or engravings, and satirical magazines such as *Le Nain Jaune* (1814-15), *La Caricature* (1830-35) and *Le Charivari*, which contained lithographic caricatures.[5] The images incorporated into these magazines were usually printed *hors texte* and appended as collectors' plates at the back of each issue, with the exception of *Le Charivari* which printed letterpress on the verso of its lithographs, but with the repopularisation of wood engraving at the end of the eighteenth century it became possible to print text and image simultaneously.

Wood engraving was executed on the end grain of hardwoods such as box and cherry and was consequently extremely durable, yielding larger print runs than copperplate engravings and etchings. At the same time, as a relief process in which the inked surface was compatible with the letterpress, it had a distinct advantage over lithography and intaglio, which had to be printed independently from the text. In England, Thomas Bewick pioneered the commercial application of wood engraving in book illustration with *A General History of the Quadrupeds* (1790) and *A History of the British Birds* (1797) whilst in France at roughly the same time Papillon claimed that Foy had begun to engrave on the end grain of pear and box.[6] At the start of the nineteenth century, the trade for popular broadside imagery and catchpenny prints which

depicted scenes of murder and morality exploited both woodcut and wood engraving, but it was not until the early 1820s that wood engraving seriously began to have an impact on the printing of cheap periodicals, starting in England with the publication of the *Mirror of Literature, Amusement and Instruction* and the *Mechanic's Magazine* in 1823.[7]

One important reason for this delay lay in the fact that the power-driven presses which were suitable for the printing of large runs of cheap papers had not long been available and were relatively expensive to buy. Koenig had first applied steam power to the traditional flat-bed press in 1810 and to the cylinder press in 1812, but due to their high cost, £900 for a single-cylinder and £1,400 for a double-cylinder press, they did not accrue a large following. *The Times* bought its first double-cylinder Koenig press in 1814 and in 1821 it was first used in France.[8] By the 1820s other cheaper and more effective prototypes came into operation in both countries and included the Applegath and Cowper four-cylinder press which was capable of printing 4,000 impressions per hour and was used by *Penny Magazine* in England and *Le Magasin Pittoresque* in France.[9] Moreover, the new power presses were initially shunned by printers and typesetters in France and England who greatly feared that their livelihoods were being put at risk by the onset of mechanisation. During the uprisings in Paris in July 1830 employees in the printing trades destroyed as many of the mechanical presses as they could in an attempt to renew faith in hand-driven machines, but as Firmin Didot was to point out, the advent of the power-driven presses had resulted in the need for more workers rather than the reverse.[10]

Professional practice and the role of the designer

The widespread application of wood engraving also depended as much on the consolidation of a feasible work-force. Shortly after the end of the Napoleonic Wars, Brevière set up a wood engraving studio in Rouen and at roughly the same time two of Bewick's disciples, John and Charles Thompson, established a workshop in Paris.[11] It was the latter who contributed to some of the earliest books in France to be illustrated with wood engravings and who along with another of Bewick's pupils, John Jackson, were to be instrumental in preparing the blocks for the *Penny Magazine* and in turn *Le Magasin Pittoresque* (figure 1). From small beginnings in the first quarter of the nineteenth century (John Jackson had commented in 1825 on the paucity of wood engravers in England and in December 1832 Édouard Charton noted that there were a mere eight engravers in France, including Andrew, Best and Leloir, who

had been responsible for carving many of the illustrations in *Le Magasin Pittoresque* and *L'Illustration*), by the second half of the century wood engraving had clearly become an established way of earning a living.[12] In 1851, for example, *Robson's London Directory* had listed forty-two wood engraving firms, whilst in 1857 *L'Artiste* remarked that there existed several large studios in Paris.[13]

But the consolidation of the number of employees within commercial wood engraving was also predicated by economic circumstances and the comparatively humble artistic status of the technique itself and of the practitioners within the profession. In the production of wood blocks, the division of labour between the artist/illustrator and the engraver on the one hand and the different levels of engraver on the other meant that wood engraving, unlike more autographic media such as lithography and intaglio, was regarded by many critics and collectors as a

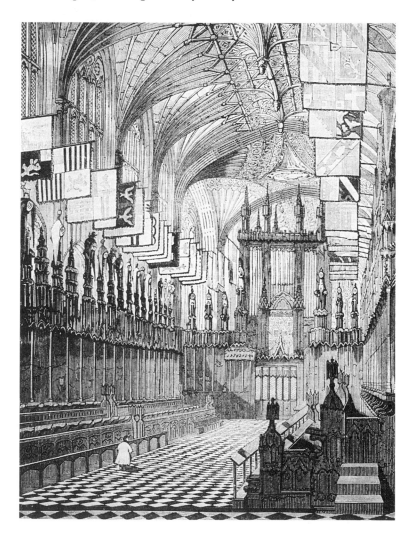

1] Interior of Windsor Chapel, wood engraving by John Jackson, *Le Magasin Pittoresque*, vol. 2 (1834).

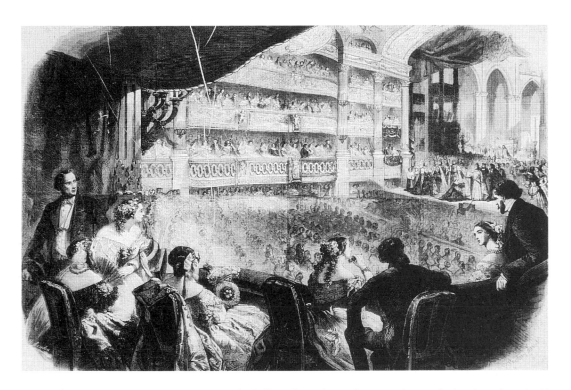

2] Double-page wood engraving of interior of Paris Opera during a performance of *Le Prophète*, *Le Monde Illustré*, 43 (February 1858).

commercial skill rather than the province of the 'true' artist.[14] Earnings within the profession were consequently variable and it is difficult to glean any definitive picture of professional practice. W. J. Linton, for example, is known to have earned over £1,764 for the work he produced for *ILN* between January and October 1846, but claims to have spent considerable amounts of money on materials and the maintenance of tools and his studio.[15] Moreover, as the standard size of the hardwood blocks used in wood engraving was roughly six square inches, any large-scale illustrations would have necessitated the formation of a composite block for which the requisite number of smaller separate pieces were bolted together. The most common practice was to divide the block amongst a team of engravers according to their individual expertise and afterwards for the chief craftsman to reconstitute it and to rectify any tonally weak or incompatible areas before printing. Sometimes the joins and cracks in the composite block were still visible in the published illustration (figure 2). Many wood engravers preparing cuts for the weekly illustrated press were also expected to work night shifts in dimly-lit studios in order to meet the necessary deadlines (according to *L'Illustration* there were usually five clear working days devoted to preparing the illustrations which were to be included in any particular issue).[16]

Henry Vizetelly, one of the most prolific wood engravers working in England during the nineteenth century, testifies in his

memoirs that piece-work of this kind was the usual method of remuneration with the price being fixed for every square inch of the woodblock to be carved.[17] More specific corroboration of this practice is furnished by bills to established engravers in 1842 which cited various rates of pay, starting with four or five shillings for the tiny silhouetted visual puns or 'blackies' executed by William Newman for *Punch* to twelve guineas for large cuts designed by Phiz (Hablot Browne).[18]

Little is recorded of the wages or conditions of wood engravers in France, but what evidence there is suggests a similar hierarchical structure. In 1834, for instance, *Le Magasin Pittoresque* reported paying 600 francs for some engravings and this sum was most likely paid either to the Anglo-French triumvirate Andrew, Best and Leloir or to Jackson or Thompson.[19] In marked contrast, the rates paid to less celebrated engravers were not only much lower but also hardly prone to improvement. A census carried out in 1848 by the *Comité du Travail* recorded average earnings of four francs per day for men and two francs per day for women employed in the printing, engraving and papermaking industries.[20] By comparison, a report into the working conditions of wood engravers in 1867 revealed that earnings were static, with average daily rates still standing at four francs (lithographers had earned at least five francs per day as early as 1824), and it painted a picture of unremitting hardship:

> Our salary is going down . . . and our needs are increasing in an appalling fashion. It is impossible . . . that today as everything gets unspeakably more expensive and when wages stay the same . . . for the average worker to feed himself on his earnings.[21]

The conditions of service were evidently arduous for most people employed in wood engraving, but the position of women within the profession was especially dismal. Women were employed on both sides of the Channel, yet their names very rarely appear in the picture credits of illustrated periodicals and books. In this respect, it is somewhat easier to glean an idea of how women slotted into the printing industry in England than in France. Several art schools, including Fanny McIan's Female School of Design, ran wood engraving classes for women and in 1838 Henry Cole had advocated that wood engraving could become a suitable occupation for 'educated gentlewomen of the middle classes', offering 'an honourable, elegant and lucrative employment, easily acquired, and in every way becoming their sex and habits'.[22] It is difficult to know exactly whether Cole meant that middle-class women were best suited to drawing designs or to carving the blocks. At any rate, the latter activity was exceptionally hard on the hands

and the eyes and was commonly regarded more as drudgery rather than the 'elegant' form of craftsmanship he implies it to have been. John Ruskin, for instance, exclaimed in one of the lectures he delivered in 1872 on the conditions of service which most wood engravers encountered, 'Mrs Beecher Stowe and the North Americans fancy they have abolished slavery.'[23] Furthermore, as we have already seen, the profession was hidebound by hierarchical structures and within such a context women still found it more difficult than men to secure employment after their initial apprenticeship. They were excluded from joining the print unions because of over-employment in the printing trade, nor were male-dominated workshops always willing to take on women, because sexual decorum demanded that they have separate workrooms.[24] Wood engraving may have been one of a few 'respectable' careers that unmarried women could pursue, but it was not one which offered the prospect of much personal advancement:

> The utmost that could be hoped for is, that after a hard practice of about two years, she might become sufficiently skillful to cut well enough for the cheap illustrated periodicals. In another two years, if kept in sufficient employment, she may be qualified to take rank among the average professional engravers of the day, which indeed, is no great position to take as an artist; but sufficient with connexions to obtain employment.[25]

As this comment suggests, those women who did succeed in breaking into such a patriarchal system did so as a result of having the right initial contacts and family ties. Thus all three of John Thompson's daughters, Eliza, Isabel and Augusta, became wood engravers, as did John Byfield's sister Mary, and Sam and Thomas Williams's sister Mary Ann.[26] Similarly, Kate Greenaway, whose father John had been a wood engraver for the *ILN* and *Punch*, went on to become one of the most successful children's book illustrators after she opened a studio in 1877 with the wood engraver Edmund Evans. In France the picture is even more sketchy, but once again family ties could assure a certain amount of credibility; the daughters of Laisné were both employed as engravers during the 1830s and 1840s.[27] Apart from this, a mysteriously-named 'Mlle B' is credited for having engraved a single block for the second volume of Hetzel's *Le Diable À Paris* (1845–46), whilst Maria Chenu is the only female credited by *L'Illustration*, for the work she executed in 1862.[28] Chenu, better known as a genre painter, was cited, however, as an illustrator rather than an engraver, and as her name appears for one year only we may assume that she was supplementing her income as an artist by contributing to the illustrated press, in itself a common practice at the time.[29]

The market demand for illustrated weeklies

After 1830, therefore, wood engraving had asserted itself as the most prevalent and viable method of illustrating periodicals, whilst the formation of a feasible work-force of wood engravers and the relative cheapness of their labour not only helped to keep down the cost of producing an illustrated magazine, but also of consuming one. It is instructive in this respect to note, for example, that the fashion weekly *La Mode Illustrée* (1859-1937) would cost eighteen francs for an annual subscription if published with steel engravings and twelve francs with wood engravings.[30] Similarly, *Le Magasin Pittoresque*, which utilised wood engraving until the 1890s, remained one of the cheapest periodicals available, retailing at a modest ten centimes (the equivalent of one old penny) per issue for most of its career.[31]

One of the earliest and cheapest of the new illustrated weeklies to utilise wood engraving was the *Penny Magazine*. Launched in 1832, it was one of several titles published under the auspices of the Society for the Diffusion of Useful Knowledge (SDUK), which had been founded in England by Henry Brougham in 1826 with the intention of producing cheap publications for the common reader, including didactic pamphlets on the natural sciences, geography and travel, history, mathematics and biography and a series of books for farmers and young readers.[32] Initially, however, these publications were met with indifference by their intended readership, and when Charles Knight, the Society's most important publisher, travelled to the industrial north, he found that SDUK publications had an insignificant circulation amongst the working classes. Writing in the 1830s, Francis Place attributed such apathy to inherent class suspicions: 'The Unionist will read nothing which the Diffusion Society meddles with - they call the members of it Whigs - and Whig means with them a treacherous rascal, a bitter implacable enemy.'[33] In marked contrast, the *Penny Magazine*, an eight-page weekly with short articles illustrated with wood engravings had accrued a following of some 214,000 readers per issue in its heyday, and was the first illustrated magazine to realise the potential of the mass market by espousing a deliberately populist and democratic ideology. As Charles Knight himself declared:

> The circulation of the Penny Magazine has opened new views as to the numbers of persons in the United Kingdom who are desirous to acquire information, when presented at a very low price, and at short intervals. For the first time, therefore, all classes may be reached more or less by a work which shall be the cheapest ever published.[34]

Penny Magazine was widely circulated and was not only available through the purchase of individual copies but could also be read

in working-class coffee-houses, factories, workshops and mech-
anics' institutes.[35] As a result, it attracted a broad spectrum of
readers ranging from the working to the middle classes, and
including at one end of the social scale a labourer from Hull called
Richard Sheldon, and at the other the illustrator for *Punch* and
Lewis Carroll's Alice stories, J. B. Tenniel, who read it in his
youth.[36] Its example was swiftly emulated by Édouard Charton in
France, who in 1833 founded *Le Magasin Pittoresque*. Like Knight
and the SDUK he eschewed an elitist approach and aimed to reach
a more catholic readership: 'Our magazine for two *sous* is a kind of
suitably different undertaking recommended to everybody; but is
particularly destined for all those who have but a humble amount
to devote to their pastimes.'[37]

In the wake of these two magazines, a flurry of popular illus-
trated weeklies began to appear after 1840, chief among them the
widely consumed penny weeklies *London Journal, Reynold's Miscel-
lany* (1846-69), and *Cassell's Illustrated Family Paper*, and the more
upmarket *ILN* in England and *L'Illustration, Le Monde Illustré*
(1857-1935) and *Le Journal Illustré* in France.[38] Within a few years
of publication the circulation figures of several of these weekly
periodicals were more or less guaranteed – *Reynold's Miscellany* had
a weekly circulation of some 200,000 copies in 1855 and according
to Henry Mayhew was avidly consumed by London's labouring
classes; *ILN* which cost five old pence initially attained a circul-
ation of 70,000 copies; *L'Illustration*, which retailed at seventy-five
centimes (roughly the contemporary equivalent of six old pence),
had a subscription rate of 48,000 copies.[39] It would appear, there-
fore, that the cheaper a periodical was to buy the more likely it
was to accrue a solid readership. As William Ivins Jun. suggests,
'It soon became evident that the greater public, while it had little
interest in the virtuosity of wood engravers or in wood engraving
as such, was very much interested in pictorial information at a
small price.'[40] But as competition stiffened, things were not to be
as straightforward as this and a low selling price could not auto-
matically guarantee healthy sales or the longevity of any
magazine. Magazines illustrated by means other than wood en-
graving, such as the satirical daily *Le Charivari* (1832-1937) and the
monthly arts review *L'Artiste* (1831-1907) in France, for instance,
managed to maintain their popularity among a relatively small
coterie of informed and well-to-do readers. *Le Charivari*, containing
lithographic caricatures, cost sixty francs per annum and had
around 2,500 subscribers between 1832 and 1846; *L'Artiste*, contain-
ing lithographic and intaglio plates, cost eighty francs per annum
and had a mere 500 subscribers in 1856.[41] The *Penny Magazine*,
meanwhile, which had started so promisingly in the 1830s, was not

able to sustain its original readership and finally ceased publication in 1846, due to competition from more lively prototypes such as *London Journal*, which led to spiralling overheads and diminishing profit margins.[42] By mid-century, therefore, astute financial management which exploited revenue from advertising, and perspicacious editorial policy which kept abreast of popular taste and emphasised the visual impact of illustrations were to be equally as strategic in a volatile buyer's market.

In 1864, *Le Journal Illustré* was launched in France as a rival to *L'Illustration*. The two periodicals were identical in terms of size and format, but *Le Journal Illustré* had seriously undercut the price of its rival, and retailing at ten centimes per copy had attained a respectable weekly circulation of 105,000 subscribers within the space of two years.[43] The discrepancy in the price of the two magazines can be attributed to two chief economic considerations: first, *Le Journal Illustré* devoted much more space to advertising and could use the revenue from this to subsidise production and circulation costs; and second, since 1860 *L'Illustration*, as a political weekly, had been subject to paying a cautionary deposit of 50,000 francs per annum to the Ministry of the Interior and, as was usually the case, reflected this cost in its retail price.[44]

The front cover of *Le Journal Illustré* of 12 February 1865 with a design by Georges Fath (figure 3) is testimony to its immense popularity and depicts a provincial scene where people of all ages, as well as different social and professional types, throng to buy the latest issue from a hawker. As such, the iconography of Fath's illustration strongly suggests that by the second half of the nineteenth century the illustrated press was being bought and read by all social classes and age groups. 'In every place magazines costing five, ten, twenty, twenty-five centimes are sold to all classes. After the revolution of 1848, the workers read avidly . . . the popular press published at that time, which seems to prove, so to speak, that it was a staple diet for the working classes.'[45]

After the 1848 revolutions in France, the economic situation had indeed begun to improve for most citizens. A survey carried out by the *Société Centrale des Architectes*, for example, revealed that building labourers in Paris in 1840 would have divested every penny of their earnings on basic essentials such as food, fuel, rent and clothing. No provision whatsoever seems to have been made for leisure pursuits, and what spare cash a worker had would probably have been spent on alcohol or tobacco rather than periodical literature.[46] To put this into perspective, an annual subscription to *Le Magasin Pittoresque* in 1850 would have been the equivalent to buying 150 eggs, 7½ kilos of meat, 25 kilos of bread and almost 10 steres of firewood.[47] Some members of the working

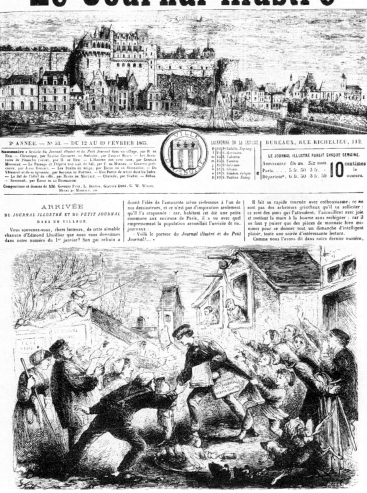

3] Cover of
Le Journal Illustré, 53
(12–19 February 1865).

classes, however, such as those employed in the glass and ceramics industries, who were earning more than the norm, would have had more spare cash to devote to pastimes.[48] In addition, even if an individual worker could not afford to purchase his own copy of any periodical, a communal subscription was a possibility and, as in Britain, there was the opportunity to consult a selection of the most popular dailies and periodicals in working-class cafés and *cabinets de lecture* (or reading rooms), 194 of which existed in 1840.[49] In 1825, a police report on one of the most notorious opposition dailies, *Le Constitutionnel,* commented both on its ubiquity and who was most likely to have been reading it:

> Which cafés, which reading room in Paris or in the whole of France doesn't have a *Constitutionnel*? . . . This paper has, perhaps, by itself

more readers than any of the others combined together ... It is the journal of the middle class and of the lowest classes. I would suggest it is the paper for everybody.[50]

By 1865, the year in which *Le Journal Illustré* first appeared, the economic situation appeared to be much rosier. The salaries of those in the building trade had risen by 25 per cent and at the same time the cost of living appeared to be rising more slowly. Furthermore, the nineteenth-century French economist Beauregard estimated that between 1820 and 1880 the cost of living had risen by just over one-third whilst salaries overall had doubled.[51] This meant that those workers in the building trade who in 1840 would have had but nothing to spare, by 1890 would have had some seventy francs per annum to devote to recreational and leisure activities.[52]

Testimony has already been cited here concerning the working-class readership in Victorian England for cheap weeklies like *Penny Magazine* and *Reynold's Miscellany*, but the demand for such periodical literature amongst the working classes would have been consolidated after 1860 by the surge of economic progress which had been grounded in industrial growth.[53] Between 1874 and 1896 the average family's disposable income rose by between 70 and 80 per cent and by the 1880s there had been a drop in the birth-rate amongst both the middle and working classes.[54] Accordingly, a significant number of the population began to have more money to devote to leisure for the first time in their lives. In turn, the economic prosperity of the illustrated press had been enhanced in England with the abolition of Stamp Duty in 1855 and Paper Duty in 1861 (the so-called 'Taxes on Knowledge'), which made it cheaper to produce and to consume periodicals. In 1865, there were 554 periodicals listed in the *Newspaper Press Directory* and over 1,000 newspapers in circulation in Britain - most of them founded after 1855.

The 1850s, therefore, mark the economic watershed when for the first time more people than ever before had spare cash to spend, and spurred on by the realisation of this, more entrepreneurs were willing to chance their luck in launching cheap illustrated weeklies to tap this potential market. Furthermore, as the front cover of *Le Journal Illustré* demonstrates, this market was to be found not just in big cities like Paris or London but, thanks to a growing network of railway communications, in the suburbs and smaller towns also.

Word and image: the new reading public

It is one thing to assert that most people would have had the wherewithal to afford an illustrated periodical after 1850 and quite

another to assume that they would have been predisposed to do so. As has already been noted, in France periodicals could be consulted in working men's clubs and cafés, whilst in Britain they could also be read free of charge in coffee houses as well as in the various Mechanics' Institutes and other organisations which existed for self-improvement. Consequently, another way of assessing the popularity of illustrated weeklies is to examine the extent to which they either benefited from or contributed to the development of literacy. As most features in the mass-circulation periodicals were enhanced with illustrations or diagrams which disrupted what Mallarmé was to call the dense *grisaille* ('greyness') of the 'unbearable column' we must also consider the renegotiation of word and image and the ways in which this could have made the prospect of reading a more attractive one.[55]

The development of literacy in both France and Britain had gained momentum in the wake of several key measures for education - in France these had included Guizot's Charter of 1833, the 1867 Education Act and Jules Ferry's Law of 1881, and in Britain the English Elementary Act of 1870 and the Scottish Education Act of 1872. As a result of such initiatives, over 90 per cent of all adults in both countries were believed to be literate by the turn of the century.[56] The role that literacy had to play in the propagation of the illustrated press is manifest in several ways. First, in the consolidation in the number of children's magazines - forty-eight new titles were published between 1850 and 1900, for example, in France, more than four times as many as had hitherto been available. Most of these were also reasonably priced, for example, *Le Magasin Illustré des Enfants* (1866) which cost five centimes; *La Semaine des Enfants* (1857-76) and the *Revue Catholique de la Jeunesse* (1850-51), which cost ten centimes apiece; and Hachette's *Mon Journal* (1881-1923), which was published monthly and cost fifteen centimes. Notwithstanding their low cost, few of the French children's magazines managed to survive and only fourteen managed to run for more than five years. As was the case with most other types of illustrated periodicals, there were simply too many offering a similar fare, and confronted with such an *embarras de richesses* the prospective consumer tended to stick with the more established titles; *L'Ami de L'Enfance*, founded in 1835, for example, and *Journal des Enfants*, founded in 1848, were both still going strong in 1880.

Second, it is evident in the number of illustrated journals which had a literary or didactic bias. In England these included *Reynold's Miscellany*, which contained popular serial fiction by its eponymous editor, and *Once A Week* (1859-65), *Good Words* (1860-71) and *The Cornhill Magazine* (1860-66), all three containing short stories

and serialisations by well-known authors like Elizabeth Gaskell and Anthony Trollope and illustrated by artists such as John Everett Millais, George Du Maurier and Arthur Boyd Houghton.[57] These magazines were aimed at the entire family and had their origins partly in popular illustrated serial editions of Dickens such as the *Pickwick Papers*, issued in nineteen monthly parts by Chapman and Hall between April 1836 and November 1837, and *The Old Curiosity Shop* and *Barnaby Rudge*, which had been serialised in *Master Humphrey's Clock* between 1840 and 1842, as well as in weekly illustrateds like *Penny Magazine* and *Le Magasin Pittoreque*, which had also aimed themselves at the broadest possible readership.[58] The kind of articles to be found in the latter were certainly diverse, covering topics as varied as the slave trade in America, metrication, itineraries to many different countries, biographies of important personalities and reviews of the artistic scene, as well as serialisations of Walter Scott's Waverley novels. Yet whether the subject-matter was banal or complex, most articles were succinct, written in a direct and straightforward manner and with no pretence to being esoteric or finely-spun works of literature. This is how *Le Magasin Pittoresque* promoted itself from the very outset in 1833:

> Our great ambition is to interest, to amuse; we let instruction follow on naturally without forcing a point . . . A swift examination of our articles will be enough to reveal that we have little literary ambition, and we wanted less to show off any talent or erudition which seek applause, rather more than a variety of knowledge, of taste and of morality. These are truly our only pretensions . . .[59]

This editorial makes no overt claims for the wood-engraved illustrations which adorned virtually every page of the popular weeklies and which formed an integral part of the narrative, often serving to sum up or foreground a particular passage of text through a judicious placement on the page. Yet as both Knight and Charton had realised, defining the interrelationship of words to images was just as serious a consideration affecting the size of any magazine's circulation as its selling price, and even when the standard of illustrations was lamentably poor and not in the least realistic, they were still printed.[60] The most common type of illustration to suffer from a desultory treatment was that representing current or topical events which, on account of their deadlines, the popular weeklies found it difficult, if not impossible, to portray with any degree of success. Figure 4, published in *L'Illustration*, for instance, depicts the royal wedding of Princess Clementine of Orléans to Prince Auguste of Saxe-Coburg in 1843, but the schematic figures appear more like puppets, and bear no resemblance to the actual persons represented.

4] Marriage of Princess
Clémentine of Orléans,
wood engraving, *L'Illus-
tration* (22 April 1843).

In such cases, the likelihood of the artist having been present is very
slim, and the illustrations which were finally printed were often
the result of embellishments or adaptations made to old blocks.
One of the most extreme examples of this practice was the first
issue of *ILN* which Henry Vizetelly claimed did not contain one
engraving that was completely original.[61] Indeed, the most consum-
mate illustrations were usually either the result of a sympathetic
collaboration between the draughtsperson and the engraver or
designed and carved by the same agency, as was the case with the
work of John Jackson (figure 1) and Andrew, Best and Leloir.

With the stiffening of competition during the 1860s, some
magazines began to emphasise the potency of the pictorial state-
ment and maintained that the written word was subservient to it.
Thus *Le Journal Illustré* in its very first issue on 14 February 1864
announced: 'Engraving speaks all languages, it is understood by all
nationalities. It is the authority that captivates; and the text, what-
ever it is, must be but its very humble servant.'[62] The idea
expressed here of a universal visual language can be attributed in
part to the commerce in images which occurred between one
country and another and which was to persist right through the
century. Many of the plates in *Penny Magazine* were also to be
found in *Le Magasin Pittoresque* during the early 1830s; the work
of the French caricaturists Gavarni, Daumier and Cham was pub-
lished in *Great Gun* during 1845; a French edition of *ILN* was
published during the 1850s; and during the 1890s the work of en-
gravers such as Smeeton and Tilly was featured in the *Magazine of
Art* and *L'Illustration*.[63]

As *Le Journal Illustré's* editorial also connotes, the public had
become much more visually, if not verbally, literate by the 1860s.

Certainly, in marked contrast to the small-scale vignettes and half-page illustrations that were a commonplace between 1830 and 1850, *Le Journal Illustré* did allow more autonomy to its engravings; as such they were often not illustrations to the text at all but highly-wrought pictures with brief captions which occupied a whole or a double page (figure 5). In their attention to detail and atmosphere, these images also paralleled the narrative structure and style of the popular realist novel, exemplified in France by Victor Hugo's *Les Misérables* (1862) and in England by Dickens and later by Trollope's *Chronicles of Barsetshire* (1855–67). Moreover, many of the illustrations published after 1860 were based on or copied directly from photographs and were produced, therefore, to satisfy a public who had clearly grown to anticipate the same degree of pictorial accuracy in illustrated journalism. Here we have the essence of a new form of spectatorship that was to be compounded by the development of the photo-weekly of the 1920s and which signals the shift to an iconocentric culture. Indeed, the centrality of the image in the illustrated press after 1850 was the cause of much dismay among many contemporary commentators, and William Wordsworth even composed a sonnet entitled 'Illustrated books and newspapers' in which he opposed the phenomenon in the following terms: 'Avaunt this vile abuse of pictured page! / Must eyes be all in all, the tongue and ear / Nothing'.[64] It would be erroneous to infer, however, that words merely became redundant in illustrated journalism during the nineteenth century. The editors of magazines may have

5] General view of Paris, double-page electrotyped wood engraving, *Le Journal Illustré* (21 February 1864).

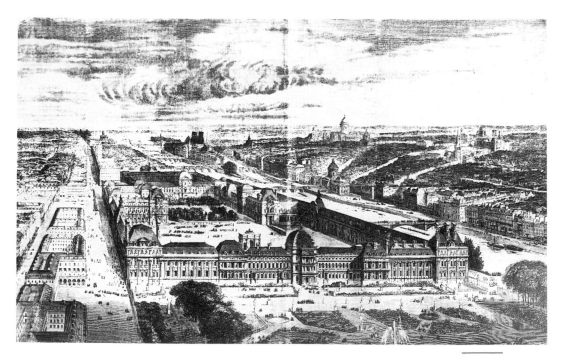

emphasised the authority of the image, and their readers may have believed that pictures were more accessible or direct than the written word, but the meanings of images reproduced in popular illustrated periodicals were at the same time always anchored or qualified by captions if not by editorial.

Photomechanisation versus wood engraving

By the 1840s the photographic industry had grown apace, particularly in the production of daguerreotype portraits and *cartes de visite*. The *carte de visite* was itself small in scale and sometimes difficult to make out, but it was cheap and, more importantly, seemed to offer an objectivity and verisimilitude which, as Charles Baudelaire attested with some scepticism, was for most people beyond reproach:

> A vengeful God has granted the wishes of this multitude. Daguerre was his Messiah. And now the public says to itself: 'Since photography gives us all the guarantees of exactitude that we could wish (they believe that, the idiots!), then photography and art are the same thing.' From that moment squalid society, like a single Narcissus, hurled itself upon the metal, to contemplate its trivial image.[65]

Notwithstanding the disavowal of photographic realism by critics like Baudelaire, the impact of the medium on the illustrated press manifested itself in two distinct phases after 1850, as we have already seen; somewhat insidiously in the first instance, in the way that wood engravings began to take on the tonal value and appearance of photographic images. This practice was particularly evident in the representation of works of art and architecture, topographic views and portraits, and there were two methods used to achieve such a photographic likeness: either a photograph was pasted directly on to the wood block, or a photographic negative was developed on a block that had been made light sensitive, and then the blocks were engraved. Moreover, following the invention of the solar camera by David Woodward in 1857, which made it possible to blow-up photographic negatives, large-scale illustrations became the norm.

The new photographic style of engraving that resulted was more tonal in appearance, with densely hatched lines and *criblée* work, as already seen in figure 5. Yet no matter how imitative of photography wood engraving became during this phase of its development, it is highly unlikely that the public would have put the same unquestioning faith in it as a mode of representation as in photography *per se*. Consequently, experiments in methods of photomechanical printing eventually led to the development

of process line engraving or *gillotage* by 1870 and the half-tone process by the 1880s.

The first of these techniques had originally been used by Firmin Gillot in the 1850s for transforming lithographs into relief blocks, and was later modified by his son Charles Gillot and Lefmann, who used photographic negatives to transfer the design to a light-sensitive metal plate.[66] From its inception, the process found application in the illustrated press. The satirical daily *Le Charivari*, for instance, which carried lithographic caricatures, switched over completely to process during the 1870s, and it also began to be increasingly utilised by weeklies like *ILN and L'Illustration* during the last quarter of the century.[67] The main drawback with process line engraving, however, was its inability to reproduce the tonal value of photographic images, and it was not until the development of photogravure in the 1880s that this became possible.

The chief method of photogravure was the half-tone process, which involved breaking down the image into a matrix of dots by photographing the subject through a screen of diagonal lines. The earliest examples of photogravure and half-tone in the illustrated press can be traced back to the 1880s in Europe and America – the *New York Daily Graphic* published its first half-tone on 4 March 1880, *ILN* in 1881 and *L'Illustration* in 1883.[68] Yet it was to take some years before half-tones totally supplanted more traditional reproductive printmaking media and before the hegemony of wood engraving was to be seriously challenged. We still find the latter being used by popular weeklies well into the 1890s in England and France. A study of the picture credits of *ILN* and *L'Illustration*, for example, reveals that a healthy number of wood engravers were still being employed between 1870 and 1900.[69]

There are several interdependent factors which help to explain the popularity of wood engraving in the face of the competition offered by photomechanisation. In the first instance, half-tones were more expensive and more painstaking to reproduce. They had to be printed on fine-grained smooth paper with a dusted finish, and for many years the cross-line screens which were necessary in their production were difficult to obtain. Moreover, the inventor of the half-tone process, Meisenbach, had guarded his original patent with secrecy and this left other printers in the unenviable position of having to work by trial and error.[70] It can be no coincidence, therefore, that the consolidation in the number of photogravure workshops during the 1890s, such as those of John Swain in England and Fernique in France, overlaps both with a marked increase in the frequency of half-tones in the established illustrated weeklies and the rise in the publication of new titles after 1895 (see table 1.1).

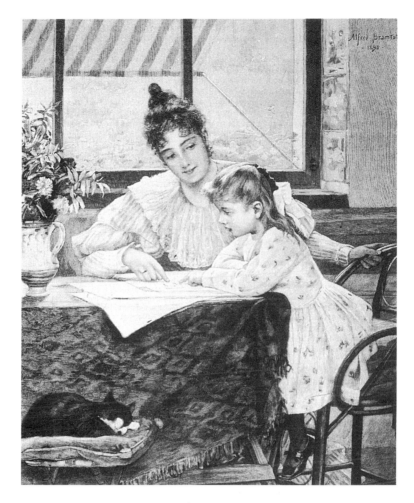

6] Wood engraving by
Émile Crosbie after
Bramtot's painting *La Leçon
du Lecture, Le Magasin
Pittoresque* (1893).

At the same time, wood engravers themselves appeared to be
galvanised by the challenge of photomechanisation and began to
produce some of their best work which, in its technical virtuosity,
could rival even the most successfully printed half-tones – for
example, for example, Crosbie's engraving of 1893 after Bramtot's
painting *La Leçon de Lecture* (figure 6). Such examples testify to the
fact that during the last quarter of the nineteenth century, wood
engraving was not only still a viable method of reproduction, but
that the status of the wood engraver had been enhanced rather
than undermined by the onset of photogravure. It is with some
justification that Henri Delaborde could write in 1889 that: 'the
vignettes which accompany the text no longer reveal the banal
imagery of former times, but more often an ingenious form of art,
competent rather than negligent, and, on many occasions, remark-
ably refined'.[71]

Representation, class and convention

One of the most significant areas in which wood engraving remained the preferred mode of representation was in the depiction of bloodthirsty or gruesome events where it was possible, with a certain amount of artistic licence, to print images which in photographic form would have been less palatable. As Walter Benjamin justly argued, therefore, the reproducible image in the context of mass-circulation weeklies demonstrated unlimited potential in its 'adjustment of reality to the masses and of the masses to reality'.[72] The editors of the popular illustrated weeklies had always been aware of the pulling power of the sensational, and the ability to record human disasters could mean big business. The circulation of the *Weekly Chronicle*, for example, soared to 130,000 copies after it had printed a series of illustrations after notorious murders in the 1830s.[73] The selling of murder as mass entertainment can be traced back to the broadsheets and ballads which were circulated during the early nineteenth century by Catnach in England (figure 7) and Pellerin in France, and which many workers probably used to decorate their homes – an illustration by John Leech in *Punch* in 1849, for instance, depicts the humble interior of a working family's home replete with two images of criminal activity hanging over the mantelpiece.[74] In the illustrated press scenes of suffering and death became more common during the 1850s and 1860s in representations of the Crimean and American Civil wars, and many illustrators such as Constantin Guys, who had been in the Crimea between 1854 and 1865, risked life and limb in their attempts to capture such events.[75] It is interesting to see, however, that even after the inception of photomechanisation, wood engravings after acts of violence were still the norm, and

7] A catchpenny print entitled *Dreadful account of a most barbarous and shocking murder committed by William Burt upon the body of his infant child, and the cruel manner in which he wounded his wife at Brighton*, wood engraving published by James Catnach, 1826.

during the late 1880s, newspapers and illustrated weeklies were handed one of the most gruesome stories yet.

From 31 August to 9 November 1888, women who lived in the Whitechapel district of the East End of London went in fear of a man dubbed 'Jack the Ripper', whose brutal sexual attacks left several prostitutes dead and horribly mutilated. The inability of the police to identify and to capture the elusive murderer led to a febrile climate of mistrust and myth-making in which the Ripper was believed to have dressed in women's clothing to lure his victims. The events in Whitechapel were widely reported by the press in uncompromising terms. On 10 September 1888, *The Daily Telegraph* contained the following description of the death of Annie Chapman:

> Early on Saturday morning a ghastly murder was perpetrated near Spitalfields market . . . The latest deed of ferocity has thrown Whitechapel into a state of panic . . . with so much cunning was the horrifying deed carried out that apparently no clue has been left which would serve to unearth the criminal . . . We are certainly led to . . . imagining the existence of some baleful prowler of the East End streets and alleys who . . . knows every bye place well, who is plausible enough in a dress to beguile his victims, strong enough to overcome them, the moment homicidal passion succeeds desire, cunning enough to select the most quiet hour and the most quiet spot for his furious assaults and possessed of a certain ghastly skill in using the knife.

In the first instance, weeklies like the *ILN* concentrated not on the actual killings which had occurred in Whitechapel, but on the lack of an adequate police guard and the poor state of housing and social deprivation in the area. Throughout the nineteenth century Whitechapel public houses had remained open from six o'clock in the evening until three the following morning, and barbaric and brutal murders had been common on the Ratcliffe Highway as early as 1811.[76] The 'certain ghastly skill in using the knife' reported by *The Daily Telegraph* was, however, amplified in the wood engravings which appeared in another popular weekly of the period, *The Illustrated Police News* (1867?-1938).

In such a context the *grand guignol* of the Ripper murders was fully indulged in graphic, if artless, detail. On 22 September and 20 October 1888, *The Illustrated Police News* had carried a series of vignettes collaged in a comic-book style which depicted many of the corporeal atrocities perpetrated by the Ripper, including images of Annie Chapman, the eighth victim, before and after death, and the discovery of a decapitated and limbless torso in Whitehall (figures 8 and 9). The standard of illustration, the format and the sensationalist tone of these articles were redolent of the kind of imagery to be found in the *Newgate Calendar* and the pictorial

fiction included in the penny dreadfuls of the 1860s such as *Boys of England* (1866–99). The latter had contained stories by Bracebridge Hemyng about a serial murderer called Jack Harkaway and which, aimed at a gullibly youthful and mostly working-class readership, was phenomenally successful – in its heyday selling 150,000 copies per week.

Whilst the inclusion of scenes of human disasters in illustrated periodicals during the nineteenth century meant that they could sustain existing circulation figures as well as pick up a more occasional readership, such illustrations were probably regarded more with mirth rather than being taken totally seriously by the public. Moreover, the predilection for representing bloodshed in woodengraved form testifies to a kind of 'visual etiquette' that allowed editors to satisfy the curiosity of their readers for grisly or horrific

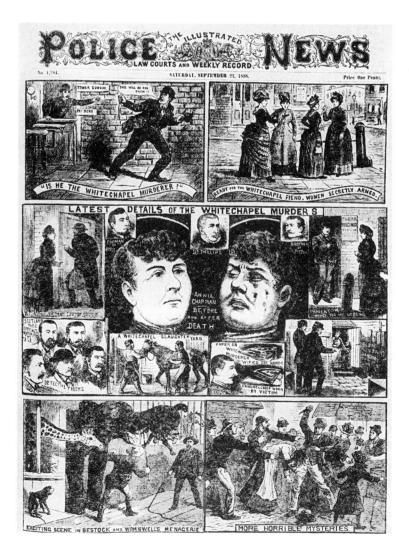

8] Wood engravings of 'The Whitechapel Mystery', *The Illustrated Police News* (22 September 1888).

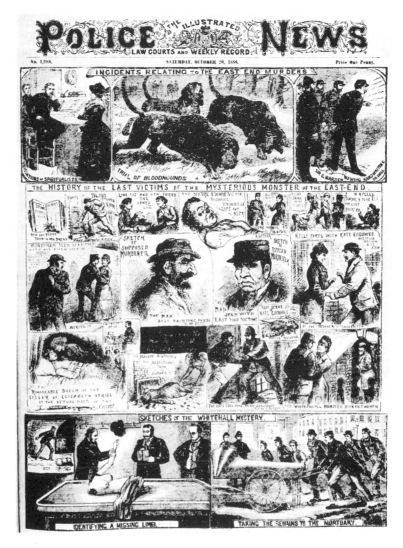

9] Wood engravings of
East-End murders, *The
Illustrated Police News*
(20 October 1888).

events without causing them too much distress or anxiety. As we
have already argued, the majority of readers of periodicals like *ILN*
and *L'Illustration* would have been by definition middle-class, and
this kind of editorial control was purposefully executed to repre-
sent events from an ideologically dominant and acceptable
perspective. This is evident not just in scenes of warfare and disasters
but in the depiction of the new urban poor of the nineteenth
century who, more often than not, became no more than senti-
mentalised types rather than real people, 'smudges in some crowded
panorama or as figures safely insulated within some charitable in-
stitution' (figure 10).[77] Indeed, most of the pictorial content of the
popular press at this time concerned itself with the world and
events of the *bon bourgeois* – scenes of glittering balls and nights at
the opera (figure 2); the latest fashions; the circumstances of the

royal families of Europe; portraits of the rich and famous; profiles of foreign lands and places to visit; reproductions of works of art – in effect, all manner of things which the middle classes could afford to see or do. Whilst this world was far removed from the actual experience of the working classes and appears to give emphasis to the idea that the majority of subscribers would have been well-off, at the same time we must bear in mind that for the working-class readers of popular illustrated weeklies such imagery was socially significant in so far as it enabled them at least to observe such activities and pursuits vicariously for minimum outlay.

Few of the best-selling illustrated weeklies, therefore, were overtly political in nature (with the exception of *L'Illustration*, discussed above) and many magazines played on the material gulf between one class and another by subverting it to their own ends – they may have been mere pence to buy, but at the same time could be extremely partisan in their editorial policy and in the items they chose to feature. For a much less culturally and ideologically hegemonic point of view we have to turn to other sources such as Henry Mayhew's *London Labour and the London Poor* (1851 and 1861), Hetzel's *Le Diable À Paris* (1845–46), both illustrated with wood engravings, or to the satirical press which lampooned all social classes and thereby provided a counter-cultural discourse with which to challenge the status quo. In its treatment of the Ripper case, for example, *Punch* sought not to dramatise the killings themselves but to ridicule the ineffectuality of the police in tracking down the Whitechapel Murderer ('Blind man's buff', 22 September 1888) and the social consequences of urban crime in its

10] 'Shoemaking at the philanthropic society's farm school at Redhill', by Frank Holl, *Graphic* (18 May 1872).

totality ('The nemesis of neglect', 29 September 1888). As Michael Wolff and Celina Fox contend:

> By keeping within the framework of convention, both as to the function and the tradition of subject matter and styles of depiction, the most successful and widely-read of the news and humorous illustrated magazines reveal the way of seeing of both artist and audience, and the constraints existing between the social experience of the city in everyday reality and its depiction on paper. The illustrated newspapers believed that their role was to depict truth without bias; the humorous magazines used bias to depict truth.[78]

Furthermore, those magazines which managed to survive depended also on a much more persuasive blend of word and image and, in some instances, prioritised images in themselves as the optimum way of captivating readers:

> Our bustling century does not always allow enough time for reading, but it always allows time for looking; where an article demands half an hour, a drawing takes a mere minute. It requires no more than a rapid glance to uncover the message it conveys, and even the most schematic sketch is always easier to understand than an entire page of writing.[79]

The faith in the pictorial statement and the interrelationship of text and image expressed here were of particular concern when it came to the production and circulation of political prints. Consequently the following chapter addresses such ideas in more detail with reference to the symbolism of the satirical and caricatural press during the nineteenth century.

Notes

1 Figures from *Newspaper Press Directory* (London, 1900).

2 These figures have been based upon those found in P. J. Jobling, *The Evolution of the Popular Illustrated Press in Nineteenth-Century France*, unpublished M.A. thesis, Royal College of Art London (1983), Appendix II, pp. 287-96. The same text also contains a fuller citation of each of the titles associated with a particular category – see Appendix I, pp. 234-86.

3 A. J. Lee, *The Origins of the Popular Press 1855-1914* (London, 1976), table 13, p. 282.

4 F. Duranty, *L'Illustration* (19 February 1870), p. 139.

5 For fashion periodicals see M. Ginsberg, *An Introduction to Fashion Illustration* (London, 1980), pp. 6-11, and A. Griffiths, M. Melot and M. Field, *Prints: History of an Art* (London, 1981), pp. 94-5. For early caricatural magazines see J. Grand-Carteret, *Les Mœurs et la Caricature en France* (Paris, 1888), p. 558. See J. P. T. Bury, *France 1814-1940* (London, 1969), p. 26 concerning subscriptions *c.* 1827.

6 For Bewick see W. J. Linton, The Masters of Wood Engraving (London, 1888) and U. Finke, 'English wood engravers and French illustrated books', in U. Finke (ed.), *French Literature and Painting* (Manchester, 1972). For Foy see

P. Gusman, *La gravure sur bois et épargne sur métal du XIV^e au XXe^e siècle* (Paris, 1916), which cites J. M. Papillon, *Traité historique et pratique de la gravure sur bois* (Paris, 1766).

7 For a fuller discussion of this iconography in Britain see T. Gretton, *Murders and Moralities, English Catchpenny Prints 1800-60* (London, 1980), and in France see Arts Council of Great Britain, *French Popular Imagery* (London, 1974).

8 J. Moran, *Printing Presses, History and Development from the Fifteenth Century Until Modern Times* (London, 1973), pp. 108-10 and 139-40.

9 *Le Magasin Pittoresque*, 48 (1834), p. 384.

10 F. Didot, *Aux anciens compagnons de ses travaux* (4 September 1830).

11 See Finke, 'English wood engravers and French illustrated books', and Linton, *The Masters of Wood Engraving*, p. 202.

12 J. A. Jackson, *A Treatise on Wood Engraving* (London, 1839), p. 359; E. Charton, *Éphémerides d'une histoire du Magasin Pittoresque*, printed in *Le Magasin Pittoresque*, frontispiece (1888). Andrew worked in Paris between 1828 and 1852 and was brought by Thompson to France as a pupil. In 1832 he formed a studio with Jean Best and Auguste Leloir. In 1841, Andrew, Best and Leloir (ABL) had contributed 41 per cent of the illustrations in *Le Magasin Pittoresque* and over 25 per cent of those in the first two volumes of *L'Illustration* (1843-44).

13 *L'Artiste*, 1:21 (1857), pp. 372-3.

14 *L'Artiste*, 10:17 (1835), pp. 193-4, for example, stated 'Between lithography and engraving proper we would have to place wood engraving . . .'

15 M. H. Spielman, *The History of Punch* (London, 1895), p. 249.

16 *L'Illustration*, 2:53 (2 March 1844), pp. 7-9.

17 H. Vizetelly, *Glances Back Through Seventy Years* (London, 1893).

18 Spielman, *The History of Punch*, pp. 34 and 413.

19 *Le Magasin Pittoresque*, 52 (1834), p. 407.

20 Cited in E. Levasseur, *Histoire des classes ouvrières* (Paris, 1903-04), pp. 300-4.

21 *Ibid.*, p. 718, which cites *Exposition de 1867: Rapports du Jury, t. III*, p. 442.

22 H. Cole, 'Modern wood engraving', *Westminster Review* (1838), p. 278.

23 J. Ruskin, *Ariadne Florentina: Six Lectures on Wood and Metal Engraving* (London, 1872), p. 359.

24 J. Buchanan-Brown, 'British wood engravers c. 1820-60', *Journal of the Printing Historical Society*, 17 (1982/83), p. 38.

25 'Our weekly gossip', *Athenaeum*, 839 (25 November 1843), pp. 1048-9.

26 Buchanan-Brown, 'British wood engravers', p. 36.

27 *Ibid.*, p. 33. Adèle Laisné did engravings for the novel *Gil Blas* in 1835 and Aglaé Laisné executed engravings after sketches by Daubigny for the novel *L'Entretien de Village* in 1846.

28 In 1862 *L'Illustration* contained thirty-four illustrations by Chenu, reflecting her expertise as a portrait painter. E. Bénézit, *Dictionnaire critique des peintres, sculpteurs, dessinateurs et graveurs, t. 2* (Paris, 1948-55), p. 710 states that she had been a pupil of Gelée and Cogniet and had shown regularly at the Salon between 1852 and 1861.

29 The artists who contributed to the illustrated press on a sporadic basis are legion; in France the credits for *L'Artiste* and *Le Charivari* include plates by Tony and Alfred Johannot, Delacroix (who also contributed to *Le Magasin Pittoresque*, 18 and 21 (1845), Achille and Eugène Deveria and Gavarni. The

last also provided many designs for *L'Illustration* and *Le Monde Illustré*, as did Janet-Lange.

30 See J. F. Vaudin, *Gazettes et gazettiers* (Paris, 1863), p. 19.

31 *Le Magasin Pittoresque* raised its price per issue to fifty centimes in 1890.

32 See S. Bennett, 'Revolutions in thought: serial publication and the mass market for reading', in J. Shattock and M. Wolff (eds), *The Victorian Press: Samplings and Soundings* (Leicester, 1982).

33 *Ibid.*, p. 227.

34 Knight's proposal for the *Penny Cyclopedia* (21 June 1832), SDUK papers, 53.

35 R. Altick, *The English Common Reader - A Social History of the Mass Reading Public* (Chicago, 1957), p. 342 and n. 63.

36 P. Anderson, *The Printed Image and The Transformation of Popular Culture 1790-1860* (Oxford, 1991), pp. 144 and 146.

37 *Le Magasin Pittoresque*, 1:1 (1833).

38 See Anderson, *The Printed Image and The Transformation of Popular Culture*, for an expanded discussion of the content of *Penny Magazine, Reynold's Miscellany, London Journal* and *Cassell's Illustrated Family Paper*.

39 A. Ellegård, 'The readership of the periodical press in Mid-Victorian Britain', *Göteborgs Universitets Årsskrift*, 63:3, *Acta Universitatis Gothoburgensis* (Göteborg, 1957); *L'Illustration* (1899). See Anderson, *The Printed Image and The Transformation of Popular Culture*, p. 91 for *Reynold's Miscellany*; H. Mayhew, *London Labour and the London Poor*, 4 vols (London [1851 and 1861-62], reprinted 1967), vol. 1, p. 25.

40 W. M. Ivins jun., *Prints and Visual Communication* (New York, 1979), p. 107.

41 *Le Charivari*, 13 (1834) cites a subscription rate of 2,500 copies daily and *Le Charivari*, 1 (1846) a subscription rate of 2,090. The lists of subscribers printed during an appeal to help pay off a heavy fine in 1834 gives us some indication of the kind of readership that *Le Charivari* predominantly had, and included lawyers, university lecturers, students of law and medicine and several anonymous *patriotes* and *républicains* - see the following issues of *Le Charivari* for 1834 - 31 January; 10,14 and 22 February; 10, 19 and 27 March; 11 April; and 1, 2 and 15 August; 'L'Histoire de l'Artiste', *L'Artiste* (26 February 1856).

42 Bennett, 'Revolutions in thought: serial publication and the mass market for reading', pp. 233-4.

43 C. Bellanger (ed.), *Histoire générale de la presse française, t. 2* (Paris, 1969), p. 311.

44 Caution money and stamp duty are discussed more fully in the following chapter on the caricatural press. *L'Illustration* began a political column on 24 November and it testified to its political stance in advertisements placed in *Le Charivari* (29 December 1860 and 15 December 1861), boasting that it was the only popular illustrated weekly subject to stamp duty and caution money. LaRoche Héron wrote scathingly in *L'Univers* (6 January, 1855) that *L'Illustration* was politically reactionary - 'scarcely anything else but *Le Siècle* in pictures. It has almost the same Voltairean spirit of the liberal of 1828 who has learned nothing nor forgotten anything; the same historical ignorance, the same hostility against religion.'

45 Inspector Gallix in the south-west of France cited in Bellanger, *Histoire générale de la presse française, t. 2*, p. 286.

46 E. Levasseur, *La Population Française, t. 3* (Paris, 1892), pp. 90-1.

47 E. Levasseur, *La Population Française, t. 2* (Paris, 1892), p. 724. See also Braudel and Labrousse, *Histoire économique et sociale de la France, t. 3* (Paris, 1975),

p. 85, which states, 'The Frenchman is a panivore. Bread occupies his thoughts, fear of going without it absorbs his every faculty.'

48 Levasseur, *Histoire des classes ouvrières*, appendix, pp. 300–34 includes the findings of a survey carried out by the *Comité du Travail de l'Assemblée Constituante* into the agricultural and industrial professions. This is the first comprehensive study to give us an indication of the earnings of the working population of the entire country. It cites glassworkers in Aisne as earning 3F.20 per day, in the Marne up to 8F, and in Aubin, Aveyron, 12F. The mean salary of all other professions has been calculated for this note to be *c.* 2F outside of Paris and *c.* 4F in Paris. All salaries quoted are based on male earnings.

49 S. Bottin, *Almanach du commerce de Paris* (Paris, 1840).

50 Cited in I. Collins, *The Government and the Newspaper Press in France* (London, 1959), p. 41.

51 Levasseur, *La Population française, t. 3*, p. 90.

52 *Ibid.,* p. 91 which states that in 1890 the annual salary was 2,400F whilst annual expenditure was 2,380F, including 50F devoted to tobacco.

53 See L. Levi, *Wages and Earnings of the Working Classes* (London, 1885), p. 53. For a succinct account of economic prosperity and social trends in Victorian Britain, see *The Oxford Illustrated History of Britain* (Oxford, 1984) and for statistical data relating to the period see C. Cook and B. Keith, *British Historical Facts, 1830–1900* (London, 1975).

54 Altick, *The English Common Reader*, p. 306.

55 S. Mallarmé, 'Le livre, instrument spirituel', in H. Moudor and G. Aubrey (eds), *Œuvres complètes* (Paris, 1945), p. 381.

56 Levasseur, *Histoire des classes ouvrières*, p. 145, and Levasseur, *La population française. t. 2*, pp. 486–91; Altick, *The English Common Reader*. See also W. Hamish Fraser, *The Coming of the Mass Market 1850–1914* (London, 1981), p. 72.

57 See F. Reid, *Illustrators of the Sixties* (London, 1928) and P. Goldman, *Victorian Illustrated Books 1850–70, the Heyday of Wood-Engraving* (London, 1994).

58 An expanded discussion of illustrated editions of Dickens's work can be found in J. R. Harvey, *Victorian Novelists and Their Illustrators* (London, 1970).

59 *Le Magasin Pittoresque*, 1:1 (1833).

60 C. Knight, *Passages of a Working Life* (London, 1864), vol. 2, pp. 262 and 284, and vol. 3, p. 82.

61 H. Vizetelly, *Glances Back Through Seventy Years* (London, 1893), p. 237.

62 *Le Journal Illustré* (14 February 1864).

63 *Great Gun*, 'Our French Express' (29 March, 3 May and 10 May 1845); *Catalogue Collectif des Périodiques. t. II* (1973), Bibliothèque Nationale, Paris contains an entry for *Illustrated London News en Français* for May 1851. *Le Charivari* also carried an advertisement for it on 16 September 1855. It has not been possible to ascertain for exactly how long *ILN* was published in a French edition apart from these references; the *ILN* archives were depleted after bombing during World War II and consequently there is no extant record of this enterprise.

64 W. Wordsworth, *Complete Poems* (Oxford, 1965), p. 383.

65 Cited in A. Scharf, *Art and Photography* (London, 1968), p. 145.

66 See G. Wakeman, *Victorian Book Illustration, The Technical Revolution* (Newton Abbot, 1973).

67 See Jobling, *The Evolution of the Popular Illustrated Press in Nineteenth-Century France*, pp. 182-6 and 224-7 for *L'Illustration*, and L. J. De Freitas, *Commercial Wood Engraving in Britain 1880-1900*, unpublished M.A. thesis, Royal College of Art, London, 1978, pp. 151-4 for *ILN*.

68 B. Newhall, *The History of Photography* (New York, 1982), p. 176 (*The Graphic*); De Freitas, *Commercial Wood Engraving*, p. 153 (*ILN*); and Jobling, *The Evolution of the Popular Illustrated Press in Nineteenth-Century France*, p. 224 (*L'Illustration*).

69 Jobling, *The Evolution of the Popular Illustrated Press in Nineteenth-Century France*, pp. 216-20; De Freitas, *Commercial Wood Engraving*, chapters 8 and 9.

70 Wakeman, *Victorian Book Illustration*, p. 139.

71 H. Delaborde, 'L'état présent de la gravure en France', *L'Illustration*, 94:2414 (1889), 462-3.

72 C. N. Williamson, 'Illustrated journalism in England, its development', *Magazine of Art* (1889), p. 298.

73 W. Benjamin, 'The work of art in the age of mechanical reproduction' [1936], *Illuminations* (London, 1970), p. 225.

74 *Punch*, 17 (1847), p. 117. The two catchpenny images represented were a broadside of the murderer Greenacre decapitating a naked female and a gallows scene.

75 See K. W. Smith, *Constantin Guys, Crimean War Drawings 1854-56* (Ohio, 1978) and K. Collins, 'Living skeletons; carte-de-visite propaganda in the American Civil War', in *History of Photography*, 12:2 (April-June 1988), pp. 103-20.

76 *ILN* (22 September 1888).

77 M. H. Wolff and C. Fox, *Pictures From the Magazines*, p. 568.

78 *Ibid.*, p. 572.

79 *L'Univers Illustré*, 1 (22 May 1858).

Suggestions for further reading

P. Anderson, *The Printed Image And The Transformation of Popular Culture 1790-1860* (Oxford University Press, 1991).

C. Bellanger (ed.), *Histoire générale de la presse française, t. 2, 1815-1870* (Paris, Presses Universitaires de France, 1969), and *Ibid., t. 3, 1871-1940* (Paris, Presses Universitaires de France, 1972).

H. Béraldi, *Les graveurs du XIX^e siècle* (Conquet, 1888).

J. Buchanan Brown, 'British wood engravers c. 1820/60', Journal of the Printing Historical Society, 17 (1982-83).

L. J. de Freitas, 'Commercial wood engraving in Britain 1880-1900', unpublished M.A. thesis, Royal College of Art, London (1978).

C. Fox, 'Graphic Journalism in England 1830-50', unpublished D.Phil. thesis, University of Oxford (1975).

J. Jackson and W. A. Chatto, *A Treatise on Wood Engraving* (London, C. Knight and Co., 1861).

M. Jackson, *The Pictorial Press: Its Origins and Progress* (London, Hurst and Blackett, 1885).

P. J. Jobling, *The Evolution of the Popular Illustrated Press in Nineteenth-Century France*, unpublished M.A. thesis, Royal College of Art, London (1983).

D. Kúnzle, '*L'Illustration*, journal universel, 1843-53', *Nouvelles de l'Estampe*, 43 (January/February, 1979) pp. 8-19.

A. J. Lees, *The Origins of the Popular Press 1855-1914* (London, Croom Helm, 1976).

W. J. Linton, *Masters of Wood Engraving* (London, B. F. Stevens, 1889).

Open University, Humanities Foundation Course, *Art and Industry*, Units 33-34 (1971).

J. Shattock and M. Wolff, *The Victorian Press: Samplings and Soundings* (Leicester University Press, 1982).

A. Sheon, 'Parisian social statistics: Gavarni, *Le Diable à Paris* and early Realism', *Art Journal* (Summer 1984) pp. 139-48.

C. N. Williamson, 'The development of illustrated journalism in England', three articles in the *Magazine of Art* (London, 1890).

M. Wolff and C Fox, 'Pictures from the magazines', in M. Wolff and E. H. Dyos (eds), *The Victorian City* (London, Routledge and Kegan Paul, 1973).

2 Censorship and symbolism: the politics of caricature and satire in France and England during the nineteenth century

> It is a coarse kind of art, cynical, an art that is not art, curious all the same as an expression of feelings of revolt, of a people that is waking up ... The role of caricature is eternal (Champfleury, *Histoire de la caricature moderne*, 1865).

One of the most significant, and certainly the most controversial, types of periodical published during the nineteenth century was the caricatural or satirical journal. This was especially the case in France where both frequent changes in regime and the concomitant struggle for freedom from censorship made for a volatile and explosive political context. Between 1821 and 1900, some 350 titles were published in France and, although the majority of them were short-lived (many lasted for a matter of months, others for a few issues), they formed the backbone of a distinctive visual and literary counter-discourse in their opposition to the hegemony of the ruling classes.[1] Amongst the most notorious and longest surviving were *La Caricature* (1830-35), *Le Charivari* (1832-1937), *Le Journal Amusant* (1856-1933), *Le Grélot* (1871-1907) and *Le Père Peinard* (1889-1902).[2] The same period in England witnessed the growth of titles such as *Town* (1837-42); *Great Gun* (1844-45), *Judy* (1867-1907), *Tomahawk* (1867-70) and *Punch* (1841-1992), the latter proving to be the longest-running, if not the most incisive, periodical of its kind.[3]

This chapter will discuss the social and political role of caricature during the nineteenth century with reference to the iconography of *La Caricature* and *Le Charivari* in France and *Punch* in England. In so doing, it explores in more particular detail the following chief themes – (i) the impact of press legislation on caricature and the symbols which artists like Daumier coined to circumvent such censorship in the historical context of the reign of Louis-Philippe in France between 1835 and 1848; (ii) the intertextuality of word and image in satirical publishing during the same period; and (iii) the relationship of caricature to theories of physiognomy and ethnology and the way that this was manifest in the treatment of Irish nationalism in *Punch*.

The social and political nature of nineteenth-century caricature can be seen to continue a tradition which had been established in post-revolutionary Europe when Romantic artists such as Gillray and Rowlandson produced savage images lampooning the corruption of the monarchy and government. These images were issued as single-sheet prints, usually etched or engraved with wordy speech balloons, and were available in monochrome and coloured formats from publishers, printsellers and pedlars. In London the chief dealers included Hannah Humphreys of Bond Street (with whom George IV had an account), Thomas Tegg of Cheapside, and James Ackermann of Piccadilly; whilst in Paris, Basset and Dumonstier in the Rue Saint Jacques, and Lemercier were responsible for the retail of caricatures and other prints. Before the 1860s, the relatively high cost of single-sheet prints, and later caricature journals sold on subscription, meant that caricature was outside the pocket of the working classes.[4] But their display in shop windows and kiosks made them a highly visible and edifying art form, eagerly consumed by all strata of society. This is how one observer described the mayhem he witnessed in front of Ackermann's shop in 1802:

> If men be fighting . . . (across the Channel) for their possessions and their bodies against the Corsican robber (Napoleon), they are fighting here to be the first in Ackermann's shop and see Gillray's latest caricatures. The enthusiasm is indescribable when the next drawing appears; it is a veritable madness. You have to make your way through the crowd with your fists.[5]

By 1830, the development of the caricatural press had begun to challenge the monopolisation of the market held by individual images. In England prototypes such as *The Satirist* (1808–14) and *The Scourge* (1811–15) were launched, and in France eleven new titles were issued between 1800 and 1830, including *Le Nain Jaune* (1814–15), *L'Homme Gris* (1817–18) and *La Caricature*. The success of the caricatural press in France during the early nineteenth century was in no small part due to the efforts of the magazine entrepreneur Charles Philipon, who between 1829 and 1836 was a major shareholder in nine periodicals, including the caricatural weeklies *La Silhouette* (1829–31) and *La Caricature*, and the daily *Le Charivari*.[6] From the outset, he exploited the expressive potential of lithography, which had been patented in Germany by Aloïs Senefelder in 1796, in the production of caricature, and thereby attracted a group of the youngest and most talented draughtsmen of the period – Deveria, Daumier, Grandville, Traviès, Gavarni and Cham among them – as well as utilising the workshop of Aubert, the

busiest lithographic printer in Paris.[7] It was to the high artistic standards of the French that Thackeray referred in his article in the *Westminster Review* of April 1839, 'Caricatures and lithography in Paris', and in which he berated British artists for their failure to realise the expressive qualities of the lithographic technique.[8] Even when *Punch* was launched in 1841 with the subtitle 'The London *Charivari*', it resorted to wood engraving for both its 'big cuts' (or whole-page caricatures), which could be removed for framing, and its small-scale vignettes. These caricatures and cartoons were the handiwork of various artists, chief of whom were J. Kenny Meadows, John Leech, Richard Doyle, George du Maurier and John Tenniel, and engraved largely by the firm of Swain and Dalziel.

Pictures speak louder than words – censorship and caricature

A staunch Republican, Philipon also formalised the running of his magazines by forming small, closed societies; each contributor had to share the same left-wing political allegiance as Philipon, who was ultimately responsible for the moral direction and the verbal and pictorial content of his periodicals until at least 1837.[9] At the outset, he was given a helping hand in expressing such political views by Article 7 of the Charter of 24 August 1830, that heralded the eighteen-year reign of the Orleanist citizen-king Louis-Philippe and which revived freedom of the press in the following terms: 'All Frenchmen have the right to publish and have printed their opinions . . . Censorship will never again be re-established.'[10]

The freedom of the press and more especially the freedom to circulate printed images had a chequered career in France during the nineteenth century, with more than 110 press edicts being passed and repealed. As a curtain-raiser to the period, the first foundations for the freedom of speech, and by extension the freedom of the press, had been laid down in the Declaration of the Rights of Man and of the Citizen in 1789. Within the space of three years, however, the tone of the Declaration had been modified to the effect that all professional practice must conform to police regulations.[11] It was this apostatic stance which was to find repercussion in all subsequent press legislation until the conciliatory reforms of 1881, which finally inaugurated freedom of the press in line with America and with what most other European democracies had known since 1848.[12] To stem the tide of political caricature there were two measures of particular significance which were implemented during the nineteenth century in France.

The first of these concerned the preliminary authorisation of images which had been introduced by Napoleon Bonaparte under

year VIII of the new Constitution (1800) and which maintained that any form of representation must be approved by the censor before it was put into circulation.[13] This measure was subject more than most to the vagaries of political interest – abolished in 1814 by the Constitutional Charter of Louis XVIII, it was reimposed between 1820 and 1830 under the Bourbon Restoration; abolished again between 1830 and 1835, it was reintroduced between 1835 and 1848 under the *juste milieu* of Louis-Philippe; the Second Republic likewise abolished it between 1848 and 1852 only to see it not only restored but also modified during the Second Empire of Napoleon III, whose Organic Decree of 1852 necessitated the approval of any living person before a caricature of him/her could be published; during the Franco-Prussian War and the Commune, 1870-71, the measure was again rescinded, but was not finally abolished until the Press Law of 1881.

The second measure concerning the deposition of a financial security, in effect payment in advance of possible fines incurred as a result of infringing any of the press laws, was established with the legislation of June 1819 at a rate of 10,000 francs.[14] Excepting the period August–December 1830, the Second Republic of 1848–52 and during 1870-71, caution money was also maintained at varying rates until 1881.[15] This punitive atmosphere was a far cry from contemporary England, where Cruikshank took £100 from the Crown, 'in consideration of a pledge not to caricature His Majesty in any immoral situation', and where, apart from the 1819 Libels Act which established stamp duty for all newspapers, there had been little censorship of political prints.[16]

The impact of such legislation in France can be gauged by the quantity of political caricatural magazines which were either published or folded in its wake. As table 1.1 demonstrates, the largest number of periodicals was issued during more liberal or anarchic periods: twenty-eight between 1848 and 1852 and thirty-seven between 1870 and 1871, for example. Towards the close of the Second Empire, when Napoleon III was becoming less popular because of his mishandling of foreign affairs and after the 1868 Press Law had brought in more freedom for the written word, publishers also seemed ready to chance their luck, and there was consequently an expansion in the number of periodicals launched – forty-six titles between 1867 and 1869. Yet few of these were to survive longer than the year of their publication.

In all countries where any form of preliminary authorisation existed, it was justified on the basis that pictures could speak louder than words. Not only this, but printed images were also highly visible in printseller's windows, newsvendors' kiosks and in advertising posters. Images were seen to appeal directly to the people's

emotions rather than to their intellect and as such were deemed
to be 'the Bible' of the illiterate. Émile Villiers was one of many
politicians who summed up this fear, declaring in the Chamber of
Deputies in 1880:

> An article in a journal only affects the reader of the newspaper, he
> who takes the trouble to read it; a drawing strikes the sight of the
> passer-by, addresses itself to all ages and both sexes, startles not only
> the mind but the eyes. It is a means of speaking even to the illiterate,
> of stirring up passions, without reasoning, without discourse.[17]

It was not just politicians who expressed the primacy of the
image over the word in caricature. Daumier himself claimed: 'If
my drawing tells you nothing, it is bad; the legend won't make it
any better. If it is good, you will understand everything unaided,
and so what use is the legend?'[18] A similar idea was reinforced by
Baudelaire in his essay on Daumier in *Quelques Caricaturistes Fran-
çais* where he states: 'The captions beneath his images hardly serve
any purpose, for generally speaking, one could do without
them.'[19] This, however, is a moot point, and during the nine-
teenth century many caricatures were just as logocentric as their
eighteenth-century antecedents had been; instead of speech bal-
loons we find legends and sometimes complementary editorial or
articles. There are indeed many examples of Daumier's work in
which the comical point is conveyed first and foremost within
and by the image – *The mother is deep in her composition* (figure 11)
or *Cursing the Landlord who Refuses to Repair the Leak* (figure 12),
for example. But equally there are many caricatures which rely on
the interdependence of text and image to get a more specific mes-
sage across, including *You were Hungry* from the *Gens De Justice*
series of lithographs (figure 13). In this print, the general point
concerning the pompousness and indifference of the legal profes-
sion is connoted in the haughty expression of the lawyer who sits
behind a desk with his hands clasped, distanced from the accused
and a police guard. The criminality of the prisoner is symbolised
by his coarse, imbecilic physiognomy and the fact that he is wear-
ing a straightjacket. The full caption, however, 'You were hungry
... you were hungry ... that's no excuse ... I am also hungry
practically every day, but that doesn't mean I steal for it!', serves
not only to emphasise the callousness of the lawyer but also, in
clarifying the particularity of the crime, draws our attention to the
injustice and inequality of society under Louis Philippe's reign. The
joke here is firmly on the ruling orders rather than on the starving
underclasses, and the crime, in effect the result of fulfilling a basic
human need, becomes condonable or 'decriminalised' through the
use of such an ironic caption.

On other occasions the use of a legend or title could serve to disguise the overt political content of the image and was a strategic way of overcoming preliminary censorship. This tactic is evident in the series of caricatural portraits which Daumier executed in 1833 for *Le Charivari*, such as *Mr Kératr* and *Mr Guiz*. By omitting to complete the proper names of the subjects represented – Kératry and Guizot are the politicians depicted – neither Daumier nor Philipon could be accused of demeaning anyone who actually existed, even if there was a marked physiognomical likeness between the caricature and the 'implied' subjects.

The question of intent is important to note in the context of political caricature, as it presented the censor with a basic dilemma concerning the right of the caricaturist to characterise or impersonate a particular subject, rather than literally to personify or represent him/her. In 1831 this dilemma resolved itself in the prosecution of Daumier's lithograph *Gargantua*, which was deposited with the censor on 16 December 1831. The print takes its cue from François Rabelais's *Gargantua et Pantagruel*, originally published in 1532–35, and which during the late eighteenth and early nineteenth centuries was believed to have been a moral and political critique on the reign of François I.[20] In the spirit of such a royal interpretation, Daumier consequently depicted Louis-Philippe as Gargantua, the giant who had an insatiable appetite. At the same time, Daumier's lithograph also seems to be based on popular

11] 'La mère est dans le feu de la composition, l'enfant est dans la baignoire!' ('The mother is deep in her composition, the baby is in the bath-tub'), lithograph by Honoré Daumier, from the series *Les Bas-Bleus*, *Le Charivari* (26 February 1844).

12] 'Brigand de propriétaire . . . qui ne veut me faire des réparations qu'au beau temps!' ('Cursed landlord . . . who wouldn't do any repairs for me when the weather was fine!', lithograph by Honoré Daumier, from the series *Locataires et Propriétaires*, *Le Charivari* (26 May 1847).

images of Gargantua which came into circulation *c.* 1810, and which either represented him consuming huge quantities of food and drink brought to his table via ladders by a procession of ordinary mortals, or in the process of post-prandial defecation.

In Daumier's lithograph, however, the two separate activities of ingestion and excretion have been conflated. Gargantua sits on a commode and with an enormous plank leading from his mouth. To the right of the image, a huddle of impoverished figures are filling baskets with pieces of gold, which in turn are delivered to the giant by obese ministers who resemble him in miniature and who climb along the plank with the baskets on their backs. At the very same time Gargantua excretes sheets of paper with the words 'Nominations de Pairs' (nominations to the Chamber of Peers) and 'Brevet de la légion' (military commission) printed on them, and these are eagerly carried off by another group of obese clones. The underlying message of the print was more than obvious to the censor; Louis-Philippe was being ridiculed as a voracious and venal ruler, someone who was both willing to rob the poor to feed the rich and prone to promoting undeserving persons to positions of privilege and rank for money or other bribes. In January 1831 Louis-Philippe had declared: 'We shall seek to hold a middle way, equally distant from the abuses of royal power and the excesses of popular power',[21] and it is the betrayal of this ideal which the Gargantua clearly symbolises. As Elizabeth Childs has argued: 'Daumier's *Gargantua* bypasses the standard convention of the feasting table in favor of a single ramp that intensifies the direct opposition between

13] 'Vous aviez faim . . . vous aviez faim . . . ça n'est pas une raison . . . mais moi aussi presque tous les jours j'ai faim et je ne vole pas pour çela!' ('You were hungry . . . you were hungry . . . well, that's no excuse . . . I'm also hungry almost every day but I don't go stealing just for that!'), lithograph by Honoré Daumier, from the series *Les Gens de Justice*, *Le Charivari* (20 October 1845).

powerless and powerful, between the feeders and the fed.'[22] Philipon published an ironic defence of the lithograph in *La Caricature* on 29 December 1831, contesting any superficial resemblance between the King and Gargantua. Nevertheless, the print was seized by the police, who ordered the destruction of the original lithographic stone, and Daumier, the publisher Aubert and the printer Delaporte were all charged with contravening the press law of November 1830 which forbade any impeachment of the King's authority, rule or character. Daumier and Aubert were each sentenced to six months imprisonment in Sainte Pélagie gaol and fined 500 francs apiece.[23]

Censorship and symbolism in France 1830-48

The period of the July Monarchy between 1830 and 1848 was one of the most punitive in terms of the legislation it introduced to stifle any political or oppositional caricature, while at the same time it tested the ingenuity of many publishers and artists who coined numerous emblems and types with which they could circumvent such legislation and impugn Louis-Philippe and his rule. The representation of Louis-Philippe as Gargantua, for example, trades on another of the key symbols from the King's early reign – that of *la poire*, or pear, which Philipon had coined a few weeks before *Gargantua* was published, and which Daumier appears to have invoked with the pyramidal-shaped head of the giant.[24]

Poire was French slang for an oaf or dim-wit, and as such the word loaned itself to Philipon as a way of summing up both the futility and the folly of the July Monarchy and the natural corpulence of the King. These two points are neatly embodied in Daumier's lithograph for *La Caricature* on 9 January 1834, *Le Passé, le présent, l'avenir*, which depicts Louis-Philippe as a pear with three identical faces merging seamlessly into each other, thereby suggesting that the past, the present and the future will be just as difficult to tell apart under his rule as the facets of a spherical object like a pear. *La poire* became one of the most instantly recognisable and popular symbols for Louis-Philippe amongst all strata of society in France; another caricature, *La Poire est devenue populaire* by Traviès, which was published in *Le Charivari* on 28 April 1833 (figure 14), for instance, represents a young street urchin sketching a pear on a Paris wall and both Stendhal, in *Lucien Leuwen* (1837), and Victor Hugo, in *Les Misérables*, (1862) commented on the currency of the pear in similar terms.[25] Moreover, unlike the characterisation of Louis-Philippe as Gargantua, with *la poire* Philipon had alighted on a symbol with which he could eschew censorship since, as he had argued during an earlier trial in November 1830, at which point

does the resemblance between king and pear mean that one could no longer draw pears?[26]

In addition to *la poire*, Philipon and his artists mobilised a whole repertory of symbols to ridicule Louis-Philippe without incurring censorship. These included several zoomorphic emblems such as the parrot and the lion and the character of Mayeux (figures 17, 18 and 19).[27] Caricatures of Mayeux can be traced back to the sixteenth century and had already appeared in Philipon's *La Silhouette* in 1829, but after the July Revolution of 1830, in the hands of the lithographer Traviès, Mayeux was used polysemously to symbolise the lot of the ordinary French citizen under Louis-Philippe's *juste milieu*. 'He was a hero - he identified problems, such as the treatment of women or the machinations of the National Guard - and called these issues to the public's attention.'[28] Between

14] 'La poire est devenue populaire! Le voyou employé aux trognons de pommes dans les théâtres des boulevards, là croque murailles pendant ses nombres loisirs, c'est ainsi que Paris s'embellit tous les jours' ('The pear has become popular! The guttersnipe, who sells apple cores in the boulevard theatres, sketches on the walls there during his considerable spare time, that's how Paris grows more lovely by the day'), lithograph by Charles-Joseph Traviés, *Le Charivari* (28 April 1833).

1830 and 1835, Philipon and his artists had been mostly successful in escaping censorship with symbols such as the *poire* and Mayeux. By 1835, however, antipathy for the reign of Louis-Philippe had reached such staggering proportions that some of the opposition press had gone so far as to express surprise and disdain that the King had not been assassinated on the anniversary of the 1830 July Revolution.[29] Thus on 26 July 1835 a small notice in *Le Charivari* exclaimed: 'Today, the citizen-king returned to Paris from Neuilly with his superb family without at all being killed on the way.' Two days later during his anniversary procession through Paris, an attempt on Louis-Philippe's life was actually undertaken by a Corsican Bonapartist named Fieschi on behalf of the Société des Droits de l'Homme.[30] As a consequence the republican press was seen to have ingenuously fomented sedition, and for many of Louis-Philippe's ministers this made it paramount to gag once and for all such potentially lethal threats of rebellion. Their retribution culminated in the stringent measures of the press law of 9 September 1835.

The September Press Law made it a criminal offence to introduce the name of the King, either directly or indirectly, when discussing the actions of his government, or to express the wish, hope or threat for the overthrow of the constitutional monarchy and the restoration of any other kind of political system (and this really meant republican). For such offences, a journal could incur fines of up to 55,000 francs. On top of this, the already rebarbative caution money was increased from 2,400 to 100,000 francs for all political papers appearing more than twice a week.[31] More seriously for the illustrated press, article 20 made all drawings, engravings and lithographs prone to preliminary censorship by the Minister of the Interior for the second time since 1822.[32] The impact of the 1835 legislation was to be swift and efficacious, particularly in the provinces, where more than thirty papers were forced to close down under the pressure of securing such large amounts of caution money.[33] Philipon likewise found the new cautionary deposit too onerous, and just two weeks before the law was enacted he decided to continue publishing *Le Charivari* and to make *La Caricature* a hostage to fortune, the last issue appearing on 27 August 1835. *Le Charivari* had accrued a more healthy subscription rate than its stable-mate[34] and in a redoubtable editorial in the issue of 11 August 1835, Philipon threw down a direct challenge to the censor, fulminating: 'POLITICAL CARICATURE WILL NOT BE KILLED OFF BY CENSORSHIP . . . and *Le Charivari* takes it upon itself to prove that it has a stronger constitution than one might suppose.' These were brave words but sadly, and somewhat predictably, in the early days of the new censorship Philipon was

to lose more battles than he would win. Up until September 1835 most of the lithographs he had published were of a political nature, but with the inception of the new legislation the tables began to turn. On 17 September the censor refused a proposed lithograph outright and for the remainder of the year fifty more issues had to be published without any caricatures. This pattern continued during 1836 when more than 50 per cent of all the issues published did not have caricatures.[35]

The action of the censor clearly seems sometimes to have caught Philipon by surprise when he thought that the lithographs he intended to publish were quite within the law. In *Le Charivari* of 15 September 1835, for example, he relates that the only reason given by the censor for refusing authorisation of a drawing of two sides of a commemorative medal recently struck in Paris, one side representing King Henry V of Navarre and the other Charles X's grandson, the Duc de Bordeaux, was that the government had denied the medal's existence.[36] In an attempt to show his readers just how small-minded the censorship could be, Philipon also occasionally printed those lithographs which had failed to gain approval, with the offending parts strategically blocked out and verbal descriptions given in their place. Thus on 6 October 1835 he published a series of small-scale sketches with one of them – a kind of fantastic pot – blocked out, and the explanation for doing so that its lid had a small resemblance to the head of a Jesuit.

From 1836, therefore, Philipon was forced to switch from political caricature to parodies of the social scene. One of the chief contributors to this field was Gavarni, whose work appeared in *Le Charivari* between 1838 and 1844.[37] His stock-in-trade became the *vie de bohème* which formed the basis of several series of lithographs such as *Fourberies de Femmes, La Boite de Lettres, Les Étudiants de Paris* and *Les Lorettes.* According to Gautier, the *Lorette* was one of the key female archetypes of the period; a new type of liberated flirt who was totally distinct from the traditional courtesan or kept woman (figure 15).[38] In his representation of the activities of these young women, Gavarni takes the part of the voyeur and he implicates us also as intruders into scenes of intimate flirtation and seduction. A similar perspective was offered by artists such as Géniole, Vernier, Bouchot and Beaumont who represented analogous types and themes.[39] In addition to these light-hearted and somewhat frivolous skits on feminine capriciousness, steel-engraved fashion plates were occasionally copied from magazines such as *Le Miroir des Dames* (1835–37) when caricatures were not available,[40] and from 1843 Cham began to execute a set of satires dealing with the French involvement in Algeria and several series sending up customs abroad.[41] Many of the latter were made at the expense of

the British, including 'Mr Trottman en voyage' (1845); 'Mœurs britanniques' (1847) and 'Voyage d'agrément à Londres' (1849). Louis-Philippe and his government had taken great pains to secure Britain as an ally despite the fact that France clashed directly with Britain more than any other power in terms of foreign policy.[42] This *rapprochement* led to the first somewhat uneasy phase of *entente cordiale* between the two nations and became a particular object of ridicule with *Le Charivari*, not only in the form of Cham's caricatures but also in its editorial. On 7 January 1844, for example, an article entitled 'Excentricités anglaises' appeared, whilst on 17 November of the same year another piece, 'Ceux qui mangent beaucoup, et ceux qui ne mange pas du tout', impugned the British class structure, calling it an 'odious oligarchy'.

Moreover, as press censorship intensified, emblems such as *la poire*, which worked on a level of metonymic substitution, renaming Louis-Philippe as another, usually fictitious, character whilst

15] 'Le Matin, Quelle agréable surprise! . . . Monsieur le Baron, je vous présente Monsieur Ernest le prétendu de ma petite soeur . . . qui est venu me demander à dejeuner sans façons' ('Morning: What a nice surprise! . . . Dear Baron, let me introduce you to Mr Ernest, the intended of my little sister, who has come to invite me to a simple dinner!' from the series *Fourberies de Femmes* (Womanly Deceits), lithograph by Gavarni, *Le Charivari* (4 May 1837).

still representing or referring to some of his actual physical features, began to be replaced by more metaphorical forms of representation in which not only the name but the actual likeness or form of the individual was considerably or totally changed. Consequently, during the second half of 1836, Philipon and Daumier started to produce caricatures based around the figure of Robert Macaire, who had originally been the principal character in a drama performed by Frederic Lemaître after the July Revolution of 1830.[43] In the play, Macaire was represented as a rank opportunist and careerist, the embodiment of the self-seeking bourgeois who could buy himself social status and who was to profit under the reign of the Citizen King.[44] As Karl Marx was to put it so aptly, Louis-Philippe's regime was 'no more than a joint stock company for the exploitation of the French national wealth', with the King himself 'a Robert Macaire on the throne'.[45] Given that the play had already achieved some considerable success with the public in Paris in portraying the venality of French society under Louis-Philippe, Philipon and Daumier had at their disposal a ready-made symbol they could exploit to rich comic effect in both word and image. In their hands, between 1836 and 1842, Macaire came in for similar treatment, cropping up in numerous professional guises - as a lawyer or financier, for example - but always as a confidence trickster or man on the make.[46] Macaire consequently afforded Philipon the opportunity to lampoon the ideology of the *juste milieu* without fear of recrimination and compensated for the block on explicit political caricatures in the wake of the September Press Law.

Intertextuality of word and image: Daumier's *Orang-Outaniana*

At the same time, the shift from overtly political to more oblique political symbolism in the period following 1835 appeared to accentuate the intertextuality of caption and image, and the message of much caricature was conveyed equally through the narrative purpose of both elements. As Charles Baudelaire was to remark in his essay *Quelques caricaturistes français* of 1857: 'Caricature from that point onwards took on a new look which was no longer especially political. It became the general satire of the people. It entered into the domain of the novel.'[47] This shift is borne out by the verbosity of the captions which accompanied the Macaire series; see for example figure 16, representing Macaire as a lawyer. Yet it was also occasionally evident in the way that some images, such as Daumier's *Orang-Outaniana* and Jacques Werner's lithographs of the same orang-utan in 1836, were complemented by the editorial of the magazine.[48]

16] 'Robert Macaire Avocat' ('Robert Macaire, Lawyer'), lithograph by Honoré Daumier, from the series *Caricaturana*, *Le Charivari* (25 October 1836).

After several unsuccessful attempts to transport an orang-utan from its native habitat in Indonesia a certain Captain Vanigsen had brought a young orphaned male alive and well to Paris on 15 May 1836, whereafter he was installed in the zoo of the Museum of Natural History.[49] This historical incident in itself is unremarkable but it did cause a stir in the public imagination. It was featured in *Le Constitutionnel* – one of France's largest-selling dailies during the nineteenth century – and in several popular weekly periodicals including the *Revue du Théâtre* and *Le Magasin Pittoresque,* which ran a factual article illustrated by Laville, and Andrew, Best and Leloir.[50]

Le Charivari also commemorated the event, first in the form of what appear to be rather straightforward physiological drawings by the natural history painter Werner.[51] The text accompanying the second of Werner's lithographs published on 5 September 1836, however, had implied that the public's curiosity in the beast was akin to its fascination with the actions of politicians and, since this

was the case, it contended that it was worth depicting as many facets of the orang-utan as possible: 'As the orang-utan in the Jardin des Plantes shares with the public curiosity the coming and going of ministers, we thought that the public would not be offended to get to know all the sides of this curious animal.' In presenting Werner's lithographs in such a context it is, therefore, more than likely that Philipon was attempting to invest them with some sort of political meaning. The implication here that the orang-utan has more than one face brings to mind Daumier's lithograph *Masques de 1831*, whilst the parallel drawn between the beast and politicians evokes the typological caricatures of Grandville such as the *Ombres Portées* (*Projected Shadows*), in which the silhouettes of a parade of French government ministers take on the physiological attributes of various beasts.[52] That Werner's illustrations could be viewed as political allegories of this kind is substantiated with the text which described the third and last of them on 16 September 1836:

> The orang-utan is undoubtedly the favourite of the public. We have represented all of his facial traits; now, here he is in action! His activity is prodigious. One does not find this either with the Minister for War, or the Ambassador in Spain, or the Attorney General; in waiting for the acts of the new cabinet, we are depicting the capers of the monkey; furthermore, one can speak of entering him into a forthcoming political assemblage.

The conflation of human and animal attributes in this instance continues a tradition that can be traced back to antiquity, but which for the visual arts became more systematised during the seventeenth century with the development of two distinct genres of painting known as *babuinerie* and *singerie*.[53] Moreover, with the rise of physiognomy during the eighteenth and nineteenth centuries the use of simian symbolism was fed into caricatural and satirical forms of representation, as in Thomas Landseer's *Monkeyana* of 1827. It was at this time also that the orang-utan began to be identified as the ape which was physically and temperamentally closest to mankind. Rousseau, for example, taking his cue from the Abbé Prévost's *Histoire générale des voyages*, postulated that the large orang-utans of Africa and India might be a primitive form of man – *l'homme sauvage*.[54] And Thomas Love Peacock in his novel *Melincourt*, published in 1817, has an aristocratically refined ape called Sir Oran Haut-ton as the hero who becomes a Member of Parliament, even though he does not have the power of speech.

Such similarities between simian and human physiognomy and behaviour are not only continued with Daumier's *Orang-Outaniana*, but the underlying sense of political criticism is also expertly rendered, and in each of the four lithographs we can find either explicit or implicit visual references to the July Monarchy

and even to Louis-Philippe himself. In the first of them, 'O qu'ils sont laids!' ('Oh, how ugly they are!'), published in *Le Charivari* on 21 September 1836 (figure 17), the tables have been turned and a group of orang-utans have become the spectators of a human zoo consisting of three *bons bourgeois*.[55] At the same time, the ape facing us with a grin on his face seems to bear a striking resemblance to the snide facial features of his contemporary, Robert Macaire and, to a certain extent, his head is redolent of the bulging rotundity of *la poire*. The remaining three lithographs of the series, meanwhile, each incorporate the caricatural figure of the hunchback dwarf Mayeux in humourous confrontation with the ape (figures 18 and 19), an idea which may have been prompted by a report in *Le Constitutionnel* for 23/24 May 1836 likening the comical physical deportment of the beast to the 'cripple Mayeux'.[56] Furthermore, in two of Daumier's lithographs his sexual prowess is overtly satirised. In the third lithograph of the series he is represented as the somewhat perturbed consort of a heavily pregnant female called Bobonne whom he admonishes for staring at the orang-utan lest their offspring 'turns out to be a monster like that'. And in the fourth, unpublished lithograph he struggles to restrain the orang-utan, who crouches on Bobonne's lap, from sexually harassing her, stammering: 'My God! But he's a rrrandy one, a Lovelace, a seducer. Warden, warden! Come quickly! Bobonne, defend your virtue!' ('Dieu de Dieu! Mais c'est un ppppolisson, un

17] 'O qu'ils sont laids!' ('Oh! How ugly they are!'), lithograph by Honoré Daumier, from the series *Orang- Outaniana*, *Le Charivari* (21 September 1836).

18] 'Voyez, Monsieur Mayeux, cet animal tient le milieu entre l'homme et le singe. Dieu de Dieu! Il peut se flatter d'être b . . . ent laid!' ('You see, Mr Mayeux, this animal is half man, half monkey. Good God! He can flatter himself for being so b . . . ugly!'), lithograph by Honoré Daumier, from the series *Orang- Outaniana*, *Le Charivari* (6 October 1836).

19] 'Bobonne, Bobonne! Tu me ferais un monstre comme ça, ne le regarde pas tant!', ('Bobonne, Bobonne! You will produce me a monster like that, don't look at him so much!'), lithograph by Honoré Daumier, from the series *Orang-Outanaiana*, *Le Charivari* (8 November 1836).

Lovelace, un séducteur. Gardien! Gardien! Arrivez donc! Bobonne defends ton bien!') There does not appear to be a strict linear development of narrative from one lithograph to the next, and since the last was not published in *Le Charivari* it is difficult to know the precise sequencing of the prints, or whether Daumier or Philipon intended it to precede the image of the pregnant Bobonne. If this were the case, the implication would be that the orang-utan rather than Mayeux was the prospective father of Bobonne's offspring (an idea which is suggested also by the captions to the two lithographs, summing up Mayeux's agitated sense of propriety). In conveying the sexual licentiousness of the ape in such a way *Le Charivari* was part of a long tradition;[57] several contemporary authors dealt with this theme: *Le Brick du Gange* by Eugène Chapus (1831), for example, tells the story of a young Hindu girl who is violated and then murdered by an orang-utan, whilst Flaubert's *Quidquid Volueris* (1837) transports a similar crime of passion to Paris.

The physiological similarities between the orang-utan, Macaire and *la poire* outlined above, and the actual inclusion of Mayeux, already seem to be sufficient grounds for interpreting the *Orang-Outaniana* caricatures as additional key symbols for Louis-Philippe and the *juste milieu*. Further evidence to substantiate this view can be traced to a key article entitled 'Ah! Si j'étais orang-utan!' which appeared in *Le Charivari* on 2/3 November 1836, between the publication of the second and the third of the *Orang-Outaniana* lithographs. The article is arranged in two columns of contrasting text – the one on the left discussing the protocol involved in the installation of the orang-utan in the Jardin des Plantes and the

other on the right the lot of the Parisian working classes.[58] Thus we are told that the orang-utan, now christened Jacke (a probable pun on the term Jocko which Buffon had introduced in the eighteenth century to describe the chimpanzee), has had at his disposal since his arrival in Paris a huge apartment divided into several rooms, cleaned and kept temperate for him 'according to the season' by a special keeper; that he is assured of the best in medical welfare, and that 'It has been remarked that Jacke carries a very beautiful, velvety coat, guaranteed to save him from the cold.' In contrast to such well-being, the right-hand column relates that 'There are in Paris, 200,000 people put up ... in the attics of La Cité, of the faubourgs St Marceau and St Antoine', in 'tiny, cramped rooms that never see daylight or rarely feel warm'. We are told that these citizens 'often fall ill in such quarters without being able to pay for a doctor or medicine', and that in an appeal made by the mayor of the twelfth district one can read how 'There are in our district, 20,000 indigents who are totally destitute ... the amounts that the alms office now has at its disposal would scarcely be sufficient to give to each of them a pair of boots which they cannot do without'.

The picture of destitution painted here by *Le Charivari* would have been a fairly accurate one of how many people were forced to live – a commission of 1832 examining the cause and effects of cholera, for instance, discovered that more than half the population of Paris was crammed into one-fifth of the total urban area and that in the Rue des Arcis every inhabitant had a mere seven square metres living-space.[59] But Philipon clearly transcends a literal exposition of such facts by juxtaposing them with details about Jacke, and from this type of oppositional dialectic the reader is left to deduce a synthetic or supplementary meaning. When we read the two texts in conjunction it becomes evident, therefore, that *Le Charivari* is making a veiled attack on the grossness of a society which could house and feed an animal with no expense spared whilst thousands of ordinary people were living in slums without sufficient nourishment, medical care or clothing. This is a message which is reinforced by the article's subtitle 'All Frenchmen are equal before the law (subtext: monkeys are superior to the French), Charter of 1830' and its conclusion which states:

> What are we to make of all this? That in the year 'almost-of-grace' 1836, under the reign of Louis-Philippe, the vast majority of poor people who are obliged to sign their supplications on the civil list: 'Your very faithful subject' or 'Your very humble servant', stand to get more if they were able to sign themselves 'Your very devoted ape'.

In essence, the overall earnest tone of the piece seems to be underpinned by such a sense of sarcasm that even when we read passages

of text in isolation we are left wondering if there is more to them than merely meets the eye. If we examine the material dealing exclusively with Jacke, for instance, we find that factual and figurative elements have been interwoven to such an extent that we begin to question whether it could also be an allegory dealing with the *juste milieu* – in this case, the protocol surrounding the setting-up of the July Monarchy and the subsequent censorship which soon followed Louis-Philippe's accession. The second and longest passage is the most telling in this respect, as it sets up a scenario containing several references to these events. Its opening paragraph relates how:

> In a short time, Jacke will have at his disposition a magnificent palace, constructed after the designs of an architect and under the immediate supervision of Mr Thiers. In that hothouse, the plants and shrubs of the American tropics will be grown, so that in the midst of this greenery, dearly bought, the orang-utan might consider himself in his own homeland. To complete the illusion, he will be fed, as far as possible, with the fruits of his country.

One of the most revealing clues in this paragraph is the mention of the politician Adolphe Thiers. Since January 1830, along with Carrel, Mignet and the Prince de Talleyrand, Thiers had propounded in Laffite's opposition daily *Le National* the return of the Orleanist house as a viable alternative to the crumbling administration of the Bourbon King Charles X.[60] In keeping, therefore, with his own theory of history as a series of 'accidents and revolutions', he nominated Louis-Philippe, at that time the Duc d'Orléans, as the most obvious and ideologically apposite contender for the Crown, since he had given early support to the Revolution of 1789 and had fought at Jemappes and Valmy.[61] Thiers himself eventually went on to become one of the most influential ministers in Louis-Philippe's government, holding various posts, including two spells as leader of the Cabinet; the reference to him as overseer in the fabrication of Jacke's 'palace' could consequently also be read as an allusion to his championing the July Monarchy.[62]

Indeed, the use of the term 'palace' gives us an additional pointer in decoding the allegory. There were in fact building works taking place at the Jardin des Plantes in 1836, including the erection of a 'little palace intended for the monkeys'.[63] But whilst the orang-utan was clearly an expensive and difficult animal to maintain, his 'home' could scarcely be regarded as palatial, judging both from the way it is depicted in the third of Daumier's *Orang-Outaniana* lithographs and the way it is described in other contemporary reports. *Le Magasin Pittoresque*, for example, stated that, 'This curious animal ... has been installed in a shed or hut placed above those of the other monkeys.'[64]

The hyperbole of *Le Charivari's* article invites us, therefore, to read further between the lines. As already suggested, the word 'palace' here could symbolise on a more general level Thiers's fabrication of the entire administration of Louis-Philippe as an expedient way of pre-empting mob rule and a threatened return to republicanism after the collapse of the Bourbon dynasty. But on another level it could refer more specifically to the costly refurbishment of two actual royal palaces undertaken after Louis-Philippe's accession to the throne; first, the rehabilitation of the Orleanist Palais Royal in Paris, which naturally had not been used by the Bourbon kings Louis XVIII and Charles X, as the rightful home of the French monarchy after the July Revolution, and second, Louis-Philippe's restoration of Versailles, effected at a cost of 23 million francs. Officially opened on 10 March 1837 this had more or less turned the palace into a museum dedicated 'to all the glories of France'.[65]

The next reference – that to the American tropical plants bought at great expense 'to make him feel more at home' – underlines the sense of allegory further by misconstruing the natural habitat of the orang-utan, whom we already know had been brought from Asia. Instead, this comment seems to be invoking the fact that Louis-Philippe had spent some considerable time in the United States himself and to be lamenting the republican political ideals he claims to have sustained there but which in the eyes of the opposition press he had long since forsaken. In his Declaration of July 1830, he had remarked: 'I am a republican. The constitution of the United States is the most perfect in my eyes',[66] and even in August 1835 he could ironically boast to the Marquis de Lafayette that 'It is impossible to have spent two years in America without being a republican. What we are lacking, is a people's throne surrounded by republican institutions and nothing but.'[67] The concluding words of the first paragraph – 'To complete the illusion, one will feed him with the fruits of his country' – again appears to work on a multiple signification. The most obvious reading would denote the predilection of Jacke for oranges and cherries.[68] A more paradigmatic reading, as well as continuing the fruit symbolism by alluding to *la poire*, could also signify the way that Louis-Philippe had been feasting himself (and indirectly the country) on the caution money, stamp duty and numerous fines that had been inflicted on the political press since the early days of his administration. Such penalties had proven to be a lucrative source of revenue for the State: a report of 1842 in *Le Charivari* revealed that since 1830 about one million francs had been paid to the treasury in fines.[69]

The theme of retribution against the press appears to be carried

into the second paragraph of the passage, although again it is
equally as entropic in conveying this message:

> Jacke became seriously ill; he was attacked by a violent inflamma-
> tion of the lungs. Our best physicians, amongst others Mr Orfila, Mr
> Serres and Mr de Blainville, were gathered together around him in
> consultation; one administered some blood-letting; then, each day,
> a doctor kept a watch *at his bedside*. One went so far as to fabricate
> some form of paternal coercion in order to make him accept by
> force the remedy which Mr de Pourceaugnac did not want at any
> price.

In October of 1836 Jacke had in fact been diagnosed as suffering
from an acute case of pleurisy, due to the damp autumn weather.
The opposition daily *Le Constitutionnel* had also contained reports
to this effect and mentioned that he was being tended by a group
of four or five doctors including those mentioned above.[70] *Le
Charivari's* treatment of the incident, however, is not so straight-
forward, once more mixing up fact with fiction, and whilst it
ostensibly deals with Jacke's chest infection, in a broader historical
context it could also be postulating an allegorical summary of the
events which had led up to the passing of the 1835 September Press
Law. In this way, the first sentence mentioning Jacke's 'inflamma-
tion of the lungs' could be an oblique reference to Louis-Philippe's
own feelings after Fieschi's abortive attempt on his life during the
parade on 28 July. It was actually the Duc de Broglie whose chest
had been grazed by a bullet as he rode down the Boulevard du
Temple, Louis-Philippe himself sustaining slight injuries to his
head and arm. But even if the king had survived the attack virtu-
ally physically unscathed, the incident was to haunt him and
cause him grief for some time afterwards through the loss of one
of his close friends, the Marshal Mortier, and the subsequent trial of
Fieschi and the other plotters, whose lives he regretted he could
not save.[71]

The allusive play of the story-line is heightened also by the
italicising of the phrase *at his bedside*, suggesting that it is not an
animal that has been ill but a human being, and by the reference
to three contemporary physicians, Orfila, Serres and de Blainville.
Even before Fieschi's assassination attempt there had been some
ministers who felt that the press was not being controlled strictly
enough by existing legislation and who seized the opportunity to
sway the king in favour of tighter press censorship. Foremost was
Persil, who had been responsible for initially introducing caution
money in 1819 and who, as *procureur général*, pursued a personal
vendetta against the opposition press, and Félix Barthe, who had
petitioned a bill in 1834 to repress independent political associa-
tions. Along with Périer, Head of Government in September 1835

and another supporter of the proposed legislation, these could be the political counterparts to Orfila, Serres and de Blainville who had kept a watch at 'Jacke's bedside'.

In direct contrast to the real persons included in the first half of the passage, the notion of fabricating 'some form of paternal coercion' and the final character mentioned in the text have their origin in a drama by Molière entitled *Monsieur de Pourceaugnac*, first performed in 1669.[72] The plot centres on the merchant Pourceaugnac who arrives in Paris from Limoges to marry Julie, the daughter of his friend Oronte. In order to win back Julie's hand, her lover Eraste contrives to make his rival an object of ridicule in the eyes of Oronte by pretending that he is suffering from melancholic hypochondria and consequently in need of medical treatment. Pourceaugnac, however, strongly resists the advances of the physicians who attempt to minister to him, protesting: 'God's blood, I ain't sick. My father, nor mother never resorted to medicine and they both died without the assistance of the doctor.'[73]

It is not surprising in this instance to find Philipon invoking a character from Molière. The theatre was a constant theme in the lithographs that Daumier produced for *Le Charivari* and both he and Philipon would in turn have sympathised with Molière's ridiculing of the medical and legal professions.[74] In the context of the 1830s, the 'means of paternal coercion' could therefore parallel the 1835 September Press Law, and as a corollary Monsieur de Pourceaugnac, who did not want Jacke to accept such a remedy at any cost, could connote either Philipon or any other editor of an opposition paper for whom the new legislation was the kiss of death. A further clue to corroborate this reading is offered in Molière's drama itself, where Pourceaugnac condemns the Parisian *laissez-faire* approach to the law, exclaiming: 'Why, this amazes me, that the forms of Justice should not be observed in this Land.'[75]

At the outset, an innocent orang-utan would appear to have been a curious choice for political or social symbolism and, in comparison to the more numerous *Robert Macaire* series of lithographs, the *Orang-Outaniana* may have been no more than a brief interlude in the fertile collaboration between Daumier and Philipon. Taken as a totality, however, Daumier's lithographs and the accompanying article, 'Ah! Si j'étais orang-outang!', can be seen to offer a complex and subtle allegory on the reign of Louis-Philippe and form an instructive insight into the way that political dailies such as *Le Charivari* sought to circumvent the stranglehold of the September Press Law of 1835 through an interdependence of word and image.

Punch, politics and 'Paddy'

The iconography of the ape was also to be found in British carica-
ture; we have already noted Landseer's *Monkeyana* of 1827, which
were harmless skits on the art establishment. But by the 1860s the
use of simian symbolism had taken on more sinister ideological
overtones in *Punch's* treatment of Home Rule for Ireland. Notwith-
standing the lack of any serious press censorship, caricature in
Britain was scarcely the same political animal as it was in France.
Thackeray had drawn a cartoon of Louis-Philippe which appeared
in *The National Standard* (1833–34) in 1833, but this was a harmless
effort compared to the vitriolic symbolism of *La Caricature* and *Le
Charivari*.[76] *Punch* likewise consolidated a middle path for carica-
tural satire to the extent that Charles Knight could refer to it more
as: 'the shrewdest observer, the most good-humoured satirist, the
most inoffensive promoter of merriment, and one of the most
trustworthy of portrait painters that ever brought the pencil to
the aid of the pen, for harmless entertainment and real moral
instruction'.[77]

The first issue of 17 July 1841 followed the example of earlier
folio volumes of caricatures such as *Figaro in London* (1831–39) and
Punchinello (1832), and became an overnight success, selling 10,000
copies, although as Marion H. Spielmann has pointed out, the ini-
tial success of *Punch* was less to do with the talent of its cartoonists
and writers and more to do with sound financial management by
the publishing firm Messrs Bradbury, Evans and Agnew.[78] Edited
by Mark Lemon until 1870 and Shirley Brooks thereafter, its early
contributors during the 1840s included the cartoonists John Leech,
Kenny Meadows and John Tenniel and the writers Henry Mayhew,
Thackeray and Douglas Jerrold.

Most of these men were radical liberals who were united in their
support of the poor and the oppressed. Between 1841 and 1848,
therefore, *Punch* attempted to expose some of the social inequalities
of Victorian society with caricatures by John Leech such as *Sub-
stance and shadow*, published on 15 July 1843 (figure 20), in which
the exhibition of cartoons to decorate the Houses of Parliament
becomes a vehicle to highlight the materialistic division between
the rich and the poor. In its early years *Punch* was equivocal about
Queen Victoria and scathing of her marriage to Prince Albert,
whom it could never forgive for being German. *The Momentous
Question* of 1845, for example, dealt with allegations that Prince
Albert had taken out shares in the new railway companies, and in
Victoria Patronising the Arts (13 July 1844) the Queen dressed as
Britannia is seen hovering over a seated infant whom she is just
about to crown with a laurel wreath. Mr Punch's commentary

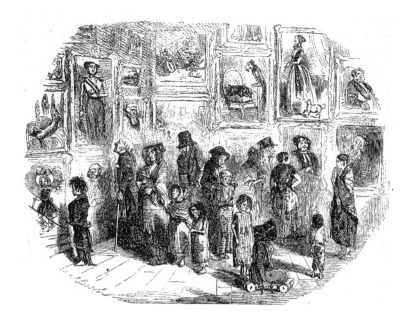

20] 'Substance and shadow', wood engraving by John Leech, *Punch* (15 July 1843).

stated further: 'It is neither correct in point of history nor compli-mentary to our Gracious Monarch, who does not patronise the British Fine Arts at all, liking, and with reason, French, German and Italian artists, much better.' The cartoon and commentary com-bined, therefore, ostensibly deal with the Queen's apathy for British art of the period, but the suggestion is also made that her taste is probably informed by Prince Albert, who was a more discerning patron of the arts – it was he who had a predilection for North Italian Renaissance and German painting, and in 1842 he had led the Royal Commission for the redecoration of the Houses of Parlia-ment. At the same time, Leech's cartoon symbolises the Queen's maternal role. In July 1844 she was expecting her fourth offspring (Prince Alfred, born one month later) and the male infant repre-sented in the drawing could be the heir apparent Prince Edward, who was then 3 years old.[79]

Notwithstanding such ridicule, Prince Albert was an avid fol-lower of *Punch*, and after the 1848 revolutions in Europe, when political radicalism was greatly feared in Britain, attacks on Victoria and Albert began to subside.[80] The consequences of such anarchy were underlined with several satires made at the expense of Louis-Philippe, such as Leech's *The Fagin of France* which, based on an earlier illustration by Cruikshank for *Oliver Twist,* depicted the pear-shaped king in prison, and *The Resignation of Louis-Philippe,* which represented him as Robert Macaire finding a new use for the *tricolore* as a handkerchief. For the most part, therefore, cartoons ridiculing the art scene, fashion and the social customs of the middle classes became common, and *Punch* showed little support

for oppositional politics, impugning the rise of the women's movement and the growth of Unionism and Socialism. In particular, the vexed issue of Home Rule for Ireland had become the central concern of *Punch*'s chauvinism by the 1860s, and it greatly opposed any attempts to grant the power of self-determination to the Irish. Anglo-Irish relations had been strained since the Irish insurrection of 1798, when rebel Catholics committed atrocities against indigenous Protestants, allegedly impaling babies and women with pikes. Some of these events were illustrated by George Cruikshank for W. H. Maxwell's *History of the Rebellion in Ireland in 1798*, published in 1845. In the same vein, *Punch* gave short shrift to Irish nationalism and the rise of Fenianism, firmly opposing Daniel O'Connell's calls to repeal the 1800 Act of Union in cartoons such as J. Kenny Meadows's *The Irish Frankenstein* and John Leech's *The Repeal Farce* of 1843. Between 1845 and 1849 it showed little sympathy for the suffering caused by the potato famine which in turn led to the intensification of Fenianism in the 1860s. It was during the 1860s also that the stereotypical representation of 'Paddy' as a threatening brute with sloping forehead, long upper lip and prognathous jaw began to be more systematically simianised in John Tenniel's cartoons for *Punch*. As L. Perry Curtis jun. contends in his admirable study *Apes and Angels*:

> For many comic artists of Tenniel's generation the advent of the revolutionary republican movement known as Fenianism, whose members were sworn to end British rule in Ireland by physical force, seemed to reveal the beast that lurked within the Irish character ... In their efforts to play up the menace of Fenianism to English civilisation, many cartoonists in London depicted Fenian Paddy as an ape-like monster.[81]

One of the most common devices in representing the rebellious 'Fenian Paddy' in such terms was to contrast him with more benign Irish role models or types. Thus in Tenniel's *The Fenian Guy Fawkes*, an ape-like dynamiter sits astride a barrel of gunpowder, surrounded by a group of children and a mother breast-feeding her baby, and in his *Two Forces* (figure 21) an Irish anarchist with a stone in his hand threatens a forthright Britannia, who wields the sword of justice and treads underfoot a notice with Land League written on it, as she comforts a weeping Hibernia.

Following the agricultural depression of the 1870s, the cause of Irish emancipation was promoted with renewed vigour. In 1877 Charles Stewart Parnell became leader of the Home Rule Party, and in 1879 the Land League was formed to press for personal ownership of land by the peasantry and the overthrow of the landlord system. This led to the passing of Gladstone's 1881 Land Act, which granted some rights of ownership to agricultural labourers, and his

support for Home Rule, which was defeated in a parliamentary vote in 1886.

However, these more positive initiatives were outweighed by the assassination of the Irish Secretary Lord Frederick Cavendish on 6 May 1882 in Phoenix Park, Dublin. After this time *Punch* stepped up its attacks on the more anarchistic strain of the Land League movement with caricatures like Tenniel's *The Irish Frankenstein* (figure 22). In this image, the usual simian symbolism has been conflated with that of a fabricated, murderous monster, suggesting that Fenianism is now a nightmarish political force beyond the control of those who were originally responsible for bringing it into existence.

In its portrayal of the Irish republican as a rampaging ape or an alien species, *Punch* relied not only on contemporary historical incidents but was also backed up by certain specious physiognomical and ethnological theories. An article in *Punch* on 18 October 1862 entitled 'The missing link', for example, served to illustrate the ethnic origins of the Irish Celt by drawing an analogy between him and the black African: 'A gulf, certainly, does appear to yawn between the Gorilla and the Negro. The woods and wilds of Africa do not exhibit an example of any intermediate animal . . . it comes from Ireland.' Within such a context the Irish, therefore, are connoted as 'white negroes', and this thought was common during the nineteenth century. During the 1870s, Dr John Beddoe promoted his 'Index of Nigrescence', which determined ethnicity

21] 'The two forces', wood engraving by John Tenniel, *Punch* (29 October 1881).

22] 'The Irish Frankenstein', wood engraving by John Tenniel, *Punch* (20 May 1882).

with regard to the colour of one's hair, skin and eyes, and which did much to confirm the impression of many Victorians that those of Celtic origins were usually darker than those descended from Saxon or Scandinavian ancestry. Daniel Mackintosh's research during the 1860s traded on a similar mythology, stating that the Gaelic type could be recognised by the following features: 'Bulging forward of lower part of face - most extreme in upper jaw. Chin more or less retreating ... (in Ireland the chin is often absent). Retreating forehead. Large mouth and thick lips.'[82]

Caricature and physiognomy

The reduction of nationality here to crude facial and corporeal characteristics was for caricature in turn informed by its affinity to portraiture and physiognomy. In the eighteenth century this correlation was expressed by several important comic artists including Hogarth, who in his *Anecdotes* claimed that caricature was merely a more grotesque or burlesque way of depicting facial features, and by Gillray, whose 'Doublures of Character' in the 1790s were based on Lavater's dictum, 'If you would know men's hearts, look in their faces.'[83] Physiognomic theory, in actuality more of a pseudo-science, can be traced back to Hippocrates and Plato, and trades on the fundamental assumption that the features of the face, and sometimes the whole head or body, are the outward manifestation of an individual's character and temperament.[84] During the seventeenth century this discourse was taken up by Kaspar Lavater with the *Physiognomical Fragments* (1772) and Pieter Camper, who postulated a theory of human intelligence based on the angle of one's face or head in profile. The facial angle was determined by measuring the intersection of a diagonal or a vertical line with a horizontal one from which Camper extrapolated that the ideal facial angle lay between 70 and 80 degrees and was to be found amongst European Caucasians. Anything less was a sign of barbarism or primitivism, and the more prognathous the jaw, the closer man was physically and mentally to the anthropoid apes.[85]

Most nineteenth-century caricaturists would have encountered such ideas in their artistic training, and would have had, therefore, a rough idea of Camper's system, if not in its original format, then certainly indirectly through texts by Anders Adolf Retzius, James W. Redfield and D'Alibert, which were steeped in the same physiognomical tradition.[86] The stereotyping of the Irish as apes can be seen as part of this tradition, and in common with most caricature trading on such symbolism, it was grounded on flimsy evidence. The Irish were genetically no closer to the monkey family than black Africans, and it is interesting to see how cartoons

like *Setting Down in Malice*, which appeared on the front cover of
the Irish satirical journal *Pat* on 22 January 1881, aimed to dispel
such racial myths by implying that these representations were no
more than the invention of English comic artists too eager to fuel
the prejudices of their readers.

As we have seen, caricature during the nineteenth century became
a more diffuse, if not a more democratic form of graphic art within
the context of periodical publishing in Britain and France, existing
at a complex intersection of aesthetic and ideological concerns.
Whilst the two countries differed from each other in terms of
politics, censorship and preferred techniques of representation,
caricatural symbolism in the illustrated press, none the less, had a
vital part to play in both of them. Subject to the exigencies of
weekly and even daily production, the nineteenth-century carica-
turist had to be well aware of contemporary events and how to
make them resonate with his/her public. It was on account of this
topicality and inventiveness that Baudelaire singled out both cari-
cature as a paradigm for modern art and the comic artist as a
Doppelgänger or special agent who simultaneously belonged to the
society in which he lived but whose power of observation allowed
him to ridicule and objectify it as an outsider.[87] At the same time,
such a rich seam of comic invention and the rapid turnover of
symbolism, especially in France, where press censorship was ex-
tremely rigorous, postulated a more knowledgeable and urbane
readership. Yet for all its complexity, caricature affords us an in-
valuable understanding not only of the various circumstances
which surround or inform cultural production itself, but also an
illuminating insight into the history of the period in which it was
produced. As L. Perry Curtis jun. argues: 'The study of comic art,
especially in its more political guise, can be an enriching experi-
ence, forcing the enquirer into fields far removed from his point
of departure.'[88]

Notes

1 See J. Grand-Carteret, 'Liste des journaux et almanachs à caricatures publiés
 1830-1887', in *Les Mœurs et la caricature en France* (Paris, 1888); H. Izambard,
 La Presse Parisienne (Paris, 1848); P. Jones, *La Presse satirique illustrée entre
 1860 et 1890* (Paris, 1856); F. Maillard, *Histoire des journaux publiés à Paris
 pendant le Siège et la Commune* (Paris, 1871). The satirical journals cited in
 these works, together with titles from other sources, have been collated by
 P. J. Jobling, *The Evolution of the Popular Illustrated Press in Nineteenth-
 Century France*, unpublished M.A. thesis, Royal College of Art, London
 (1983), pp. 240-50.

2 Dates cited in *Catalogue collectif des périodiques*, 4 vols Bibliothèque Nation-
 ale (Paris, 1967-77).

3 There are no comprehensive listings of the satirical press in Britain during this period comparable to those for France mentioned in note 1. See, however, G. Everitt, *English Caricaturists and Graphic Humourists of the Nineteenth Century* (London, 1886); M. H. Spielmann, *The History of Punch* (London, 1895); and S. Houfe, *The Dictionary of British Book Illustrators and Caricaturists 1800-1914* (London, 1978).

4 See C. A. Ashbee, *Caricature* (London, 1928), p. 47.

5 *Ibid.*

6 See J. Cuno, 'Charles Philipon, La Maison Aubert and the business of caricature in Paris, 1829-41', *Art Journal* (Winter 1983), pp. 347-54.

7 *Ibid.*

8 There were two collections of caricatures in Britain at this time which exploited lithography, John Doyle's *Political Sketches*, 1829-51, which sold for two shillings apiece, and *Everybody's Album and Caricature Magazine*, 1834-35, published by J. Kendrick with illustrations by Grant and retailing for sixpence plain, one shilling coloured.

9 Cuno, 'Charles Philipon, La Maison Aubert and the business of caricature in Paris'.

10 J. B. Duvergier, *Collection complète des lois, décrets, ordonnances, règlements et avis du Conseil d'État*, t. XXX (Paris, 1830), p. 110. Unless otherwise stated, all translations from the original are by the authors.

11 C. Bellanger, *Histoire générale de la presse française 1815-70*, t. 2 (Paris, 1969), p. 3.

12 Nearly every European country, with the exception of Britain, had imposed preliminary censorship on political imagery until this point, and in Russia censorship of the press persisted right through the nineteenth century.

13 *Arrêté du 25 nivôse an VIII*, articles 1-3.

14 Loi 9-10 juin 1819, article 1. See Lepec, *Bulletin annoté des lois, décrets et ordonnances*, t. XVI (Paris, 1837), pp. 533-4.

15 During the July Monarchy it stood at 2,400F between 1830 and 1835 and at 100,000F between 1835 and 1848; during the Second Empire it stood at 50,000F between 1852 and 1870.

16 W. Feaver, *George Cruikshank* (London, 1974), p. 11.

17 *Journal Officiel* (8 June 1880), 6,212-13.

18 J. R. Kist, *Daumier, Eyewitness of an Epoch* (London, 1976), p. 3.

19 C. Baudelaire, *Oeuvres Complètes*, edited by C. Pichois, 2 vols (Paris, 1975-76), p. 1,006.

20 See E. C. Childs, 'Big trouble: Daumier, Gargantua and the censorship of political caricature', *Art Journal* (Spring 1992), p. 29.

21 Cited in H. A. C. Collingham, *The July Monarchy - A Political History of France 1830-48* (London, 1988), p. 108.

22 Childs, 'Big trouble: Daumier, Gargantua and the censorship of political caricature', p. 28.

23 For a fuller discussion of the prison conditions in Ste Pélagie facing political offenders see R. J. Goldstein, *Censorship of Political Caricature in Nineteenth-Century France* (Ohio, 1989).

24 *Les Poires* by Philipon was published in *La Caricature* (24 November 1831).

25 Charles Joseph Traviès de Villiers (1804-59) had made his debut as a genre painter at the Salon of 1823. As a caricaturist he contributed to both *La*

Silhouette and *Le Charivari* between 1829 and 1846. Beginning in 1843 he also made several lithographs for the fine art review *L'Artiste*.

26 Childs, 'Big trouble: Daumier, Gargantua and the censorship of political caricature', p. 33.

27 'Le Perroque, animal bavard, vindicatif et entêté', *Le Charivari* (8 February 1834); 'L'Antre du lion', *Le Charivari* (21 September 1834).

28 E. K. Menon, 'The image that speaks: the significance of M. Mayeux in the art and literature of the July Monarchy', in P. Ten-Doesschate Chu and G. P. Weisberg (eds), *The Popularization of Images: Visual Culture under the July Monarchy* (Princeton, 1994), p. 45. This is an insightful and convincing reappraisal of the connotations of the hunchback Mayeux.

29 *La Corsaire* (24 and 27 July 1835) and *La Quotidienne* (5 and 21 July 1835) had included articles to this effect.

30 For a fuller account of the Fieschi affair, see Collingham, *The July Monarchy – A Political History of France 1830–48*, chapter 13.

31 See Duvergier, *Collection complète des lois, décrets, ordonnances, règlements et avis du Conseil d'État*, 35, pp. 256-61 for article 13 of the September 1835 Press Law and caution money, and Bellanger, *Histoire générale de la presse française 1815-70*, t. 2, p. 405 for articles 1, 2 and 4 regarding the potential for fines.

32 Duvergier, *Collection complète des lois, décrets, ordonnances, règlements et avis du Conseil d'État*, 35, Article 12 of the Law of 25 March 1822 stated that 'Any publication, sold or put on sale, on display, into distribution, without preliminary authorisation from the government, of engraved and lithographed drawings, will, by this sole deed, be punished with imprisonment of three days to six months, and a fine of ten to five hundred francs' (*Ibid.*, 23, p. 481).

33 See I. Collins, *The Government and the Newspaper Press in France 1814-1881* (London, 1959), p. 282.

34 The average subscription to *Le Charivari* in 1834 was 2,500 copies daily (*Le Charivari* 13 (1834)). By 1846 this had risen by nearly 10 per cent to 2,740 (C. Bellanger, *Histoire générale de la presse française*, t. 1, p. 146).

35 There was a total of 52 issues of *Le Charivari* for 1835 and 198 for 1836 which appeared without illustrations (a full list of these is in Jobling, *The Evolution of the Popular Illustrated Press in Nineteenth-Century France*, n. 26, p. 122). It is worth citing such figures since, for 1836 at least, they clearly do not concord with the records kept in the register of non-authorised prints in the *Archives Nationales*, Paris, which cites only 50 censored works for that year. See M. P. Driskel, 'Singing the Marseillaise in 1840: the case of Charlet's censored prints', *Art Bulletin* (December 1987), p. 604.

36 *Le Charivari*, 259 (1835): 'Cette médaille est celle qui a été frappée dernière-ment à Paris, en l'honneur du Duc de Bordeaux, et dont l'existence a été nié par le gouvernement'.

37 During the 1840s, Gavarni was one of the most prolific contributors to *Le Charivari*, even outstripping the volume of lithographs executed by Daumier for several years – in 1840, he supplied 176 lithographs, and 194 in 1841.

38 T. Gautier, *Portraits contemporains* (Paris, 1874), pp. 331f.

39 Vernier, 'Les grisettes' and 'Les physionomies du bal', *Le Charivari* (1845), *passim*; Bouchot, 'Les quartiers de Paris, *Le Charivari* (1845), *passim*; Beaumont, 'L'Opéra au XIXᵉ siècle', *Le Charivari* (1844), *passim*.

40 *Le Charivari*, 94 (1836).

41 Cham (Amédée de Noé) was one of the most prolific contributors to the illustrated press from the 1840s until his death in 1879; his work is to be

found also in *L'Illustration*, *Journal Amusant*, *Le Monde Illustré* and *L'Univers Illustré* in France, and in *Illustrated London News* and *Puppet Show* in England. See D. Kunzel, 'Cham: the popular caricaturist', *Gazette des Beaux Arts* (December 1980), pp. 213-24.

42 For a fuller account of this policy see Collingham, *The July Monarchy – A Political History of France 1830–48*, chapters 15 and 23.

43 Lemaître's personification of Macaire had been inspired by a drama by Chevrillon, Lacoste and Chaponnier entitled *L'Auberge des adrets*, which was premiered on 2 July 1823 and ran until 2 April 1824 in Paris with moderate success. Lemaître more successfully transformed the character from a small-time thief into a careerist and opportunist to sum up the entrepreneurial spirit of the July Monarchy. See A. Hubschmid, *Daumier – l'œuvre lithographique*, t. I (Paris 1977), pp. 116-17.

44 The July Monarchy had witnessed the consolidation of the bourgeoisie, with the huge exodus of citizens from the countryside who were trying to make their fortune in cities like Paris and Lyon; between 1831 and 1846 the population of France's larger towns in general increased by about 22 per cent (C. Pouthas, *La Population française* (Paris, 1956)). Clearly, the expansion of the bourgeoisie witnessed considerable variations and differences within its broader classification.

Whilst all social classes and professions were grist to the mill for Philipon and Daumier, the Macaire series and many other of their collaborations, such as *Les Bons Bourgeois* deal more obviously with the newly franchised middle classes.

45 R. Passeron, *Daumier* (New York, 1981), p. 115.

46 The Macaire lithographs appeared in *Le Charivari* under the title *Caricaturana* between 20 August 1836 and 25 November 1838. A second series named after Macaire was published between October 1840 and September 1842.

47 C. Baudelaire, *Curiosités esthétiques et autres écrits sur l'art* (Paris, 1968), p. 85.

48 Three *Orang-Outaniana* were published in *Le Charivari* on 21 September, 6 October and 8 November 1836 respectively. A fourth lithograph in the series, 'Dieu de Dieu! mais c'est un pppolisson, un Lovelace, un séducteur, Gardien, Gardien! arrivez donc! Bobonne défends ton bien!' did not appear in *Le Charivari* but was published only as a proof print without text (L. Delteil, *Catalogue raisonné de l'œuvre lithographié de Honoré Daumier* (Paris, 1904), entry no. 2,142, pp. 460-1).

49 *Le Magasin Pittoresque*, 4:28 (July 1836), pp. 223-4: 'L'orang-outang du Muséum d'histoire naturelle de Paris' states that before the arrival of the ape in 1836, the museum possessed only the skeleton and the stuffed skin of an orang-outan which had been donated by the Empress Josephine (see also *Le Magasin Pittoresque*, 37 (September 1835), pp. 294-5).

50 *Le Constitutionnel*, 'Intérieur, Paris 23 Mai', pp. 144 and 145 (23 and 24 May 1836), and *Le Magasin Pittoresque*, 4:28 (July 1836), pp. 223-4. An article simply entitled 'L'Orang-outang' was published in a supplement to the *Revue du Théâtre*, 197ᵉ livraison, t. VIII (May 1836), p. 302.

51 Werner's three lithographs appeared in *Le Charivari* on 31 August, 5 September and 16 September 1836 respectively. See note 48 above regarding Daumier.

52 Jean Isidore Gérard Grandville (1803–46) was another prolific illustrator for the popular press during the nineteenth century; he executed approximately 3,000 lithographs, engravings and other prints in his artistic career. His speciality was for caricature or allegory, drawing analogies between

mankind and animals. For a full overview of Grandville's *œuvre* see G. Sello, *Grandville: Das gesamte Werk*, 2 vols (Munich, 1969). For a more concise discussion of Grandville's work see C. F. Getty, 'Grandville: opposition, caricature and political harassment', *Print Collector's Newsletter*, 14 (January/February 1984), pp. 197-201.

53 See F. Haskell and N. Penny, *Taste and the Antique* (London, 1981), p. 79 for references to Aristotle and Galen. In the seventeenth century, *babuinerie*, the genre of painting monkeys aping the labours and pleasures of man had been popularised in the Low Countries by Bruegel and David Teniers the younger. A similar genre known as *singerie* became popular in France in the eighteenth century as, for example, in Watteau's *Les Singes Peintres*, and engravings after Christophe Huët's designs published *c.* 1745 as *Singeries ou Différentes Actions de la Vie Humaine Représentées par des Singes* provided the basic motifs for decorations on porcelain, marquetry, tapestry and embroidery.

54 See C. Frayling and R. Walker, 'From the orang-utan to the vampire: towards an anthropology of Rousseau', in R. A. Leigh (ed.), Rousseau after Two Hundred Years (proceedings of the Cambridge Bicentennial Colloquium, Cambridge, 1982).

55 The fuller legend to this lithograph reads: 'On viewing this crowd of visitors, who offer so varied an assortment of misshapen, bandy-legged ones, of dwarves, daddy-long-legs, of figures plain, foolish, pale or repulsive, there is no doubt that the animal would be in the right to protest against the axiom "the orang-outan is very like mankind". The poor monkey tells himself unequivocally, like the lion in the fable: "Oh! if only my comrades knew how to paint!"' A source of inspiration for this print in the *Orang-Outaniana* could have been Giambattista Casti's *Gli Animali Parlanti* (The Talking Animals), first published in 1802.

56 *Le Constitutionnel*, 23/24 (May 1836): 'Intérieur, Paris 23 May' contains a report on the anatomy of the orang-outan and concludes that 'this would be, in a word, to characterise him perfectly as a plaster cast almost to the point of naming him *M. Mayeux, the cripple'*.

57 See W. C. McDermott, *The Ape in Antiquity* (Baltimore, 1938).

58 The same dialectic of setting down two contrasting columns of text to make comparisons between the inequality of the social system also crops up in several other issues of *Le Charivari*, such as the article 'Mort de faim!' in the issue of 9 November 1836, or the issue of 17 February 1841, which contrasts the lavish baptism of Princess Victoria in England with the death of a starving labourer who has left behind a pregnant wife and numerous offspring.

59 See Collingham, *The July Monarchy – A Political History of France 1830-48*, p. 332.

60 See entry for Thiers in the *Nouvelle Biographie Générale*, t. XLV (Paris, 1866), pp. 178-9.

61 *Ibid.* In *Le National* (9 February 1830), Thiers had proposed the candidature of the Duc d'Orléans and backed this up in an article in the same paper on 30 July 1830, proposing him as King of the French.

62 Thiers headed the Government between February and August 1836 and March and October 1840. For a comprehensive account of Thiers's career, see J. P. T. Bury and R. P. Tombs, *Thiers 1797-1877 – A Political Life* (London, 1986).

63 Reported in 'nouvelles diverses', *Le Siècle* (20 October 1836).

64 *Le Magasin Pittoresque*, 4:28 (July 1836), p. 223.

65 See Collingham, *The July Monarchy – A Political History of France 1830–48*, p. 98, and J. Barry, *Versailles: The Passions and Politics of an Era* (London, 1972), p. 476.

66 Quoted in *Le Charivari* (29–30 July 1834).

67 *Ibid.*

68 *Le Magasin Pittoresque*, 4:28 (July 1836), p. 224: 'Le jeune orang aime beaucoup les cerises, les oranges et se montre indifférent aux biscuits et au pain.'

69 In *Le Charivari*, 27 March 1842, a special issue printed in red ink entitled 'Œufs de Pâques Politiques' raised the spectre of the broken promises of the Charter of 1830, claiming that since 1830 there had been 900 prosecutions against the press, 500 years of prison sentences and about 1,000,000 francs in fines.

70 See *Le Constitutionnel* (21 October 1836 – 'Intérieur, Paris 20 Octobre' and 23 October 1836 – 'Intérieur, Paris 22 Octobre').

71 Collingham, *The July Monarchy – A Political History of France 1830–48*, p. 96 and also T. E. B. Howarth, *Citizen King – The Life of Louis-Philippe* (London, 1961), pp. 183–4.

72 *Monsieur de Pourceaugnac* was first performed on 6 October 1669 at the Château Chambord, and published on 3 March 1670; during the nineteenth century performances of the play took place in Paris at the Théâtre Française (see La Musée des Arts Décoratifs exhibition catalogue, *Expostion du IIIᵉ Centenaire de la Mort de Molière* (Paris, 1973), p. 73. The name *Pourceaugnac* is meant to convey the characteristics of the pig being derived from the old French *pourceau* and the 'unfashionable manners of any of those towns in the south or west of France whose names end in *-ac*' (see H. Gaston Hall, *Comedy in Context: Essays on Molière* (Jackson, Miss., 1984), p. 91.

73 Molière, *Monsieur de Pourceaugnac* (Paris, 1673), Act I, scene viii.

74 Daumier is reputed to have told Houssaye, the director of the Comédie Française, that Molière was his master in art (see O. W. Larkin, *Daumier: Man of His Time* (London, 1967), p. 190). The first representation by Daumier of a theme by Molière is probably the lithograph, 'Le Malade Imaginaire: Je suis perdu', published in *Le Charivari* (21 May 1833) as part of the 'Imagination' series (fifteen plates published between 14 January and 19 October 1833), whilst the earliest example of an illustration dealing with the theatre is probably 'Passé Minuit: Théâtre du Vaudeville', published in *Le Figaro* (23 June 1839). The majority of Daumier's theatrical drawings, oils and watercolours belong to the early 1850s–1860s. Daumier began to satirise the legal profession in isolated lithographs from the 1830s, but more consistently with his series *Les Gens de Justice*, executed between 1845 and 1848.

75 Molière, *Monsieur de Pourceaugnac*, Act III, scene ii.

76 *The National Standard (and Journal of Literature, Science, Music, Theatricals and the Fine Arts)*, 18 (4 May 1834).

77 C. Knight, *Passages of a working life during half a century*, vol. III (London, 1864–65), pp. 247–8.

78 See M. H. Spielmann, *The History of Punch*, pp. 30–40; the Bradbury and Evans Archive, *Punch*, London contains detailed acounts of the company's finances.

79 Between 1840 and 1857, Queen Victoria bore nine children: the first, Princess Victoria, was born in 1840, and the last, Princess Beatrice, in 1857.

80 Sir T. Martin, *Life of the Prince Consort*, vol. II (London, 1875–80), p. 269.

81 L. Perry Curtis, jun., *Apes and Angels: the Irishman in Victorian Caricature* (Washington, DC), 1971), p. 37.

82 *Ibid.*, pp. 17–21.

83 J. K. Lavater, *Essays on Physiognomy for the Promotion of the Knowledge and Love of Mankind*, translated by T. Holcroft (London, 1789).

84 See L. Perry Curtis, *Apes and Angels*, p. 6.

85 *Ibid.*, chapter 1.

86 *Ibid.*, and D'Alibert, *Physiologie des passions, ou nouvelle doctrine des sentiments moraux* (Paris, 1825).

87 M. Hannoosh, *Baudelaire and Caricature: from the Comic to an Art of Modernity* (Pennsylvania, 1992) is a solid and impressive study of these aspects of Baudelairean theory.

88 Curtis, *Apes and Angels*, p. ix.

Suggestions for further reading

A. Adburgham, *Punch: a History of Manners and Modes 1841-1940* (London, Hutchinson and Co., 1961).

Champfleury, *Histoire de la Caricature Moderne 1865-90*, t. 5 (Paris, Dentu, n. d.).

E. C. Childs, 'Big trouble: Daumier, Gargantua, and the censorship of political caricature, *Art Journal* (Spring 1992), pp. 26–37.

I. Collins, *The Government and the Newspaper Press in France 1814-1881* (Oxford University Press, 1959).

I. Collins, 'The Government and the press in France during the reign of Louis-Philippe', *English Historical Review*, vol. 69 (1954), pp. 262–82.

J. Cuno, 'Charles Philipon, La Maison Aubert and the business of caricature in Paris 1829-41, *Art Journal* (Winter 1983), pp. 347–54.

L. P. Curtis, jun., *Apes and Angels: the Irishman in Victorian Caricature* (Washington, DC, Smithsonian Institution Press, 1971).

M. P. Driskel, 'Singing the Marseillaise in 1840 – the case of Charlet's censored prints', *Art Bulletin* (December 1987), pp. 604–25.

R. J. Goldstein, *Censorship of Political Caricature* (Ohio, Kent State University Press, 1989).

J. Grand-Carteret, *Les Mœurs et la caricature en France* (Paris, Librairie Illustrée, 1888).

M. Hannoosh, *Baudelaire and Caricature: From the Comic to an Art of Modernity* (Penn State Press, 1992).

S. Houfe, *John Leech and the Victorian Scene* (Woodbridge, Antique Collectors' Club, 1984).

A. Hubschmid (ed.), *Honoré Daumier: l'œuvre lithographique*, 2 vols (Paris, Hubschmid, 1978).

F. E. Huggett, *Victorian England as Seen By Punch* (London, Sidgwick and Jackson, 1978).

P. Jobling, 'Daumier's Orang-Outaniana', *Print Quarterly*, 10:3 (1993), pp. 231–46.

S. Lambert, *The Franco-Prussian War and the Commune in Caricature 1870-71* (London, Victoria and Albert Museum, 1971).

A. B. Maurice and F. T. Cooper, *The History of the Nineteenth Century in Caricature* (London, Grant Richards, 1904).

R. Patten, *George Cruikshank's Life, Times and Art*, vol. 1: *1792-1835* (London, Lutterworth Press, 1992).

M. H. Spielman, *The History of* Punch (London, Cassell and Co., 1895).

T. D. Stamm, *Gavarni: Caricature and the Critics*, Ph.D. Thesis, Bryn Mawr College, 1979.

P. Ten-Doesschate Chu and G. P. Weisberg, *The Popularization of Images: Visual Culture under the July Monarchy* (Princeton University Press, 1994).

R. Terdiman, *Discourse/Counter Discourse: the Theory and Practice of Symbolic Resistance in Nineteenth-Century France* (Ithaca, Cornell University Press, 1985).

H. P. Vincent, *Daumier and His World* (Evanston, Ill., Northwestern University Press, 1968).

J. Wechsler, *A Human Comedy: Physiognomy and Caricature in Nineteenth-Century Paris* (London, Thames and Hudson, 1982).

G. P. Weisberg, 'Louis Legrand's battle over prostitution: the uneasy censoring of *Le Courrier Français*', *Art Journal* (Spring 1992), pp. 45-50.

3 *Fin-de-siècle* poster design: objectifying national style, pleasure and gender

> Understood by people of all ages, loved by the masses, the poster speaks to the universal spirit: it has come to satisfy new aspirations and this love of beauty which the education of taste spreads and develops without interruption ... Its art has neither less meaning nor less prestige than the art of fresco (Roger Marx, *Les Maîtres de l'Affiche*, 1898).

It was during the nineteenth century that the large-scale lithographic poster came of age. Starting with the monochrome typographic flysheets of the 1830s, issued mainly by publishing houses and theatres, and culminating in the more ebullient, colour designs of the 1890s, the advertising poster totally transformed the urban scene, being displayed not just on city walls and omnibuses, in shops and cafés, but also in galleries and exhibitions. The proliferation of so many posters in such contexts clearly testifies to their popularity with both producers and consumers, and in coming to terms with their history we must take into consideration several interdependent factors. Consequently, this chapter will explore the evolution of the modern poster with regard to the so-called colour revolution of the 1890s, and investigate several important issues concerning reproduction and representation. As is the case with caricature in the nineteenth century, France was the pioneer of this new hybrid form of graphic art/design, and the discussion which follows is predominantly concerned with the history of the French poster in the 1890s, although some consideration of British and American material is also included. The kind of questions we wish to pose here centre around the status of the poster, which appeared to hover paradoxically between art and commerce and between propaganda and entertainment. We shall, therefore, be looking at the poster as an ideological construct, and investigating both its aesthetic and political signification in the 1890s. As such, we will encounter Art Nouveau debates on nationalism and style, as well as the objectification of pleasure and sexuality in poster iconography.

The colour lithographic revival of the 1890s

It was largely due to developments in the printing of colour lithographs that the new poster style of the 1890s came about. By this time, posters could also be reproduced photomechanically by means of *gillotage*, which was a method of relief printing introduced by Charles Gillot and Lefmann in the early 1870s (see chapter 1). Eugène Grasset's 1892 design, *L'Encre Marquet*, was reproduced in this way, but the technique tended to result in hard, black outlines and subfusc coloured elements. In contrast, colour lithographic printing offered more subtle, brighter effects and gradation of tone and was consequently more popular. Polychromatic lithographs had, in fact, been possible since the early nineteenth century. In 1817, Aloïs Senefelder had published his Bulgarian Fair series of colour prints, and in the 1830s and 1840s caricatural and topographical lithographs were also printed in colour. These included many images by Daumier reissued in caricatural albums by Aubert, and works such as David Roberts's *The Holy Land* (1842-49), and Baron Taylor's monumental undertaking, *Les Voyages Pittoresques*, published in twenty volumes between 1820 and 1878. Yet even though the colour in these prints had been achieved by use of multiple stones instead of being applied locally with rags to one and the same stone, a process known as *à la poupée*, more often than not the designs looked like black and white drawings to which colour had been applied as an afterthought. As a result, colour lithography was brought into disrepute and known pejoratively as *vulgaire chromo* for many years afterwards.[1]

Within the history of printmaking, Jules Chéret is usually cited as the chief protagonist in the colour lithographic revival. Chéret had been experimenting with techniques for printing in colour as early as 1856, whilst in London, but it was not until his return to Paris ten years later that he began to establish his new colour style. From the very outset, he had conceived his designs in terms of colour, and his process was based on the superimposition of three separate stones printed in strict registration. These comprised an initial stone with black outlines, a red touchstone, and the *fond gradué*, a gradated colour stone, which established cool and warm tones. The use of the *fond gradué* together with *crachis*, in which ink was spattered on to the stone with a brush, enabled Chéret to overcome the limited effects of earlier lithographic colour printing and afforded him a rich palette of intermediary tones with which he could achieve atmospheric and painterly effects. By 1884, he had produced some 1,000 posters in this manner, advertising a wide range of entertainments, services and products (figure 23), and in 1900 was created *Chevalier de la Légion d'Honneur* by the French

23] *Scaramouche*, colour lithograph by Jules Chéret, 1894.

Government for having applied art to industrial and commercial printing.[2]

Chéret was, therefore, pivotal in helping to forge a new role for colour lithography during the last quarter of the nineteenth century, and his posters transcended categories of taste by bringing art to the streets. Georges Auriol, the editor of *Le Chat Noir*, for instance, referred to Chéret as 'the great illustrator of the streets of Paris', and went so far as to declare that: 'I possess posters by Chéret which I certainly would not exchange for paintings by artists however celebrated.'[3] Furthermore, Chéret's poster work was greatly admired by the embryonic Parisian avant-garde, including Seurat, and he often sided with the anti-academic, anarchic group known as *Les Incohérents* (1882–95), designing posters for their 1886 and 1889 exhibitions. Consequently, in his wake, a whole generation of young artists, printers and dealers began to earn a living within the lithographic trade. These included principally a band of artists who had been studying at the independent Académie Julian and who came together in the late 1880s under the name *Nabis* or 'prophets' – Pierre Bonnard, Henri Ibels and Édouard Vuillard – and Toulouse-Lautrec.

Bonnard produced over 250 lithographs between 1889 and 1902, under the influence both of Gauguin's colour-rich, spare style and

the example of Japanese pictorial aesthetics, which are discussed in more detail later in this chapter. This approach to form and colour is evident in the posters he designed to advertise Debray's *France-Champagne* in 1891 (figure 24) and the Natanson brothers' journal of the arts *La Revuè Blanche* (1891–1906) in 1894. Bonnard's designs also demonstrate a new, expressive treatment of typography which was conceived at the outset as an integral element in the composition and in complete harmony with the illustration, and are far-removed from earlier lithographic prototypes such as Manet's *Les Chats* (1868), in which letterforms appear to have been added as an afterthought. In *La Revue Blanche*, for instance, word and image have been brought into strict interplay through the neat device of the closed umbrella which doubles up to signify the letter 'v' in 'Revue'.

It was Bonnard who was responsible for introducing Toulouse-Lautrec to the medium sometime around 1890. Lautrec had originally trained as an artist in the studio of the conservative academic painter Léon Bonnat in 1882 and afterwards in the more relaxed atmosphere of Fernand Cormon's studio in Montmartre. From the mid-1880s, he began to earn his living as an illustrator for several of the new literary and artistic reviews, including the cabaret artiste Aristide Bruant's *Le Mirliton* (1885–1906) and *Le*

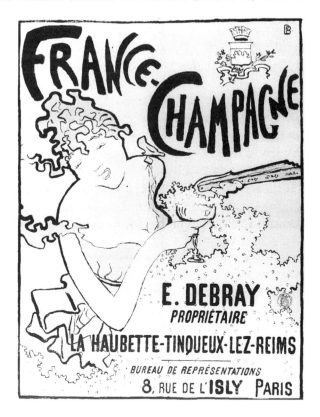

24] *France-Champagne*, colour lithograph by Pierre Bonnard, 1891.

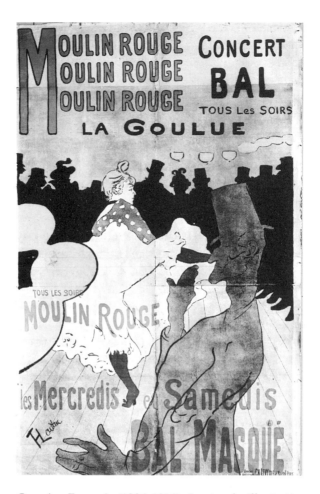

25] *La Goulue at the Moulin Rouge,* colour lithograph by Henri de Toulouse-Lautrec, 1891.

Courrier Français (1884–1914). Lautrec's illustrations were reproduced photomechanically by process line engraving, but they did help him to evolve a simplified, graphic style which he adapted to the production of his colour lithographs.

Between 1891 and 1901, he designed over 368 lithographs, of which only 28 were posters. The first of these, *La Goulue at the Moulin Rouge* (figure 25), exploited the printing process devised by Édouard Duchâtel in his treatise on artistic lithography of 1893. In effect, Duchâtel's method was no more than a modified version of the three-colour overlay system originated by J. C. LeBlon in the 1720s, and entailed the use of four stones, one for each of the primary colours, which were printed in strict sequence (yellow followed by red and blue) and one for printing black, which was added last of all. Ultimately Lautrec found this procedure too limiting, and he abandoned it in favour of more *ad hoc* and intuitive methods of printing, using a fresh stone for each of the colours he had incorporated into his design rather than achieving intermediary tones exclusively through overlaying one primary colour on top

of another. At the same time, he deployed *crachis* in many of his posters and lithographs to add texture to areas of transparent colour.

In achieving such effects, most *fin-de-siècle* lithographers depended on the expertise of master-printers – Lautrec collaborated with Père Cotelle and Ancourt; Bonnard with Ancourt and Clot. Clot had set up his own business in 1895 and was responsible for printing every colour lithograph that Bonnard designed for the print dealer Ambroise Vollard, including his illustrations to Paul Verlaine's erotic verse in *Parallèlement* (1900) and a French translation of Longus' Greek romance *Daphnis et Chloé* (1902). In 1897, however, Clot became the centre of controversy concerning the printing of Cézanne's colour lithograph *The Bathers*. Cézanne had drawn his design in black crayon on lithographic transfer paper, and afterwards added water-colour to black and white impressions of it which served as a guideline to help the printer in the creation of the colour stones. The controversy centred on the combined issues of authorship and originality, and added fuel to a long-standing aesthetic debate which had maintained that colour lithography was not a legitimate form of autographic, artistic expression. Since 1891 a statute of the Society of French Artists decreed that no colour prints would be admitted for exhibition at the annual Salon,[4] and as late as 1898 Henri Lefort, the President of the Section of Engraving and Lithography, in addressing the Committee of 90 who had been pressing for the repeal of this edict, declared: 'By its essential principles, its origins and its traditions, the art of the print is unquestionably the art of black and white. This is the traditional classification to which it is attributed.'[5]

The collaborative relationship between the artist and the printer had been necessitated by the registration of each colour stone in the right sequence, a skill which most artists did not have. Of more concern to patrons and collectors of prints was the artist's ability to conceive an original design, and this was seen as the redeeming quality that distinguished the modern colour print from its predecessors. This was the case propounded by André Mellerio in his influential text of 1898, *La Lithographie en Couleurs*:

> It seems to us that colour lithography has not existed before in the conditions in which we have seen it bloom, and consequently it is the distinctive artistic form of our time ... The modern print was no longer a facsimile reproduction of just any original work in colour, but a personal conception, something realized for its own sake ... This principle, applied victoriously by Chéret to the poster, whose nature and function made it special, was to be applied by others to the print, whose characteristics differed in many ways.
> But the right of the colour print to exist comes directly from the principle we consider an axiom: any method or process which an artist develops to express himself, is for that very reason legitimate.[6]

Furthermore, Mellerio affirmed the role of the printer, which he saw not as an impediment to artistic progress, but rather more as liberational for the artist: 'This close and much needed collaboration between the artist and the printer would be reached by suggestion and agreement. They would thus overcome the difficulties of the craft at the same time that the liberated inspiration would assert itself more directly and more intensely.'[7]

Notwithstanding the reservations of the Salon and official artistic organisations, therefore, the status of the colour lithograph as a valid art-form was beginning to be vindicated by a mutually supportive network of independent artists, printers, patrons and dealers. During the 1880s there had only been a handful of dealers in Paris selling contemporary colour posters and prints, including Edmond Sagot, who in 1881 had opened his shop, the *Librairie des Nouveautés et Librairie Artistique*, to patronise new artists – in 1886 he sold posters by Chéret, and in 1892 posters and prints by Lautrec – but by the 1890s there were at least twenty-three different dealers promoting colour lithography. These included Mellerio, who established the bi-weekly *L'Estampe et l'Affiche* between March 1897 and December 1899, which contained lists of prints sold by dealers, reviews, and monographs on contemporary designers; André Marty and Ambroise Vollard, who founded *L'Estampe Originale* (1893–95) and the *Album Des Peintres-Graveurs* (1896) respectively to publish lithographs by Lautrec, Bonnard and Chéret, and etchings by Whistler and Bracquemond in quarterly issues; and Roger Marx, who edited *Les Maîtres de l'Affiche* (1896–1900) as a way of giving collectors the opportunity to own small-scale versions of the most popular posters of the period.[8] At the same time, the modern poster was the focus of several independent exhibitions starting in 1884 at the *Palais Vivienne* in Paris and followed in 1889 by the *Galerie Préaubert* in Nantes. In 1889, posters were also on show at the *Exposition Universelle* in Paris and in 1895 were a central feature of the *Centenaire de la Lithographie* (figure 26).

Yet for these artists and patrons, it was not just the formalism of the modern colour lithographic poster with its emphasis on flat surfaces, broad areas of unmodulated colour and simplified shapes and outlines, which was so attractive, but also its democratic and utilitarian nature. The *Nabis*, for instance, were committed to the ideal that the contemporary artist should be responsible for the creation of objects for everyday use, and Lautrec, in an interview in 1894, also called for 'fewer artists and more good craftsmen'.[9] Moreover, Lautrec did not shy from marketing his work as widely as he possibly could; nor was he unduly concerned about the commercial connotations of working with graphic media, regarding it

as a lucrative source of income – in 1892 his designs were actively being sought by Sagot, who sold posters like *Ambassadeurs: Aristide Bruant* and *Reine de Joie* for three and four francs respectively. Indeed, given that posters were advertisements for various products and services, they were far cheaper than other types of prints to produce in terms of cost per unit. A typical four-colour poster measuring 135 × 92 cm, if printed in an edition of 1,000 copies, for example, would have cost one franc and thirty nine centimes per unit during the 1890s (the equivalent of four and a half new pence).[10] The general public were quick to realise, however, that as a highly visible and democratic art-form, posters did not necessarily have to be paid for, and the most popular designs were often purloined from street walls just as soon as they had been pasted up; witness the *fin-de-siècle* writer and aesthete Félix Fénéon:

> They don't pretend to be precious stuff; they'll be torn down in a little while and others will be put up, and so on: they don't give a damn! That's great! – and that's art, by God, and the best kind, mixed in with life, art without any bluffing or boasting and within the easy reach of ordinary guys.[11]

By the mid-1890s, the use of colour lithography and the French poster style had also begun to influence designers in other countries. The work of French artists had been disseminated across Europe in periodicals such as *The Studio* (founded in 1893), *Pan* (1895) and *Art et Décoration* (1897), and poster exhibitions were also held in various countries. The Westminster Aquarium exhibitions and the Kensington Fine Art Society brought examples of posters by Chéret, Toulouse-Lautrec, and Bonnard to Britain for the first time after 1894, although F. L. Emanuel commented that the work was not popular with the public.[12] International commerce between various designers and collectors also had a part to play in popularising French graphic design. Julius Meier-Graefe who co-edited *Pan* had visited London in 1893 and afterwards Paris, where he met Siegfried Bing, and Toulouse-Lautrec had visited London in 1896. William Nicholson and James Pryde (alias the Beggarstaff Brothers) and Dudley Hardy had all trained in Paris and had absorbed the flat tones of the *Nabis* and the exuberance of Chéret respectively into their own poster designs of the 1890s; witness Hardy's *Gaiety Girl* of 1894 and the Beggarstaffs' *Don Quixote* of 1895. Other British designers, such as Aubrey Beardsley and The Glasgow Four (Charles Rennie Mackintosh, Herbert McNair, and Margaret and Frances Macdonald) were more eclectic in their approach and less enslaved stylistically to the example of French poster designers. The Glasgow four combined at will Celtic and Japanese-inspired motifs to forge an individualistic style of their

own, based on an attenuated and rectilinear treatment of human and organic forms.

In America, the first exhibition of French posters had been held at the Grolier Club in New York in 1890 and likewise showcased designs by Chéret and Lautrec as well as work by Steinlen and Grasset. The evolution of the modern poster in America during the 1890s became entwined with the publishing houses of popular magazines and artists such as Edward Penfield, who worked for *Harper's Bazaar*, and Maxfield Parrish, who worked for *The Century*. Writing in 1895 to John Hilliard, editor of *The Union and Advertiser*, Penfield admitted his indebtedness to the simplicity and modernity of both French and British graphic design, which had helped him to conceptualise the posters he executed after 1893 to advertise monthly editions of *Harper's*.[13]

Style, modernity and nationalism

The number of artists who had been attracted to designing colour lithographic posters by the 1890s had simultaneously upgraded the standards of commercial printing and created a new market for art dealers and collectors. Consequently, the status of posters at this time oscillated between art and commerce – produced in the first instance to promote various products and services, posters in themselves became objects of desire for consumers. But posters were more than just collectable and attractive pieces of design; with regard to style and iconography they were also implicated in wider issues concerning nationalist propaganda and gender politics.

The investiture of Chéret by the State in 1900 was predicated not only by his development of the lithographic technique and his application of art to commerce, but also because of the way that his form of representation appeared to be steeped in the traditions of the Rococo style. Roger Marx had framed Chéret in such an eighteenth-century context in an essay of 1913, *L'Art Social*, comparing his contribution to poster design with that of Debou-court and Watteau to graphics and painting in the original Rococo period.[14] The question of alighting upon a style which would be appropriate to the modern era of Art Nouveau was one which preoccupied politicians as well as artists and writers, and was en-visaged as a significant way of reasserting French hegemony over the rest of world in cultural production, following the débâcle of the Franco-Prussian War in 1870 and the blood-letting of the Com-mune in 1871.[15] Between 1885 and 1895, France's heavy industrial output and export market began to stagnate and to lose ground in relation to the major Western economies of Britain, Germany and America. During the last quarter of the nineteenth century the

French were particularly apprehensive of Germany, and enmity between the two countries was underscored by Prince Wilhelm's remarks in 1881 at the inauguration of the Berlin Museum, 'We defeated France on the battlefields in 1870. Now we want to defeat her in commerce and industry.'[16]

In 1889, the World Exposition in Paris gave France the opportunity to rise to this challenge and to vindicate itself in the field of cultural production by showing indigenous design in an international context. The Prime Minister, Jules Ferry, wanted to commemorate the centennial of the French Revolution by affirming a vision of the new French Republic which would celebrate modern science and industry. As part of the exhibition two new structures were added to the cityscape, the Gallery of Machines and the Eiffel Tower. Each symbolised French leadership in engineering - the Gallery had the greatest span of any building erected at that time and the Tower was the tallest in the world. The Vicomte Melchior de Vögué, writing in the *Revue des Deux Mondes*, saw both structures as emblematic of 'a new world', with the Eiffel Tower as a wrought-iron steeple in a new, universal Church of technological progress.[17] Alfred Picard, the deputy director of planning for the 1889 Exhibition, meanwhile, glorified the Eiffel Tower 'as a brilliant manifestation of the industrial strength of our country'.[18]

During the same period, craft production had also begun to decline in France. After 1873, exports of jewellery, ceramics and furniture were down whilst imports were increasing, and craftsmen were finding it difficult to meet the supply and demand for their products in the new department stores. This led the liberal government of the Third Republic to espouse an ideology of protectionism and nationalism with regard to French craft production. In 1882, it began to liaise with the Union Centrale des Arts Décoratifs (UCAD) under the auspices of Antonin Proust, who was Minister for the Arts. The UCAD had campaigned hard in its journal, the *Revue des arts décoratifs* (1878-82), to make industry more aware of good design and for the establishment of a museum of industrial art and regular exhibitions of the applied arts. Likewise, Georges Berger, the deputy Prime Minister, identified craftsmen as indispensable to the French economy, and he postulated that it was their work and not that of industrial technology which would provide the platform for cultural regeneration. Similar points of view were put forward by other apologists for craft production - in his polemic *Pour la défense de nos industries d'art* in 1898, Marius Vachon gave support to the idea that France was regarded as the centre of fashion, taste and manners by her economic competitors, and André Marty, who was appointed director

26] *La Centenaire de la Lithographie*, colour lithograph by F. Hugo d'Alési, 1895.

of the *Journal des Artistes* in 1892, began to run a series of articles on the future of French exports. Marty had been greatly influenced by the writings of William Morris, and he called on young artists to do their 'patriotic duty' by getting involved in the decorative arts.[19] In this way, he believed France could lead the world in design, and that colour lithography and graphics would have a particularly instrumental part to play in such a regeneration.

At the end of the nineteenth century, the French had reclaimed lithography as their own invention, celebrating its centenary in 1895, even though the technique had been introduced first of all in Germany by Senefelder in 1796. For them, such a claim was demonstrably justified in the light of the artistic development of the medium in France by the likes of Carle Vernet and Nicolas-Toussaint Charlet, who began to produce lithographs soon after Peter Friedrich André had set up a printing practice and been granted an import licence in 1802, and more especially on account of the achievement of poster designers such as Chéret in the 1890s.[20] Hugo d'Alési's 1895 poster *La Centenaire de la Lithographie* (figure 26) is an interesting iconographic comment on such attitudes, and draws together two key historical moments in the

evolution of lithography in France. It depicts a 'nouvelle femme' browsing at a print stall by the Seine; she holds up a black and white print of a grenadier, produced by Charlet around 1818, for inspection, whilst a contemporary poster designed by Chéret for the Courmont-Frères publishing house is propped up on the stall in front of her.

The Rococo revival versus *japonisme*

The rehabilitation of lithography and the way in which French artists had pioneered a new form of poster design were in turn mobilised in nationalistic debates concerning both the hegemony of France in craft production and the need to evolve a distinctive, period style. Propaganda for a national style after 1871 centred around two chief ideals – on the one hand, the resuscitation of eighteenth-century Rococo, and on the other, the espousal of a new form of representation based on Japanese aesthetics.

The neo-Rococo lobby was initiated in the 1880s and was given official support by the Marquis Philippe de Chennevières as director of the Ministry of Fine Arts between 1873–80 and by his successor Antonin Proust, both of whom championed the Rococo as the indigenous and natural national style of France. This ideology was reinforced in several scholarly works of the period, including Roger Portalis's *Les Graveurs du XVIIIᵉ siècle* (1880), Désiré Guilmard's *Les Maîtres Ornemantistes* (1881–82) and Pierre de Nolhac's *La Reine Marie-Antoinette* (1890). Probably the most systematic writing on the art of the eighteenth century was Edmond de Goncourt's *La Maison d'un artiste*, published in two volumes in 1881, which championed the epoch of Louis XV as one 'which quested for beauty in all things'.[21] The Goncourts were avid collectors of Rococo *objets d'art*, and in 1869 they installed their collection in their own home in Auteil on the outskirts of Paris. For them, the virtue of the Rococo period resided in its organicism, that is, the treatment of an interior as a complementary and harmonious entity, in which each piece of design or furniture shared the same vocabulary of form. Their home consequently reconstituted this organic ideal with its intimate, compartmentalised spaces and diminutive, feminine pieces of furniture and design which were unified into a holistic ensemble. But the Goncourts' historicism was also a reinterpretation of the Rococo style, updated for a late nineteenth-century sensibility. In this, they were influenced as much by the aesthetic ideas of the 'new psychologists' Dr Moreau de Tour and Dr Jean-Martin Charcot, who had argued that a well-balanced interior should be an antidote to, or neurological refuge from, the frenzy of the contemporary city, which tended to destabilise and attenuate the nervous system.[22]

Many of the articles written by the Goncourts on eighteenth-century art were republished in 1893 with an introductory essay by Roger Marx, who extolled the Rococo period as that of the 'quintessential French genius',[23] and interest in the style also encouraged State patronage of architecture and design on several levels, including the restoration of original eighteenth-century buildings such as Robert de Coffe's façades for the Bibliothèque Nationale, and the admission of the decorative arts to the Salon after 1889 on an equal footing to painting and sculpture. In the same context, posters by Chéret such as *Théâtre des fantoches* (1900) and *Scaramouche* (1894; figure 23), as Roger Marx pointed out in his 1913 essay, appeared to be contemporary counterparts to eighteenth-century paintings like Fragonard's *The Lover Crowned* (*c.* 1770) in their exuberant use of colour and undulating lines and in their sensual iconography, which dwells on a life of unbridled entertainment in the form of feasting, drinking and sexual encounter. But Chéret's work was also essentially different from Rococo antecedents both in its use of the colour lithographic technique and in his objectification of fin-de-siècle pleasure and sexual politics, which were to influence the style and subject-matter of Seurat's painting and which are discussed below.[24]

By the 1890s, Rococo had been accepted as the official cultural heritage of France and seemed to offer the basis for evolving a national and a patriotic style in the context of Art Nouveau. It formed, however, one of two chief stylistic tendencies at this time, the other taking its cue not just from the past but also from the example of a foreign culture – Japan. The craze for Japanese culture in France, and for *ukiyo-e* woodcuts in particular, followed the resumption in trade between Japan and the West in 1854 and was manifest in two phases, the first roughly between 1860 and 1880 and the second during the 1880s and 1890s.[25]

During the first phase of influence, several important stores were opened in Paris to sell Japanese wares, including those of Édouard Desoye in 1862 and Siegfried Bing in 1875. The World's Fair in 1867 and exhibitions in Vienna in 1873 and Philadelphia in 1876 also showcased Japanese art and design, and after the Meiji Restoration in 1868 a deliberate policy to disseminate Western methods of production and consumption was instituted to facilitate Japan's transition to a modern market economy. At the same time, the Société du Jing-lar was formed in Paris, and by 1872 Philippe Burty had coined the term *japonisme* to describe the work of those artists and designers who had begun to emulate Japanese aesthetic principles.[26] Of chief interest were the *ukiyo-e* woodcuts, or prints of the floating world, which many graphic artists in the West admired for their compartmentalised and flattened treatment

of space and use of unmodulated areas of tone and colour. This stylistic approach is evident in the etchings that Whistler produced between 1859 and 1871 representing life along the river Thames.[27] *Rotherhithe III* (1860), for example, has been spatially organised into four asymmetrical rectangles through the incorporation of a vertical post and low horizon line, whilst two seamen loom large in the foreground of the composition. All of these devices have a tendency to flatten out the pictorial perspective in keeping with the *ukiyo-e* tradition, but in attempting to translate the economical spatial and chromatic effects of the Japanese woodcut into his monochrome intaglio prints, Whistler's compositions were compromised by the temptation to add depth and detail with cross-hatched lines.

A more fully-fledged and sympathetic understanding of Japanese prints and decorative art ensued during the second wave of *japonisme* after the 1878 Exposition Universelle. In an article in 1882 the jewellery designer Lucien Falize had undermined his own gratuitous and cavalier copying of Japanese prototypes thus:

> Do you know what made this artisan of Kyoto give his vase the shape of a gourd or a bulbous root? Have you penetrated the symbol of the white deer? To what end do you copy these peach flowers or white quince branches? You write this language drawn by the Japanese as you have copied all the religious symbols of all people – without understanding them.[28]

One year later, knowledge of Japanese culture in France had been consolidated by two chief projects organised by Louis Gonse – the first major retrospective exhibition of Japanese art held in Paris, at the gallery of Georges Petit, and the publication of his two-volume scholarly history, *L'Art japonais*. Gonse's initiative was followed by Siegfried Bing, who probably did more than anyone else to champion Japanese art and design during the 1890s. Between 1888 and 1891 he published *Le Japon artistique* (also published in an English edition) and curated an exhibition of 700 Japanese prints at the École des Beaux-Arts in the spring of 1890. The latter was attended by many young artists of the period, including Mary Cassatt, who wrote to Berthe Morisot: 'You who want to make colour prints, you couldn't dream of anything more beautiful.'[29]

Cassatt was one of several Post-Impressionists who both studied and collected prints by masters of *ukiyo-e* such as Utamaro, Hokusai, Kuniyoshi and Hiroshige and who used their art both technically and iconographically as the basis of a modern, graphic idiom in colour. In Cassatt's case this involved working with drypoint and aquatint and culminated in the ten colour plates she produced for an exhibition at Durand-Ruel's Gallery in April 1891.

For others, namely Bonnard, Vuillard and Lautrec, this new art was grounded in the colour lithographic print and poster. The expressive potential of the colour lithograph had already been realised by Chéret's printing methods, but by 1890 Alexandre Lunois had introduced the technique of wash lithography, which allowed artists to replicate the quality of Japanese water-based inks and their bold use of unmodulated colour.[30] Bonnard, who became known as 'Le Nabi très Japonard', exploited this process most fully in the album of twelve lithographs, *Quelques aspects de la vie de Paris*, which he executed for Vollard between 1895–99 and which were inspired by Hiroshige's *One Hundred Famous Places in Edo*.[31] These images and posters, such as *La Revue Blanche* (1895), also demonstrate an unattenuated use of shallow space and foreshortened perspective, and Bonnard openly admitted that the study of Japanese prints had taught him that: 'It was possible to translate light, form and character with nothing but colour, without resorting to shading.'[32]

The same pictorial aesthetics can be found in many of Toulouse-Lautrec's poster designs of the 1890s. Lautrec had first been introduced to *ukiyo-e* woodcuts in 1882 by the American painter, Harry Humphrey Moore, whilst a student in the studio of Léon Bonnat, and in 1883 he visited Gonse's exhibition at the Georges Petit Gallery.[33] Lautrec was probably more adventurous and dramatic in his effects than Bonnard, however, deploying not only uptilted perspective and flat areas of colour but also tending to truncate forms with the picture's edge, as in *Le Divan Japonais* (1892), where the singer Yvette Guilbert has been 'decapitated' at the top left of the image, and often applying *crachis* to add texture, as in *Jane Avril au Jardin de Paris* (1893).

The vogue for Japanese-inspired graphics and decorative art was hotly contested following the erection of Bing's Maison de l'Art Nouveau at the 1895 Salon of the Champ de Mars. Bing had invited the Belgian designer Henry Van de Velde to devise three interiors and Bonnard, Vuillard, Ibels and Lautrec to design a series of stained-glass windows in the Japanese manner. Many critics, including Edmond de Goncourt, attacked the Maison for its unpatriotic use of art and design, and the furniture designer Charles Genuys went so far as to propose an ideal of artistic nationalism in an article in the *Revue des arts décoratifs* in 1897 entitled 'A propos de l'art nouveau, soyons français!' ('With regard to Art Nouveau, let us be French!'). Genuys did not exactly reject foreign art and design out of hand and argued more for the use of the indigenous aesthetic forms which were naturally associated with a particular nationality (in the case of France, preferably Rococo): 'It is not that the artists of these countries are insincere; they are true to their

races, to their countries, to themselves. And we would be dishonest to imitate them in our country, so different from theirs. This sense of art flows from the race.'[34]

Yet for Bing this was to miss the point, and he retaliated by affirming that his aim was to create a climate for innovation in which 'French genius' would not be superseded but expanded by emulating Japanese principles of decoration. The desired goal should not be the mere imitation but the assimilation of the organic aesthetics of Japan, which would 'enrich the old patrimony with a spirit of modernness' and thereby assist the creation of a distinctly national, avant-garde form and style.[35] These ideas had been adumbrated by one of the chief supporters of Japanese prints, Philippe Burty, in his lectures and writing during the 1880s. Burty stressed that Japanese designers always based their decorative forms on an observation of nature and that their work consequently embodied an ideal of harmony and elegance to which French designers should aspire.[36]

Clearly, in demonstrating a predilection for either a neo-Rococo or *japoniste* formalism, artists and designers working in the 1890s could in turn implicate themselves in broader ideological debates concerning nationalism and patriotism. For the most part, the younger generation of avant-garde practitioners such as Bonnard, Lautrec and Vuillard tended to side rather more with the ideas propounded by Bing and Burty and were forthright in their espousal of *japonisme*, but in his first poster design in 1891, *France-Champagne* (figure 24), Bonnard appears to have self-consciously set out to appease both camps. This hybrid work fuses together elements of neo-Rococo exuberance – the frothing foam of the champagne, for example, which is redolent of Chéret's graphic style – with the flatness and simplicity of Japanese *ukiyo-e* prints, as witnessed in his economical treatment of facial expression, which is similar to Utamaro's depiction of courtesans.

The Japanese style can also be found in the poster design and graphics of most other European countries and in America during the 1890s. Given that these countries had not recently suffered military defeat or humiliation, its espousal was not, however, embroiled within nationalistic debates as it had been in France. In Britain, the craze for Japanese artefacts which had started in the 1860s had likewise been transformed in the 1880s by the Aesthetic Movement's more thorough understanding of Japanese aesthetic principles dealing with flatness and organic form. During the 1890s, therefore, poster designs by Aubrey Beardsley to advertise *The Studio* and the work of Charles Rennie Mackintosh (who had begun to collect Japanese prints around 1890) display a more economical and unmodulated use of form combined with an expressive

use of line. Indeed, through their use of elongated forms and stylised vegetation, the Glasgow Four articulated Japanese prototypes within the context of their own vernacular roots to forge a distinct Celtic graphic identity, much as Lautrec and others had used *ukiyo-e* as the basis for a modern idiom in French poster design. At the same time, American graphic design began to be transformed by *japoniste* tendencies. Although America had been trading with Japan since the mid-1850s, it is more likely that American poster artists were prompted to deploy Japanese pictorial aesthetics in their own graphic design after they had seen works by French artists at the 1890 Poster Exhibition at the Grolier Club in New York.

The poster as a vehicle for pleasure

The iconography of most posters produced in Europe after 1890 was unremittingly devoted to the representation of a life of pleasure. Many posters in Britain were produced for the new theatres and music-halls which had become part of the urban scene after the 1870s. In London, these included the Prince of Wales Theatre, for which Dudley Hardy executed a series of *Gaiety Girl* posters, the Savoy Theatre, for which he produced *The Yeomen of the Guard* (1897), and the Lyceum, for which the Beggarstaff Brothers designed *Don Quixote*. A greater emphasis on leisure could be found in Paris, where the scope and range of places of entertainment was much more diverse than in Britain. As early as 1830 Heinrich Heine had remarked in *Lutèce* that what the French thirsted for most of all was not equality of rights, but equality of pleasure or *jouissance*, the word used to describe sexual pleasure or bliss.[37] During the last quarter of the century this quest was given a renewed impetus, and Paris became a 'virtual theatre in the round' with new parks, outdoor cafés, cabarets and new forms of transportation for reaching them, namely the omnibus and the Métro.[38] By the 1880s the cityscape was also transformed by the new boulevards, the erection of the Eiffel Tower and the church of the Sacré Cœur. The last had been proposed by the National Assembly as a symbol of atonement for France's defeat in the Franco-Prussian War in 1870. The foundation-stone of the cathedral was laid on 16 July 1875, and building was completed just before the outbreak of World War I. The Sacré Cœur was situated on the Butte Montmartre, which by the early 1880s had become the focus both for artistic activity and for night-life in Paris. Many of the artists who were involved in poster production either lived there or had studios in the district, and the imagery they generated more often than not depicted the people and places of entertainment they encountered.

The night-life of Montmartre was notoriously hedonistic and was centred on the theatre and the cabaret. The two largest were *Le Moulin Rouge*, constructed in 1889 by Charles Zidler, where La Goulue and Valentin le Désossé performed, and *Le Moulin de la Galette*, owned by Nicholas Charles Debray, which had originally started life in 1834 as *Le Moulin Radet*, and which had a roof-top platform offering an unblocked view over the rest of Paris. Other smaller concerns were equally popular – *Le Casino de Paris*, for example, founded in 1890 and *Le Divan Japonais*, founded in 1883 by the poet Jean Sarrazin, at which the chanteuse Yvette Guilbert performed. The Boulevard Rochechouart contained several alternative venues such as Rodolphe Salis's *Le Chat Noir* and Aristide Bruant's *Le Mirliton*, which also held exhibitions of posters and published their own eponymous journals; and the *Quat'z' Arts*, founded in 1893 by François Trombert and christened after the annual ball of the École des Beaux Arts. The latter became the chief watering-hole of poets, artists and writers and may also possibly have been Montmartre's homosexual bar.[39]

All of these cabarets and bars were promoted in posters by artists such as Lautrec, Théodore Steinlen and Georges Redon, and the vision they offered was one of unbridled pleasure. In France during the nineteenth century this was regarded by the middle classes as the natural reward for a strict and ascetic upbringing in childhood, during which time pleasure was sublimated to the fundamental desire of forming the right social groupings. All signs of individuality were to be suppressed and children protected against undesirable influences. This outlook is compounded both in sociological works of the period dealing with child-rearing, which sustained the idea that children are barbarians who need to be moulded, and the best-selling literature for children, including the Comtesse de Ségur's *Les Malheurs de Sophie* (1857) and *Les Petites Filles Modèles* (1858). Above all else, the awakening of female sexuality was feared by parents, a point which is symbolically addressed by Steinlen in his 1894 poster *Lait Pur Stérilisé*, where a young girl is seen in the childish pursuit of drinking milk, whilst three cats, connoting sexual desire, throng at her feet for succour. As such, they appear to beckon her into a world of adult pleasure in which the consumption of milk would be supplanted by the partaking of alcohol.

Until the nineteenth century, alcohol was a luxury afforded mostly to the well-off, with the public at large usually only indulging itself on feast days and ceremonial occasions, such as weddings. By 1850 the price of alcohol, which included a wide range of licit and illicit industrial liquors and spirits, had dropped dramatically and was within the pocket of all but the destitute. A survey

undertaken by the Parisian Chamber of Commerce in 1848 repor-
ted that the average construction worker was spending more on
drink than on lodging for his family, and in 1852 the Swedish
physician Magnus Huss coined the term 'alcoholism' initially to
sum up the situation in France, which had the highest *per capita*
consumption of alcohol in the West.[40] In Britain, consumption of
alcohol was also prevalent amongst the working classes – in 1876
the average annual consumption of beer was 34.4 gallons *per capita*
– and the public house remained the hub of artisanal social life.[41]
After 1830, drinking in Britain had begun to be segregated accord-
ing to social class, with 'hotels' catering for the middle and upper
classes and pubs for the working classes. The 1890s witnessed a peak
in the construction of Victorian pubs, which became places of
great architectural elaboration, replete with stucco, woodcarving,
mirrors and brass ornamentation.[42]

The predilection of the working classes for alcohol at this time
was in no small part due to the poor quality of public drinking
water which until the late nineteenth century could be a greater
carrier of disease – indeed, the epithet 'buveur d'eau' in France
became current as a term of abuse for anyone who was either too
impecunious to buy alcohol or foolish enough to risk his or her
life by imbibing water. In France, alcohol could be consumed
widely at any time of the day, not only in bars, but also in cafés.
The latter had been viewed with great suspicion as the incubators
of social and political unrest by the French authorities, who put
them under police surveillance until 1880. After restrictions were
lifted, the number of cafés increased steeply so that by 1900 there
were some 435,000 of them in France, that is one for every eighty
of the country's inhabitants.[43] Cafés were also places of sexual
encounter – barmaids and waitresses were often expected to wear
alluring or *décolleté* attire to keep male customers happy, and pros-
titutes could use them as a rendezvous for plying their trade.

Advertising the New Woman – sex and sexuality

Indeed the position of women during the 1890s was central to the
whole culture of pleasure and to its representation in the work of
painters and poster designers alike. Lautrec's *Moulin Rouge* or *Divan
Japonais*, Bonnard's *France-Champagne*, Mucha's *Bières de La Meuse*
(1898), Herbert McNair's and Margaret and Frances Macdonald's *The
Glasgow Institute of Fine Arts* (1894), Dudley Hardy's *A Gaiety Girl*,
and Joseph Christian Leyendecker's poster for the August 1896
edition of *The Century* – all of these works and many others by well-
known graphic artists make symbolic links between the female
figures portrayed and the products and services they advertise,

whether those products and services were the direct concern of women or not. At the same time, the *fin-de-siècle* witnessed a challenge to the prevailing patriarchal notions of femininity and the status of women in society which were crystallised in 'the woman question'. As Shearer West argues: 'The 1890s was a period of transition and disruption for women, and attitudes about women, which appeared in journalism, literature and art, inevitably gravitated towards the extreme ends of a complex debate.'[44]

In many countries during the second half of the nineteenth century women had been pressing for female emancipation and for equal social, judicial and political rights. In Britain female Chartists had been agitating for access to Parliament and the right to vote during the 1860s, although without much success. Their cause was later taken up by Mrs Fawcett's National Union of Women's Suffrage Societies, founded in 1897, and the Pankhursts' Women's Social and Political Union in 1903. The two chief changes to affect the legal and professional status of British women were the Married Women's Property Acts of 1870 and 1872, which prohibited husbands from having automatic access to their wives' assets, and the admission of women to university education. By the mid-1870s women's colleges had been established at the universities of Oxford, Cambridge and London, although female students were not allowed to sit for degrees at this time.

In France state-sponsored secondary education for women had been introduced in 1880 by the deputy education minister Camille Sée, and by the 1890s this had enabled many women to become primary school teachers for the first time.[45] Proto-feminists had also found a voice at the first International Congress on Women's Rights, held at the 1889 Paris Exhibition, and in the spate of feminist periodicals which were launched between 1889 and 1900.[46] Although French feminists were mostly middle-class and few in number, their cause transcended social and political divisions and they campaigned for fundamental rights for all women, regardless of age, class or profession. One of their chief targets was reform of the Civil Code in order to give married women some independence and control of family finance in line with the legislation passed in Britain in 1870. They also agitated to change the law concerning adultery which could punish unfaithful wives with imprisonment and social ostracism whilst allowing unfaithful husbands almost unbridled freedom in extra-marital liaisons. Even the murder of an adulterous wife was justified as a male prerogative, whereas wives could only prosecute their husbands if they dared to bring their mistresses into the family home. This in itself, however, was no safeguard against husbands sleeping with maid-servants, and notwithstanding the new divorce laws which were

passed in 1884 to empower women to initiate divorce proceedings, in many middle-class households *droit de seigneur* was exercised without impunity and tolerated for the sake of maintaining family unity.[47] In Maupassant's realist novel *A Woman's Life* (1883), for instance, the heroine Jeanne catches her husband *in flagrante delicto* with their maid Rosalie but is persuaded by the parish priest to forgive her husband's indiscretion since the child she is carrying 'will be a new bond' between them and 'a guarantee of his fidelity in future'.[48]

In fact, the birth-rate had been decreasing during the last quarter of the century in France and Britain and this was perceived by the body politic in both countries to be one of the most significant threats to patriarchy. For middle-class families especially, the financial constraints of educational and household fees militated against having too many children and by the 1880s the Protestant working classes also began to have fewer offspring. Contraception had a large if often unreliable part to play in family planning in England at this time. Various forms of contraception had been available since the early nineteenth century, such as the vulcanised rubber condom, which had been introduced in 1844, and from the 1880s a wide supply of birth control devices was available to both men and women, including pessaries, sponges, syringes and the cervical cap.[49] Even in Catholic France, where contraception was outlawed, the birth-rate had begun to decline and the population to stagnate after 1889, as more and more middle-class women turned to professions. Such a decline was viewed as extremely dangerous by French politicians, given that the German birth-rate in 1891 was about double that of France, and to help counteract this trend, Dr Jacques Bertillon founded the National Alliance for the Increase of the French Population in 1896.[50]

Consequently, a new moral climate grew up in the 1890s during which politicians set out to return women to the domestic sphere of motherhood and to undermine their newly won academic and professional independence. In this context, philosophical, biological and medical authority was invoked to oppose the rise of the 'New Woman'. The chief contention of this predominantly male perspective was that women became destabilised both physically and mentally by taking up either education or a career. Nietzsche argued in *Beyond Good and Evil* in 1886, 'When a woman has scholarly inclinations there is usually something wrong with her sexuality', and Victor Jozé maintained that 'Feminists are wrong when they turn women away from the duties of their sex and when they turn their heads with illusory emancipatory ideas which are unrealizable and absurd.'[51] Darwinian evolutionary theory was likewise mobilised to enforce the essentialism of a

woman's reproductive role. In 1896, for example, Senator Jules Si-
mon published an anti-feminist article entitled 'Il faut rester
femme' ('It is necessary to remain a woman') in which he wrote:
'Everything in a woman, her body, her mind, and her character,
has been planned by nature's creator as a preparation for child-
bearing.'[52]

Underpinning most of these arguments was a fundamental
belief that emancipated females were in many respects either mas-
culinised or sexually unbridled prostitutes.[53] In France, the
hommesse ('little man') also became a current representation of the
active 'New Woman' who inverted normative gender roles by par-
taking in traditionally 'manly' pursuits. The *hommesse* was a
common stereotype in the popular illustrated press, usually de-
picted smoking a cigarette, and either clad in frock-coat, shirt and
tie as in Guillaume's cartoon *L'Émancipation de la Femme* ('Female
Emancipation') for *Gil Blas Illustré* in 1893, or with bicycle and
knickerbockers as in Pepin's front cover illustration for *Le Grelot*
on 19 April 1896.

Prostitution was equally as much regarded as a moral threat to
the stability of the social order by spreading the incidence of
venereal disease. In England the Contagious Diseases Acts of 1864,
1866 and 1869 had sought to arraign prostitutes through medical
examination and rehabilitation, and during the 1880s Senator René
Bérenger instituted the Society Against Licence in the Street in
order to control soliciting in the public spaces of Paris. His clean-up
campaign was directed principally at working-class women,
mainly laundresses and seamstresses, many of whom were forced
to turn to prostitution in the evenings to bolster their meagre
incomes. The discriminatory tactics of the moral brigade is paro-
died in Willette's cover illustration for *Le Courrier Français* on 31
January 1892, which represents a young, working-class girl sus-
pected of sexual indecency being handcuffed and dragged off by
a smug, male undercover agent.

It is interesting to see how the advertising posters and promo-
tional graphics of the period which represent the female form have
a tendency to invert or to sublimate both class concerns and the
threatening nature of the 'New Woman' by turning her into a
fetishistic object of masculine desire. Octave Uzanne, in essays such
as *Coquetteries féminines*, written in 1893, and *La Femme à Paris, nos
contemporains* in 1894, insisted that the female form was an essen-
tial adornment within the French decorative arts and that
feminism was a sexual perversion. He invoked Madame de Pompa-
dour and Marie Antoinette as the ideal of femininity and cited
underwear as the item of clothing through which women could
assert their individual sexuality. A 'vision of the beneath', he called

it, where a husband could 'lose himself in soft and evanescent delicacies of colours, groping for supremely sheer and subtle textures'.[54] This type of 'New Woman' is exemplified by Lautrec's high-kicking *La Goulue at the Moulin Rouge* (figure 25) who 'allows the spread of her legs to be glimpsed through the froth of pleats and reveals clearly, just above the garter, a small patch of real, bare skin',[55] and also by the alluring and half-dressed *grisettes* to be found in works such as Chéret's *La Loïe Fuller, Folies-Bergère*, 1893 (the term *chérette* was coined especially to describe his representation of modern young women), Bonnard's *France-Champagne*, and Mucha's *Bières de la Meuse*. In these posters, women are objectified as 'earthly goddesses' and female sexuality is symbolically linked with the products or services they advertise. The women depicted in them proudly display their bodies and breasts through flimsy or diaphanous garments and appear to offer up both the products they promote and themselves for the gratification of the (male) spectator/purchaser. In 1898 Alfred Choubrac fell foul of the censor with his poster design for the literary journal *Fin de Siècle*, which depicted a scantily clad female with her legs provocatively splayed, but representations of women in their underwear rarely seem to have been arraigned by the 1882 law against obscenities. As Ann Ilan-Alter appositely maintains: 'Advertising artists tantalized and titillated, so that while the censors came to see and to examine, they withdrew, understanding that what tantalized and titillated would also calm and assuage.'[56]

In the main, this objectification of femininity appeared to be for the exclusive delectation of the male spectator, but there were also many designs by both female and male artists in which the register of pleasure is represented in more ambivalent terms. Clémentine-Hélène Dufau, for instance, portrays herself as a 'New Woman', smoking and drinking, in her prize-winning design for Byrrh tonic wine in 1903 (figure 27).[57] She wears a *décolleté* gown and her hair-style is soft and feminine. Whilst her dress code and pose are alluringly provocative, however, her gaze does not meet ours, and in the way that she holds her glass of wine and cigarette she appears altogether more resolute and in control of her own sexuality. Such a portrayal forms a marked contrast to the more passive and coy women represented smoking in the Job cigarette-paper campaigns by Georges Meunier (1894) and Chéret (1895). Similarly, several male artists were concerned with the depiction of more positive or realistic female stereotypes. At one end of the ideological spectrum these include socialist posters such as Steinlen's *Petit Sou* (1900), which symbolises woman as the political liberator of the proletariat who leads the people to the dawning of 'Les Temps Nouveaux' or 'The New Age',[58] and at the other,

social depictions of working-class women such as Toulouse-Lautrec's *Elles* series of colour lithographs, which were commissioned in 1896 by the publisher Gustave Pellet. Lautrec based these on first-hand experience of living in brothels between 1892 and 1895, and not just casual or sporadic visits to them. Here, the artist reveals a more sympathetic understanding of prostitition by placing it in a social context. He does not present us with ideal types, but with working-class women of different ages whom we witness in their daily routine – washing themselves and combing their hair either before or after the sex act. Rather than condemning their profession on moral grounds, Lautrec unequivocally represents it on its own terms, and in images such as *Woman Fastening a Corset, Passing Conquest* implies that the obscenity of prostitution is as much to do with the men who seek such pleasure as it is with the women who supply it.

The posters of the 1890s clearly have a significant role to play in the history of graphic communications on several levels. In the first instance, they initiated a truly modernist aesthetic for graphic design in their bold use of colour, inventive treatment of space

27] Poster design for Byrrh by Clémentine-Hélène Dufau, 1903.

and form and in their sympathetic integration of typographic and pictorial elements. Moreover, the lithographic poster of the *fin-de-siècle* was not just an autonomous work of art, but a piece of commercial design that could be bound up with various cultural concerns. As we have seen with reference to France, for instance, during the 1890s posters were produced within the context of propagandist debates on artistic modernism and cultural and national identities. At the same time, posters were mobilised as vehicles for promoting pleasure, and commodities as diverse as alcohol, tobacco, bicycles and lamp oil were objectified more often than not with resort to female/feminine stereotypes. We should bear in mind, however, that the posters of the period were not produced either exclusively by male artists or only as incitements to purchase for men. Posters for the theatres, cafés, cabarets and publishing houses made a direct visual appeal to both sexes, and many advertising cosmetics, such as Chéret's poster for *La Diaphane rice powder* (1890), were aimed at a female market. The posters of the *fin-de-siècle*, therefore, embodied the visual celebration of a capitalist culture and one in which, moreover, human beings could be represented as commodities by being symbolically linked with the products advertised. As such, they adumbrate a materialist ideology which Thorstein Veblen described as 'conspicuous consumption' in *The Theory of the Leisure Class* in 1899, and which was to be more acutely realised in the photographic advertising of the 1920s and afterwards. Henceforth, Judith Williamson has argued, people were no longer to be identified by what they produced but by what they consumed:

> Advertisements are selling us something else besides consumer goods: in providing us with a structure in which we and those goods are interchangeable, they are selling us ourselves . . . We are both the product and consumer; we consume, buy the product, yet we are the product. Thus our lives become our own creations, through *buying*.[59]

Notes

1 H. Bouchot, *La Lithographie* (Paris, 1898), p. 241. Speaking of the situation after 1840 he states: 'A dater de ce moment, la chromo litho était classée à un rang inférieur dont elle ne sortira guère que de notre temps.'

2 L. Broido, *The Posters of Jules Chéret* (London, 1980), p. xiii.

3 *Le Chat Noir* (18 January 1890).

4 Société des Artistes Français, *Exposition 109, Palais des Champs-Elysées, règlements, section de gravure et de lithographie* (Paris, 1891), p. ccviii.

5 'Rapport motivant la non admissibilité des gravures en couleur au salon, presenté au comité des 90, le 24 janvier', *La Lithographie*, 10 (March 1898), pp. 1–3.

6 Translation by M. Needham in P. D. Cate and S. H. Hitchings, *The Colour Revolution: Colour Lithography in France 1890-1900* (Santa Barbara, 1978).

7 *Ibid.*

8 *Les Maîtres de l'Affiche* cost 2F. 50 for four issues, and was a very economical way of reproducing posters such as Lautrec's *La Goulue* of 1897, which originally would have cost 25F. One of the problems with Roger Marx's production, however, was that it standardised posters of different dimensions to its own format of 11. 25 × 15. 5 in.

9 The interview was given to his friend Henri Nocq in *Journal des Artistes* (1894) and reprinted in H. Nocq, *Tendances nouvelles: enquête sur l'évolution des industries d'art* (Paris, 1896), p. 46. Translation in D. W. Druick, 'Toulouse-Lautrec: notes on an exhibition', *The Print Collector's Newsletter*, 17:2 (May-June 1986), p. 46.

10 P. D. Cate, 'The popularization of Lautrec', in *Henri de Toulouse-Lautrec: Images of the 1890s* (New York, 1985), pp. 87-88.

11 F. Fénéon in J. U. Halperin (ed.), *Œuvres plus que complètes* (Geneva, 1970), pp. 229-31.

12 F. L. Emanuel, *Illustrators of Montmartre* (London, 1904), p. 84.

13 Metropolitan Museum of Art, New York, *American Art Posters of the 1890s*, 1987.

14 Roger Marx, *L'Art Social* (Paris, 1913), pp. 162-3.

15 For a deeply researched and erudite discussion of this situation see D. Silverman, *Art Nouveau in Fin-de-Siècle France: Politics, Psychology, and Style* (California, 1989).

16 *Ibid.*, p. 55.

17 *Ibid.*, p. 4.

18 *Ibid.*

19 A. Marty, *Journal des artistes* (11 December 1892).

20 See *Revue des arts graphiques* (28 September 1895). For an account of early nineteenth-century lithography in France see H. Bouchot, *La Lithographie* (Paris, 1890).

21 E. de Goncourt, *La Maison d'un artiste*, t. 2 (Paris 1881), pp. 186-7.

22 See Silverman, *Art Nouveau in Fin-de-Siècle France*, chapter 5 for an account of this phenomenon. For a contemporaneous account of the aetiology of *fin-de-siècle* neurosis see M. Nordau, *Degeneration* (London, 1895).

23 E. de Goncourt and J. de Goncourt, *Études d'art: Le Salon de 1852, la peinture à l'Exposition de 1855, préface de Roger Marx* (Paris, 1895), pp. i-xix.

24 For a full discussion of Seurat's interest in the iconography of Chéret's posters, see S. Le Men, *Seurat et Chéret: le cirque, le peintre et l'affiche* (Paris, 1994).

25 One of the best accounts of these developments is still Cleveland Museum of Art, *Japonisme: Japanese Influence on French Art 1854-1910* (Ohio, 1975).

26 P. Burty, 'Japonisme I', *La Renaissance littéraire et artistique*, 4 (1872), pp. 25-6.

27 For an exhaustive account of Whistler's intaglio work see K. A. Lochnan, *The Etchings of James McNeill Whistler* (New Haven, 1984).

28 L. Falize (writing under the pseudonym M. Josse), 'L'art japonais', *Revue des arts décoratifs*, t. 3 (1882-83), pp. 330-31.

29 Cited in N. M. Mathews (ed.), *Cassatt and her Circle: Selected Letters* (New York, 1984), p. 214.

30 C. Roger-Marx, *L'Œuvre gravé de Vuillard* (Monte Carlo, 1948), p. 14.

31 C. Chassé, *The Nabis and their Period*, translated by Michael Bullock (New York, 1969), p. 67.

32 A. Terrasse, *Pierre Bonnard* (Paris, 1967), p. 10.

33 Lautrec wrote a letter to his father on 17 April 1882 concerning his first encounter with Japanese *ukiyo-e*. See L. Goldschmidt and H. Schimmel (eds), *Unpublished correspondence of Henri de Toulouse-Lautrec* (London, 1969), p. 74.

34 C. Genuys, 'A Propos de l'art nouveau, soyons français!', *Revue des arts décoratifs*, 17 (1897),, pp. 2-3. Translation by Silverman, *Art Nouveau in Fin-de-Siècle France*, p. 281.

35 Cited in Silverman, *Art Nouveau in Fin-de-Siècle France*, p. 283.

36 See, for example, P. Burty, 'Conférence du Japon', *Revue des arts décoratifs*, 5 (1884-85), p. 388.

37 Quoted in E. de Goncourt, *Journal des Goncourts*, t. 6 (28 September 1844 entry), t. 6 [1878-84] (Paris, 1906).

38 P. D. Cate, 'Paris seen through artists' eyes', in *The Graphic Arts and French Society 1870-1914* (New Brunswick, 1988), p. 6.

39 This is suggested in Abel Truchet's drawing, *Les Grecs, c.*1895, in which his depiction of the bar is based on that in the Quat'z'Arts. Truchet's drawing also includes a waiter without trousers and a board on the wall which plays on the pun Règle du Jeu de l'Oie (Rules for the Goose Game).

40 See S. Barrows, 'Nineteenth-century cafés: arenas of everyday life', in Pleasures of Paris: Daumier to Picasso (Museum of Fine Arts, Boston, 1991), p. 18.

41 H. W. Fraser, *The Coming of the Mass Market 1850-1914* (London, 1981), p. 208.

42 See M. Girouard, *Victorian Pubs* (London, 1975).

43 Barrows, 'Nineteenth-century cafés', p. 24.

44 S. West, *Fin-de-Siècle: Art and Society in an Age of Uncertainty* (London, 1993), p. 86.

45 By 1896 there were 46,000 women working as primary school teachers in France. See S. Barrows, *Distorting Mirrors: Visions of the Crowd in Late Nineteenth-Century France* (New Haven, 1981), pp. 55-6.

46 Between 1889 and 1900, twenty-one feminist periodicals were published in France. See Karen Offen, 'Depopulation, nationalism and Feminism in fin-de-siècle France', *American Historical Review*, 89 (1984), p. 654, and C. Goldberg Moses, *French Feminism in the Nineteenth Century* (Albany, New York, 1984).

47 Offen, 'Depopulation, Nationalism and Feminism in fin-de-siècle France', pp. 648-76. In Germany, wives were regarded as subordinate to their husbands in the eyes of the law – the Civil Code of 1900 stated that the husband had the right to make all decisions in married life, including whether his wife should be allowed to work or not. See A. Grossman, 'The New Woman and the rationalisation of sexuality in Weimar Germany', in A. Snitow, C. Stansell and S. Thompson (eds), *Powers of Desire: the Politics of Sexuality* (New York, 1983), p. 12.

48 G. de Maupassant, *A Woman's Life*, translated by H. N. P. Sloman (Harmondsworth, 1965), p. 99.

49 See J. Parisot, *Johnny Come Lately: a Short History of the Condom* (London, 1987), p. 25, and A. Leathard, *The Fight For Family Planning: the Development of Family Planning Services in Britain 1921-74* (London, 1980), p. 6.

50 See R. D. Mandel, *Paris 1900: the Great World's Fair* (Toronto, 1967), p. 145.

51 F. Nietzsche, *Beyond Good and Evil* (Harmondsworth, 1990), p. 101;

V. Jozé, 'Le Féminisme et le bon sens', *La Plume*, 154 (15–30 September 1895), pp. 391-2.

52 Simon, 'Il faut rester femme', *La revue: Ancienne revue des revues*, 18 (1896), pp. 135-41, cited and translated by Silverman, *Art Nouveau in Fin-de-Siècle France*, p. 73.

53 See J. Walkowitz, *Prostitution and Victorian Society: Women, Class and the State* (Cambridge, 1980), and J. Walkowitz, 'Male Vice, Female Virtue', in *Powers of Desire: the Politics of Sexuality* (New York, 1983), pp. 420-8.

54 O. Uzanne, 'Coquetteries féminines', *La Grande Dame*, 1 (1893), pp. 75-8, cited and translated by Silverman, *Art Nouveau in Fin-de-Siècle France*, p. 71.

55 *Gil Blas* (May 1891).

56 A. Ilan-Alter, 'Paris as Mecca of pleasure: women in fin-de-siecle france', in *The Graphic Arts and French Society 1871-1914*, p. 79.

57 The Byrrh poster design competition of 1903 was one of several to be sponsored by large organisations and manufacturers in the late nineteenth/early twentieth century – others included those for the journals *L'Éclair* in 1897 and *The Studio* in 1898. Dufau's design was later published as a postcard in 1908. See R. Bargiel, *Les Concours d'Affiches vers 1900, Byrrh L'Affiche Imaginaire* (Paris, 1992), p. 50.

58 See A. Dardel, *'Les Temps Nouveaux' 1895-1914: un hebdomaire anarchiste et la propagandie par l'image* (Paris, 1987).

59 J. Williamson, *Decoding Advertisements: Ideology and Meaning in Advertising* (London, 1978), pp. 13 and 70.

Suggestions for further reading

J. Abdy, *The French Poster, Chéret to Cappiello* (London, Studio Vista, 1965).

G. Adriani, *Toulouse-Lautrec: the Complete Graphic Works, a catalogue raisonné* (London, Royal Academy of Arts, 1988).

G. Bernier, *La Revue Blanche, ses amis et ses artistes* (Paris, Éditions Hazan, 1992).

J. Block, *Homage to Brussels: the Art of Belgian Posters 1895-1915* (Rutgers, Zimmerli Art Museum, State University of New Jersey, 1992).

L. Broido, *The Posters of Jules Chéret* (London, Dover, 1980).

H. Bouchot, *La Lithographie* (Paris, 1890).

C. Campbell, *The Beggarstaff Brothers* (London, Barrie and Jenkins, 1990).

F. Carey and A. Griffiths, *From Manet to Toulouse-Lautrec* (London, British Museum, 1978).

P. D. Cate (ed.), *The Graphic Arts and French Society 1871-1914* (New Brunswick and London, Rutgers University Press, 1988).

P. D. Cate and S. H. Hitchings, *The Colour Revolution: Colour Lithography in France 1890-1900* (Santa Barbara, Peregrine Smith, 1978).

Cleveland Museum of Art, Ohio, *Japonisme: Japanese Influence on French Art 1854-1910* (Cleveland, 1975).

D. W. Druick, 'Toulouse-Lautrec: notes on an exhibition', *The Print Collector's Newsletter*, 17:2 (May-June 1986), pp. 41-7.

W. H. Fraser, *The Coming of the Mass Market 1850-1914* (London, Macmillan, 1981).

S. Gill, 'Steinlen's prints: social imagery in late nineteenth-century graphic art', *The Print Collector's Newsletter*, 10:1 (March–April 1979), pp. 8-12.

C. Hall, *Theatre Posters* (London, Victoria and Albert Museum, 1983).

U. E. Johnson, *Ambroise Vollard Éditeur: Prints, Books, Bronzes* (New York, Museum of Modern Art, 1977).

J. King, *The Flowering of Art Nouveau Graphics* (London, Trefoil, 1990).

P. Leprieur, *La Centenaire de la Lithographie* (Paris, 1896).

V. Margolin, I. Brichta and V. Brichta, *The Promise and the Product: Two Hundred Years of American Advertising Posters* (London, Macmillan, 1979).

R. Marx, *Masters of the Poster 1896–1900* (London, Academy Publications, 1977).

A. Mellerio, *La Lithographie en couleurs* (Paris, L'Estampe et l'Affiche, 1898).

Metropolitan Museum of Art, New York, *American Art Posters of the 1890s* (1987).

Museum of Fine Arts, Boston, Mass., *Pleasures of Paris: Daumier to Picasso* (1991).

Museum of Modern Art, New York, *Pierre Bonnard: The Graphic Art* (1989).

C. Roger-Marx, *Graphic Art of the Nineteenth-Century* (London, Thames and Hudson, 1969).

H. Schardt, *Paris 1900 – The Art of the Poster* (London, Bracken Books, 1987).

D. L. Silverman, *Art Nouveau in Fin-de-Siècle France: Politics, Psychology, and Style* (University of California Press, 1989).

S. West, *Fin-de-Siècle: Art and Society in an Age of Uncertainty* (London, Bloomsbury, 1993).

Looking right and left: graphic propaganda in Britain after 1914

'Lads you're wanted, go and help'.
On the railway carriage wall
Stuck the poster, and I thought
Of the hands that penned the call

Fat civilians wishing they
'Could go and fight the Hun'.
Can't you see them thanking God
That they're over forty-one?
 Julian Grenfell, 'Recruiting', 1914–15

The literature on propaganda is vast and offers analysis of a diffuse range of themes, practices and media. It has been the critical concept underpinning discussion of various phenomena including voting patterns, consumerism, wartime oppression and resistance, educational practices and matters of religion. Moreover, it has tended to be regarded as a feature of the modern world, the product of mass communications and mass politics, though many older practices have been identified as forms of propaganda. Thus historians have considered subjects as diverse as the formulation of rules of rhetoric in ancient Greece and the moral and political messages of Hollywood films in terms of propaganda. The scale and range of this literature is testimony to the problems facing those who wish to define the term 'propaganda'. Jacques Ellul, in a systematic study of the subject, claimed that virtually all biased forms of communication produced in a society were to some degree an expression of propaganda, even if such biases were unintentional.[1] Such all-encompassing definitions open up a subject so large that propaganda seems to become an indiscriminate category. Indeed, one of the particular issues facing those who wish to produce a universal definition is that propaganda, like any expression of culture, has been in constant historical flux. Consequently in this chapter we will consider graphic propaganda *historically* in the period which saw the most dramatic shifts and developments in both the concept and the practice of propaganda. This was, at

least in terms of Britain and Europe, the first half of the twentieth century.

The meaning of 'propaganda'

The ways in which the meaning of words alter and develop over time can be understood as an index of broader social and historical changes in culture. The currency of a word is a measure of the significance attached to a particular concept or thing by the society which speaks that word. Words do not signify outside actual social and historical relationships, but are invariably social products themselves. Over time the meanings of words, as Raymond Williams has shown, can be extended or transferred, consolidate or decline.[2] Some words, especially those which involve values or imply judgements, become more volatile during periods of rapid change and transition. The term 'propaganda' underwent a significant development in its usage in the fifty or so years before the outbreak of the Second World War. By the 1920s, propaganda, as a concept, was predominately being used with its modern valency as biased communication. A cartoon by Bernard Partridge, 'The smoke screen clears', produced for *Punch* in 1939 to comment on broken Nazi promises, offers a good example (figure 28). The incarnation of propaganda in the form of a smoke-belching serpent was an easily understood symbol. Propaganda was identified by Partridge as savage irrationality guided only by lies and aggression, the antithesis of all that is rational and reasonable. His image neatly expressed a view of propaganda which still prevails today, i.e. a synonym for brainwashing and the manipulation of the truth for ill intent. And the meaning attached to propaganda in this 1939 cartoon can be confirmed by the shrill warning of many contemporaneous views: 'the rape of the masses'; 'a system of organised falsehood'; 'Machiavellian'. But these views concerning the power of propaganda were relatively new. With its origins in the verb 'to propagate', the word had had since the seventeenth century a relatively neutral, uncontroversial register.[3] Propaganda, even in the nineteenth century, was largely used in the sense that we might use 'publicity' today. By the time that Partridge produced his cartoon a significant and relatively rapid shift seems to have occurred. Most commentators agree that the major, traumatic effects on the consciousness of the modern mind produced by the First World War were the major factor in this extension of meaning. In fact, propaganda enjoyed attention in the form of an entry in the *Encyclopædia Britannica* for the first time in 1929, having been unconsidered in the previous edition (1913), the last before the outbreak of the Great War. Moreover, the *Punch* cartoon

28] 'St George and the
Dragon. The smoke screen
clears', cartoon by Bernard
Partridge, *Punch* (29 March
1939).

makes indirect reference to posters of the Great War. The incarn-
ation of propaganda as a serpent drew upon the recent revalor-
isation of the myth of Saint George and the Dragon.[4] This
mythological narrative had been widely exploited in First World
War poster imagery produced, as has often been noted, by both
the British and the Germans. Posters commissioned by official Brit-
ish organisations such as the Parliamentary Recruiting Committee,
as well as many short stories and poems published in the popular
press and newspaper reports of fantastic appearances of this knight
on a white charger on the battlefields, drew upon this widely
understood myth. Honour, valour and other noble values were
unmistakably posited against unrestrained evil. Saint George and
the Dragon was a simple rhetorical opposition which drew upon
some distant realm of timeless national history and suggested the
inevitable vanquishing of a savage foe that was 'beyond' nature
(and one which, according to the most aggressive Allied propa-
ganda, had succumbed to Satanism). The brutality and horror of
modern warfare was mediated through an image which offered a
fictive, romantic image of conflict. Yet within a matter of just over
twenty years, the metaphor of chivalric valour was revived on the
pages of *Punch* to form a kind of accusation against the graphic
propaganda of the First World War.

The graphic propaganda of the First World War

The gulf between popular images of military conflict at the out-break of war and the experience in the mud of Ypres, the Somme and Passchendaele was immense. Romantic faith in heroism, hon-our and duty was extinguished by trench warfare, mortar-fire and poison gas. The First World War was a truly cataclysmic event in history. This conflict, in its scale, in the exploitation of industrial-ised warfare and chemical weapons, in breaching the 'traditional' confines of the battlefield to affect the lives of all Europeans, ushered in a new age in which man's invention and industry were fully revealed, for the first time, in terms of its awful potential for destruction. The war was fought in a rapidly changing world where popular support for the conflict was, more than at any time before, a necessary condition of victory. Consequently, the cam-paign mounted by the British Government to secure various kinds of material support from the people, as well as enlisting public opinion, was larger, more costly and more intense than any before. In an age before television and radio broadcasting, this campaign inevitably exploited forms of print. In particular, the lithographic poster, a mature form of graphic communication by 1914, was given a prime role in the campaign to persuade men, in the language of contemporary posters, to 'Fill the Ranks'.

At the outbreak of the conflict Britain was the only belligerent nation which did not operate a system of conscription; this was introduced in January 1916 as the flood of volunteers began to dry up and the British army suffered great losses on the Western Front. The standing army of 160,000 men stationed throughout the Em-pire was also significantly smaller than those of her enemies. Consequently, at the end of August 1914 the War Office established the Parliamentary Recruiting Committee (PRC), a cross-party body largely made up of politicians and trade unionists, to co-ordinate voluntary recruitment.[5] One of the activities undertaken by the PRC, through its Publications Sub-Department, was to issue posters encouraging men to enlist in the army as well as other campaigns such as the drive to recruit workers for the munitions factories. In 1920, two commentators estimated that in the eighteen months before the introduction of conscription, the PRC had commis-sioned over 100 different designs printed in runs of up to 40,000 copies and was responsible for producing over two and half million posters in total.[6] The first appeals for recruits (predating the forma-tion of the PRC and following authorisation by Parliament to increase the army to a target figure of 500,000 men) were typo-graphic announcements such as 'Your King and Country Needs You. A Call to Arms'. But, as recruitment began to dwindle in the

autumn of 1914, the PRC adopted more sophisticated strategies in the form of graphic imagery and emotional appeals. Although regulated and subject to official sanction, the system of poster production was a haphazard affair. Many images were designed by printers' 'art departments'; in other words, usually by formally untrained printers who had risen to the 'drawing board' often by dint of a talent for sketching. Many posters, therefore, resembled pre-war advertising campaigns in format and sentimental imagery. Typically, PRC posters were not the result of a direct commission in the form of a 'brief' from the organisation's headquarters at 11 Downing Street, but 'volunteered' by commercial printers.

In the later stages of the war a broader range of themes was addressed in official posters, produced from June 1917 by the National War Aims Committee (often in conjunction with other wartime departments and agencies such as the National War Savings Committee and Women's Land Service Corps). These dealt with war loans; donations in support of voluntary organisations such as the '1914 War Society' which appealed for money to rehabilitate disabled veterans in 'healthy, rural surroundings'; donations for refugees in continental Europe; appeals to women to volunteer to work in munitions factories or on the land; and thrift and prudence, particularly in the use of foodstuffs and materials imported from overseas. Government-sponsored designs were augmented by posters commissioned from unofficial bodies such as the Underground Railway Company in support of the 'war effort'. It is, however, hard to identify significant differences between state-sponsored 'official' imagery such as that produced by the PRC and other kinds of graphic works. Beyond their primary aims to enlist men or to raise money, these posters generally sought to raise morale. Explicit images of fighting were rare. Combat was often symbolised by more palatable emblems of social unity or national identity such as John Bull. Less intentionally, early posters generally addressed their viewers in what George Orwell, writing almost thirty years later, called 'demotic speech', i.e. the tendency of official publications to speak in an authoritarian tone stressing justice, responsibility, stoicism and duty.[7] Working-class men and women were regaled with images and exhorted in a tone of language which resonated with the rhetoric of Empire and the public school. Most famously they were told that 'Your Country Needs You', a command matched by the incriminating, pointing figure of Field Marshal Lord Kitchener. As the war ground into stalemate in the quagmire of the trenches and as the impact of the slaughter and the scale of injury was felt at home, the tone and address of PRC posters began to change; potential soldiers were offered camaraderie; 'shirkers' and 'slackers' were reproached with recriminating

images of women and children; and visions of an idyllic rural Britain hinted at the threat of war to the 'Old Country'.

In 1939, writing about the literature of the Great War, Orwell noted that the only works written about the conflict which had endured were those which touched upon private experience, even if it be 'the nightmare happening in the void'.[8] The public realm had been contained by an atmosphere of patriotism, masculine heroism, martyrological celebrations of valour and virtuous justification which largely extinguished explicit opposition to the war and defused public expressions of concern about the conduct of the War Office and other state bodies. This was not simply a matter of censorship, though the State erected a substantial apparatus of control in the form of the Press Bureau established at the outbreak of the war for the management of the 'news' from the fronts, and the Defence of the Realm Act passed in August 1914, which conferred upon the State extraordinary powers in the name of national security. The Act's regulations, as they affected the press, were designed to ensure reliance on official information and discourage unofficial attempts to collect information about the conduct of the war. Even though the Press were firmly behind the Government, the ordinances of the official censors were increasingly paranoid. In April 1916, for example, the publication of solutions to chess puzzles was banned (unless the editors of newspapers were certain of the reliability of their correspondents), in fear of unintentionally disseminating covert communiqués to secret agents. As Cate Haste has shown, the effect of Government attempts to control the Press did not result in the circumspect spread of official news.[9] In contrast, the paucity of information published left the public in a state of ignorance and bewilderment. Lacking knowledge of the actual events and conditions of the war, public opinion clung on to romantic myths of heroism. Of course, expressions of pacifism and anti-militarism were made during the conflict by organisations such as the Liberal-led Union of Democratic Control and the No Conscription Fellowship, but the atmosphere of jingoism and militarism made public declaration of such views difficult and even dangerous. Pacifism was attacked as treachery and as the refuge of cowardice in the patriotic press, and speakers at public meetings were assaulted. Even soldiers fighting at the Front colluded in an atmosphere of hysterical patriotism and mythologised valour. One soldier wrote in 1916: 'This isn't war as the world understands it, the truth of the matter is that everyone out here considers it only fair to one's woman to hush up the worst side of the war and make light of it.'[10] The posters produced by the PRC and other bodies were the most publicly visible 'evidence' of this national mood. Public opinion and

the poster were bound together in a complex, mutually reinforcing relationship. The meaning ascribed to a particular design by contemporary viewers must be framed not only in the context of prevailing public opinion; we have also to consider how the formation of public opinion was influenced by propaganda. In addition, we need to take into account the dominant ideologies which were common in wartime Britain as well as the specific and potent tropes which embodied them.

Women of Britain say 'Go!', designed by E. V. Kealey for the PRC in 1915, typifies what, in many ways, became one of the most controversial and denounced forms of hortatory poster after the

29] *Women of Britain say –*
'Go!', lithographic poster
by E. V. Kealey, 1915.

war, that of an emotional or moral reproach (figure 29). It shows, in a rather conventional style, a family group of a mother and two children standing by the open window of what we take to be their home. They watch as the tail-end of a troop of soldiers departs into the rural landscape, presumably taking the paterfamilias off to the battlefields. The primary audience for this poster is clearly intended to be those men who have yet to enlist, but a second audience is also addressed – 'the women of Britain'. Female 'war work', as defined by this appeal, was to act as a persuader, to act as an agent for the State. This role was made quite explicit in other official propaganda. One typographic poster asked 'the young women of London' whether their 'best-boy' was 'wearing Khaki': 'If your young man neglects his duty to his King and Country, the time may come when he will NEGLECT YOU. Think it over – then ask him to join the army TO-DAY.'[11] The explicit message of Kealey's poster, as propaganda, is hard to misunderstand. It is useful, however, to effect a distinction between propaganda and ideology here. The intention of the propagandist, in this instance the PRC, to persuade men to enlist is clear. Yet the way in which this image constructs and mobilises meaning is not solely the product of the efforts of PRC propagandists, for it relies on a combination of graphic codes and particular ideologies current in Edwardian and wartime Britain which were outside the control of Kealey and the PRC. The poster, for example, divides the scene represented into two clear environments: inside the home and outside in the public realm. The women and children (including a young boy who draws away from the 'feminine' clasp of mother and daughter) are located in the former and the soldiers in the latter. Ideologies of masculinity and femininity had in the Victorian period effectively gendered the home as a feminine space.[12] The ideology of the 'separate spheres', whilst under threat from the women's suffrage movement and changes in employment and legislation over property rights, underwent a kind of rehabilitation in the conservative atmosphere of wartime Britain. Some suffragettes, for example, agreed to suspend their campaign for the vote 'for the duration' in the spirit of national sacrifice. Consequently, to 'place' the male viewer of this poster graphically inside the home was to issue a challenge to his masculinity, a challenge that would only be met if he crossed into the public 'setting' of the Forces. Other attendant ideologies apparent here include that of motherhood. As Caroline Rowan has shown, in the context of war and the demographic impact of the slaughter on the battlefront, motherhood took on a magnified significance.[13] In 1916 a pamphlet was produced entitled *A Little Mother*, which identified a woman's role in war thus:

It is we who 'mother the men' who have to uphold the valour, honour and traditions not only of our Empire but of the whole civilised world ... we women pass on the human ammunition of 'only sons' to fill up the gaps, so that when the 'common soldier' looks back before 'going over the top' he may see the women of the British race at his heels, reliable, dependent, uncomplaining.[14]

In this light, the representation of motherhood in the poster becomes a visual confirmation of a woman's duty as the mother of future soldiers.

The effectiveness of these posters during the war was predicated by the embodiment of ideologies such as this in ways that appeared 'matter of fact', and which consequently made them difficult to contest. Posters which effortlessly confirmed, for example, popular prejudices about the enemy or virtuously affirmed the British 'way of life' were likely to be most successful with the public. The potency of much poster propaganda of the period lay in what Roland Barthes in his book *Mythologies* describes as 'naturalisation'.[15] He charges the critical observer with the responsibility of examining how 'mythical' images and representations come to seem natural and unproblematic; how the contingencies of history and the complex negotiations and tensions of social and political life appear to 'evaporate' in such images, coming to seem commonplace, natural and unquestionable. In figure 29, for instance, we should consider how war might be understood as a conflict between good and evil, or a woman's role as unmistakably that of mother. In this sense, propaganda, particularly that produced by hegemonic institutions such as the State, can be seen to function as an untroubling confirmation of the 'way things are'. 'In passing from history to nature', writes Barthes,

> myth acts economically: it abolishes the complexity of human acts, it does away with all dialects, with any going back beyond what is immediately visible, it organises a world without contradictions because it is without depth, a world wide open and wallowing in the evident, it establishes a blissful clarity: things appear to mean something by themselves.[16]

Furthermore, mythical images rely 'parasitically' on other representations in order to achieve this 'naturalisation', and in this sense, British posters of the First World War drew upon and extended a 'reservoir' of images and themes which had a heightened valency in the charged atmosphere of war reporting. Their effectiveness was enhanced by their 'intertextuality', i.e. the potential (and functional necessity) to invoke connotations with other constructions of meaning. Knowledge drawn from other images or texts gave the viewer of these posters 'information' with which

he/she could confirm the meaning of these usually drawn, histori-
cally unspecific visual tropes.

A poster, *Red Cross or Iron Cross?* designed by David Wilson (figure
30), depicts the torture of an injured allied soldier by a German
nurse. As if the image was not clear enough, the accompanying
caption explains the scene, and as the image was probably produced
towards the end of the conflict, the viewer is given a new task, that
of remembering such 'crimes' in the peace to come. Furthermore,
this image was printed when the emphasis of British propaganda
(now produced under the aegis of the National War Aims Commit-
tee (NWAC)) changed to persuade the people that the war had to
be resolved in Britain's favour and, to counteract the growing anti-
war movement, that absolute commitment was needed in what
was claimed to be the 'Final Push'. The NWAC, with the War Propa-
ganda Bureau (better known as Wellington House),[17] was respon-
sible for producing notorious 'atrocity propaganda'. The Press were
encouraged to report in lurid detail 'war crimes' committed by
German troops in occupied territory. Ghastly stories appeared
(apparently confirmed by books and pamphlets published by Wel-
lington House) which offered accounts of rape and child murder,

30] *Red Cross or Iron
Cross?*, lithographic
poster by David Wilson,
c. 1917.

and tales of the mutilation and abuse of British corpses in 'cadaver factories'.[18] Occasionally, faked photographs or vivid sketches would accompany these stories as visual 'evidence'. After the war, the majority of these tales proved to be fictive or highly distorted. One such historic event vividly embroidered by both Wellington House and the NWAC was the shooting of Nurse Edith Cavell by the Germans in Brussels in October 1915 for aiding the escape of Allied soldiers. Her execution was exploited throughout the world in publications such as *The Death of Edith Cavell* (London, 1915) and in sentimental postcards, as 'evidence' of German brutality and the unyielding decrees of the Prussian military law in the face of a British nurse's bravery and decency. Cavell was recast as an 'Angel of Mercy', a popular 'genre' of wartime representation. Whilst Wilson's poster does not make direct reference to Cavell's case, the cruelty of the fictive German nurse is measured against the British nurse's 'virtue'. This image also includes another mythologised stereotype which had particular wartime currency, i.e. the 'Hun', represented as caricatures of Kaiser Wilhelm II, toying with his moustache, and Marshal von Hindenburg. As Steve Baker has shown, this stereotype of the 'Hun' was a particular construction of 'Germanness' which drew upon the latent currency of misunderstood Darwinian thinking ('survival of the fittest' and 'that man descends from animals like apes') and the 'principles' of physiognomy (see chapter 2).[19] In particular, certain graphic codes were almost invariably used to signify 'innate' German traits: weak-jawed, corpulent, pig-eyed characters prevailed. On occasion, the caricature of the 'Hun' was exaggerated into an ape-like character to suggest the regression of the German 'race' along the evolutionary path. Such caricatural representations of the German officer served to reinforce public perceptions of the inhumanity of their foe. Rudyard Kipling, writing for the *Morning Post* in June 1915, baldly stated: 'however the world pretends to divide itself there are only two divisions in the world today – human beings and Germans'.[20] Consequently, the First World War poster has to be understood as part of a larger and interconnected system of more or less official forms of propaganda, including newspapers reports and cartoons, popular novels and other literary forms, works of fine art, plays on military themes and films with titles such as *Backbone Britain*, *Once a Hun, Always a Hun* and *Ready, Aye, Ready*. Even the advertising of commonplace goods such as Beecham's Pills and de Reszke cigarettes published in magazines like *The Sphere*, a popular weekly read by a largely middle-class readership, took on the 'voice' of propaganda during the conflict. In effect, a thorough-going and disparate alliance spoke in concert in support for the war.

After 1918 some commentators were highly critical of British wartime posters of the kind described above. In a 1920 survey of the posters produced by all the belligerent nations, Martin Hardie and Arthur K. Sabin made a somewhat odd, though not unusual, assessment of the British designs. They were critical of what they felt to be the aesthetic deficiencies of these posters produced by printers. Schooled in the aesthetic 'standards' of posters produced by artists such as Henri de Toulouse-Lautrec in France and the Beggarstaff Brothers in Britain, as well as a relatively developed critical discourse about the merits of the modern lithographic poster in publications like *The Poster*, these high-minded critics found them 'vulgar' and 'insipid' when compared to those produced by continental designers, including the Germans, who displayed a keen understanding of 'modern' principles of design. In contrast, British design appeared as conservative and emotionally charged as pre-war advertising, yet propaganda, as many of its critics and advocates in the inter-war period were keen to stress, required assessment not by aesthetic standards, but by its actual effects. Much of the literature on the British posters of the Great War claims that they scored a great victory in, for example, securing the recruitment of 2,467,000 soldiers in the first eighteen months of the conflict, that is 24 per cent of available men. Yet many factors such as poverty and the relatively good pay offered by the army (particularly when some employers continued to pay wages to their employees fighting in the trenches), may have been instrumental in encouraging recruitment,[21] and several PRC posters featured the revised scales of allowances and military pay issued in May 1915. Consequently, it would be difficult to retrieve the meanings attached to these posters by contemporaries on the basis of the images alone. In fact, diaries and letters occasionally throw up evidence to suggest that some viewed the mawkish sentiment of these posters and their attempts to provoke feelings of guilt with disdain. Lady Cynthia Asquith, writing as the first clouds of poison gas spilled across the battlefield at Ypres, for example, recorded in her diary on 8 May 1915: 'London, I think, looks distinctly more abnormal now - more soldiers, more bandages and limps and more nurses - quite a sensational sense of strain. Raw recruits led by band still make one cry and everywhere the rather undignified, bullying posters - very, very dark at night.'[22] Nevertheless, in the tendentious culture of wartime Britain such expressions of dissent remained largely in the private realm. It was only in the post-war period that public debate about the effects of the propaganda of the Great War took place.

The legacy of the graphic propaganda of the First World War

In the aftermath of the Great War a public autopsy was carried out on the effects and the ethics of propaganda. Much of this attention was dedicated to the 'atrocity propaganda' produced by the British. Various publications such as Arthur Ponsonby's *Falsehood in Wartime* (1928) and Campbell Stuart's *The Secrets of Crewe House* (1920) illustrated the extent to which wartime propagandists had disseminated lies as factual 'evidence' of German brutality. Myths of awful, evil acts by the enemy and the overbearing claims about the justness of the Allied cause, produced for domestic and international consumption, as well as the propaganda used to demoralise the German forces (in the final month of the war, the British dropped 5,360,000 leaflets over German lines)[23] were widely credited as being a major factor in the Allied victory, not least by German commentators. In particular, the central claim of all war propaganda – that the conflict was a means of defence against a menacing aggressor – collapsed into confused ambiguity in the peace. The declaration made at the outset of the conflict that Britain sought no territorial gain, or that the war was a conflict to end militarism, for example, was soundly rebuffed after 1918.[24] The attack on propaganda made by Arthur Ponsonby, a prominent Liberal MP, was the most vexed:

> In calm retrospect we can appreciate better the disastrous effects of the poison of falsehood, whether officially, semi-officially, or privately manufactured. It has rightly been said that the injection of the poison of hatred into men's minds by the means of falsehood is a greater evil in war-time than the actual loss of life. The defilement of the human soul is worse than the destruction of the human body.[25]

Many commentators felt aggrieved at the gulf between the image of war in propaganda and their own experiences of it. C. E. Montague, for instance, entitled the memoirs of his experiences during the conflict *Disenchantment*, to express his scorn.[26] It is notable that Montague, a journalist on the *Manchester Guardian* who enlisted with the 24th Royal Fusiliers in December 1914, had worked as an intelligence officer on the Western Front. His role was to take important visitors to the battlefront, including some of the most active figures in the production of graphic and literary propaganda, such as the official war artists Louis Raemakers, Muirhead Bone and Francis Dodd. In the mood of post-war recrimination and reflection, the British poster also came under attack. Orwell, writing about the ways in which covert pacifism amongst school boys during the First World War developed into a contempt for militarism in adulthood in the 1920s, recalled:

1914–1918 was written off as meaningless slaughter, and even the men who had been slaughtered were held in some way to blame. I have often laughed to think of that recruiting poster, 'What did you do in the Great War, daddy?' (a child is asking this question of its shame-stricken father), and of all the men who must have been lured into the army by just that poster and afterwards despised by their children for not being Conscientious Objectors.[27]

The public silence that had enveloped the conduct of the campaigns to influence public opinion during 1914–18 was swamped by a post-war wave of critical comment. All critics, whether pragmatic apologists recognising the State's need to influence public opinion or strident critics of 'pernicious' strategies of deception, shared the view that the propaganda of the First World War had been unequivocally successful. This critical re-examination came to a head in the early 1930s, when the movement for disarmament and pacifism reached its height with exhibitions and popular publications such as T. A. Innes and Ivor Castle's *Covenants With Death* published to accompany an exhibition of photographs at Dorland Hall in London revisiting the horror of the Great War[28] and posters such as Jean Carlu's *Pour le Désarmement des Nations* (For the Disarmament of Nations) published by the *Office de Propagande Graphique pour la Paix* (Office of Graphic Propaganda for Peace) in Paris, enjoying widespread reproduction.[29]

One major effect of this public inquisition was that most post-war British governments were reluctant to be seen to engage in propaganda, coming to view it as 'un-English' and a vulgar practice, only made necessary by circumstances of war. One commentator argued that it broke with British *'laissez-faire* tradition'.[30] Consequently, in the first months of the peace the major state propaganda agencies such as NWAC were closed down, despite pleas that they should be converted to peace-time roles. In 1932 a civil servant working for the Foreign Office articulated a point of view that prevailed in the early 1930s:

> The real trouble centres around the use of the word propaganda. This word was in particularly bad odour for some time after the war. In the News Department we constantly avoided using it and there have been occasions when we have written to our press officers and other correspondents abroad asking them to use the word 'publicity' or any other euphemism rather than 'propaganda'.[31]

Whilst British governments of the period sought to avoid being seen as sponsors of propaganda, they nevertheless engaged in the production of 'publicity'. In fact, some voices associated with the State argued strongly for its peacetime usage. Stephen Tallents, for example, was the author of a pamphlet in 1932 entitled *The Projection of England*, in which he insisted that the prejudice of senior

civil servants and politicians against 'publicity' needed to be con-quered.[32] Using the anodyne and carefully inoffensive euphemism, 'national projection', Tallents, a career diplomat and civil servant, proposed that the national characteristics of 'reticence and mod-esty' would act as guarantors of dignity in the production of official propaganda. He proposed that agencies working on behalf of the nation should produce material to promote trade within and outside the Empire; to encourage tourism; and to sustain national prestige overseas. In this way, the kind of propaganda proposed by Tallents was intended to be an affirmation or celebra-tion of English 'virtues'.

Various state-sponsored propaganda programmes of the period reflected Tallents's concerns with 'dignified national projection'. The Empire Marketing Board (EMB, 1928-33), for example, was a major patron of graphic designers and film-makers through its schemes to promote the products of Empire, largely foodstuffs, in the United Kingdom.[33] This agency, enjoying official support in the form of government subventions, was directed by a committee which included figures from the advertising profession, business-men and Tallents as its secretary. Designs, commissioned by the publicity committee's poster sub-committee under the chairman-ship of Frank Pick,[34] were a significant element in these campaigns, taking the largest share of the promotional budget. Over 800 posters were commissioned in seven years. These images were available in different formats, from the largest hoardings (10 × 20 ft) to small bills for window displays. The EMB also erected 1,800 dedicated poster hoardings away from commercial sites across the country, thereby avoiding the 'indignity' of commerce. In the same spirit, the design and content of the posters was self-consciously 'superior' to advertisements. The EMB commissioned 'by invitation' many well-known artists including Edward McKnight Kauffer and Gerald Spencer Pryse. Often the terms of the 'brief' were firmly predeter-mined by the EMB, and artists would be asked to resubmit work which failed to display sufficient technical accuracy or lapsed into fantasy. The tone of the captions used to accompany these pain-terly images was characteristically sober and restrained, unlike the hyperbole of modern advertising. In fact many of the posters were printed on stiff card and distributed to schools, or reproduced in educational textbooks. The aim of these designs was, in the first instance, to make the public aware of the products of Empire, whether South African fruit, dairy produce from Australia or Rho-desian tobacco, but more generally these posters were effective propaganda for imperialism *per se*. Whilst individually many of these posters seemed to focus on single products of particular ter-ritories, the effect of hundreds of posters surveying the world was

to create the impression of a harmonious *'blend'* of peoples or a united *'family'*. In fact, both of these metaphors recurred in EMB propaganda: F. C. Harrison's poster, *Making the Empire Christmas Pudding* (1928), for example, showed a British woman cooking the raw materials of Imperial territories to make the traditional dish; and H. S. Williamson's design, *John Bull, Sons and Daughters* (1928) exploited the interrelated domestic themes of the family and the home in an image of Empire symbolised as a grocer's shop displaying notices with slogans like 'The Empire is Your Garden'. Moreover, the EMB posters were a graphic justification for the innate chauvinism of the British Empire. Many reinforced prevailing notions of cultural and biological 'difference' between colonisers and colonised. In their didactic, educational tone these posters characterised the 'right' of the British to rule over 'inferior' peoples as a civilising mission. In 1930 Adrian Allinson, for example, was commissioned by the EMB to produce a pair of posters on the theme of 'colonial progress' (figures 31 and 32). These images established a contrast between traditional patterns of life in East Africa and the changes brought by imperial 'know-how': 'old-style' human porterage through the trackless bush was compared with modern motorised transport on man-made roads and bridges. Allinson's painterly style, though displaying traces of a post-impressionist sensibility, was sufficiently realist to be presented as visual evidence of the difference between 'old' and 'new'. This kind of propaganda operated by positing a series of simple binary oppositions or differences: black/white; dressed/ undressed; nature/ culture; mechanised/hand-powered; cultivated/ uncultivated; masculine/feminine; intellectual labour/physical labour; individual/mass; and so on. It is interesting to note, however, that whilst the EMB was a thoroughly imperialist agency in function and ideology, it showed some sensitivity to a growing climate of distaste with the exploitation of the dominions. Allinson was requested by the East Africa Trade Commissioner through the agency of Pick and the EMB, to remove a whip from the hand of his white overseer and draw in its place a tobacco pipe, since the connotations of peremptory (in)justice and discipline suggested by such a weapon presumably distracted from the imperial claims to be a 'civilising' influence on the subject people of Empire.[35] The EMB's stress on dignity and education was to some degree a reflection of widespread post-war distaste for propaganda. The temperate and informative tone of EMB posters was a careful strategy to avoid the accusations of deception and mendacity which the propaganda of the Great War had attracted. Nevertheless, other factors continued to fuel public concern about the effects of propaganda. In particular, perceptions about the science of psychology, the force of advertising

31] *East African Transport –
Old Style*, lithographic
poster by Adrian Allinson,
published by the Empire
Marketing Board, 1930.

EAST·AFRICAN TRANSPORT~OLD STYLE

32] *East African Transport –
New Style*, lithographic
poster by Adrian Allinson,
published by the Empire
Marketing Board, 1930.

EAST·AFRICAN TRANSPORT~NEW STYLE

and the uses of propaganda by the totalitarian states in Europe accentuated the sense of fear attached to this concept.

Modern psychology, the product of nineteenth-century clinical research by figures such as Hippolyte Bernhcim and Wilhelm Wundt, was still in its infancy in the inter-war period. Nevertheless, popular and sometimes exaggerated accounts of the ways in which science could identify human susceptibility to suggestion had great impact. The Russian scientist Ivan Petrovich Pavlov's research into conditioned reflexes made in 1901, for example, became widely known and was discussed in the press and in popular texts on psychology.[36] On the basis of his research, which used dogs as subjects, the suggestibility of animals to predetermined stimuli was assigned to humans. The logic of Pavlov's findings, as reported at the time, seemed to suggest that people might be susceptible to subtle techniques of brainwashing and thereby be compelled to

behave in ways outside their conscious control. In some ways reports about this research merely confirmed the prejudices of earlier writers, who saw the masses as a malleable underclass easily whipped up into the 'mob'. The discoveries of psychology concerning human instincts were claimed by the most alarmist commentators to offer the propagandist an arsenal of determinist techniques that would lead to the 'rape of human will':

> The ordinary man, not yet armoured against propaganda, succumbs like an Eskimo to measles . . . (P)sychologically assaulted and ravaged with impunity . . . he will be found enthusiastically supporting campaigns aimed at his own subversion . . . He thinks, when he thinks, on the ideas and facts presented. The control of his thought materials, through selection and interpretation, is accordingly a most effective control over his convictions and conduct. Suffering from the effects of propaganda the sufferer is the last to admit that he is sick . . . The sensations that the propaganda germ set up have the seeming authenticity of normalcy.[37]

In addition to the perceived threat of psychology, developments in advertising in the inter-war period also accelerated the fear of propaganda. Advertising, a practice commonly discussed as a field of propaganda, took on a recognisably modern form as it began to make use of market research, psychological studies into consumer motivation (usually American research into so-called 'behaviourism'), the skills of professional designers and illustrators, and systematic approaches to planning campaigns.[38] The erstwhile sophistication of these strategies of persuasion alarmed intellectuals such as Bertrand Russell, who demanded that children be trained to study advertisements critically, to see through their dubious assertions.

Above all, it was the example and, to some extent, the threat posed by the propaganda activities of the Fascist and Communist states of Europe which exercised the minds of many in the United Kingdom. In marked contrast to Britain, these states made significant and systematic investments in propaganda in the inter-war years. From its earliest days during the period of the Civil War (1917–21), Soviet Russia initiated programmes of propaganda which were designed to elicit support for the revolution in a massive country populated by a largely illiterate, peasant people. Similarly, propaganda, in the form of persistent claims to restore Germany to its former status and free the nation from the 'shackles of Versailles', fuelled Hitler's rise to power before 1933 and subsequently became a major feature of state activity after March of that year, when Joseph Goebbels formed the *Reichsministerium für Volksaufklärung und Propaganda* (Ministry for People's Enlightenment and Propaganda).[39] Its chief agency, the *Reichskulturkammer* (National

Chamber of Culture), established on 22 September 1933, extended total state control over the public media, nationalising radio broadcasting and the press and making unequivocal use of the poster and the cinema. Paradoxically, the Nazis' notorious enthusiasm for propaganda can be traced to British successes in this field during the First World War. Hitler in *Mein Kampf* (1926) described British atrocity propaganda as 'ruthless as it was brilliant',[40] and he acknowledged that many of the characteristic strategies of Nazi propaganda, such as the use of emotionally charged appeals, originated in British practices. When the Nazis were firmly entrenched in power, many British intellectuals looked at their propaganda practices with anxiety:

> We have seen whole populations strip themselves, or consent to being stripped, of almost every form of freedom which their fathers held to be good. They have given up their right to choose their own rulers, to express their own opinions, to be told the truth about matters which concern them, to organise their own economic interests and to educate their own children according to their own beliefs. Dreading war, the Germans have consented to prepare, and to be drilled, for war, as no nation since the days of the Spartans has ever been drilled.[41]

In the 1930s perceptions about the effects of Nazi propaganda as well as concerns about the widespread ignorance of the British population of current affairs at home and abroad were major triggers for a concerted effort to produce graphic propaganda, but also for a second post-war wave of publications about propaganda itself. Unlike the critical commentaries produced in the aftermath of the Great War, some writers were forceful advocates for its production. In fact, a 'campaign' to encourage the British State to revive practices which it had abandoned with such alacrity after 1918, gradually gained momentum through the 1930s.

The Left and propaganda

The fear of being seen to engage openly in propaganda was not felt unanimously across British political culture in the inter-war period. Various intellectuals associated with the Left pressed for increased propaganda activity by the State in order to raise public knowledge. A functioning democracy, it was argued in a campaign which gained momentum as the threat of war grew closer, required that its citizens be well informed.[42] In fact, some figures such as John Grierson, a social scientist and film-maker working under the auspices of the EMB and the General Post Office, saw the production of propaganda as the means of ensuring that people did not fall sway to mass manipulation.[43] In the same spirit

Amber Blanco-White claimed that the Left, whether radical or reformist, needed to engage in a 'propaganda of truth' to cultivate public knowledge: 'a self-respecting citizen, possessed of a social and political conscience, with a healthy mind which does not shirk responsibility, but is capable of forming and defending its own social judgements'.[44] This was, in the author's view, quite incompatible with kinds of psychologically-driven propaganda produced by Fascist states which were 'designed to secure . . . mental and emotional degradation in the peoples under their care'.[45] The Left in the 1930s was particularly exercised with the issue of public enlightenment. The press and publishers in Britain were regarded to have failed in this respect; newspapers such as the *Daily Mail* and *The Observer* were vehemently attacked as apologists for Hitler's Germany.[46] Moreover, the desire for enlightenment would seem to be confirmed by the size of the public's appetite for knowledge about contemporary affairs. When in 1938, for example, the Penguin imprint published a 'Special' on the 'Munich Crisis' over Czechoslovakia, *Europe and the Czechs* by Sheila Grant Duff, the entire first edition of 50,000 copies sold out over one weekend. Consequently, many broadly left-wing initiatives of the period such as the Left Book Club (founded 1936), *Left Review* (founded 1934), Mass Observation (founded 1937) and the Artists' International Association (founded 1933) can be seen as attempts to bridge this knowledge gap, i.e. to make information available to ordinary British people about the state of the world affected by the Depression, international relations, or matters of health education at a cost that was not prohibitive. The Left Book Club, for example, offered its members inexpensive books on historical themes and current affairs by writers such as Sidney and Beatrice Webb, George Orwell and Arthur Koestler. 'The aim of the club', wrote Victor Gollancz, its founder, in 1936, 'is a simple one: it is to help in the terribly urgent struggle for world peace and for a better social and economic order and against Fascism by giving us all who are determined to play their part in this struggle such knowledge as will immensely increase their efficiency.'[47]

In this statement Gollancz identified the major issues which concerned the Left in Britain in the 1930s: the effects of the Depression, apparent in the failure of capitalist society to meet the most basic needs of its citizens in terms of housing and employment, and the rise of Fascism both on the continent and at home in the shape of Oswald Mosley's British Union of Fascists. In terms of graphic propaganda these were the major political causes taken up in left-wing work. Furthermore, they propelled many artists and intellectuals who might otherwise have been disdainful of tendentious or political cultural practice to become, to use a contemporary

term, 'engaged'. The leftward shift of intellectual life was one of the most striking features of British culture in the period. One latterly notorious Communist, Anthony Blunt, recalled that: 'quite suddenly, in the autumn term of 1933, Marxism hit Cambridge ... almost all of my younger friends had become Marxists and joined the Communist Party ... undergraduates and the graduate students were swept away by it and during the next three or four years almost every intelligent student who came up to Cambridge joined the Communist Party at some time during his first year'.[48]

The Artists' International Association (AIA), an alliance of artists seeking to turn their work to political ends, offers evidence of the appeal of the Left to a large section of artists working in Britain. Within two years of the publication of its statement of aims published in *International Literature* in 1934, it had grown rapidly from 32 founders to nearly 1,000 members and scored extraordinary success in attracting some of Britain's leading painters, graphic designers and sculptors to its ranks. The AIA organised exhibitions, encouraged the production of various forms of graphic propaganda, raised funds for causes such as the International Brigades fighting in the Spanish Civil War and was the sponsor of congresses and lectures addressing questions of how artists should respond to the changing political climate of the 1930s. In terms of propaganda, two broad circles can be distinguished within the AIA: a small group of founding members who were committed to left-wing political activism (sometimes by membership of the Communist Party of Great Britain) and who were practitioners of graphic design, cartooning and printmaking; and a much larger general membership made up of artists working in all fields, including Eric Gill, Henry Moore and Laura Knight, who exhibited with the Association in order to express their opposition to Fascism and to call for social justice. For such members of this disparate alliance, political allegiance with the Left did not necessarily dictate the content of their work, but was a matter of choosing to exhibit under the flag of the AIA at group exhibitions such as 'The Social Scene', held in a showroom in Charlotte Street, London in 1934, and the much larger 'Artists Against Fascism and War' in Soho Square, London in November of the following year. It would, however, be erroneous to suggest that the broader membership of the AIA was not concerned with questions of propaganda. When, for example, a reviewer in the *Catholic Herald* inveighed against exhibitors participating in 'The Social Scene' show as 'a section of an army of propagandists' who disguised their Marxism under a 'semblance of concern for world peace',[49] Eric Gill, a Roman Catholic and Socialist artist in the Fabian mould, was prompted to respond. He rebuffed this reviewer, calling for an

understanding of art which went beyond a connoisseurial pleasure in formal qualities and aesthetics ('a sort of cultured drug traffic') to recognise 'all art as propaganda', whether for the Church, for the *status quo* or for social change.[50] Furthermore, debates conducted under the aegis of the AIA on the appropriate form and role of 'committed' art sought to identify the 'correct tendencies' in left-wing art. This dispute was largely contested by supporters of Soviet-style Socialist Realism like Laszlo Peri, and Surrealism, favoured by figures like Herbert Read.[51] But it was the work of a core group of graphic activists at the heart of the AIA that offered a significant development in terms of the production of propaganda in Britain after 1918. An understanding of the potential of Modernism charged graphic work produced by 'the three Jameses' (James Fitton, James Boswell and James Holland) with a critical vigour which marked it out as an advance in propaganda technique.

Although the AIA functioned as a political commonweal for fine artists, photographers and designers, its origins lay in the activities of a committed core of political artists including 'the three Jameses', Cliff Rowe, Pearl Binder and Misha Black who formed this alliance (at first under the name of the Artists' International) in 1933. At the outset this organisation defined its role as the union of 'working units ready to execute posters, illustrations, cartoons, book jackets, banners, tableaux, stage decorations, etc.', disseminating this propaganda to counter 'Imperialist War on the Soviet Union and Fascism and Colonial Oppression'.[52] These figures were all active on the Left and keen supporters of the Soviet Union (Rowe and Binder lived and worked there before the founding of the association). They were also predominately graphic designers and illustrators whose work often appeared in small-circulation socialist journals such as *Left Review* and mass-circulation newspapers such as the *Daily Mirror*. Howard Wadman, writing in *Typography* in 1937, made a direct connection between the political activism of these figures and their professional work as graphic designers and illustrators:

> Latter-day capitalism has called into being an enormous machine of commercial propaganda, which is manned very largely by clever young men who are socialists. You will find them on newspapers, in the cinema, in advertising, in broadcasting. They are interesting and dangerous, these young people of the Left, because theirs is not the simple agitation of the have nots. They are highly paid and comparatively free, but their daily work gives them exceptional opportunities for seeing the wasteful and trivial uses to which our economic system puts the vast powers of the modern world. When such men turn from their bread and butter to the sphere of political propaganda the results are decidedly significant and may one day

"BUY NATIONAL" The Capitalist's Solution

HERE ARE THE CONSEQUENCES
THERE'S A PROFIT IN THEM TOO—BUT NOT FOR US WHO WORK

HOW THE VOLUME' OF INTER-
NATIONAL TRADE HAS FALLEN
1929 1930 1931 1932 1933 1934
100 85·4 74·1 75·1 77·2 78·0

BUY BRITISH
BUY JAP
BUY AMERICAN
BUY FRENCH
BUY GER
BUY ITALIAN

£239,000 £9,96_,000 £11,3__,000 £29,624,_00
1933 1934 1935 1936
BUT THE VALUE OF ARMS
FIRMS' SHARE CAPITAL RISES

The figures are for Vickers Lt
Cammell Laird, John Brown & C
Fairey Aviation & Rolls Royce

"In many cases the resumption of industrial activity is connected directly or indirectly with the manufacture of war material and army reorganisation. It is needless to insist on the dubious and psychologically depressing economic character of such activities."
Report of the League Economic Committee, 1935

33] Page spread from *It's Up To Us*, pamphlet designed by The Alpha Group, published by *Left Review*, 1936.

be decisive . . . their pamphlets and posters for the Left must be held partly responsible for the fact that at last the young people of Eng land are taking an interest in politics and they are all travelling in the same direction.[53]

The appeal of what then was described as 'commercial art' was not simply a matter of economic exigency during the Depression, though Holland claimed that the collapse of the market for their art stiffened many artists' resolve to use their work to discredit capitalism.[54] The techniques of commercial advertising offered a modernised form of graphic communication that these young intellectuals were keen to exploit. Wadman's article included an illustration from *It's Up to Us* (1936), a pamphlet produced by the Alpha Group, a collective of graphic designers including Fitton, Boswell and Holland (figure 33). This sixpenny 'propaganda for peace' was published by *Left Review* in an edition of 50,000 copies, to counter enthusiasm for rearmament. Hamilton Fyfe writing in *Reynold's Magazine* described the pamphlet's design as a combina-tion of 'types of many sizes and varieties with pictures and diagrams, displaying facts and figures in the clearest way possible, throwing in quotations from speeches, manifestos, interviews, articles, with effect at once horrifying and humorous'.[55] The lively, multi-layered and heterogeneous style of *It's Up to Us* – a synthesis of graphic and textual fragments – followed inventive continental models of propaganda design such as Kurt Tucholsky and John Heartfield's highly successful collaborative book project, *Deutschland, Deutschland ueber alles* ('Germany, Germany above Everything') (Berlin, Neuer Deutscher Verlag, 1929)), which was a

double-barrelled graphic and literary indictment of the philistin-ism and indifference of bourgeois life in Weimar Germany. Similarly, images on the pages of *It's Up to Us* make direct visual reference to Soviet photomontage designs by figures like Alexan-der Rodchenko. The influence of Soviet and German left-wing propaganda was particularly marked on these British designers.

The lessons learnt from continental Modernism encouraged an enlivening of British propaganda. By the early 1930s a steady flow of ideas and images from the Soviet Union and Germany were absorbed in Britain. Individuals, sometimes fleeing from Fascism in Central Europe, such as László Moholy-Nagy, the Hungarian-born photographer and designer who had worked at the Bauhaus, and the photographer, Edith Tudor-Hart (née Suschitzky), brought direct experience of continental debates and practices, and British artists and designers often reciprocated by travelling in the oppo-site direction.[56] Continental work was given exposure in Britain in exhibitions and publications: George Grosz's work, for example, was exhibited under the title of 'Social Satires' at the Mayor Gallery in London in 1934 (though his illustrations had been reproduced in British publications since the mid-1920s).[57] In fact, Grosz's work was so well known amongst left-wing intellectuals in Britain that it was used by some reviewers as a yardstick to judge political art. Similarly, El Lissitzky's constructivist works and multi-layered ex-hibition designs were reviewed in British magazines such as *Commercial Art*,[58] and Soviet films by directors like Sergei Eisen-stein and Vsevolod Pudovkin, key practitioners of cinematic montage, were shown, despite censorship by the British Board of Film Censors, through the agency of the London Film Society, the Workers' Film Society and a distribution company specialising in Soviet material, Kino Films.[59]

Modernist culture in the Soviet Union under Lenin and in We-imar Germany had developed a number of critical notions which had had significant effects on the production of graphic and photo-graphic propaganda (see chapters 5 and 6). The practice and theory of graphic and filmic *montage*, the technique of layering or placing incongruous or unusual material together, were of particular importance in the history of graphic propaganda. The Marxist critic, Walter Benjamin, prompted by the photomontage work of John Heartfield (see figure 44), the 'Epic Theatre' of Bertolt Brecht and the work of Soviet film-makers, observed in 1934 that 'montage interrupts the context into which it is inserted'.[60] The explosive potential of montage was, for Benjamin, a means by which the uncritical complacency of viewers could be challenged into con-sciousness about the organisation of the world and their own place in it. Furthermore, montage not only constituted an innovative

technique which challenged normative constructions of meanings, it also functioned as symbolic rupture or fragmentation of its sources. Montage, in the hands of continental Modernists, was not claimed as an organic reflection of the world: it called to attention the fact that it was in itself an artificial construct. It was self-consciously *anti-naturalistic*. The impact of forms of Modernist montage on the core of graphic activists working at the heart of the AIA was particularly marked. James Fitton's cartoons reproduced on the pages of *Left Review* and in pamphlets such as *It's Up to Us*, used incorporated elements 'plundered' from the press. Fitton conscientiously reproduced them as newspaper cuttings to remind his reader of the familiar sources that he had used. His cartoon, *The Bishop of London's Balance Sheet* (*Left Review*, March 1935), for example, incorporates two short texts from the *Evening Standard* and depicts the bishop dressed in full pontifical robes, using his mitre to beg for money, his eyes cast down with the shame of the pauper (figure 34). The drawing acts as a junction, making the purpose of bringing these two texts together evident, with the bishop's

34] 'The Bishop of London's balance sheet', cartoon by James Fitton, published in *Left Review* (March 1935).

apparent 'penury' measured against the profusion of his larder and the comfort of his drawing-room. As such the cartoon disrupts the seemingly detached and impartial tone of the newspaper report. In fact, it is the conventionally unchallenged 'currency' of these cuttings, coming recognisably from the world of actual events and living people, which gives Fitton's image its potency. He asks the reader of 1935 to consider what constitutes a 'fair deal', whereas the *Evening Standard* leaves the issue unquestioned. Fitton's montage does not act as a naturalising confirmation of the way that the world was organised, but instead interrupts the seemingly incontestable voice of the press and makes his own political views evident. In this way Fitton drew close to the dramatic principles developed by Bertolt Brecht, a key theorist of the political potency of montage. In fact, the first British translation of Brecht's writings on his principles of 'Epic Theatre' could be found in *Left Review* at this time.[61] The German playwright's own aims of 'forcing the spectator to consider the action', so as to 'wake his activity', and of compelling 'him to come to a decision' through 'montage' and 'argument', are paralleled in Fitton's design. Despite such invention and, in the *Bishop of London's Balance Sheet*, criticism of how the mainstream media of the 1930s operated in support of forms of conservatism in Britain, Fitton and his colleagues, Boswell and Holland, who developed comparable practices, were not paragons of political rectitude. They were not able to transcend the deep-seated social prejudices of their time. A. L. Lloyd, a socialist writer and collector of folk-songs, reviewing a collection of cartoons by 'the three Jameses' objected to one graphic stereotype deployed by them in the following terms: 'I declare that, in my opinion, derision of Fascism through the representation of homosexuality serves but little purpose except to display some sexual chauvinism.'[62]

Britain in the period between the First World War and the outbreak of the second great conflict of the century witnessed more propaganda activity and more discussion about the ethics and consequences of propaganda than at any time before. This can be seen to range from the confirmatory, ideologically conservative, official propaganda of the State, which drew on the irrational fears and instincts of Britons during wartime, to the disruptive, unofficial works produced by the Left twenty years later, which asked the viewer to consider how the meaning of the work was constructed. As strategies, the two were highly divergent but, to some extent, the propaganda of the Left in the 1930s can be viewed as a response to the vainglorious, assuaging images produced during the Great War. However, as Wadman was keen to point out in

1937, propaganda should not be measured by effects but by results. Montage as a strategy was not inherently effective. Its achievements, limited from the outset by the relatively marginal context in which many of these works appeared, largely resulted from its novelty during this period. Theodor Adorno, writing in the 1960s, claimed that the technique of montage seemed to have slid into banality and, in becoming commonplace, had lost its potential to disrupt: 'The principle of montage was supposed to shock people into realising just how dubious any organic unity was. Now that the shock has lost its punch, the products of montage revert into being indifferent stuff or substance.'[63] The idea of neutralisation and the incorporation of modernist principles to which Adorno alludes here, became especially acute in the wake of a post-war consumer culture, and are discussed in the chapters that follow.

Notes

1 J. Ellul, *Propaganda: the Formation of Men's Attitudes* (New York, 1965).

2 R. Williams, *Keywords* (London, 1976).

3 The word is usually traced to a Vatican committee established in 1622, the *Sacra Congregatio de Propaganda Fide*, to promote the Roman Catholic faith abroad. See, for example, G. S. Jowett and V. O'Donnell, *Propaganda and Persuasion* (Newbury Park, Calif., 1992), p. 2.

4 See Mark Girouard, *The Return to Camelot: Chivalry and the English Gentleman* (New Haven, 1981), pp. 275-93.

5 See Philip Dutton, 'Moving images? The Parliamentary Recruiting Committee's poster campaign, 1914-1916', in *Imperial War Museum Review*, 4 (1989), pp. 43-58. The PRC was only one of a number of official bodies charged with the production of propaganda; see M. Sander and P. M. Taylor, *British Propaganda during the First World War* (London, 1982), chapters 1 and 2.

6 M. Hardie and A. K. Sabin, *War Posters Issued by Belligerent and Neutral Countries 1914-1919* (London, 1920), p. 8.

7 G. Orwell, 'Propaganda and Demotic Speech' (1944), in *George Orwell: Complete Writings* (London, 1980), p. 636.

8 G. Orwell, 'Inside the Whale' (1940), in *The Collected Essays, Journalism and Letters of George Orwell*, vol. 1 (London, 1968), pp. 523-4.

9 C. Haste, *Keep the Home Fires Burning: Propaganda in the First World War* (London, 1977), pp. 30-1.

10 A soldier writing on 6 November 1916 quoted in L. Housman (ed.), *War Letters of Fallen Englishmen* (London, 1930), p. 30.

11 British poster illustrated in M. Rickards, *Posters of the First World War* (London, 1968), figure 23.

12 L. Davidoff and C. Hall, *Family Fortunes: Men and Women of the English Middle Class 1780-1850* (London, 1987), *passim*.

13 See C. Rowan, 'For the duration only: motherhood and nation in the First World War', in *Formations of Nation and People* (London, 1984), p. 154.

14 *A Little Mother* (1916), quoted in J. MacKay and P. Thane, 'The English-woman', in R. Colls and P. Dodd (eds), *Englishness, Politics and Culture 1880-1920* (London, 1986), p. 221.

15 R. Barthes, *Mythologies* (London, 1973), pp. 142-5.

16 *Ibid.*

17 The War Propaganda Bureau operated in an international context and produced propaganda designed to counter German ideology and enlist support of neutral countries for the Allies.

18 See Sanders and Taylor, *British Propaganda*, pp. 141-50.

19 See S. Baker, 'Describing images of the national self: popular accounts of the construction of pictorial identity in the First World War poster', *Oxford Art Journal*, 13:2 (1990), pp. 24-30.

20 R. Kipling quoted in H. D. Lasswell, *Propaganda Technique in the World War* (London, 1927), p. 91.

21 B. Curtis, 'Posters as visual propaganda in the Great War', *Block*, 2 (1980), p. 48.

22 C. Asquith, *Diaries 1915-1918* (London, 1968), p. 17. We are grateful to Caroline Windsor for this information.
 Ironically, her father-in-law, Prime Minister Asquith's rather literary and sometimes convoluted speeches were quoted at length in PRC posters.

23 A. J. MacKenzie, *Propaganda Boom* (London, 1938), p. 14.

24 With regard to these particular claims, (i) British expenditure on the fighting services was greater in 1924-25 than it had been in 1913-14, and (ii) Britain actually gained 1,415,929 square miles at the end of the conflict. See A. Ponsonby, *Falsehood in Wartime* (London, 1928), pp. 162-6.

25 *Ibid.*, p. 18.

26 C. E. Montague, *Disenchantment* (London, MacGibbon and Kee Ltd., [1922] 1968).

27 G. Orwell, 'My country Right or Left' (1940), in *The Collected Essays, Journalism and Letters of George Orwell*, vol. 1 (London, 1968), p. 537.

28 T. A. Innes and I. Castle (eds), *Covenants With Death* (London, Daily Express Publications, 1934).

29 See *Commercial Art* (December 1932), pp. 228-9.

30 R. S. Lambert, *Propaganda* (London, 1938), p. 152.

31 R. Kenney (Foreign Office minute dated 19 February 1932), quoted by P. M. Taylor in *The Projection of Britain* (Cambridge, 1981), p. 5.

32 S. Tallents, *The Projection of England* (London, 1932).

33 See S. Constantine, *Buy and Build: the Advertising Posters of the Empire Marketing Board* (Norwich, 1986).

34 See C. Barman, *The Man who Built London Transport: a Biography of Frank Pick* (Newton Abbot, 1979).

35 Constantine, *Buy and Build*, p. 8.

36 See Y. P. Frolov, *Pavlov and his School* (London, 1937).

37 A. D. Weeks, quoted in M. Grant, *Propaganda and the Role of the State in Inter-War Britain* (Oxford, 1994), p. 10.

38 See T. R. Nevett, *Advertising in Britain: a History* (London, 1982), pp. 145-68.

39 See D. Welch (ed.), *Nazi Propaganda: the Power and the Limitations* (London, 1983); D. Welch, *The Third Reich: Politics and Propaganda* (London, 1993);

B. Taylor and W. Van der Will (eds), *The Nazification of Art* (Winchester, 1990).

40 A. Hitler, *Mein Kampf* (London, [1926] 1992), p. 167.

41 A. Blanco-White, *Propaganda* (London, 1939), p. 13.

42 The literature making the case for increased state propaganda in the 1930s and 1940s was considerable and includes R. S. Lambert, *Propaganda* (London, 1938); A. J. MacKenzie, *Propaganda Boom* (London, 1938); J. Hargrave, *Words Win Wars* (Wells, 1940); 'Scipio', *100,000,000 Allies If We Choose* (London, 1940).

43 J. Grierson, *Grierson on Documentary*, edited by F. Hardy (London, 1946); J. Grierson, 'Propaganda for democracy', *The Spectator* (11 November 1938).

44 Blanco-White, *Propaganda*, p. 297.

45 *Ibid.*

46 See Anon., *The Power of the Press* (London, 1936).

47 V. Gollancz, 'Editorial', *Left Book Club News* (4 May 1936).

48 A. Blunt, 'From Bloomsbury to Marxism', *The Studio* (November 1973), p. 167.

49 A *Catholic Herald* review (27 October 1934) quoted in *Left Review*, 1:9 (June 1935), p. 340.

50 E. Gill, 'Eric Gill on art and propaganda', *ibid.*

51 See R. Radford, *Art for a Purpose: the Artists' International Association 1933–1953* (Winchester, 1987), pp. 64-101.

52 The 'Artists' International Statement of Aims' (1934) is reproduced in the Museum of Modern Art, Oxford exhibition catalogue, *AIA: the Story of the Artists' International Association* (1983), p. 11.

53 H. Wadman, 'Left-wing Layout', *Typography*, 3 (Summer 1937), p. 25.

54 James Holland (1936) cited in Radford, *Art for a Purpose*, p. 35.

55 H. Fyfe cited in *Left Review* (September 1936), back page.

56 For an excellent survey of this transfer of ideas and people see D. Mellor, 'London-Berlin-London: a cultural history. The reception and influence of the New German Photography in Britain 1927-1933', in D. Mellor (ed.), *Germany: the New Photography 1927-1933* (London, 1978), pp. 113-30.

57 See E. Toller, *Brokenbrow*, illustrated by Grosz (London, 1926); G. Grosz, *A Post-War Museum* (London, 1931).

58 J. Tschichold, 'Display that was Dynamic Force. Exhibition stands designed by El Lissitzky', *Commercial Art* (January 1931), pp. 21-6.

59 See R. Bond, 'Cinema in the Thirties: documentary film and the Labour Movement', in J. Clark, M. Heinemann, D. Margolies and C. Snee (eds), *Culture and Crisis in Britain in the 1930s* (London, 1979), pp. 241-56.

60 W. Benjamin, 'The author as producer' (1934), in *Understanding Brecht*, translated by J. Heckman (London, 1973), p. 99.

61 B. Brecht, 'The German drama: pre-Hitler', *Left Review* (July 1936), pp. 504-7.

62 A. L. Lloyd, 'Our James: a calendar for 1936', *Left Review* (January 1936), p. 184.

63 T. Adorno, *Aesthetic Theory* (London, 1984), p. 223.

Suggestions for further reading

M. Balfour, *Propaganda in War 1939-1945: Organisations, Policies and Publics in Britain and Germany* (London, Routlege & Kegan Paul, 1979).

J. Clark, M. Heinemann, D. Margolies and C. Snee (eds), *Culture and Crisis in Britain in the 1930s* (London, Lawrence and Wishart, 1979).

P. Dutton, 'Moving images? The Parliamentary Recruiting Committee's poster campaign, 1914-1916', *Imperial War Museum Review*, 4 (1989), pp. 43-58.

P. Fussell, *The Great War and Modern Memory* (Oxford University Press, 1975).

F. Gloversmith (ed.), *Class Culture and Social Change: a New View of the 1930s* (Sussex, Harvester Press, 1980).

M. Grant, *Propaganda and the Role of the State in Inter-War Britain* (Oxford, Clarendon Press, 1984).

C. Haste, *Keep The Home Fires Burning: Propaganda in the First World War* (London, Allen Lane, 1977).

G. S. Jowett and V. O'Donnell, *Propaganda and Persuasion* (London, Sage Publications, 1992).

R. Radford, *Art for A Purpose: the Artists' International Association 1933-1953* (Winchester School of Art Press, 1987).

M. Sanders and P. M. Taylor, *British Propaganda during the First World War 1914-18* (London, Macmillan, 1982).

J. Symons, *The Thirties: a Dream Revolved* (London, Faber & Faber, 1975).

P. M. Taylor, *The Projection of Britain: British Overseas Publicity and Propaganda 1919-1939* (Cambridge University Press, 1981).

5 Between utopianism and commerce: modernist graphic design

> The Russian rationalist says one type only in everything that is printed. We must have standardisation, he contends. We must cut out this *bourgeois* pandering to ostentation and display.
>
> The advertisement typographer, on the other hand, must have many types. The advertisement he designs must be different from their neighbours – at any price!
>
> Then comes the typographical purist. He says, 'show me first the paper type, for there many questions of shape and serif, weight and colour that I must settle.'
>
> And so we go on, taking refuge at last in the eternal evasion of *chacun à son goût* (printer's advertisement in *Art and Industry*, July 1937).

In May 1928 the city of Cologne hosted *Pressa*, the *Internationale Presse Ausstellung* (International Press Exhibition). This exhibition set out to survey contemporary developments in the business of printing, publishing and advertising. On a site that ran for three kilometres alongside the Rhine, *Pressa* filled forty-two buildings and three main exhibition halls displaying graphic works commissioned by various official German bodies as well as exhibits from twenty-four countries including Czechoslovakia, Hungary, China, Britain, the United States and the Soviet Union. Commonplace forms of print such as newspapers and travel posters were on display alongside artists' books and other high cultural forms. Although, as Jeremy Aynsley has shown, the exhibition was organised to emphasise Cologne's importance as a major commercial and cultural centre and to stress German pre-eminence in printing and typography,[1] visitors to *Pressa* encountered strikingly innovatory work by a variety of designers from across Europe. Posters designed by Jan Tschichold, a Swiss design reformer working in the *Meisterschule für Deutschlands Buchdrucker* (German Master Printers' School) in Munich, could be found in the House of the Workers' Press, a flat-roofed, white-walled Modern Movement building. The dramatic interiors of the Soviet Pavilion designed by El Lissitzky which included photomontages by the avant-garde artists Gustav Klutsis and Sergei Senkin, drew extensive comment in the press.[2]

El Lissitzky's spaces were, according to contemporary opinion, an extraordinary environment:

> all the possibilities of a new exhibition technique were explored: in place of a tedious succession of framework, containing dull statistics, he produced a new, purely visual design of the exhibition space and its contents, by the use of glass, mirrors, celluloid, nickel and other materials; by contrasting these new materials with wood, lacquer, textiles and photographs; by the use of natural objects instead of pictures ... by bringing a dynamic element into the exhibition by means of continuous films, illuminated and intermittent letters and number of rotating models. The room thus became a sort of stage on which the visitor himself seemed to be one of the players. The novelty and the vitality of the exhibition did not fail: this was proved by the fact that this section attracted by far the largest number of visitors, and had at times to be closed owing to over-crowding.[3]

El Lissitzky's exhibition pavilion was a graphic environment in which Soviet ideology, channelled by designers who had emerged from the avant-garde, was powerfully expressed through astonishing typographic, photographic and symbolic devices. Organised in twenty sections – huge photomontaged murals captioned with bold slogans and free-standing displays in the symbolic forms of the rollers of rotary printing presses and the red five-pointed star bedecked with print – celebrated the social and political achievements of the press as a force for progress in the USSR.

Such innovatory displays offered the visitor the opportunity to assess the practice of the design traditionalists who proliferated at *Pressa* against the innovations of designers like Tschichold and Lissitzky. The impact of their displays was not simply a matter of aesthetic and technical novelty. Sophie Lissitzky-Küppers recalled, for example, that the owners of large firms whose pavilions on the exhibition site failed to attract audiences sent their publicity directors to learn from her husband, El Lissitzky.[4] New styles of graphic design seemed to have much to offer business as a signifier of modernity and as a powerfully affective mode of address. The successful presence of graphic design which was produced according to a modernist creed by politically radical designers in the prevailingly conservative and commercial environment of a German trade fair raises the central paradox which will be addressed in this chapter. *Pressa* was not the first exhibition to display photomontaged posters and other distinctly modern graphic forms. There had been a number of exhibitions in Europe in the 1920s which put graphic design on gallery walls alongside abstract painting or in the pages of avant-garde manifestos. Unusually, however, *Pressa* located modernist graphic design in a commercial

and professional setting. How, therefore, did Modernism with its roots in utopian and avant-garde culture fare in the world of business? In approaching this question we need to consider the evolution of graphic principles and forms in the context of an incipient modernist search for a common language of graphic design in Central Europe in the 1920s.

der ring 'neue werbegestalter'

Whilst early traces of a distinctly modern aesthetic were evident in the formalism of the *fin-de-siècle* poster with its emphasis on flat surfaces and simplified shapes (for example, Bonnard's *France-Champagne*, figure 24), by the 1920s a more vigorous form of Modernism was beginning to be contested. Cubism had radically altered the treatment and perception of form and space, and moreover the Russian Revolution invested designers like El Lissitzky with a new sense of political purpose stimulating a wholesale reassessment of representation and production. At the same time in Germany the term *Modernismus* became current as a way of summing up two chief tendencies in artistic production: on the one hand it referred to an aesthetic form of Modernism such as Expressionism; and on the other, it referred to avant-garde groups such as the Dadaists, who espoused industrial culture, including the mass media, modern technology and urbanism. This embrace with mass-produced culture proved to be the intellectual touchstone of a mature style of modernist graphic design which was emergent in Central Europe in the late 1920s. In 1927 many of the key figures behind this development formed a professional alliance, *der ring 'neue werbegestalter'* (The Circle of 'New Advertising Designers').[5] Members included artists and designers from a variety of backgrounds: key figures in the Dada movement in the late 1910s and early 1920s such as the German artist, Kurt Schwitters, who had set up his own advertising agency *Merz-Werbezentrale* in 1924; Dutch Modernist designers, Piet Zwart and Paul Schuitema; László Moholy-Nagy, the Hungarian artist who had reorganised the highly influential *Vorkurs* (Preliminary Course) at the Bauhaus; a clutch of designers who worked as educationalists in German art and design schools, including the Swiss typographer Jan Tschichold and Georg Trump (both teachers at the German Master Printers' School in Munich), Max Burchartz (at the *Folkwangschule* in Essen) and Walter Dexel (at the *Kunstgewerbeschule* at Magdeburg); Friedrich Vordemberge-Gildewart, a painter associated with the Dutch *De Stijl* group; and César Domela, a Dutch painter living in Germany who organised the *Fotomontage* exhibition at the *Staatliche Kunstbibliothek* (State Art Library) in Berlin in the spring

of 1931; and Willi Baumeister and Hans Leistikow, whose designs featured as covers for the influential Modern Movement periodical, *Das neue Frankfurt*. Although the group took its decisions democratically, Schwitters was the *ring*'s guiding force, organising its sporadic meetings. Beyond offering its members a forum for the exchange of ideas and new designs, the *ring* promoted their work and the forms of graphic Modernism that they advocated through touring exhibitions which circulated through Germany, Switzerland, Scandinavia and Holland in the late 1920s and early 1930s.[6] In fact, the *ring*'s first show was held in Cologne's Kunstgewerbemuseum one month before *Pressa* opened (and the work of various *ring* members could be found throughout the site). The *ring* invited other artists and designers to participate in these exhibitions, including the *Bauhäusler* Herbert Bayer and Joost Schmidt, as well as John Heartfield, renowned for his biting political photomontages for the communist press in Germany (figure 44), and the constructivists Karel Teige from Prague and Lajos Kassak from Budapest. Although the constitution of this association was self-consciously internationalist, Germany was the intellectual rendezvous for many of its members.

Despite the diversity of their backgrounds, certain typical characteristics were common to the graphic works designed by *ring* members. In particular they showed a strong interest in typographic reform and in the use of photographic images. *ring* members, for example, tended to favour *Futura*, a geometric, *sans serif* typeface designed by Paul Renner and issued by the Bauer type-foundry between 1927 and 1930 in an extensive range of weights and sizes that could be used as both a book face and for displays. Historic typefaces like black-letter *Fraktur* were rejected by Schwitters and his colleagues, because they suggested origins in pre-industrial, calligraphic forms. They claimed that such faces inhibited easy comprehension because of their complexity and typographic embellishments. In contrast, *sans serif* letter-forms like *Futura* were regarded as more legible and efficient. In fact, these modernist designers regarded their research into type design as a collective, experimental process which would lead to a typographic *Ur-form*, that is, a universal, international alphabet of letter-forms which could be used for all graphic needs and to transcend local conventions and stylistic affectations. Moholy-Nagy had complained in 1925 that: 'we do not even possess a type-face that is correct in size, is clearly legible and lacking in any individual features and that is based on a functional form of visual appearance without distortions and curlicues'.[7] In the same year, Herbert Bayer at the Bauhaus experimented with designs for an *Einheitsschrift* (universal alphabet) and Jan Tschichold designed a

single-alphabet type derived from a primary geometry of circles and right angles in 1929. Bayer, driven by an overriding concern with typographic efficiency and function, even suggested the abolition of lower-case letter-forms, claiming that they were phonetically redundant.[8]

As designers, the *ring 'neue werbegestalter'* modernists preferred photographic illustrations to hand-rendered graphic processes such as engraving. Their enthusiasm for the camera was driven by a rich current of intellectual enquiry into the nature of the photographic image which was taking place in Central Europe in the 1920s.[9] In fact, *ring* members and their associates were active protagonists in these debates. In his celebrated 1925 book, *Malerei, Fotografie, Film* published by the Bauhaus, Moholy-Nagy argued that the photograph, despite its long history, had been dominated by peculiarly *unphotographic*, 'pictorial' and painterly ways of recording the world,[10] whereas the camera offered undervalued and unique ways of 'making visible'. He was particularly interested in experimental forms of photography such as the photomontage and photogram (that is, a camera-less photograph made by exposing sensitised paper to light). His friend El Lissitzky, working for the German ink manufacturer Pelikan, produced some highly inventive advertisements using the photogram technique. His 1924 advertisement for the company utilised the shadow of the company's bottled product, a pen and silhouetted lettering to great effect (figure 35). Jan Tschichold, in contrast, was enthusiastic about contemporary advertising photography, which had become an established field of professional practice. Writing in *Commercial Art* in 1930, he applauded the 'supernatural clearness' of such images.[11] The techniques of advertising photography – sharp-focus and attention to detail as well as a tendency to isolate the object photographed by recording it without indication of scale and proportion – produced compelling, graphic images. Tschichold's view was an affirmation of the *Neue Sachlichkeit* (New Objectivity) aesthetic associated with photographers like Albert Renger-Patzsch (see chapter 6). These different forms of modernist photography were widely utilised in designs by *ring* members. Paul Schuitema, the Dutch designer producing publicity for P. Van Berkel, a Rotterdam-based company manufacturing weighing and cutting equipment, for example, exploited serial images of repeated mechanical parts to connote mass production and the firm's prolific scale of manufacture (figure 36). The heightened realist style of these gleaming images accentuated the quality of materials used in the company's products. And montage allowed Schuitema to reveal the process of manufacture or concealed features of these highly engineered products through multiple views. Put to such

35] Photogram produced by El Lissitzky for Pelikan, 1924.

36] Prospectus for P. Van Berkel, designed by Paul Schuitema, 1930.

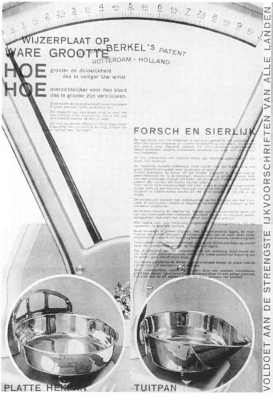

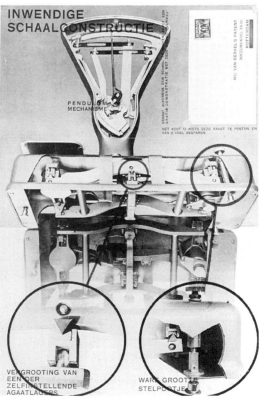

uses, photomontage, which in this context had roots in the transgressive, collaged images produced by Dada artists like Hannah Höch and John Heartfield in the early years of the Weimar Republic in Germany, was recast as an efficient and transparent means of producing complex and semantically rich images which could be quickly comprehended by the viewer. Franz Roh noted in 1929 that photomontage 'took rise from futurism and dadaism, and has gradually been clarified and simplified. Photomontage, formerly a demolishment of form, a chaotic whirl of blown up total appearance, now shows systematic construction and an almost classic moderation and calm.' [12]

Photography and modern typography were synoptically fused by Moholy-Nagy in his design concept of 'typofoto'. The 'typofoto' was, in his vision, the logical result of the development of new photomechanical printing processes from the late nineteenth century, allowing the traditional technical divide between image and typography to be overcome (and, as such, anticipated the first commercially available photocomposing systems, introduced in 1936). This presented an opportunity to design textual elements with visual impact beyond their main function as semantic signifiers and to use photographs as more than mere illustrations:

> typographical materials themselves contain strongly optical tangibilities of which they can render the content of the communication in a directly visible – not only in an indirectly intellectual – fashion. Photography is highly effective when used as typographical material. It may appear as illustrations beside the words, or in the form of '**phototext**' in place of words, as a precise form of representation so objective as to permit of no individual interpretation.[13]

As we have seen, Schuitema's work for Van Berkel seemed to meet Moholy-Nagy's prescription. He used words composed of simple, *sans serif* letters for their graphic, visual effect, sometimes printed over photographs.

The interest of modernists such as Moholy-Nagy, Tschichold and Schuitema in photography and modern typography was not simply a matter of aesthetic inclination or novelty. These designers and their colleagues across Central Europe were motivated by a common mission to discover rational principles of design that met not just the needs of the age but standards of good design which would prevail in the future. In his statements about typofoto, Moholy-Nagy, for example, confidently predicted that the future of modern graphic design lay in this kind of fusion of text and image. The expression of such aspirations for the future implied a messianic role for the modern designer to prefigure a better world where visual communication would enlighten rather than simply reproduce the prevailing taste, attitudes and conditions of the day.

Graphic design would, in Moholy-Nagy's words, be 'part of the foundation on which the *new world* will be built'.[14] In this way modernity was not simply a matter of contemporaneity – it was a 'project'. The quest for ideals in design implied a utopian and constructive view of progress in the world. It was, in essence, a political view which some, though not all, designers allied to socialist and communist politics. Within the modernist project, the designer's role was elevated to a didactic relationship with clients, printers and consumers. Schuitema, recalling his commissions between 1926 and 1933, claimed with some self-aggrandisement that:

> The printers did not know, for instance, whether the current typographical principles had any aesthetic value or not, or whether this form of expression would last or was merely ephemeral. The designer himself was hard, matter of fact, unwilling to make concessions, adopting a 'take it or leave it attitude' ... And the artist [*Künstler*] had a definite function to perform in society. He thought not of success but of essential values and ignored all else.[15]

For many ring members, Schuitema's 'essential values' and principles of design could be derived from modern technology: 'It is the utilisation of potentialities offered by the machine that is characteristic of and, in terms of evolution, authoritative for the techniques of our present-day works. Thus, printed matter today will have to correspond to the most modern machines; that is, it must be based on *clarity, conciseness* and *precision*.' [16] The vagaries of style, it was suggested, could be overcome by the rigour of technology. This was not, however, intended to determine a fixed language of form. Rather, 'driven' by the metronome of technology, graphic design could find ever-evolving principles which would be subject to change and invention without recourse to any 'eternal' or classical laws of design. This was a form of technological determinism, though designers like Schwitters were keen to acknowledge that their common and developing language of graphic Modernism could not be reduced to simple formulae and could be, they warned, susceptible to misapplication by insensitive hands. The actual impact of the machine on graphic design, however, was as much a matter of suggestion as technical determination. The preference for *sans serif* typography, for example, did not result from any technical advantage to the printer: instead it was given a symbolic association with the unadorned aesthetic of machines and a frequently stressed concern with 'rationality' and 'efficiency', traits associated in the mind of the modernist designer with industrial technology. At its most extreme, a kind of romanticism underpinned this fetishism for technology: 'The engineer is the creator of our time', asserted Tschichold; 'To characterise his works: economy, precision, composition from pure, constructive forms whose

shape corresponds to function. Nothing is more characteristic of our time than these witnesses to the inventive genius of the engineer: Airport, Factory, Underground railway-carriage. These are standard forms: Typewriter, Lightbulb or Motorcycle.'[17] Just as the engineer and the machine became signifiers of modernity, the *sans serif* typeface and photographic illustrations became signifiers for a conspicuous Modernism.

Many *ring* members were enthusiastic propagandists writing and publishing books, journals and articles.[18] One of the most influential texts was Tschichold's *Die neue Typographie* ('The New Typography') of 1928. This book enumerated a set of practical principles which would guide the modern designer. Whilst, as its title suggests, Tschichold's particular concern was with typography, his attention focused on a range of printed forms such as the book, the advertisement and the prospectus, as well as on the organisation of various graphic elements such as the photograph and geometric devices such as diagonal and horizontal rules. In fact, in Britain his phrase, 'the new typography' was used as a synonym for modernist practice.[19] Tschichold's system underscored the following chief points: asymmetry in layout and composition; *sans serif* typefaces as the expression of the age; the use of different typographic weights and sizes (on a monochrome scale), rules and other graphic devices to give emphasis and lead the viewer's eye in an effective manner; photographs in preference to other forms of illustration; and the use of an underlying grid as a means of constructing a page or a poster. Throughout Tschichold's survey of new design principles, he stressed *function*, which was not a matter of puritanism or utilitarianism, but the rational utilisation of the elements available to the designer. In addition, Tschichold's book also offered a synopsis of the history of the visual arts. *Die neue Typographie* testified to the extent to which these modern designers regarded themselves as inheritors of an avant-garde 'tradition' that could be traced back to the iconoclasm of futurist *mots en liberté* and dadaist experimentation, and the utopian abstractions of the Russian Constructivists in the early 1920s. In this genealogy, he claimed that the modernist designer had learnt much from the artistic avant-garde of the early twentieth century and informed his readers that: 'the laws of this kind of typographic design represent nothing other than the practical application of the laws of design discovered by the new painters'.[20] The formalism of abstract paintings such as El Lissitzky's dynamic, spatial compositions ('Prouns') of the late 1910s and the early 1920s, for example, could be invoked in appeals for the modern designer to increase a 'sense of urgency' in his or her work through the use of vertical and diagonal lines. This recent history, occurring within

the life of one generation, described the artistic and professional development of many of the members of the *ring* and their allies. El Lissitzky, Moholy-Nagy and Schwitters had each played significant roles in the practice and discourse of abstract art in the early 1920s. Nevertheless, Tschichold's inclusion of this historical summary in his book signalled an awareness that these artists and designers had moved away from the orthodox confines of the gallery in order to apply modernist thinking in everyday life. Although the Russian Constructivists had already identified this step as the future role of a socially engaged art – Nikolai Tarabukin describing it in 1921 as an advance *From the Easel to the Machine* – the circumstances of Central Europe at the time when Tschichold wrote *Die neue Typografie* gave this shift quite a different significance.

In 1925 George Grosz, a left-wing artist, and Wieland Herzefelde, a socialist publisher, reflected on the role of modernist art and design in the cultural and political climate of Weimar Germany in their pamphlet, *Die Kunst ist in Gefahr: ein Orientierungsversuch* ('Art is in Danger: An Essay in Direction').[21] This expanded polemic rejected the technical conservatism and social elitism of oil-painting (truisms found in many avant-garde manifestos of the period) and mapped out the future role of the artist:

> Today's artist, if he does not want to run down and become an antiquated dud, has the choice between technology and class warfare propaganda. In both cases he must give up 'pure art'. Either he enrols as an architect, engineer, or advertising artist in the army (unfortunately very feudalistically organised) which develops industrial powers and exploits the world; or, as a reporter and critic reflecting the face of our times, a propagandist and defender of the revolutionary idea and its partisans, he finds a place in the army of the suppressed who fight for their just share of the world, for a significant social organisation of life.[22]

The choice between commerce and social revolution presented by Herzefelde and Grosz was *the* significant intellectual dilemma facing many modernist graphic designers. Although some were sympathetic to the idea of a rupturing political revolution akin to that which had occurred in Russia in 1917, the likelihood of such a dramatic change in Central Europe was clearly waning by the mid-1920s.[23] The uprisings and formation of workers' councils in Germany and Hungary after the First World War had been brutally put down. And during the acute economic crisis of the early 1920s, dramatically illustrated by hyperinflation in Germany in 1923, attempts to revive the revolutionary mood through general strikes had met with indifference. In contrast, commerce and industry in the Netherlands, Germany, Czechoslovakia and other Central

European states had begun to prosper, sometimes through significant investment by foreign capital and state subventions. *Pressa* was, for example, supported by the Stresemann administration which was keen to build up the national economy.[24] For a short period until the Depression industry enjoyed a phase of relative modernisation and expansion. In this context, the scope for modernist graphic design seemed to be slipping away from revolutionary politics towards commercial advertising. Consequently, in the years following the publication of *Die Kunst ist in Gefahr* many modernist graphic designers developed close relationships with sympathetic corporate and institutional clients not only for economic reasons but, as we will see below, in a attempt to resolve the conflict between commerce and political engagement that Grosz and Herzfelde had identified. Piet Zwart, for example, designed a number of brochures and around 300 advertisements for the *Nedelandsche Kabelfabriek Delft* (Dutch Cable Factory in Delft) between 1923 and 1933, and we have already noted that Schuitema worked for Van Berkel in the late 1920s, and Schwitters was commissioned in 1929 by the Hanover City Council to standardise its printed matter and, in fact, to introduce a corporate identity for this civic body.[25] Schwitters, at this stage in his multi-faceted career as an artist and a designer, had established a professional practice – a small consultancy with a wide range of clients – which was to become the archetypal organisation of design practice in the West in the years after the Second World War. Schwitters's Hanover-based business, *Merz Werbenzentrale* (with a branch in Dresden run by his associate, Margit von Plato), took responsibility for working with clients, producing designs and instructing printers.[26]

Before considering this issue of commerce and political engagement in the work of *ring* designers in more detail, two general points need to be made about modernist graphic design. First, there is a danger of overstating the unity and collectivity of the *ring*. Inevitably, given their intellectual aspirations disputes arose between members. Walter Dexel, for example, writing in the *Frankfurter Zeitung* in 1927, took an ascetic's dislike to the decorative quality and dramatic compositional devices in Moholy-Nagy's work, and Schwitters criticised Bayer's and Tschichold's experiments with alphabets that excluded upper-case letters as being difficult to read.[27] However, the formation of their professional alliance in 1927 and the largely productive nature of their disagreements attest to the sense of common purpose shared by the *ring*. Second, the Modernism advanced by this group was not the only kind of new graphic design found in the period. In America, Britain, France and Poland new styles of what was often described as 'commercial art' emerged in the 1920s without the theoretical,

systematic and political character of many Central European experiments. Designers like A. M. Cassandre (born Adolphe Jean-Marie Mouron) and Jean Carlu in France, Tadeusz Gronowski in Poland and the Anglo-American designer, E. McKnight Kauffer, produced modish lithographic poster advertisements. Characteristically, these designers tended to display their modernity in a restrained graphic style: usually flat, simple and chromatically rich forms (sometimes modelled in space by using an airbrush to achieve gradations) and the careful integration of letter-forms into the overall composition. Cassandre's design for a lithographic poster, *Nicholas* of 1935 is a striking combination of static and animated elements (figure 37). The swirling bottles held in the hands of a delivery-boy, a familar figure in French advertising in the inter-war period, seem to create a cinematic effect, and the rhythmic, multi-coloured background echoes the painterly effects of Robert Delaunay's *simultanéste* paintings of the 1910s. Whilst a number of similar concerns can be detected between the work of *affichistes* such as Cassandre and the advocates of the new typography – not least in their shared faith in the significance of graphic design as a popular art form and in the powerful impact of monumental, simple images – important differences can be identified. Cassandre, for example, working closely with lithographic printers using flat-bed cylinder presses and stones achieved distinctive hand-rendered imagery, his 'signature style'. And despite occasionally writing about his work, he did not press the case for the widespread application of his style. Cassandre's Modernism was the product of his own artistic invention, and an intelligent and elegant assimilation of the inventions of contemporary

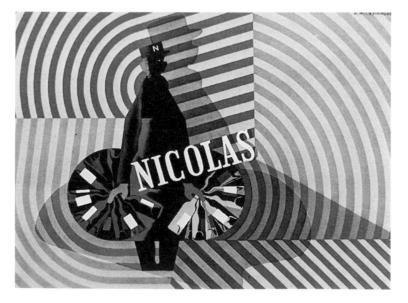

37] *Nicholas* poster designed by A. M. Cassandre (Alliance Graphique), 1935.

movements in French painting such as Cubism and Purism. Largely detached from any overriding political or social concerns, modern designers in these countries tended to regard their relationship with clients as unproblematic. Cassandre understood his role to be that of an efficient communicator. In 1933 he is recorded as stating: 'The poster is only a means to an end, a means of communication between the dealer and the public, something like telegraphy. The poster plays the part of the telegraph official: he does not initiate news, he merely dispenses it.'[28] Modernism, in the hands of designers like Cassandre, was, therefore, less a project than a style, albeit a highly artistic and much celebrated one.

The modernist project and commerce

After the crises of the early 1920s, the relative stability of the German economy and to a large degree those of her neighbours, resulting in increased productivity and the introduction of modern technology, seemed to augur an era which would improve the quality of life across the social scale. Mass production and the mass media seemed to promise a new popular culture which would embrace all aspects of life. The increasing visibility of a new urban mass culture – film, radio, the illustrated press, sports and other forms of popular entertainment – had a marked effect on everyday as well as 'intellectual' life. In both content and form Alfred Döblin's famous 1929 novel, *Berlin Alexanderplatz*, reflected this new culture, viewing the city from its underworld and incorporating snatches of 'low' culture from advertisements and chorus-line songs. In a similar spirit, Hans Siemsen, writing in *Die literarische Welt* in 1926, suggested that new mass media such as the cinema and the illustrated press engaged a new, wider audience than traditional, elite culture (see chapter 6). Even advertisements on billboards, he claimed, were a new literature for 'non-readers': 'Who reads Pascal? Everyone knows Odol' (a brand of mouthwash).[29] In the context of contemporary opinion, both the work and principles of the advocates of the new typography can be seen as an intervention in the mass, commercial culture of Central Europe in the economic revival of the mid-1920s. They sought, as Maud Lavin has shown, to orient mass culture towards their cherished principles of rationalism and functionalism.[30] The attraction of commercial graphics like advertising, brochure and prospectus design, was not simply a result of financial vicissitudes in the turbulent economies of Central Europe in the 1920s.[31] The interest of many artists in such forms of graphic design predated the economic depression that set in after 1929. These predominately left-wing artists claimed that the commercial world offered an

opportunity to democratise art; the antipathy between avant-garde, high modernist culture and capital familiar after the Second World War had yet to harden. Writing in the Berlin art magazine *Das Kunstblatt* in June 1928, Gustav Friedrich Hartlaub, director of the Mannheim Kunsthalle, claimed that the new advertising was a 'truly social, collective, mass art: the only one we now have. It shapes the visual habits of that anonymous collectivity, the public. Little by little an artistic attitude is hammered into the mass soul by poster hoardings.'[32]

It would seem that with the exception of figures like Heartfield working almost exclusively for communist presses, modernist designers did not invest energy in political agitation ('agitprop'), but towards the more general and ambiguous notion of 'progress'. However, they seemed to relinquish any direct concern with the effects of their work as promotional material for commerce and industry. Schwitters, in a 1928 essay seeking to emphasise the visual impact of the new typography, stressed the importance of 'not the "what" but the "how" ... we see and hear'.[33] In other words, he was engrossed with the methods of producing striking graphic images, and not the meanings that they might contain, i.e. with the syntax rather than semantics of modern advertising. In his concern with technique, Schwitters absolved his designs and those of his colleagues from any responsibility for the promotion of capitalist ideology. His view might have had little significance were it not for the fact that, as we have seen, this current of modernist graphic design was motivated by a sense of utopianism, and many members of the *ring* were active in left-wing politics (though Schwitters himself was relatively apolitical until the Nazi regime). Tschichold had been so enamoured of the Soviet Union that he had signed his works 'Iwan (or Ivan) Tschichold' for a period in the 1920s, and worked for German trade unions; two Dutch members of the *ring*, Domela and Schuitema, worked for the left-wing publishers De Baanbreker-Servire in The Hague, the radical magazine, *Links Richten*, and trade unions such as the *Centrale Bond Transportarbeiders* (Central Transport Workers' Union). The apparent contradictions of designing for commerce yet advocating anti-capitalist politics were not overlooked by contemporary commentators. Ivan Goll, a journalist and poet, disparaged the claims of modern advertising to 'educate mankind' when it sought to depress the powers of reason in the viewer through emotive graphic effects.[34] And Alfred Kémeny, a prominent Marxist art critic, impugned such modernist practice, exclaiming: 'The purpose of advertising is, of course, to persuade people to serve the profit interests of the various capitalist enterprises. But this "harmless", seemingly apolitical appeal turns only too easily into outright propaganda for the capitalist system.'[35]

As we have already noted, the *ring* designers and their allies
were successful propagandists for modernist graphics. But the rea-
sons why commerce and industry were attracted to such design
cannot be put down to their effective self-promotion alone.
Certainly not all businesses were sympathetic to it, some associ-
ating the new typography with left-wing politics. Stanley Morison,
the British typographer, recalled coming to Tschichold's defence
when was he was denounced by a pen manufacturer as a com-
munist.[36] And long-established industries such as tobacco and
alcohol producers exploited more traditional symbolism in their
publicity and so provided few opportunities for the graphic in-
vention of these modernists. In general there is evidence to suggest
that the principles of the new typography appeared to correspond
with the ascendant technocratic ideologies of German industry
in the period. As industries grew larger and as family-run firms
were transformed into corporate concerns, there was strong fasci-
nation with new forms of scientific management and industrial
organisation such as Taylorism (named after the American pro-
moter of time and motion studies, Frederick Winslow Taylor).
Through a systematic study of the organisation of production, the
operation of efficient technology and the division of labour, out-
put could be increased and wastage reduced. But the appeal of
scientific management was not always driven by the profit mo-
tive. Wilhelm Kalveram, a lecturer in political science from
Frankfurt, characterised scientific business management as a kind
of ethical duty: 'The rationalisation of office operations, if it is
carried out in the proper spirit, has to result in an increase in per
capita productivity and the living standards of the general popu-
lation and therefore lead to new employment opportunities.'[37]
This new managerial ideology made an intellectual investment in
concepts such as rationalisation and efficiency, the keywords of
the modernist graphic designer. Both cultures, therefore, shared
much in common: the *sachlich* quality and modernity of the new
publicity matched the rationalism and innovation of scientific
management. Moreover, increased production and accelerated
manufacture through the adoption of new practices such as the
assembly line required the use of advertising to capture larger
markets of consumers. This correspondence of interests was con-
firmed by the nature of some of the key industries which
patronised *ring* designers – light engineering and communications,
both areas undergoing tremendous modernisation and expansion
in the period. And, of course, it was the ostensible novelty of
modernist graphic design which these companies wished to ex-
ploit to commercial advantage. Novelty, however, was not a value
that the *ring* designers admired. Although welcoming invention

as 'the sum total of all the best efforts to rise above the age', they distrusted novelty and fashion. Tschichold in his book, *Typographische Gestaltung*, for example, objected to the new typography being regarded as 'fashion'.[38] Novelty and fashion implied a modishness and ephemerality that would undo any claims to have established lasting principles of good design. In this sense the two ideologies of Modernism and capitalism were at odds, for commercial publicity tends to accentuate novelty as a means of stimulating sales. This tension was a major issue affecting the subsequent development of modernist graphic design, a theme to which we will return below.

The modernist diaspora

Whilst modernist graphic design was found across Europe, and many of its practitioners espoused an explicitly internationalist view of design, Germany became the meeting-ground for Central and Eastern European designers as well as Swiss and Dutch figures who had been important theorists and practitioners of the new style. The rise to power of the Nazis in 1933 had a dramatic affect on all their careers, as well as on the development of modernist graphic design. As the National Socialists took the reins of power, they initiated a politically-motivated purge of modernist culture which caused an intellectual haemorrhaging of the region. Tapping currents of nationalism and xenophobia, Modernism was excoriated by Nazi cultural ideologues like Alfred Rosenberg as *'Kulturbolschewismus'* (cultural Bolshevism). And exploiting the social disquiet and alienation wrought by the uneven distribution of the benefits of modernisation, they promoted a romantic, conservative vision of a nation rooted in the rural landscape or historic urban settings like Nuremberg and Munich. The successful promotion of these strains of Nazi ideology required a scapegoat, which was found in the internationalist, anticipatory and socialist culture of Modernism. The Bauhaus, for example, was forced by the Nationalist Socialist-controlled council in Dessau to leave the city in October 1932. Accused of being a centre of Jewish influence, decadence and cultural Bolshevism, it relocated to Berlin and survived less than six months in its new location until staff, under Nazi pressure, voted to close the school down.[39]

Within the general vilification of modernist culture, the new typography was identified as being alien, proto-communist and un-German. In contrast, the Nazis celebrated and encouraged the use of black-letter Gothic forms, which were declared to be an historic expression of German-ness. This view, reinforced by official practice and policy, corresponded with the Nazi's *völkisch* and

conservative ideology. But, as Robin Kinross has shown, there was not an absolute hegemony of Gothic type in Germany after 1933. Futura, the modernist typeface *par excellence*, continued to be widely used, because of its simple clarity. And in 1941 official attitudes *vis-à-vis* typography reversed; the Gothic was suddenly disparaged as a 'Jewish' letter-form, and Roman typefaces found favour as a graphic analogue to Hitler's favoured neo-classical architecture.[40] Similarly, photomontage, which had been a strong signifier of modernity, was sometimes exploited in National Socialist periodicals like *Illustrierter Beobachter*. Curious images were published, for example, which montaged *völkisch* photographs of muscular rural labourers into pastoral landscapes, and exhibitions such as the 1935 Autobahn Project deployed some of the striking photomontage effects developed by El Lissitzky's Soviet Pavilion at *Pressa*.

Despite the Nazis' ambiguous attitudes to the technical inventions of modernist design,[41] figures like Tschichold suffered directly as a consequence of Nazi cultural dogma. In early March 1933, one month after the Nazis took control of Germany, he was arrested and accused of being a 'cultural Bolshevik' and of producing 'un-German' design. Following a Nazi injunction, he was barred from his position as a teacher in Munich. On his release after six weeks' imprisonment, Tschichold fled with his family to Basle. Although few other members of the *ring* were as directly threatened by Nazi authority as Tschichold, all felt the impact of the dramatically changed political climate in Central Europe. Writing to Herbert Read from Berlin, Moholy-Nagy described the intellectual atmosphere in the capital in 1934 thus: 'The situation of the arts around us is devastating and sterile. One vegetates in total isolation, persuaded by newspaper propaganda that there is no longer any place for any other form of expression than the emptiest phraseology.'[42] In the first years of the National Socialist regime many foreign members of the *ring* resident in Germany fled abroad: Domela arrived in Paris in 1933, where he established a studio producing advertisements; and Moholy-Nagy, in a mood of desperation, moved to London in 1935, where he worked extensively in advertising, photography and film until 1937, when he emigrated to America. Politically active figures were particularly vulnerable. In April 1933 John Heartfield was forced to leave Berlin for Prague in circumstances similar to Tschichold (and in 1938, he too came to Britain).

Professional life in Nazi Germany for modernist designers who avoided political controversy and fell within Nazi ethnic decrees could, however, be sustained at least until the clouds of war gathered over Central Europe. Until 1938, Herbert Bayer enjoyed a busy

career as art director for German *Vogue* and as the chief designer for the Dorland Advertising Studio in Berlin, working on major accounts, for example, for Elizabeth Arden, the Kellogg Company and Blaupunkt.[43] However, he too departed Germany in 1938. As if to lament his leaving, *Gebrauchsgraphik*, a leading design perodical, published a survey of his work in advertising over the previous decade.[44] Works by Bayer illustrating this article suggest a kind of thawing (or an exhaustion) of the doctrinal and radical rigour of Weimar Modernism. The use of 'unmodern' typography in advertising, for example, was acceptable to Bayer because of valuable associations such forms might trigger in the minds of consumers with the product advertised. His designs, elegant montages of drawings, photographs and 'found' images, were strongly inflected with an introspective, surrealist mood. His advert for Adrianol Emulsion reproduced an image of the head of a classical statue, the *Hermes* of Praxiteles, overprinted with a medical diagram of the respiratory passages in the head, set against a wintery street scene. The resulting image, printed in four colours, though unorthodox, was visually very effective (figure 38). Even though advertising seemed a neutral sphere and outside Nazi interest, Bayer came

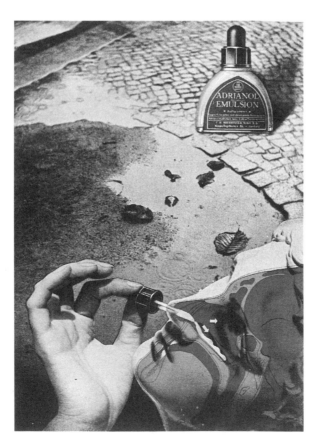

38] Advertisement for Adrianol Emulsion, designed by Herbert Bayer, Berlin, *c.* 1935.

under political pressure. In 1935, working on the design of a cata-
logue for an exhibition, *Das Wunder des Lebens* (The Wonder of
Life), organised by the *Messenamt* in Berlin, he was obliged by the
Ministry of Propaganda to insert an image of Hitler to illustrate
the *Führerprincip* (Leadership principle), a central tenet of Nazi
ideology.[45] When in 1938 Bayer left with his Jewish wife and
daughter for America, he was in good company with many promi-
nent modernist artists and designers from Germany and other
states, caught in the whirlwind of European politics in the late
1930s. Schwitters too, for example, left for Norway in January 1937,
the same year that his collaged art works were exhibited for public
ridicule at the notorious *Entartete Kunst* (Degenerate Art) exhibi-
tion in Munich.

Whilst it is apparent that Nazi attitudes to modernist graphic
design were far from consistent, official rhetoric was clear. The
Nazis wished to use the forms of Modernism in art and design
which had flourished in the Weimar years as a scapegoat. Ironi-
cally, however, they actually contributed to its transmission
around the world. The forced diaspora of artists and designers from
the turbulent political environment of Central Europe created an
effective and motivated international force of propagandists for
Modernism, particularly in the USA, where a relatively large num-
ber of exiled artists and designers settled, including between 1937
and 1939, Gyorgy Kepes, László Moholy-Nagy, Will Burtin, Herbert
Bayer and Ladislav Sutnar.

The modernist project and corporate America

After crisis-torn Europe, America was a welcoming environment
for a number of European graphic designers, whether temporary
visitors like Jean Carlu or those like Bayer who became permanent
residents. Bauhaus-trained Will Burtin, who arrived from Germany
in 1938, professed his pleasure in finding an environment free of
the oppressive constraints of tradition or dogmatism.[46] American
assimilation of European Modernism, however, predated the arri-
val of these political refugees. A number of European designers
working in magazine publishing in the 1920s and 1930s had had a
notable effect on the role of the art director in periodical publish-
ing. In 1928 Condé Nast, the New York publisher of magazines like
Vogue, Vanity Fair and *House and Garden*, sought out the Russian-
born art director of German *Vogue*, Mehemed Fehmy Agha, to
design his magazines. Between 1929 and 1943 Agha worked for
Nast, bringing a European sensibility inflected with fashionable
French style and German Modernism to these American maga-
zines. Agha was the first of a wave of European art directors lured

to America in the 1930s, including Alexey Brodovitch, who worked on the rival publication *Harper's Bazaar* from 1934. In his work for Condé Nast, Agha is widely credited as inventing the modern profession of the art director.[47] A strongly innovative and domineering figure, he developed a number of studio practices and approaches to design that prevail even today, in an era dominated by the computer. He conceived layout in double-page spreads where text and image were synthesised to common graphic effect, and would sometimes plan the page layout on to grid-sheets before commissioning his photographers, who included Edward Steichen and Cecil Beaton. As a designer, Agha brought a rich knowledge of European experiments in magazine design, not least innovations introduced into the layout and dramatic use of photography in German illustrated magazines like *Münchner Illustrierte Presse* during the Weimar Republic and French publications like *Vu* (see chapter 6). Nevertheless, it would be mistaken to regard Agha's work as derivative, and he consistently experimented with the margins of received wisdom in magazine design in the 1930s, whether printing pictures into the bleed-edge or using silhouette effects. Agha's attitude to the theoretical, doctrinal aspects of Modernism was disparaging. Writing in *Advertising Arts* in 1930 he ridiculed the 'vagabond theories originated by Spaniards in France and exported to Germany via Russia, arrived back in France via Holland and Switzerland, only to settle down in Dessau and be taught to Japanese students by Hungarian professors'.[48] Agha, though averse to theorical Modernism, was, none the less, strongly attracted to its novel formalism and recommended that young designers plunder 'the temple of Constructivism'. *Advertising Arts* – the most sophisticated publication of its kind in America – was an important source for modernist style between 1930 and 1935, with articles on many experimental Europeans, including Cassandre and Brodovitch. Similarly, European magazines like *Commercial Art* and *Gebrauchsgraphik* were imported into America.

Paul Rand attributed his education as a graphic designer to his teenage discovery of these magazines in the late 1920s and early 1930s.[49] Rand, a young designer before the Second World War who established a career as the art director of magazines like *Esquire* and *Apparel Arts* and then after 1945 in the corporate sector, working for clients like IBM and Westinghouse, has often acknowledged the influence of European Modernism on his work. However, this influence had been for the large part drawn from the painterly and aesthetic current of Modernism, exemplified in the work of such figures as Pablo Picasso, Fernand Léger and Joan Miró. For Rand, the lessons of Modernism could be learned from the formal and aesthetic adventure of Cubism and painterly abstraction. Modern

art presented a kind of aesthetic standard towards which design should aspire: 'That which makes for good *advertising* is one thing, and that which makes for good *art* is another; but that which makes for good *advertising art* is a harmonious resolution of both.'[50] Rand's work as a designer has been shaped by a sense of personal vision and a strong aesthetic sensibility, characteristics which he effectively promoted in his own writings, including the highly influential book, *Thoughts on Design* (1947). This strong vein of aestheticism has been a defining characteristic of much post-war American design, and marks it as distinct from the collective, programmatic character of Central European Modernism. Similarly, whilst Rand espoused a number of notions about design in his writings, these were rarely articulated as practical formulae but tended to be rather more ambigious statements about the nature and truth of design. Above all, Rand consistently emphasised unity, simplicity and invention as key guarantees of 'Good Design'.

Whether produced by native talent or imported expertise, modernist languages of design, such as those developed by Agha and Rand at the beginning of his career, were already established in the USA by the late 1930s. Traditional forms of design such as the advertisement composed of 'classical' columns of text, separated from small, conventional engraved images in a stable, symmetrical layout, were already outdated. Consequently, exiled graphic designers from Central Europe arrived into a professional environment that was increasingly susceptible to the appeal of modernist graphic design. Herbert Bayer's early career in America is a good illustration of the warm reception of a European 'pioneer' of Modernism. Within weeks of his arrival in America, Bayer came into contact with the Container Corporation of America (CCA), a company producing paper packaging in Chicago, under the chairmanship of Walter Paepcke.[51] The CCA had a relatively advanced attitude to design, employing from 1936 a director of design, Egbert Jacobson, who was responsible for the visual appearance of all aspects of the Corporation's activities. In 1937 the CCA, on the recommendation of its advertising agency, N. W. Ayer and Son, had initiated a programme of advertisements in the business periodical *Fortune*, which were designed by leading modernist designers including Cassandre, Kepes, Matter and, from 1938, Bayer. These advertisements were invariably dominated by striking visual effects and included little text, save for a brief and often aphoristic statement. Bayer's early work for the CCA included a number of these advertisements. A July 1941 design, 'Weakness into Strength' (figure 39) exploited photographic and typographic elements in a tight, angular composition exaggerated by stretching the type used in the advertisement's slogan. A few months before

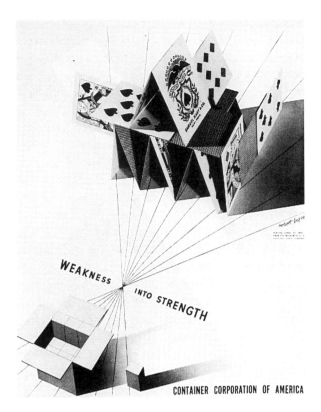

WEAKNESS

INTO STRENGTH

CONTAINER CORPORATION OF AMERICA

39] Advertisement for the
Container Corporation of
America, designed by
Herbert Bayer, *Fortune*
(July 1941).

America's entry into the war, the CCA was keen to redirect the use of paper into packaging, thereby releasing other materials for the war effort. Bayer found a simple graphic metaphor to describe this process and suggest a wartime mood of resolution. In the post-war period Bayer's designs for the CCA expanded from such advertisements to include the company's internal communications as well as unique publications such as the *World Geo-Graphic Atlas* (1953), a vast project which took him five years to complete and resulted in a 368-page book with 120 full-page maps. This publication, produced to celebrate the Corporation's twenty-fifth anniversary, was an inventive synthesis of complex climatic, geographic, political and economic data through an elegant arrangement of maps, symbols and lucid typography. Bayer used this project as a vehicle to make an environmental case for the care of the entire planet and for careful use of natural resources.

In such projects Bayer exercised a great degree of artistic autonomy. In fact, he enjoyed a privileged place within the CCA and became chairman of the Corporation's design department in 1956. He was, after all, probably the most distinguished European designer working in American advertising and graphic design, and Walter Paepcke was keen to act as his patron. This was not, as Neil Harris has shown, an uncommon attitude in American

corporations, which took on a self-determined role as the bene-factors of culture.[52] Moreover, Bayer's advertisements and the *World Geo-Graphic Atlas* seem to have been the application of a principle which had been lionised by the Bauhaus and other Central European modernists, that is, the union of art and life. However, these CCA designs were not the product of pure altruism. The Corporation produced few branded goods that could be sold in an orthodox manner to a consumer market. Its approach in promoting the CCA as a benign, prestigious and culturally sophisticated organisation, was a means of distinguishing its place in a market full of competitors. It could even be argued that these 'artistic' advertisements obscured the Corporation's primary concern, the pursuit of profit.

Bayer's CCA commissions have been widely acknowledged as marking a significant shift in the development of modernist graphic design in America. Whereas in the 1930s influential figures had made an impact on the design of magazines and in particular, art and fashion periodicals such as *Harper's Bazaar* and *Apparel Arts*, after 1945 many modernist designers pursued careers in the corporate sphere. American industry, prospering and expanding in the post-war period, turned to designers to promote a strong corporate image to various audiences, including their own employees, share-holders and the public. Whilst the invention of logos and symbols to represent commercial concerns was not new, design was increasingly used in a systematic fashion to unite large conglomerates and to promote a coherent and vigorous public image. In America, this developed into a professional sphere of design with its own literature, research processes and interests that extended beyond graphics into architecture and interior schemes, vehicle liveries and company uniforms, and even the styling of products.[53] From 1959 Paul Rand, for example, worked with the architect Eliot Noyes, as well as with Charles Eames and Herbert Matter on the corporate identity programme for Westinghouse, resulting in packaging, advertising and signage.[54] Such designers, by presenting themselves as a technocratic profession ('experts') to a managerial class ('executives'), were at the same time developing their own professional standards and codes and successfully insinuated themselves into the corporate sphere in the 1950s.[55]

In the American context, the modernist aesthetic seemed to have much to offer large concerns like Westinghouse. The widely espoused 'principles' of simplicity and clarity matched the needs of clients seeking to bring disparate branches of their businesses responsible for a variety of services and products under the authority of a single, clear identity. Similarly, the abstract and simplified language of modern design allowed these increasingly

multinational corporations to display a strong visual identity which transcended national boundaries. This practice of modernist design within the corporate environment has been the subject of critical discussion. Some writers, such as Maud Lavin, have suggested that in the context of the American corporation, the modernist designer's avowal of truth and simplicity in design was disingenuous.[56] She suggests that the economic, technical and social complexity of enormous commercial organisations was actually obscured or concealed in designs by figures like Rand or Bayer. Other critiques of the reception of modernist graphic design in America suggest that the relocation of Modernism into the corporate sphere effected a dissipation of the radical agenda and utopian aspirations developed in Europe in the 1920s. Lorraine Wild, for example, writes: 'designers in America retained only its [Modernism's] formal aspects, which evolved into the visual language of contemporary American institutions and corporations'.[57] Consequently, the way in which it was disseminated in America and the willingness of the émigrés and exiles who arrived in the 1930s to work for corporate clients, she suggests, meant that Modernism was more a look than an ideology. However, the process that Wild describes was already under way in Europe in the late 1920s, when the *ring* designers sought to practice within commerce. American culture, it would seem, stands indicted for something that was, arguably, an inevitable outcome of Modernism's uneasy cohabitation with commerce.

Furthermore, not all émigré designers in America abandoned the modernist agenda to take on the highly personalised and aestheticised approach to graphics that seemed to prevail amongst the so-called 'New York School' of designers like Rand. Ladislav Sutnar, a Czech, who, working on the Czechoslovak pavilion at the New York World's Fair, found himself stranded in America after Germany's annexation of the Sudetenland and worked on a number of publications in the 1940s and 1950s for Sweet's Catalog Service, based in New York, producing his *Catalog Design Process* in 1950 (figure 40).[58] This publication, produced to advise manufacturers in the design of information accompanying their products, extended inter-war experiments in legibility and the presentation of information. Drawing upon practices established by the new typography and the Bauhaus, Sutnar exploited the signifiers of the Central European sensibility of the 1920s: Futura, assymetric composition and typofoto. For Sutnar, these were not simply stylistic affectations but an expressed concern with the communicative function of his work and the easy comprehension of information. With the exception of American graphic design education,[59] such functionalism placed Sutnar on the margins of American graphics.

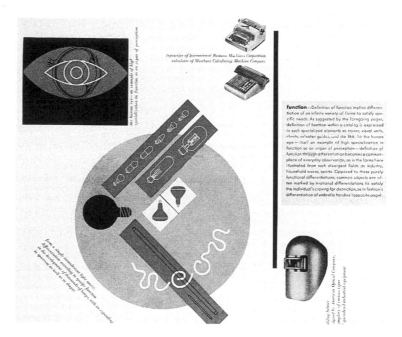

40] Page from *Catalog Design Process* (Sweet's Catalog Service, 1950), designed by Ladislav Sutnar.

However, similar enthusiasms continued to drive the modernist project in Europe, the most significant of which being the so-called 'Swiss School' of graphic design.

The modernist project and the Swiss School

Unlike most European countries, Switzerland had been able to maintain a vigorous culture of Modernism in art and design throughout the Second World War by virtue of its neutrality. Some designers, such as Max Huber, who had been a student in Milan and subsequently worked at Studio Boggeri, returned to Zürich in the early years of the War. After the war Swiss designers like Armin Hoffmann and Emil Ruder achieved great international acclaim for their spare, economic designs and scrupulous, systematic approach to theory. The 'Swiss School' – still a synonym for methodical, responsible design today – was to some degree a misnomer, for this movement was international (some writers prefer to use 'International Typographic Style' to describe it), and it saw the potential for the universal application of its ideas. Swiss modernists found allies in America and, more notably, at the *Hochschule für Gestaltung* in Ulm, Germany which opened in 1955.[60] Furthermore, the key protagonists of Swiss School design sought international audiences for their ideas. Between 1958 and 1965 four designers from Zürich, Richard P. Lohse, Josef Müller-Brockmann, Hans Neuberg and Carlo V. Vivarelli, edited *Neue Grafik*, a journal which was published in German, French and English. This periodical became

the organ of an informal 'movement' in design which coalesced through personal contacts and a shared ideology in the late 1940s and 1950s.

In addition to the confident and single-minded views advanced in its pages, *Neue Grafik* was a clear demonstration of their preferred practice in publication design (figure 41). Neuberg's page layout was structured by a square mathematical grid divided into four columns. He arranged the text, black and white photographic illustrations (sometimes overprinted with a single colour) as well as white or unprinted space, to achieve a rather sober asymmetry. The text was set in Akzidenz Grotesque, a nineteenth-century *sans serif* face. In 1959 Emil Ruder, a tutor at the School of Applied Arts in Basle, identified particular elements of the Swiss 'system'. The following principles were described as the foundations of good design: a text, he argued, should be easily readable and letters arranged, in the first instance, for legibility rather than for their visual impact; the unprinted, white spaces on the page should be recognised as being as much an element in the design of a page as the printed forms; layouts should be based on a grid structure, thereby ensuring consistency; simple typeforms should be exploited for their universality, clarity and impersonality; and illustration, preferably photographic, should be used to provide variety and contrast within an orderly and geometric layout.[61] Clarity and order were characterised as a designer's *duty* to the audience for his or her work in all fields of graphic design. Consequently, this 'duty' could be fulfilled, for example, by designs which set the title of the work, the name of the product or service

41] Double-page spread from *Neue Grafik*, 9 (March 1961), designed by Hans Neuberg.

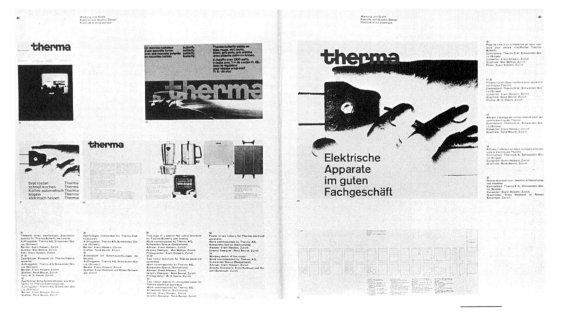

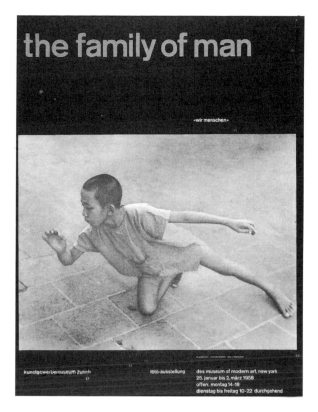

the family of man

‹wir menschen›

kunstgewerbemuseum zürich foto-ausstellung des museum of modern art, new york
25. januar bis 2. märz 1958
offen: montag 14-18
dienstag bis freitag 10-22 durchgehend

42] Poster for *The Family of Man* exhibition held at the Zürich Kunstgewerbemuseum in 1958, designed by Josef Müller-Brockmann.

in the largest letters, or in the selection of 'objective' photographic images.[62] Müller-Brockmann's 1958 poster for the Zurich Kunstgewerbemuseum exhibition of photographs, *The Family of Man*, which had been organised by Edward Steichen on behalf of the Museum of Modern Art in New York three years earlier, is an attractive example of the application of Swiss School principles. The various elements banded on a rectangular grid deliver the necessary information economically to the viewer (figure 42).

The Swiss School's creed was a self-conscious continuation and reaffirmation of the principles of the new typography before the Second World War, a tradition described as 'Konstruktive Grafik'. In fact, some of these Swiss designers were active vigilantes railing against what they saw as erroneous revisions of modernist principles of graphic design. In 1946 Max Bill, a graduate of the Bauhaus and a founder of the Hochschule für Gestaltung, marshalled an attack on Jan Tschichold, who had retreated from the dogmatic Modernism that he had formulated in the mid-1920s.[63] Similarly, *Neue Grafik* and other sympathetic publications such as Karl Gerstner and Markus Kutter's book, *Die neue Graphik* (1959), included celebratory surveys of exemplary practice before the war, including the work of Swiss designers such as Bill as well as members of the *ring* and Bauhaus masters and students.[64] Sharing many of the

same formal concerns as their pre-war progenitors, Swiss School designers also tended to be more concerned with method and approach than content. However, these long-established principles of modernist design were given a new epistemological grounding in the 1950s. Swiss School attitudes displayed traces of a systematic, research-orientated approach to graphic design – a new scientism that was to find much favour in design theory in the 1960s. In 1947 Bill had suggested that 'it is possible to develop art on the basis of a mathematical way of thought'.[65] In the late 1950s Swiss School thinking drew close to this in advocating systematic design methods and problem-solving research.[66]

In the 1950s the changing economic context in Switzerland and particularly in neighbouring states such as Germany affected attitudes to commerce and capitalism. Switzerland's long-held commitment to political neutrality and participatory democracy (if only in terms of male suffrage) insulated it, to some degree, from the major social shift under way in Western Europe through the expansion in consumer culture. But Swiss designers and their colleagues abroad (particularly in West Germany, where American models of economic production and consumption were central to the political 'redirection' of the new democratic State)[67] had to face the impact of consumerism on the way that they approached their work. In this changing cultural and economic environment, Swiss School designers were not directly opposed to commerce (nor could they afford to be, as it provided employment). But their design and theory can, nevertheless, be seen as a kind of critical practice which sought to ameliorate the worst affects of consumerism on society. Early traces of this tendency can be found, for example, in the ways in which modernist journals reported developments in graphic design in the people's republics of Eastern Europe. Polish Posters of the 1950s – painterly and semantically complex film and theatre publicity designed by figures like Henryk Tomaszewski and Wojciech Zamecznik – were often celebrated in the Swiss journal *Graphis* and other magazines as an antidote to the imagery of the brash, fantasy world of American film posters and 'vulgar' pulp magazines.[68] Such forms were seen as the visible expression of the spectre of Americanisation which seemed to threaten not only local culture but also the modernist project. The fantasy and emotionally-charged appeals of such popular graphics were attacked by Swiss School designers and their allies in journals like *Neue Grafik*, who envisaged a different kind of modern design, working in the service of both commerce and society. Richard P. Lohse, an abstract painter and editor of the magazine, considering the 'Sociological position of the graphic designer' in 1959, asked:

whether, where certain products are concerned, the more advanced forms of graphic design do not merely play the titivating role which cosmetics assume in the world of fashion. In assessing the value of the graphic designer's work we must nevertheless keep count of how much artistic ability, *moral powers of resistance* and knowledge of continuing cultural and psychological conditions are necessary in order to produce results which will stand up to the harsh judgement of contemporary criticism.[69]

The expression of Lohse's 'moral powers of resistance' in Swiss School graphic design was to be found in its principles of objectivity; 'good' advertising showed products clearly, without resort to fantasy or frivolity, and gave factual information about the item for sale without blandishment. Legibility and the use of 'documentary' photographs were a means of resisting the encroaching values of tawdry commerce: 'We come to . . . the question as to whether the effect of advertising is intellectually sound. If a graphic designer is not clear sighted and sensitive in this respect he might do great harm.'[70] Although the designer, as an employee, did not have the authority to determine the final appearance of the campaigns on which he or she worked, Swiss School designers saw themselves as lobbyists who could influence clients to follow the course of good design. Moreover, they sought work in the public sphere which afforded opportunities to practice for the civic good, for example the corporate identity scheme for Swissair, produced in the late 1950s, and many public information campaigns and posters advertising cultural events, such as Müller-Brockmann's poster, described above.[71] With their watchwords of 'sincerity', 'responsibility' and 'ethics', the Swiss School was guided by a humanist sensibility. Less than forty years after its formulation, the social role of graphic design was still a central tenet of the modernist project, but the approach of modernist designers to working for commerce had shifted. Modernism, clinging to a relatively stable graphic language, had moved from what might be described as *avant-gardism* to *arrière-gardism*. Modernist design seemed to have lost its anticipatory, utopian vision of the early 1920s and had undertaken, as the Swiss example shows, the task of tempering what were regarded to be the excesses of advertising and commercial graphic design.

Notes

1 J. Aynsley, 'Pressa Cologne, 1928: exhibitions and publication design in the Weimar period', *Design Issues*, 10:3 (Autumn 1994), pp. 53–76.

2 S. Lissitzky-Küppers reproduces various favourable responses to the Soviet Pavilion in her monograph on her husband, *El Lissitzky: Life, Letters, Texts*, translated by H. Aldwinckle (London, 1968), pp. 85–6; see also H. K. Frenzel, 'Pressa, Cologne 1928', in *Gebrauchsgraphik*, 5:7 (1928), pp. 4–18.

3 J. Tschichold, 'Display that has Dynamic Force: exhibition rooms designed by El Lissitzky', *Commercial Art* (January 1931), p. 22.

4 Lissitzky-Küppers, *El Lissitzky*, p. 85.

5 This chapter's discussion of the *ring* group draws upon excellent research by Maud Lavin. See M. Lavin, 'Photomontage, mass culture and Modernity', in M. Teitelbaum (ed.), *Montage and Modern Life 1919-1942* (Cambridge, Mass., 1992), pp. 36–59.

6 There is a complete list of *ring* exhibitions in the catalogue to an exhibition, '*Typografie kann unter Umständen Kunst sein*', held at the *Landesmuseum*, Wiesbaden, 1990.

7 L. Moholy-Nagy, 'Zeitmässe Typographie – Ziele, Praxis, Kritik', in *Gutenberg-Festschrift* (Mainz, 1925), reproduced as 'Contemporary Typography – Aims, Practice, Criticism', in K. Passuth, *Moholy-Nagy* (London, 1985), p. 259.

8 This last innovation was probably inspired by W. Porstmann's book *Sprache und Schrift* (Berlin, 1920). See R. Kinross, 'Large and small letters: authority and democracy', *Octavo*, 5 (1988), unpaginated.

9 See F. Roh and J. Tschichold, *Foto-auge, 76 Fotos der Zeit* (Stuttgart, 1929), reprinted as *Photo-Eye, 76 Photos of the Period* (New York, 1973); and D. Mellor (ed.), *Germany: The New Photography 1927-33* (London, 1978).

10 L. Moholy-Nagy, 'Fotografie', in *Malerei, Fotografie, Film*, vol. 8 in the Bauhausbücher series (1925), reproduced in an English edition and translated by J. Seligman as *Painting, Photography, Film* (London, 1969), p. 27.

11 J. Tschichold, 'The composite photograph and its place in advertising', *Commercial Art* (December 1930), pp. 237–49.

12 Roh and Tschichold, *Photo-Eye*, p. 17.

13 L. Moholy-Nagy, 'Typofoto', in *Malerei, Fotografie, Film*, p. 40.

14 *Ibid.*, p. 38.

15 P. Schuitema, 'Neue Typografie um 1930', *Neue Graphik*, 10 (1961), p. 16.

16 Moholy-Nagy, 'Contemporary typography', in Passuth, *Moholy-Nagy*, p. 293.

17 J. Tschichold, *Die neue Typographie* (Berlin, 1928), p. 11.

18 A number of *ring* members contributed to *Gefesselter Blick* (Intense Gaze), a collection of essays and reproductions of contemporary advertisements. See H. and B. Rasch (eds), *Gefesselter Blick: 25 Kurze Monografien und Beiträge über neue Werbegestaltung* (Stuttgart, 1930).

19 See, for example, *Commercial Art* (July 1930), a theme issue on the New Typography; and J. Tschichold, 'Abstract painting and the New Typography', *Industrial Arts*, 1:2 (Summer 1936), pp. 157–64.

20 J. Tschichold quoted in R. Kinross, *Modern Typography* (London, Hyphen Press, 1992), p. 86.

21 G. Grosz and W. Herzefelde, *Die Kunst ist in Gefahr: ein Orientierungsversuch* (Berlin, 1925), reproduced in translation (by G. Bennett) in L. R. Lippard (ed.), *Dadas on Art* (Hemel Hempstead, 1971), pp. 79–85.

22 *Ibid.*, p. 85.

23 For a discussion of the changing political and cultural climate of Weimar Germany see J. Willett, *The New Sobriety: Art and Politics in the Weimar Period 1917-1933* (London, 1978).

24 *Ibid.*, pp. 95–6.

25 See W. Heine, '"Futura" without a future: Kurt Schwitters' typography for

Hanover Town Council, 1929-1934', *Journal of Design History*, 7:2 (1994), pp. 127-40.

26 *Merz Werbenzentrale* was evidently very busy. Schwitters claimed to have had more than 400 print commissions in a twelve-month period in 1929-30. See D. A. Steel, 'Kurt Schwitters: poetry, collage, typography and the advert', *Word and Image*, 6:2 (April-June 1990), p. 204.

27 K. Schwitters, 'Moderne Werbung', *Typographische Mitteilungen* (October 1928), published as 'Modern advertising', in *Design Issues*, 9:2 (Spring 1993), p. 67.

28 'Art and Poster Art by A. M. Cassandre', *Gebrauchsgraphik* (January 1933), p. 5.

29 H. Siemsen, 'Die Literatur der Nichtleser', in *Die literarische Welt*, 2:37 (10 September 1926), 4, reproduced in translation by Don Reneau as 'The literature of non-readers', in A. Kaes, M. Jay and E. Dimendberg (eds), *The Weimar Republic Sourcebook* (Berkeley, 1994), p. 664.

30 Lavin, 'Photomontage, mass culture and modernity', in Teitelbaum, *Montage and Modern Life*, p. 53.

31 It should be noted, however, that this was an acknowledged factor in the appeal of commercial work for some. Schwitters recorded that 'A man has to survive. So once again I looked for the best job. This time it was advertising and typographic design in general.' See Steel, *Word and Image*, 209.

32 G. F. Hartlaub, 'Kunst als Werbung', in *Das Kunstblatt* (June 1928). There is an English translation (by J. Cullars) of Hartlaub's article in *Design Issues*, 9:2 (Spring 1993), pp. 72-6.

33 K. Schwitters, 'Gestaltende Typographie', in *Der Sturm* (September 1928). There is an English translation (by J. Cullars) of this article in *Design Issues*, 9:2 (Spring 1993), p. 67.

34 See Willett, *The New Sobriety*, p. 137.

35 Durus (pseudonym of A. Kémeny), 'Fotomontage, Fotogramm', *Der Arbeiter-Fotograf*, 7 (1931), pp. 166-8. This essay is reproduced in translation (by Joel Agee) in C. Phillips (ed.), *Photography in the Modern Era: European Documents and Critical Writings, 1913-1940* (New York, 1989), p. 182.

36 See N. Barker, *Stanley Morison* (London, 1972), p. 213.

37 W. Kalveram, 'Rationalisierung in der kaufmännischen Verwaltung', in L. Elster (ed.), *Handwörterbuch der Staatswissenschaften* (Jena, 1929), p. 803. This text is reproduced in Kaes, Jay and Dimendberg, *Weimar Republic Sourcebook*, p. 185 (the translation is by D. Reneau).

38 J. Tschichold, *Typographische Gestaltung* (Basle, 1935), p. 28. This book was translated by R. McLean as *Asymmetric Typography* (London, 1967).

39 See G. Naylor, *The Bauhaus Reassessed* (New York, 1985), pp. 175-9.

40 See Kinross, *Modern Typography*, pp. 101-2.

41 For a discussion of the incorporation of modernist technology into the reactionary ideologies of conservative sections of Weimar society and National Socialism see J. Herf, *Reactionary Modernism: Technology, Politics and Culture in Weimar and the Third Reich* (Cambridge, 1984).

42 L. Moholy-Nagy, letter to H. Read (Berlin, 24 January 1934), published in Passuth, *Moholy-Nagy*, p. 405.

43 The most comprehensive source on Bayer's life and work is A. A. Cohen, *Herbert Bayer* (Cambridge, Mass., 1984).

44 See *Gebrauchsgraphik*, 15:6 (June 1938), pp. 2-16.

45 This catalogue is reproduced in *Industrial Arts*, 1:4 (Winter 1936), pp. 313-18.

It is notable that Bayer defaced the image of Hitler in his own copy; see S. Kasher, 'The art of Hitler', *October*, 59 (Winter 1991), pp. 49-86.

46 W. Burtin, 'Integration: the New Discipline in Design', *Graphis*, 27 (1949), p. 233.

47 See R. R. Remington and B. J. Hodik, *Nine Pioneers in American Graphic Design* (Cambridge, Mass., 1989), pp. 8-26.

48 M. F. Agha, 'What makes a magazine modern?' *Advertising Arts* (October 1930), p. 16, cited in L. Wild, 'Europeans in America', in the Walker Art Centre, Minneapolis exhibition catalogue, *Graphic Design in America: A Visual Language History* (1989), p. 160.

49 P. Rand, interviewed by S. Heller in *Graphic Design in America: a Visual Language History* (Minneapolis and New York, 1989), p. 193.

50 P. Rand, *Thoughts on Design* (New York, 1947), p. 1.

51 For discussion of the CCA patronage of modern design see J. S. Allen, *The Romance of Commerce and Culture: Capitalism, Modernism and the Chicago-Aspen Crusade for Cultural Reform* (Chicago, 1983), pp. 3-34; and G. F. Chanzit, *Herbert Bayer and Modernist Design in America* (Ann Arbor, Mich., 1987), pp. 183-204.

52 See N. Harris, 'Designs on demand: art and the modern corporation', in *Cultural Excursions* (Chicago, 1990), pp. 349-78.

53 In the 1950s *Print* magazine took a strong interest in corporate identity design. See *Print* (May-June 1957), a special issue on this theme.

54 See 'Four major corporate identity programs', in *Print*, 14:6 (November-December 1960), pp. 31-50.

55 For a parallel study see D. P. Doordan, 'Design at CBS', *Design Issues*, 6:2 (Spring 1990), pp. 4-17.

56 See Lavin, 'Design in the service of commerce', in *'Graphic Design in America: a Visual Language History*, p. 135.

57 Wild, 'Europeans in America', in *Graphic Design in America: a Visual Language History*, p. 168.

58 K. Lönbert-Holm and L. Sutnar, *Catalog Design Process* (New York, 1950); see also Remington and Hodik, *Nine Pioneers in American Graphic Design*, pp. 137-49.

59 Moholy-Nagy had been at the forefront of attempts to re-establish the Bauhaus in America in the late 1930s. See A. Findeli, 'The methodological and philosophical foundations of Moholy-Nagy's pedagogy in Chicago', *Design Issues*, 7:1 (Fall 1990), pp. 4-19.

60 This college, established by Inge Scholl, Otl Aicher, Hans Werner Richter and Max Bill, defined its role as an intellectual and practical continuation of the work begun by the Bauhaus. Its Visual Communication Section was directed by Friedrich Vordemberge-Gildewart who had been a member of the *ring* and *De Stijl*. See R. Kinross, 'Hochschule für Gestaltung Ulm: Recent literature', *Journal of Design History*, 1:3/4 (1988), pp. 249-56, for a survey of recent literature on Ulm.

61 See E. Ruder, 'The typography of order' in *Graphis*, 15:85 (September/October 1959), pp. 404-6.

62 See E. Scheidegger, 'Photography and Advertising Design', *Neue Grafik*, 4 (December 1959), pp. 29-38.

63 See Kinross, *Modern Typography*, pp. 106-8.

64 K. Gerstner and M. Kutter, *Die neue Graphik* (Teufen, 1959); H. Neuberg, 'The best recently designed Swiss posters 1931-1957', *Neue Grafik*, 1 (1958);

P. Schuitema, 'New typography around 1930', *Neue Graphik*, 10 (1961); C. Belloli, 'Pioneers of Italian graphic design', *Neue Grafik*, 3 (September 1959); R. P. Lohse, 'A pioneer in the art of photomontage, John Heartfield', *Neue Grafik*, 8 (December 1960); H. Berlewi, 'Functional design of the twenties in Poland', *Neue Grafik*, 9 (March 1961); H. L. C. Jaffé, 'Piet Zwart, a pioneer of functional typography', *Neue Grafik*, 10 (June 1961); R. P. Lohse, 'Book jackets of the 1930s', *Neue Grafik*, 16 (June 1963).

65 Bill cited in A. Hill, 'Max Bill', in *Typographica*, 7 (undated), p. 23.

66 See, for example, J. Müller-Brockmann, *Gestaltungsprobleme des Grafikers / The Graphic Artist and his Design Problems* (Teufen, 1961).

67 See R. Willett, *The Americanization of Germany, 1945-1949* (London, 1989).

68 See D. Crowley, '"An art of independence and wit": the reception of the Polish Poster School in Western Europe', in Biuro Wystaw Artystycznych Pawilion Wystawiony, Cracow, *100 lat polskiej sztuki plakatu* (100th Anniversary of Polish Poster Art), exhibition catalogue (1993), pp. 25-9.

69 R. P. Lohse, 'On the sociological position of the graphic designer', *Neue Grafik*, 3 (October 1959), p. 59 (our emphasis).

70 R. S. Gessner, 'The graphic designer and his training', *Neue Grafik*, 3 (October 1959), p. 52.

71 See Swissair, *Typographica*, 11 (undated), pp. 10-14.

Suggestions for further reading

J. S. Allen, *The Romance of Commerce and Culture: Capitalism, Modernism and the Chicago-Aspen Crusade for Cultural Reform* (University of Chicago Press, 1983).

Biuro Wystaw Artystycznych Pawilion Wystawiony, Cracow, *100 lat polskiej sztuki plakatu* (100th Anniversary of Polish Poster Art), exhibition catalogue (in Polish and English), 1993.

D. A. Boczar, 'The Polish poster', *Art Journal*, 44 (Spring 1984), pp. 16-27.

K. Broos and P. Hefting, *Dutch Graphic Design* (London, Phaidon, 1993).

B. Buchloh, 'From Faktura to factography', *October*, 30 (Fall 1984), pp. 81-119.

G. F. Chanzit, *Herbert Bayer and Modernist Design in America* (Ann Arbor, Michigan, UMI Research Press, 1987).

K. Gerstner and M. Kutter, *Die neue Graphik* (Teufen, Arthur Niggli, 1959).

R. Kinross, *Modern Typography: an Essay in Critical History* (London, Hyphen Press, 1992).

M. Lavin, 'Ringl + Pit: the representation of women in German advertising, 1929-33', *Print Collector's Newsletter*, 16:3 (July-August 1985), pp. 89-93.

R. McLean, *Jan Tschichold: Typographer* (London, Lund Humphries, 1975).

J. Müller-Brockmann, *Gestaltungsprobleme des Grafikers/The Graphic Artist and his Design Problems* (Teufen, Arthur Niggli, 1961).

R. R. Remington and B. J. Hodlik, *Nine Pioneers in American Graphic Design* (Cambridge, Mass., MIT Press, 1989).

F. Roh and J. Tschichold, *foto-auge* (Stuttgart, 1929) (English edn: *Photo-Eye* (New York, Arno Press, 1973)).

H. Spencer, *Pioneers of Modern Typography* (London, Lund Humphries, 1969).

M. Teitelbaum (ed.), *Montage and Modern Life 1919-1942* (Cambridge, Mass., MIT Press/Boston, Institute of Contemporary Arts, 1992).

J. Tschichold, *Typographische Gestaltung* (Basle, 1935) (English edn: R. McLean (ed.), *asymmetric typography* (London, Faber & Faber, 1967)).

Walker Art Centre, Minneapolis, exhibition catalogue, *Graphic Design in America: a Visual Language History*, 1989.

J. Willett, *The New Sobriety: Art and Politics in the Weimar Period 1917-1933* (London, Thames and Hudson, 1978).

6 A medium for the masses II: modernism and documentary in photojournalism

> The subject consists of nothing else but the collection of facts, though facts on their own scarcely offer anything of interest. The important thing is to be selective; to choose the moment of truth with regard to a meaningful reality (Henri Cartier-Bresson, *The Decisive Moment*, 1952).

As discussed in chapter 5, European graphic design and typography after World War I were greatly transformed by the contribution of avant-garde artists. At the same time, modernist aesthetics in photography also began to change the form and content of the popular illustrated weekly, which underwent its first significant phase of redevelopment in Germany during the Weimar Republic (1918–33). By the 1920s, both existing titles like *Berliner Illustrirte Zeitung* (Berlin Illustrated Times) (*BIZ*) and new magazines like *Münchner Illustrierte Presse* (Munich Illustrated Press) (*MIP*) and *Arbeiter Illustrierte Zeitung* (Worker's Illustrated Times) (*AIZ*), began to publish work by modernist photographers such as Felix Man and André Kertész as well as photomontages by John Heartfield and Hannah Höch. In turn, many avant-garde designers, writers and editors helped to launch *Vu* in France (founded 1928). This was probably the most aesthetically pleasing and innovative of the photojournals of the period, attracting a wide array of talented producers: its editor was Lucien Vogel; the mast-head was designed by the poster artist A. M. Cassandre; Alexander Liberman became chief artistic director between 1933 and 1936; and contributing photographers included Kertész, Maurice Tabard and Germaine Krull (figure 43). More earnest prototypes such as *Weekly Illustrated* and *Picture Post* (*PP*) also emerged in Britain after many producers were forced to flee Germany following the political ascendancy of the Nazi Party in the early 1930s.

The intervention of modernist aesthetics in periodical publishing engendered not only new modes of production but also new forms of spectatorship, as fresh ways of perceiving reality were encouraged through the intermeshing of text and pictures into photo-essays. Consequently, these are the issues which will be

addressed in this chapter, and in accounting for both the aesthetic evolution and the ideological purpose of the modern photojournal in Europe, we will consider the codes of professional practice, technologies and markets involved. The role of photomontage, the impact of *Neue Sachlichkeit* (New Objectivity) and documentary expression on photography, and the interdependence of word and image are of principal concern in this context. These will be examined with reference to photojournalism in Germany and more particularly in *Picture Post*'s representation of warfare and welfare between 1938 and 1945.

Photomontage and photojournalism

The photomechanisation of printing had been possible since the

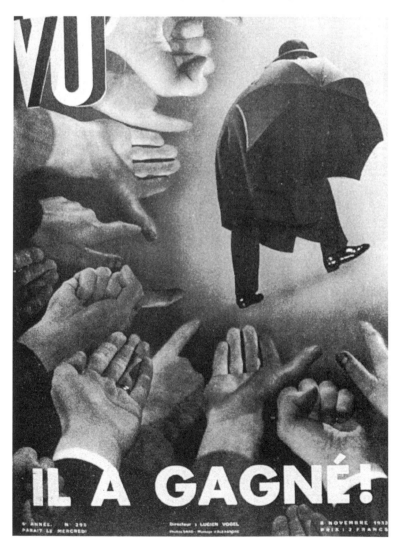

43] Cover of *Vu*
(8 November 1933),
montage by Alexandre
under the art direction of
Lucien Vogel, masthead
designed by
A. M. Cassandre.

1880s, but did not become the norm until the early twentieth century. By this time, most of the periodicals which had previously relied on wood engraving had turned over to the half-tone process (see chapter 1), and newspapers like *The Daily Mirror* had also started to print photographic images alongside letterpress as early as 1904. Although photographs ostensibly offered a more realistic form of representation, editors seemed little concerned with the visual aesthetics of page layout, and cost and speed of reproduction were probably the two chief factors contributing to the widespread espousal of photomechanisation at this time – during the 1850s the preparation of a woodcut had cost fifty pounds and could take a whole day, whereas by 1913 it cost four pounds and took fifty minutes to print a photograph.[1] After the end of World War I, the producers of photojournals in Germany began to respond more cogently to the dynamism of modern, urban living and to the ways in which the multiplicity and pace of everyday existence had been embodied in new forms of representation. In the case of photography, this challenge to artistic perception had initially manifested itself in the espousal of photomontage by Dada artists, who were intent on redefining the scope and role of art in the context of industrial culture; witness Hannah Höch: 'Our whole purpose was to integrate objects from the world of machines and industry in the world of art.'[2]

In this way, photomontage became an agent of aesthetic and social reform and was a deliberate reaction against the exclusivity of avant-garde painting (and in particular against the art of Expressionism). In Germany, as in Russia, its production was intended to reflect more meaningfully the new social and political order of the post-war era, in which mass-reproduced objects and images would form the basis of a democratic, utilitarian culture. New compositions were created by reconstituting fragments of photographs excised from other sources, including popular American magazines like *Colliers* and *McCalls*. The use and circulation of photomontage at this time, therefore, was distinct from nineteenth-century prototypes such as Henry Peach Robinson's painterly combination prints, or Eugène Appert's propagandist montages against the Paris Commune of 1871.[3] Yet modernist photomontage did not break entirely with avant-garde practice, despite the anti-art stance of its practitioners, and the impact of cubist spatial aesthetics is evident in many montages of the period. In Höch's *Dada-Ernst* of 1920–21, for example, segments of a nonsynchronous reality including a pair of splayed, female legs, scenes from a boxing match, and a skyscraper, are simultaneously brought together and any sense of linear perspective is totally disrupted. The resulting conflation of conceptual and material

reality in such compositions led Franz Roh to comment in his 1925 essay *After Expressionism* that photomontage synthesised the two most powerful tendencies in modern visual culture – extreme fantasy and extreme sobriety.[4]

In the context of periodical publishing in Germany, John Heartfield was the first, and possibly the most systematic, practitioner of photomontage. Heartfield had been christened Helmut Herzfeld, but along with Georg Grosz, who became George Grosz, had Anglicised his name in 1916 in protest against anti-British prejudice during World War I. At the same time, under the influence of his father he became active in left-wing politics, and he co-founded the Malik Verlag with his brother Wieland Herzfelde and Grosz in 1916. The Verlag's publications, such as *Neue Jugend* (1916–17) and *Jedermann sein eigner Fußball* ('Everybody His Own Football', banned after one edition in 1919), contained designs and photomontages by Heartfield and were intended to promote the group's pacificist ideals by offering left-wing material to the working classes at a low price.[5] Indeed, from the outset Heartfield realised the potential of photomontage as an essentially political medium that could be manipulated to transcend or to counteract the propagandist lies of mainstream press photographs which he believed had helped to prolong the war even after the defeat of German troops.[6] During the 1920s, he began to consolidate his political ideals under the influence of Soviet Productivists such as Boris Arvatov and Gustav Klutsis, who had emphasised photomontage's links with a mass-produced, industrial culture, and in the book jackets he designed for Willi Münzenberg's Neuer Deutscher Verlag after 1921.[7]

Münzenberg was also the editor of *AIZ*, founded in 1921 and in existence in one form or another until 1938, and *Der Arbeiter Fotograf* (The Worker-Photographer) published between 1926 and 1932.[8] Both magazines were oppositional in their politics, siding with the Worker's International Relief movement in the 1920s, and they actively encouraged the working classes to become the producers of their own history by writing and taking photographs. *AIZ* was the more successful of the two titles, accruing a solid circulation of half a million copies in its heyday, the majority being sold to skilled and unskilled labourers, according to a survey held in 1929.[9] One of the main factors contributing to its success were the photomontages which John Heartfield produced between 1929 and 1938. By this time, his approach to montage had become more economical in its treatment of form and content, and using both commentary and imagery that he had gleaned from the mass media, as well as original photographs made especially for him by Wolf Reissman, Heartfield tended to imitate the

dialectical montage of the Soviet cinema pioneered by Sergei Eisenstein. In films such as *Strike* (1924), Eisenstein would combine two oppositional elements into a 'montage of attractions',[10] so as to create a third (and usually political) effect – the dismemberment of society and the expendability of human life under autocratic rule, for example, were suggested by scenes of the protesting masses being shot down by the Russian army intercut with images of a bull being slaughtered in an abattoir. Deploying a similar technique, Heartfield attempted to symbolise the corruption and folly of the Nazi Party in word and image with his photomontages during the 1930s. Thus, in a cover for *AIZ* on 16 October 1932 captioned *The Meaning of the Hitler Salute: Millions Stand Behind Me! A Little Man asks for Large Gifts*, an image of Hitler saluting is dwarfed by the figure of an obese businessman standing behind him who appears to be pouring millions of Reichsmarks into the palm of his hand; whilst in a full-page montage on 19 December 1935, he satirises Goering's admonition to the German people to eat more iron by representing a family sitting down to consume a meal consisting entirely of metal objects (figure 44).

44] 'Hurrah, die Butter ist alle!', ('Hurrah, the butter is finished!') photomontage by John Heartfield, *AIZ* (19 December 1935).

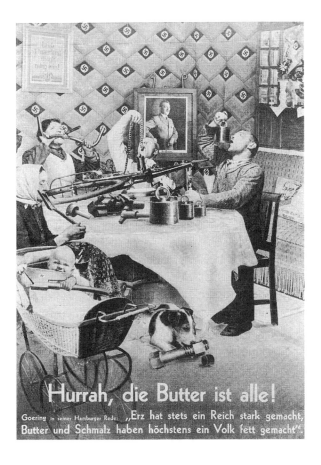

The mainstream photo-weekly in Germany during the 1920s

Photomontage, however, was not exclusively the province of political journals and had also begun to make inroads into mainstream magazines during the 1920s and 1930s. *BIZ*, for example, published Höch's April-Fool parody, *The Botanical Garden's Interesting New Acquisitions*, in 1921 and later featured work by Carl Schnebel, such as *Election Fever* (20 March 1932). *BIZ* had originated in 1891 and was one of several best-selling titles published by the powerful Ullstein Verlag, which had been founded in Berlin in 1858 by the democratic Jewish paper-merchant Leopold Ullstein (figure 45). After 1918, the Ullstein Verlag was a diverse publishing company dealing in sewing patterns, commissioning advertisements, and was the owner of nineteen newspapers and magazines. In addition to *BIZ* it published the family weekly *Die Grüne Post*; the women's periodicals *Die Dame* and *Blatt der Hausfrau*; the scientific review *Koralle*; the humorous monthly *Uhu*; and *Querschnitt*, which was an intellectual review of high culture. Most other major cities also published their own weekly illustrateds, most notably *MIP*, which started publication in 1923 with Stefan Lorant (who

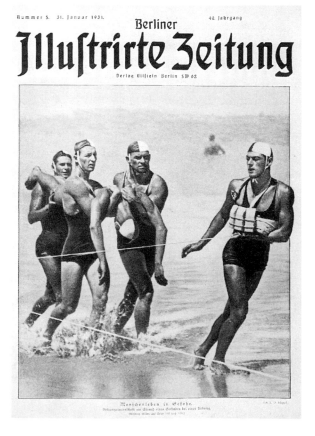

45] 'Menschenleben in Gefahr' ('Human life in danger'), photograph by Emil Otto Hoppé, *BIZ* cover (No. 5, 31 January 1931).

was later to play a major part in British photojournalism) as picture editor, and *Kölnische Illustrierte Zeitung*, in 1926.

By the mid-1920s the practice of photojournalism itself had been transformed by several important developments. First, new equipment had been introduced in 1924, such as the Ermanox small-plate camera which facilitated shooting indoors, with its wide-aperture (f/2) lens, and the hand-held 35mm Leica camera. The latter, however, was not greatly used until interchangeable lenses for it became available in 1930, and even then many photographers preferred to use either a Contax, which offered more accurate rangefinding, or a Leica camera in conjunction with Contax lenses.

Second, the owners and editors of the weekly illustrateds began to commission work from the most creative, modernist photographers. Both Stefan Lorant at *MIP* and the magazine division of the Ullstein Verlag under the aegis of Herman Ullstein, with Kurt Szafranski as manager and Kurt Korff as editor-in-chief, bought work by Moholy-Nagy, Kertész, Man Ray, Man, Tim Gidal, Kurt Hübschmann (later Hutton), Alfred Eisenstaedt, Emil Otto Hoppé and others, from large picture agencies such as *Dephot* (*Deutsche Photodienst*), founded in 1928 and run by Simon Guttman, and *Weltrundschau*, owned by Rudolph Birnback.[11] This meant that most photographers were employed on a free-lance basis, and staff photographers were rare – only Martin Munkacsi, a prominent sports photographer, was on the permanent payroll at *BIZ*, for instance. At the same time, although it was the picture editor who was ultimately responsible for how the photographer's work actually appeared on the page, a minimum remuneration had been instituted as early as 1908 by the Verband Deutscher Illustrations-photographer (German Union of Illustrative Photographers). Indeed, after 1924 there were high fees to be paid for the best photo-essays and competition was stiff. In 1928, initial contracts could be in the region of 250 Reichsmarks (the equivalent of twelve pounds at that time), and Harald Lechenperg cited earnings of 1,500 Reichsmarks for one double-page spread published in *BIZ*.[12]

BIZ usually consisted of anything between twenty and fifty pages, and the typical content would include literary serialisations such as Vicki Baum's *Menschen in Hotel* (published in *BIZ* between 31 March and 30 June 1929 and later dramatised as the film *Grand Hotel* in 1932); photo-essays; cartoons and puzzles; and advertising, which was a lucrative source of revenue – on average, *BIZ* carried ten pages of advertisements for various products ranging from toiletries to travel services, and generated half of its income from these and the other half from sales.[13] The photo-essays, which were between two and four pages in length, had text set in the traditional

German gothic typeface known as *Fraktur* and photographs of different dimensions organised into interrelated units. Although pictorial content was diverse, embracing current affairs, politics and cultural events, the most prevalent type of photo-essay was usually light in tone and had a human interest. Here the lives of ordinary men and women as well as those of the rich and famous from all over the world were represented. Moreover, in common with nineteenth-century illustrated prototypes (see chapter 1), it was the pictures that conveyed the main thrust of the idea or theme under discussion, and as such they took precedence over the written word, which was kept to a minimum. Writing in 1927, Kurt Korff attributed this shift towards an eidetic culture to the dynamic pace of modern life, and linked the serial format of the photo-essay and

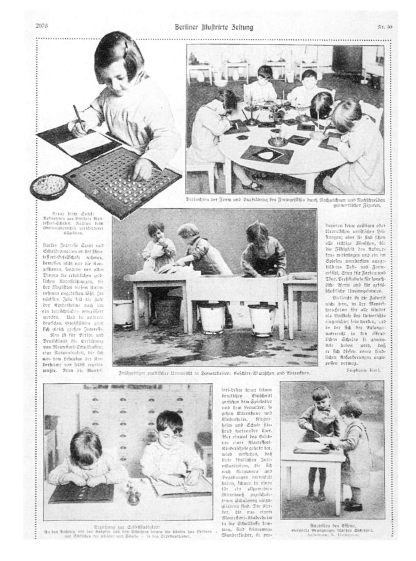

46] Lernen beim Spiel, Das Montessori-system setzt sich durch' ('Learning by play, the Montessori System wins through'), photographs by R. Horlemann, *BIZ* (11 December 1927).

the changes in spectatorship that it implied with the evolution of the narrative cinema:

> It is no accident that the development of the cinema and the development of [BIZ] run roughly parallel. To the extent that life became more hectic, and the individual was less prepared to leaf through a magazine in a quiet moment ... it became necessary to find a sharper, more efficient form of visual representation, one which did not lose its impact on the reader even if he only glanced fleetingly at the magazine page by page ...
>
> The BIZ recognized this changed attitude toward pictures early and consciously developed it. This new standpoint had to make itself felt at the early stage of selecting the pictures, for not every picture alone conveyed an impression of the desired intensity. The picture has to have the most intense possible concentration, has to capture a situation at its climax; when it does, it occasionally achieves an effect that remains out of reach of even the most eloquent text.[14]

As Korff also implies, however, from the 1920s onwards the photo-essay was a more thoughtfully designed entity than its antecedents. The structure and flow of the layout was carefully orchestrated by combining photographs into a sequential narrative in which pictures of different sizes overlapped and were combined with both lower- and upper-case types of different weights, as in the features 'Das große Erdbeben-Ungluck in Japan' ('Big earthquake misfortune in Japan') from *BIZ*, 17 April 1927 and 'Lernen beim Spiel, Das Montessori-System setzt sich durch' ('Learning by play, the Montessori System wins through'), from *BIZ*, 11 December 1927, with photographs by R. Horlemann (figure 46).

Neue Sachlichkeit, the machine aesthetic and photo-journalism in Germany

After the mid-1920s, the new photographic culture in Germany began to overlap with the modernist aesthetic of *Neue Sachlichkeit* or 'New Objectivity', a term which had originated at the Mannheim Kunsthalle exhibition organised by Gustav Hartlaub in 1925. The paintings on display, including portraits by Georg Schrimpf, effected an acute sense of realism in representation, although one which also attempted to make everyday life resonate with significance. The meaning of *Sachlichkeit* signalled, therefore, both a dispassionate sense of observation and a fetishistic belief in the object or person represented as a thing of beauty in its own right. In photography, such objectivity was achieved through framing the shot and without resort to retouching or picture-cropping, and often led to ordinary objects being rendered unfamiliar through

the use of close-ups, strange angles, birds-eye and skyscraper per-
spectives.[15] This was manifest in picture papers like *BIZ* in the
numerous photo-essays dealing with technological innovations in
building, such as steel-framed skyscrapers and the radio tower in
Berlin; new forms of industrial machinery; and an intense interest
in aviation.[16]

One of the earliest practitioners to justify *Neue Sachlichkeit* pho-
tography was Albert Renger-Patzsch, who in his essay, *Die Freude
am Gegenstand* (Joy before the Object), published in *Das Kunstblatt*
in 1928, argued that:

> The rigid adherence of 'artist-photographers' to the model provided
> by painting has always been damaging to photographic achieve-
> ment. There is an urgent need to examine old opinions and look at
> things from a new vantage point. There must be an increase in the
> joy one takes in an object, and the photographer should become
> fully conscious of the splendid fidelity of reproduction made possi-
> ble by his technique.[17]

Renger-Patzsch himself had unequivocally celebrated plant-
forms, life-forms and objects of all kinds in the hundred
photographs included in his 1928 book *Die Welt ist schön* (The
World Is Beautiful). The types of objects for which he demonstrated
a clear predilection were industrial engines and mass-produced
goods; a pulley-wheel from the Siemens Electrical factory, for
example, which he photographed reverentially in close-up in a
manner similar to Germaine Krull's images of *BIZ*'s new printing
press in 1927,[18] to emphasise both the sheen and texture of its surface
and its geometrical precision. These forms were seen to encapsulate
the essence of modernity and expressed the *Schönheit der Technik*
(The Beauty of Technology), the title both of articles in *BIZ* on 6
September 1925, with photographs of factories and steel bridges,
and *UHU*, 5 (1926), with photographs of cooling-towers, and of a
book by Franz Kollman in 1928. As such, they were symbolic of a
more buoyant industrial economy which had begun to vindicate
itself with foreign aid from America through the Dawes Plan and
the concomitant currency reform of 1924/25.[19]

This keen sense of perception was also applied to the objectifi-
cation of commodities in advertising, and even if readers could not
afford to consume the products they saw, they could none the less
take pleasure in their clear and alluring representation in the new
photo-weeklies. Moreover, within such a consumer culture,
women became a particular target for both advertisers and picture
editors, but the products with which they were associated more
often than not harped on normative patriarchal stereotypes, such
as the good wife and mother (Pixavon Shampoo, *BIZ*, 21 July 1929)
and the inanimate mannequin (Three Flowers Powder, *BIZ*, 28

Träumen Sie von der schönsten Stunde Ihres Lebens,
in der man Sie zur Pixavon-Königin krönt —

· PIXAVON - WETTBEWERB ·

47] Advertisement for
Pixavon Shampoo, 'Dream
about the most beautiful
hour of your life when you
are crowned Pixavon
Queen', *BIZ* (14 October
1928).

February 1929), and their desires were ultimately framed with
the object of catching a man, as in the dream montage accompa-
nying the Pixavon Beauty Contest promotion (*BIZ*, 14 October
1928, figure 47).

At the same time, the role of urban culture had an enormous
part to play in *Neue Sachlichkeit* imagery. During the Weimar period
the *Großstädte*, cities with populations of half a million inhabitants
or more, became the focus of intense debate.[20] On the one hand
supporters of the city such as Paul Sander suggested that the evol-
ution of modern culture was intrinsically linked to urban life,
whilst on the other detractors such as Berthold Brecht maintained
that city life was oppressive and unhealthy.[21] In the pages of *BIZ*,
the city was represented unequivocally as a vehicle for technologi-
cal and architectural progress. This was emphasised, for instance, in
photo-essays concerning foreign cities such as Moscow, New York
and São Paolo, but more particularly *BIZ* tended to concentrate on
the changes and achievements that were taking place in German
cities.[22] Thus it ran features on the electrification of the Berlin
railway network (13 July 1924); the design and construction of the
new, modernist *Siedlungen* (housing estates) such as Bruno Taut's
development at Brenzlauer Berg, Berlin (9 December 1928); and

futuristically scientific buildings such as Mendelsohn's Einstein Tower laboratory at Potsdam (16 December 1928).

The out-and-out urbanist and consumerist ethic of these mainstream magazines and their idealising of the machine aesthetic certainly helped them to maintain healthy circulation figures which were far in excess of their political counterparts – in May 1931, for example, *BIZ* sold 1,753,850 copies and *MIP* approximately 900,000 copies.[23] In addition, the types of reader that the popular photo-weeklies attracted was much more disparate than that of *AIZ*, and as Maud Lavin has suggested, their circulations were too large to have been restricted to one class.[24] The political bias of the best-selling weeklies was consequently negligible and tended towards the middle ground. This was partly due to the fact that most of the images they printed were produced on a freelance basis by photographers who did not have a specific editorial policy in mind, and who had their work syndicated for publication through one of the large picture agencies. With the rise of the Nazis, who had gained the largest number of seats in the *Reichstag* in the November 1932 elections, however, the popular weeklies became more prone to party political propaganda and to distorting the actual historical situation.

An interesting case in point is a photo-essay by Neudin published in *MIP* in November 1932 and entitled 'Geht es wieder Aufwärts?' ('Is it going forwards again?'). In this, a series of photographs representing active factory assembly lines at the Lorenz Company in Berlin were woven together to suggest that Germany's economic crisis was finally coming to an end and employment and productivity were once again on the increase.[25] But as *AIZ* was swift to point out, the piece was no more than a calculated fiction which had used out-of-date photographs to achieve its impact. In December 1932 it reprinted the original feature in its entirety alongside more recent photographs depicting the same factory deserted, under the title 'Bildfälschung im Dienste der "Wirtschaftsankurbelung"' ('Fake pictures at the service of "Economic Reflation"') and contesting: 'Instead of 800 male and female workers, there are only five women and one man . . . employed here.'[26] *AIZ* consequently represented an alternative objectivity, disrupting popular assumptions about the beauty of everyday reality and things as well as the idea that Taylorist methods of production and the machine aesthetic would automatically lead to increased efficiency and employment. The same criticism was also levelled at Renger-Patzsch by left-wing authors like Klaus Jürgen Sembach, who thought his fetishisation of technology and mass-produced goods trivialised the real sociological implications of the modern workplace, and that his book *Die Welt*

ist Schön would have had little clout with the millions of workers who had been made redundant by the mechanised asssembly-line systems of the 1920s and 1930s.[27]

As had been the case with the satirical press during the nineteenth century, therefore, opposition to the mainstream ideologies of the 1920s and 1930s was to be found on the Left and in the counter-cultural press rather than in the best-selling photo-weeklies. In this context, the stereotyping of women as wooden mannequins or as wives and mothers was likewise subverted in the early 1930s by Grete Stern and Ellen Auerbach, under their business pseudonym of Ringl + Pit. In advertisements such as that for *Petrole Hahn* (1931), they deconstructed the artifice and masquerade of the advertising system by conflating animate and inanimate forms – the head and shoulders of a glamorous mannequin dressed in a sensible night-gown, for example, have been juxtaposed with a human hand holding a bottle of hair oil.[28] Yet as the National Chamber of Culture flexed its political muscle after 1933, it became increasingly difficult to circulate any texts that were critical of its hegemony.[29] Many publications folded or were published in exile – between 1933 and 1938 *AIZ* was published by the Malik Verlag in Prague – and many practitioners were forced to leave Germany because of their Jewish backgrounds. These included Erich Salomon, who went to Holland, Kurt Hübschman, Felix Man, Tim Gidal, and the picture editor Stefan Lorant, who came to Britain. Their diaspora resulted in the evolution of a second wave of popular photojournals to which they made a significant contribution.

Photojournalism in Britain after 1934

Stefan Lorant, who was Jewish-Hungarian, came to Britain in 1933 after spending six months in 'protective custody' as a political offender in Nazi Germany.[30] Shortly after his arrival he persuaded John Dunbar, editor-in-chief at Odhams publishing house, that popular journalism in Britain was lacking in photo-weeklies similar to the German prototypes of the 1920s. This initiative resulted in the publication of *Weekly Illustrated* on 7 July 1934 which cost 2*d* and which accrued a respectable circulation of a quarter of a million copies until it was combined with *Passing Show* to form *Illustrated* in February 1939. Maurice Cowan was the editor, Lorant picture-editor and, although picture credits were not cited, the chief contributors were the émigrés Man (who produced 46 photo-essays in total) and Hübschmann, now known as Hutton (60 photo-essays), and the British photographers James Jarché (190 photo-essays) and Bill Brandt (45 photo-essays).[31] Photo-essays usually occupied a double page, and like those of their German

counterparts, the images crystallised the essence of the subject represented with text kept to a minimum, as evidenced in two features published in 1934 with photographs by Man: 'Street scene', dealing with life in London by night, and 'The world's study', about the British Museum reading room in Bloomsbury. The work of Bill Brandt was to loom more largely in two other important titles that Lorant was also responsible for helping to launch, the monthly *Lilliput*, which came out in July 1937 and merged with *Men Only* during the 1950s, and *Picture Post*, which first appeared on 1 October 1938 and ran until 1 June 1957 (figure 48).[32] Lorant set up *Lilliput*, 'the pocket magazine for everyone', in collaboration with Alison Blair, and edited it until 1938. In addition to Brandt, many important European avant-garde photographers contributed work to it, including Kertész, Moholy-Nagy and Brassaï. Placing an emphasis on the New Objectivity, the photographs which appeared often had strange angles and, inspired by Eisenstein's cinematic montage of attractions, were also often arranged by Lorant as oppositional pairs on facing pages, so as to elicit a supplementary meaning or third effect. This was used with both social and political objectives in mind - see figure 49, for example, in which two photographs by Ladanyi have been juxtaposed to

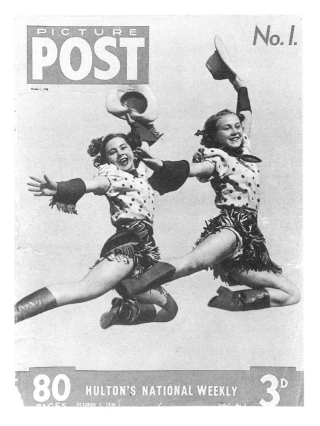

48] *Picture Post*, cover of the first issue (1 October 1938).

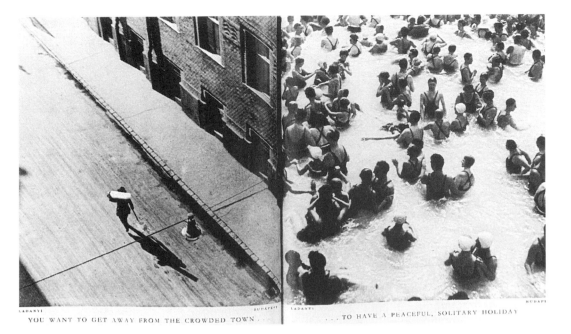

YOU WANT TO GET AWAY FROM THE CROWDED TOWN TO HAVE A PEACEFUL, SOLITARY HOLIDAY

49] 'You want to get away from the crowded town ... to have a peaceful, solitary holiday', photographs by Ladanyi, *Lilliput*, (July–December 1939).

make a wry comment on our need to get away from it all, and figure 50 juxtaposing an agency photograph from Keystone of a rich child all ready to go skiing in the Alps with one by Brandt of a poor child in a squalid tenement. By far the most common visual aesthetic to be found in British (and American) photojournalism during the 1930s and afterwards, however, was that of documentary expression, which was concerned with the representation of ordinary people in their social and political contexts, and which had gained unparalleled status in the wake of the Great Depression.

50] 'Rich man's child' and 'poor man's child', photographed by Bill Brandt, *Lilliput*, (July–December 1939).

In America, for instance, the Information Division of the Resettlement Administration, which had been set up in 1935 (and became known as the Farm Securities Administration (FSA) after 1937) employed photographers such as Walker Evans and Dorothea Lange to chart the plight of unemployed and itinerant farm workers; and in Britain, Mass Observation, which was set up in 1937 by Charles Madge and Tom Harrison, employed Humphrey Spender to photograph the impact of unemployment on the working-class communities of Bolton.[33] James Jarché's 'Do something for Jarrow' for *Weekly Illustrated* (6 August 1936) and dealing with the visit of the Duchess of York to the town springs from the same humanist concerns. Here Jarché uncompromisingly represents the destitution of the townspeople, but at the same time underscores their determination to survive.

Although photographs dealing with social issues had been produced since the middle of the nineteenth century, for example, Charles Nègre's representation of the working classes in Paris, in relation to the visual arts the documentary concept owes its origins to film-makers such as Dziga Vertov in Russia and John Grierson in Britain. Starting in the 1920s both producers, in strict reaction to the dominant Hollywood star system, determined to emphasise the factual and the everyday in their films, as a way of instructing or keeping the public historically informed.[34] Soon afterwards the term also gained currency to describe photographs as if they were unmediated, eyewitness accounts of the event. William Stott writing about the use of documentary in America during the 1930s states that it became: 'a rhetoric as definite as tragedy, epic or satire, the crucial difference being that its content is, or is assumed to be true . . . All emphasis is on the evidence; the facts speak for themselves.'[35] At the same time, however, many critics and producers including John Grierson, began to expound the inherent contradictions and limitations concerning the alleged objectivity or realism of the discourse. It is commonly agreed that it was Grierson who first gave currency to the term documentary as 'the dramatization of actuality' in his review of Robert Flaherty's film *Moana* in 1926, subsequently going on to amplify his theory in various writings during the 1930s and 1940s:

> realist documentary . . . has given itself the job of making poetry where no poet has gone before it, and where no ends, sufficient for the purposes of art, are easily observed. It requires not only taste but also inspiration, which is to say a very laborious, deep-seeing, deep-sympathising creative effort indeed . . . The process will be one of interpretation rather than one of record . . . My separate claim for documentary is simply that in the use of the living article, there is *also* an opportunity to perform creative work.[36]

The kind of creative inspiration which the producer should bring to bear in his or her representation of actuality is evident in the work of many photographers who contributed to photo-weeklies such as *Picture Post*. One thinks here of the brooding tonalism and nightmarish quality of much of Brandt's imagery, imbued with the spirit of Surrealism that he had first encountered in Man Ray's studio in Paris in 1929. In 'The magic of a car's headlights', for example (*PP*, 31 March 1945), subjects suddenly loom out of the intense darkness, transfixed by a burst of penetrating light. At the same time, the interpretative nature of documentary expression in the context of photojournalism is mediated by the interplay of images with images, and images with text, each element serving to qualify another and symbolising the social or political significance of the subject(s) portrayed.

Picture Post and documentary: warfare and welfare 1938-50

Of all the photo-weeklies published in Britain, *Picture Post* was the most popular. Published by Edward Hulton and retailing at 3*d* per copy it attained a circulation of well over a million copies every week during World War 2.[37] In what is probably still the most illuminating theoretical insight into its ideological purpose, Stuart Hall argues that the success of the magazine was predicated by a particular 'way of seeing' which emanated from the documentary discourse of the 1930s and the specificity of the historical moment in which it was produced: 'The collective social experience and the formation of a distinctive "social eye" reciprocally informed and determined each other. Both arose as an active response to the "real movement" of history.'[38] Although *Picture Post* continued to be published for nearly twenty years, Hall also contends that in the final analysis its reputation will always be 'indelibly linked in the collective imagination with the documentation of the British people at war',[39] the muted grey tones of its photographs being the perfect visual equivalent for the mood of wartime austerity, and that 'the decisive years of *Picture Post* - 1940-50 - coincided with Hopkinson's editorship'.[40]

This, however, is not entirely accurate, and it was the magazine's first picture-editor, Stefan Lorant, whose contribution set the seal on the magazine's popularity and provided a sense of ideological continuity which was carried into the war years and afterwards by Tom Hopkinson, who took over as editor between 1940 and 1950. Lorant's stewardship of *Picture Post* may have been short-lived (he fled Britain for America in July 1940, fearing the possibility of a German invasion and the threat of internment as

an alien), but he was responsible for establishing the magazine's documentary style and for alerting its readers to the threat of fascism through a series of imaginative photo-essays. From the outset, he also presided over *Picture Post*'s 'social eye', for which it garnered a reputation as champion of the welfare of every British citizen, regardless of age, gender or class.

Under Lorant's editorship, the serial presentation of photographs in *Picture Post* emulated German prototypes quite closely; photo-spreads often ran to fourteen pages, and it occasionally featured photomontage in the first two years of its run, such as the image of two flying elephants, which was an attempt to symbolise the precarious status of peace in Europe during the autumn of 1938.[41] In general, the predilection was for as clear an exposition of the subject as possible; individual pictures usually gained more visual impact by being woven into photo-essays that relied on pithy captions and striking photographic juxtapositions so as to invite comparison or analysis. Although the pictures which appeared in the magazine were not credited until 1945, we do know the names of a small nucleus of photographers who were contributors before that time. These included the three German émigrés Kurt Hutton, Felix Man and Tim Gidal, as well as Robert Capa, Humphrey Spender, Bill Brandt and Bert Hardy.[42] At the same time, Lorant occasionally published the images which he had received either from official channels like the German Ministry of Propaganda or from the other contacts he still had in Germany.[43]

Lorant was unequivocal in his efforts to reveal the political immorality of fascism and he rose to the challenge of galvanising a readership who were largely apathetic to the issue by whatever means he could. A Mass Observation Poll held in August 1938 had revealed that the majority of the public regarded themselves immune to the mounting crisis in Europe,[44] and this attitude had been compounded with the signing of the Munich Treaty on 30 September of the same year by Neville Chamberlain, whose declaration, 'I believe this is peace for our time' (reprinted in *Picture Post* on 8 October 1938), had lulled the nation into a false sense of security. Initially Lorant attempted to get his anti-fascist message across with imaginative photo-spreads dealing with the persecution against the Jews. These include one of the magazine's best-known features, 'Back to the Middle Ages', with its portraits of Goering, Streicher, Hitler and Goebbels straddling two pictures of desecrated Jewish stores, and its gallery of some of 'The world-famous Jews for whom there is no room in Nazi Germany today'.[45] But he also alighted on the Spanish Civil War as a more topical and cogent example with which to actualise the struggle against

fascism in Europe, with photo-essays featuring dramatic pictures by Robert Capa.[46]

By the Spring of 1939 'war fever' had become more acute, following the German invasion of Czechoslavakia and the likelihood of Poland also being invaded. From this point onwards, Lorant's propaganda campaign began to emphasise the dangerously insidious nature of Nazi rule by illustrating its impact on the everyday life of the average German citizen, as in the photo-essay 'Berlin on a sunny day' (*PP*, 3 June 1939), for example, which draws together sets of oppositional images on facing pages to underline the tension between traditional social customs and the militarisation of the urban scene. In particular, Lorant underscored the immorality of the Third Reich with photo-essays depicting the impact of Nazi culture on children. 'Inside a Nazi school' (*PP*, 1 July 1939) was somewhat obvious in it emotional effect, quoting Hitler's thoughts on education directly from *Mein Kampf*, as well as those of Hans Schwemm, who as leader of the Nazi Teachers' Union had declared: 'this Lord God has sent Adolf Hitler to us, that he has allowed us the grace to become a people again. We will, Adolf Hitler, so train the German youth that they will grow up in your world of ideas, in your purposes and in the direction set by your will.' Consequently we are shown the Nazification of German children in several pictures of young boys and girls poring over the *Völkischer Beobachter*, the official organ of the Nazi Party, and in another a boy is seen delivering a speech to his classmates, his clenched fists and air of conviction clearly indebted to Hitler's style of oratory.

'A German girl came to London and these were her impressions' (*PP*, 26 August 1939), comprising eight snapshot-size photographs with brief captions, was more subtle and metaphoric in conveying its message (figure 51). At the outset we are told 'The German girl wrote these words herself', and the captions, addressed *ad hominem* in fractured, ungrammatical English, would certainly appear to bear this out. Thus we are told that in England 'the sheeps lives free' and that 'We hear much about English justice in my country. The justice we cannot see. He is forbidden to photograph. But in a shop I find the judgeman's wig. He is to me the face of English justice.' The caption accompanying the picture of the female speaker, meanwhile, states: 'They talk and talk. Sometimes they shout. They say whatever thing they please. No one arrest them. No one take them off and shut them up. They talk till they are tired.'

The pigeon-English and the choice of somewhat eccentric stereotypes lends the piece an air of naive authenticity and plays on the British sense of humour – is not this, after all, how charming or quaint we should like to appear to outsiders? Yet it is highly

unlikely that a little German girl ever came to England (she does not appear in any of the photographs in the way that we might expect of a tourist, nor is it clear that she is the unconvincing archetype, Miss Schmidt, mentioned in one of the legends), and instead what we appear to be presented with is a clever piece of mediated emotional propaganda in which the girl actually

51] 'A German girl came to London and these were her impressions', *Picture Post* (26 August 1939).

Picture Post,
August 26, 1939

A GERMAN GIRL CAME TO LONDON

THE GERMAN GIRL WROTE THESE WORDS HERSELF. . . .
"I am in your city one week. I send you the pictures of the things I see. I write for each picture what it is I like. The policemen, of course, because each one of them is to me a father."

. . . The Sheeps, I Think, Is Happy . . .
"If a person want to build a house here on this side of Piccadilly, he is told he must not do it. They say 'No: It is a park.' The other side he must pay very much to build. But the sheeps lives free."

. . . The Hard Hat of the Bowler . . .
" 'I think, sir, you have taken my bowler hat,' says the phrase-book I am given. The people here must say it all the time. They wear all, these hard hats of the bowlers, all alike as one another."

. . . The Real Toy Soldier . . .
" 'Is he real?' I ask my girl-friend. 'Is he a toy? Does he answer? Can we touch him?' But my girl-friend say 'No. You cannot touch. He is not yours. He is the King's.' "

58

becomes a symbolic spokesperson for Lorant's own political opinions. Such an act of metonymic substitution enables Lorant to make an appeal to his readers in more direct and acceptable human terms - an innocent German child speaks to us 'openly' and 'honestly' about her preferences for the British way of life which, as she perceives it, is distinguished by freedom and citizenship.

AND THESE WERE HER IMPRESSIONS

Picture Post,
August 26, 1939

The Face of English Justice

"We hear much about English justice in my country. The justice we cannot see. He is forbidden to photograph. But in a shop I find the judgeman's wig. He is to me the face of English justice."

. . . The Englishers, They Talk of Nothing Else . . .

"'It is a lovely day, Miss Schmidt.' 'It is not any more lovely to-day, Miss Schmidt.' 'How I wish it were a lovely day, Miss Schmidt !' These are the things the Englishers all talk of. And no wonder is it !"

. . . Herr Staatsbanknachrichtenträger . . .

"Such a man in Germany, he has a big grand title. He is Herr Staatsbank-nachrichtenträger, at the least. But here you call him 'bank messenger,' and he walk without a gun."

. . . Why They Say This is the Freest Country

"They talk and talk. Sometimes they shout. They say whatever thing they please. No one arrest them. No one take them off and shut them up. They talk till they are tired. Then they go home."

59

Soon after the publication of this psychologically seductive essay, Lorant emigrated to America, but *Picture Post* kept up its propaganda war against Hitler and the Nazis under the editorship of Tom Hopkinson, with special issues like 'What we are fighting for', published on 13 July 1940. In several respects there was little else for him to print. Reports of how poorly British Forces were faring had been strictly controlled by Lord Raglan at the Ministry of Information until the tide had turned in favour of the Allies with the raid against Rommel in Libya in 1942.[47] On November 4 1939, for example, *Picture Post* published an article opposing the government ban, commenting favourably on how both French and German photographers were allowed to circulate their images with impunity. To underline the point, five blacked-out spaces were printed under the ironic leader 'Pictures we should like to publish – We can't see the need of a black-out. Can you?' Moreover it was to take one whole year after the outbreak of war before fighting actually caught up with the British population and that pictures of the Blitz began to appear.

The Blitzkrieg tactics of the Germans were known to the British but they had experienced them only vicariously during the first year of the war through press images which had depicted atrocities against human life on mainland Europe. *Picture Post*, for example, published such tragically moving photographs as those of a Polish peasant lying dead in his cart in 1939 and a wounded father discovering the dead body of his daughter in Holland in 1940.[48] From June 1940, however, light bombings had been experienced over many areas of Britain, and by September of the same year London was forced to come to terms with German tactics when the first wave of mass bombings hit the East End.[49] In the issue for 28 September 1940 a ten-page article, 'East End at war', was published. The main body of text interestingly drew out the surreal quality of trying to lead an ordinary life under the continuous threat of air-raids and the possibility of waking to find your home reduced to nothing more than a pile of rubble: 'Even an actual bombing is remembered by many people as if it had actually been a dream . . . Of the actual bombing, it would be rash to say that anybody can get used to it in *fact*. What is more clear is that people can get used to it in *mind*.' Ultimately, however, the author of the article dwelled on the resilience of the East-Enders themselves:

> that real mixture of fatalism and perkiness which has come to be known as 'Cockney' is everywhere to be heard even from the hardest-hit people . . . Most common of all is the simple feeling of a Stepney woman who just said: 'I don't know what it's all in aid of, but I can tell you when I look round I'm thankful to be alive'.

(Continued on page 18)

52] 'The East End at war',
Picture Post
(28 September 1940).

In a similar vein, nearly all of the twenty-four photographs de-
picted scenes of the direst devastation, yet most of them were
captioned in such a way as to counter any sense of defeat or des-
peration (figure 52). Mr W. G. Brooks, for example, who returning
to his bombed home from an air-raid shelter to discover an Income
Tax Demand among his post sits stoically 'Amid the remains of his
house' and 'tackles the annual problem', while Mrs Marsh the
seamstress returns to work surrounded by the glass of broken win-
dow panes and exclaims, 'Me? ... I'm all right. The person you
ought to feel sorry for is the old chap who owns the shop. ' The
same resigned tone informs the photo-essay 'The morning after
the Blitz' on 3 May 1941 which contained a pivotal full-page image
ostensibly showing us an old man traversing the ruined remains
of his home (figure 53). It is titled 'The man the Nazis are trying to
rattle: a British citizen of 1941' and the legend goes on to state: 'He

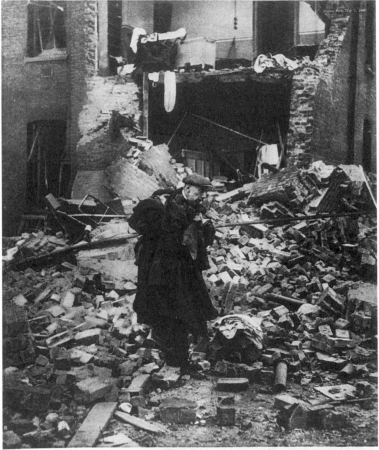

The Man the Nazis Are Trying to Rattle: A British Citizen of 1941
He is the English city dweller. His home is the Nazi bombers' target. His few poor possessions, bought with the savings of years, are their military objective. And when a bomb falls, and makes of his home a shapeless heap of bricks, he calmly salvages what he can and starts afresh. 15

53] 'The morning after the Blitz – the man the Nazis are trying to rattle', *Picture Post* (3 May 1941).

is the English city dweller. His home is the Nazi bombers' target. His few possessions, bought with the savings of years, are their military objective. And when a bomb falls, and makes of his home a shapeless heap of bricks, he calmly salvages what he can and starts afresh. ' The photograph, however, has a rather staged aspect about it; the garments the old man is carrying appear too pristine and it is improbable that they would have been miraculously spared from bomb damage. Nor does the patronising tone of the caption seem to be the natural response of someone who has suddenly discovered his home razed to no more than 'a shapeless heap of bricks'. This is how Edie McHardy, for instance, described a similar experience in Greenwich in 1941:

> When the all-clear sounded and we emerged, a terrible sight awaited us as the smoke from the burning docks was billowing everywhere in thick black clouds. The two girls who lived next door and I walked along Charlton Road to the Village and we met many people who'd been caught out shopping, etc., and were trudging home – all

with the same shocked look. It was an awesome sight looking down
upon the river and across to North Woolwich and the Isle of Dogs –
just flames and smoke. It seemed that nobody could have survived
such a fire.[50]

The case of those Londoners who were forced to escape bomb
attacks in communal shelters or in Underground stations was like-
wise represented as testimony to the endurance of a nation under
siege. In 'Shelter life', a photo-essay by Bill Brandt published on 26
October 1940, for example, people of all types and ages are port-
rayed sharing a communal shelter and getting on with it in
good-humoured camaraderie.[51] These images of ordinary citizens
seemingly unphased by a war-torn environment serve to demon-
strate the extent to which *Picture Post* was indulging in the popular
mythology of British invincibility in order to keep public morale
high at a time when it appeared as if the Allied forces had lost the
initiative (by the summer of 1940 the British army had already
been chased out of northern France and Norway).[52] As such, the
magazine took inspiration from both Home Intelligence reports
and Winston Churchill, who had foregrounded the indomitabil-
ity of the nation with his legendary chauvinistic speech in the
House of Commons on 4 June 1940.[53] On to this, however, *Picture
Post* had also grafted a sense of community spirit, propagating the
ideology of the 'People's war' and thereby implicating every
citizen, regardless of age, gender or class, in a co-ordinated struggle
against the enemy.

In its blurring of social and political distinctions, *Picture Post*
invoked both the contribution of official or public service institu-
tions and of women to set the right moral or patriotic tone. To
this end, the BBC was singled out for special treatment on 15 March
1941, and the pivotal position of women within the war effort was
likewise portrayed in several photo-essays between 1938 and 1945.
These included features on the Women's Voluntary Service for
Civil Defence (WVS), which had been founded in May 1938 by
Lady Reading and which was open to women of all ages from 16
to 80, whether skilled or unskilled, as well as the Women's Home
Defence Movement which had been formed by Dr Edith Summer-
skill in December 1941 as a way of helping women to learn how
to use firearms.[54] By far the most pressing demand, however, was
the need to fill labour shortages in farming, in the metal, muni-
tions, chemical and transport industries, and in services such as
banking, catering and entertainment with skilled female workers.
Both the Ministry of Labour and the statisitician Helen Markower,
working in co-operation with the Oxford Institute of Statistics,
estimated that the total number of women who would be required
to help out at the peak period of the war would be 4 million. But

as the Labour MP Ellen Wilkinson pointed out in her far-sighted article 'Women in war' for *Picture Post* on 9 March 1940, the mass mobilisation of so many women workers could only be brought into effect with proper consideration of the health, training and occupational conditions of the work-force. Notwithstanding the fact that very few of these provisions were actually put into practice during the war, many women did volunteer for work on the Home Front (by 1943, there were 7.5 million women in paid employment, with 1.5 million in the essential industries) and they were positively supported by *Picture Post* for having done so. In such respects we might well believe that the magazine was breaking new ground in terms of its sexual politics, but whilst the war period was an exceptional one for women in terms of labour opportunities and sexual freedom, in essence *Picture Post* clung on to more traditionally patriarchal values, upholding a woman's 'rightful place' as a dutiful wife and mother.

The subservient nature of a woman's work had already been expressed in three articles illustrated with photographs by Bill Brandt in 1939: 'Nippy' (dealing with the everyday life of a young waitress employed by Lyons's tea-shops), 'A barmaid's day', and 'The perfect parlourmaid'.[55] This theme was carefully orchestrated during wartime and is well to the fore in 'The warning of Plymouth' (*PP*, 17 May 1941), which focused on the plight of the Widdicombe family to demonstrate the impact of concentrated German air-raid attacks in 1941. The Widdicombes had been left with no more than a lorry for their home, but in most of the pictures it is the women who are seen to be actively coping with the hardship of a refugee existence and attempting to maintain a semblance of normal family life (figure 54). Mrs Widdicombe and her elder daughter still attempt to keep house, tending to the needs of the younger children and making the beds or preparing the evening meal. Mr Widdicombe meanwhile is represented as an inert but meditative stalwart, chatting to his friends or simply sitting pondering the future. The caption to the photograph of him sitting on top of the rubble which was once his home, for example, relates 'Now his home is gone. His business is gone. Patiently he salvages what he can to start his life again', and is redolent of the spirit of defiance which was adumbrated in the legend accompanying the portrait of 'The man the Nazis are trying to rattle' published only two weeks earlier (figure 53).

Not only is it the women who soldier on as home-makers but they are also depicted taking the time to maintain a beauty routine; the Widdicombe's eldest daughter is shown resourcefully applying her make-up in the rear-view mirror of the lorry and using a chair stacked high with pillows as a substitute dressing-

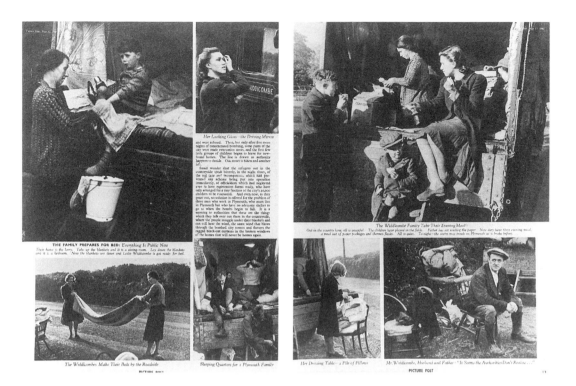

THE FAMILY PREPARES FOR BED: *Everything Is Public Now*
Their home is the lorry. Take up the blankets and it is a sitting-room. Lay down the blankets and it is a bedroom. Now the blankets are down and Leslie Widdicombe is got ready for bed.

Her Looking Glass—the Driving Mirror

The Widdicombe Family Take Their Evening Meal
Out in the country lane, all is peaceful. The children have played in the fields. Father has sat reading the paper. Now they have their evening meal, a meal out of paper packages and thermos flasks. All is quiet. To-night—the sirens may break on Plymouth as it broke before.

The Widdicombes Make Their Beds by the Roadside

Sleeping Quarters for a Plymouth Family

Her Dressing Table—a Pile of Pillows

Mr. Widdicombe, Husband and Father: "It Seems the Authorities Don't Realise . . ."

PICTURE POST

54| 'The warning of Plymouth', *Picture Post* (17 May 1941).

table. Renewed emphasis was placed on the role of feminine glamour during wartime by Anne Scott James, who had been appointed as *Picture Post's* first women's editor in February 1941. Scott James did little, however, to disavow normative stereotypes, and the subtext behind many of the beauty and fashion features which she edited implied that a woman should take care of her appearance for the sole purpose of keeping or attracting a man. The challenge of women wearing trousers, for example, is seen as acceptable practice for work but otherwise is met with a firm rebuff: 'there's no need to keep them on after working hours ... Slacks around the streets may save stocking coupons, but they don't improve the look of the town.'[56] And even at the end of what must have been for very many women, long and arduous days, it was still imperative to show some feminine allure; witness the photo-spread 'Here are two new ways of going to bed' (*PP*, 8 March 1941), which featured the latest nightgowns available and concluded: 'Whatever else women wear this spring, no one could say that they look dull in their bedrooms ... Coloured socks to wear while you potter about to do your hair ... There is even bedroom jewellery (though you don't go to sleep in it!). '

A more positive deal not only for women but for the nation as a whole was on offer with *Picture Post's* involvement with social reconstruction. Under the aegis of Lorant from 1938 until 1940 and

Tom Hopkinson for the remainder of the war period the ideological stance of the magazine tended to the left, and this was pursued not only through a concerted effort to expose the threat of fascism in Europe but also through the representation of social and working conditions in Britain. The impact of the Depression in terms of working-class poverty and unemployment was a familiar theme in the pre-war issues, but in contrast to Mass Observation's documentation of working-class culture in the north-west and its photographs of Bolton and Blackpool in 1937, *Picture Post* dealt with poverty and unemployment as they were affecting both the north and the south of the country. Thus articles about life on Tyneside (where 21 per cent of the local population were unemployed), with photographs by Humphrey Spender, and the squalid housing conditions in the East End of London, with photographs by Bill Brandt, were published in 1938 and 1939 respectively.[57] With these two photo-essays there is little indication of any social polarisation and in each 'half' of the country the working classes are seen to be part of the same struggle for a decent standard of living.

One of the magazine's most revealing and sustained insights into the effects of unemployment was its 'before and after' case study of Alfred Smith, a 35-year-old spray-enamel maker from Peckham who had lost his job due to occupational sickness and had been out of work for three and a half years. With the nine page photo-essay on 21 January 1939, featuring photographs by

55] 'Employed!', *Picture Post* (11 March 1939), p. 57.

56] 'Employed!', *Picture Post* (11 March 1939), p. 59.

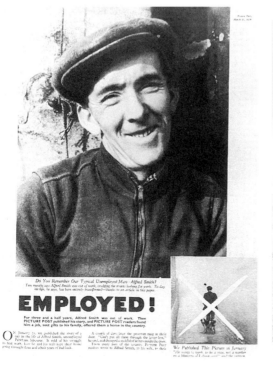

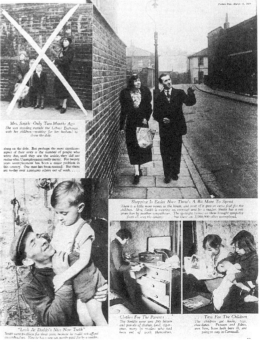

Kurt Hutton, *Picture Post* presented a touching, if tragic, homily to Smith's predicament, using him as a paradigm for the almost three million people who were unemployed at that time. The seventeen gritty images are uncompromising in their portrayal of penury and desolation. We are shown Mr Smith stoically suffering the ignominy of having to queue up for unemployment benefit and aimlessly trawling the streets and labour exchange for a job; we see him, his wife and their four children eking out a meagre living, shopping for the cheapest goods and subsisting in a cramped and dingy four-room basement. His only relaxation is a vain attempt to cultivate a yard which is 'unspeakably grim'. In contrast three months later, Lorant ran an article called 'Employed! Alfred Smith is happy' (*PP*, 11 March 1939). On the first page of the feature, a photograph from the earlier piece depicting Mr Smith walking with his dog into the mist was reprinted *sous rature* and juxtaposed with a larger portrait of the same man smiling to show off his new false teeth, partially paid for by a donation from one of *Picture Post's* readers (figure 55). On the pages that followed, two more of the pictures from the earlier photo-essay again reappeared *sous rature* and were coupled with more positive images, namely the photograph of the queue in the unemployment exchange, which was reprinted alongside photographs of Mr Smith at work digging air-raid trenches and drawing his weekly wage, and the picture of his wife and children waiting for him outside the Labour Exchange, which re-emerges in the context of several images of the Smith family enjoying their new material comforts (figure 56).

Whilst *Picture Post* was evidently motivated by a social conscience in bringing the plight of the homeless and the jobless to the attention of its readers, with the portrayal of Alfred Smith it unambiguously appeared to fall in line with the hegemonic idea that any job is better than no job at all. We are informed that Mr Smith is a skilled tradesman but that the only work he can find is digging trenches in London's parks. In return for fifty-four hours of this hard labour he was a mere £1. 10 per week better off than when he was on the dole, earning a weekly wage of £3. 50.[58] What seems to matter more here to *Picture Post* is the fact that Mr Smith has at least found a job and has thereby salvaged some of his dignity and manhood. The fact that like most of the working classes he was scarcely earning a decent living for his efforts does not enter into the argument, and we must question the failure of the magazine to challenge the exploitative nature of Mr Smith's employment situation.

With the advent of the war, however, the theme of reconstruction was pursued with renewed vigour and ideological conviction and several numbers of *Picture Post* were exclusively

devoted to it.[59] Of these one issue in particular, 'A plan for Britain' on 4 January 1941, tackled various social and political problems with dazzling prescience. All of the articles were written by eminent authorities – Thomas Balogh put forward the case for work for all; A. D. K. Owen formulated a plan for social security (interestingly the picture of Alfred Smith and his dog was used once more to illustrate this article); A. D. Lindsay postulated a system of universal education; Julian Huxley and Dr Maurice Newfield called for a public health service and child welfare centres; J. B. Priestley wrote about the need for adequate leisure amenities; and Maxwell Fry and Elizabeth Denby envisaged town planning and housing respectively along the lines of the International Modern Movement (figure 57). As with Ellen Wilkinson's earlier piece on working women, the issues were dealt with in purely human terms and were logically thought out with regard to their

PLANNING AS IT CAN BE DONE : *The Illuminated Roadway of the Future*
The traffic problem is one of the key factors in successful planning. We have modern materials, modern brains. Together they can produce such wonders as this road-junction outside New York.

in need of an overhaul. The family car is choked up and wastes petrol and oil faster than we can afford. Scrap it and buy the post-war model, in instalments, with allowance for the old.

This, roughly, gives you the justification for replanning and rebuilding if things were normal.

They are not normal. As I write, bombs are dropping on London and fire is raging. Some people imagine that what is destroyed is a good riddance. This is mistaken, because bombing is haphazard, and the bad street plan, which bombs never really destroy, is the root evil. But when

people say, as they do, that the East End of London is no loss to us, they make a confession of real relief that they have no longer to answer their consciences for those slums and muddles. They hope to rebuild to better standards. They begin, in fact, to have a real "will" to plan.
Continued overleaf

Planning Applied to a Housing Estate
Leeds abolished 23 acres of obsolete housing at one sweep. The new flats, laid out spaciously, will house nearly a thousand families.

Not Too Soon to Start : Bombed Coventry Re-plans
The City Architect surveys his model of the reconstructed city centre—the Coventry of the future.

PICTURE POST

57] 'A plan for Britain', *Picture Post* (4 January 1941).

implementation. In postulating a national social security system, for instance, Owen tabled a minimum wage for all able-bodied adults and the introduction of children's allowances, which would be paid for either in cash or in coupons. Maxwell Fry's article', 'The New Britain must be planned', addressed the need for zoned town planning with factories and industrial buildings set apart from residential areas; co-ordinated shopping centres; communal housing standing in parkland and wide tree-lined roads linking the separate zones together. And J. B. Priestley, advocating State funding for the arts and the provision of civic centres for film and drama, also made a special plea for adequate leisure time for housewives, albeit couched in somewhat patronising prose: 'constant drudgery takes more out of a woman than a man. The ideal for a woman is shortish bouts of hard work that she cares about, with plenty of hours off for the arts and graces and her personal relationships.'

Both the frequency with which such articles appeared and *Picture Post's* approach to such social issues testify to the fact that for its editors the war was not just about the heroics of battles or fighting but about more basic human needs as well. These were also the issues which seemed to attract most attention from *Picture Post's* readers – the 'Plan for Britain' published in January 1941, for example, led to floods of letters supporting it and to a conference subsequently held in the home of Edward Hulton between the authors, readers and other experts in the field.[60] If the period 1938–45 was to have any positive value at all, therefore, it would reside in the legacy of a more democratic social order, and it is in this respect that warfare and welfare were inextricably linked together in *Picture Post.* The price that would have to be paid to the ordinary British citizen for the unswerving endurance and patriotism that had been demanded of him/her during the war was nothing less than the total eradication of poverty, unemployment, bad housing and poor health. *Picture Post* was not only committed to such an ideal; it also realised that the reconstitution of British society was not something that should be left as a tentative outcome or consequence of the war years, but should be regarded as a process intrinsic to the war effort itself:

> Our plan for a new Britain is not something outside the war, or something *after* the war. It is an essential part of our war aims. It is, indeed, our most positive war aim.
> We believe that, after this war, certain things will be common ground among all political parties . . . Let us agree now on the greatest possible amount of common ground, so that – when peace comes, or before – we can proceed wholeheartedly and at once to carry through at least so much of our plan.[61]

During the Second World War, therefore, its advocacy for social welfare continued unabated and it allied this in turn to a sense of national unity and collectivism. Thus we can trace a clear ideological trajectory during the first six or seven years of the magazine's existence, from the pre-war issues with their photo-essays on the threat of fascism, unemployment and bad housing, through to the war years and the representation of the 'People's war' and reconstruction. This is not to suggest, however, that the magazine was altogether progressive or consistent in its political outlook, as closer examination in this article of its mediation of unemployment and its attitudes to gender has revealed. Equally, any impartial perspectives which it brought to bear on the objectification of the rise of fascism, the way in which it represented this as a threat to both the British and the German people, for instance, were eventually dissipated by its overt nationalism and, in portraying the invincibility and courage of the British public during the Blitz, *Picture Post* was just as prone to mythologising the situation as government propaganda.

The shift towards consumerism and youth culture

The war period witnessed *Picture Post's* most fecund and successful phase of publication and in this respect the magazine can be regarded as both a product and a victim of the collectivist ideology of the time. In 1951, the Tory Party won a General Election and the earnest social and moral crusade of *Picture Post* appeared to be awkwardly out of step with the incipient consumerism of the post-war era. During the 1950s, its circulation figures began to dwindle and its own hegemony was challenged by the advent of less sober weeklies like *Reveille* and *Weekend*.[62] These periodicals embraced more openly the cultural impact of America and mass media such as pop music, television and the cinema. Consequently, they made a more direct and wider appeal to a youthful market, something which *Picture Post* failed consistently to achieve, a point made all the more ironic by the fact that both the first and last issues of *Picture Post* featured the same image of two young female dancers jumping for joy in the air. Whilst *Picture Post* had shown some awareness of the lifestyles of young people in the broader context of reconstruction, running a feature on 2 January 1943, for instance, entitled 'Are we planning a New Deal for youth?', essentially its vision was outmoded and concerned more with the youth it knew, rather than with the teenager who was to emerge as a potent cultural and economic force by the late 1950s. This dilemma is demonstrated in the magazine's attitudes towards the impact of American culture on post-war society. In

articles such as 'The American invasion' (*PP*, 31 July 1948), 'Can't we do better than this?' (*PP*, 6 May 1950) and 'The best and worst of Britain' (*PP*, 19 December 1953) Americans were portrayed as being to blame for the loosening of moral attitudes amongst British youth who, according to Edward Hulton, now 'prefer Victor Mature to God because they can understand Victor – and he relieves the monotony of their lives; as far as they know, God doesn't.'[63]

At the same time, *Picture Post* had done little to help promote the status of the photojournalist in the same way as had occurred in Germany during the 1920s or in America, where the international photo-agency Magnum had been founded in 1947 and the American Society of Magazine Photographers in 1948.[64] As well as being the birthplace of the new youth culture, America had realised more successfully the need to encourage young photographers to enter the profession. In its fifteenth anniversary issue on 26 November 1951, for instance, *Life* announced the winners of its Young Photographers' Contest, which had attracted 1,730 entrants.[65] The winners included Dennis Stock and Elliott Erwitt who won first and second prize respectively in the picture story division, and Carroll Seghers and Robert Frank who won first and second prize respectively in the individual pictures section. The work of these young photographers reinforced the humanist tradition of the documentary style established during the 1930s by the likes of Walker Evans and Dorothea Lange, but more compellingly, according to the photographer Edward Steichen, who was one of the competition judges, had initiated a shift towards a culture based more on music and on images.[66] It was this culture which was to dominate the production and consumption of graphic design and photography by the 1960s and the implications of which are discussed in the following chapters.

Notes

1 See W. Owen, *Magazine Design* (London, 1991), p. 16.

2 Quoted in Van Deren Coke, *The Painter and the Photograph* (New Mexico, 1972), p. 259.

3 Peach Robinson had used this method to construct narrative compositions such as *Fading Away* (1857) in emulation of Pre-Raphaelite paintings. Appert's work, such as *The Execution of Gustave Chaudey* (1871), functioned more as ideological state apparatus and bolstered the bourgeois hegemony by portraying the Commune as a society of unprincipled left-wing traitors. See G. Doy, 'The camera Against the Paris Commune', *Photography/Politics 1* (London, 1979), pp. 13–26.

4 F. Roh, *Nachexpressionismus* (Leipzig, 1925), pp. 45–6.

5 Malik sold portfolios of Grosz's work in signed and unsigned editions in

order that the former would subsidise production and circulation of the latter. In 1923, for example, *Ecce Homo* was advertised in four editions ranging in price from 16 to 700 marks.

6 Heartfield had expressed this opinion in conversation with Bengt Dahlbäck at the Modern Museum in Stockholm in 1967. See P. Pachnicke and K. Honnef, *John Heartfield* (New York, 1992), p. 14.

7 Klutsis had declared that 'Photomontage, as the newest method of plastic art, is closely linked to the development of industrial culture and of forms of mass cultural media.' For a fuller discussion of Russian montage see M. Tupitsyn, 'From the politics of montage to the montage of politics', in M. Teitelbaum (ed.), *Montage and Modern Life 1919-42* (Massachusetts, 1992), pp. 82-127.

8 See *Der Arbeiter-Fotograf, Dokumente und Beiträge zur Arbeitfotografie 1926-32* (Cologne, 1977).

9 *AIZ* found that 42 per cent of its readers were skilled workers, 33 per cent unskilled, 10 per cent white-collar workers, 5 per cent youths, 3½ per cent housewives, 3 per cent self-employed, 2 per cent independent, and 1 per cent civil servants (*Arbeiter Illustrierte Zeitung*, 41 (1931)).

10 See S. Eisenstein, *The Film Sense* (London, 1943), and S. Eisenstein, *Film Form* (New York, 1949).

11 Other important agencies were Zander and Labisch, Atlantic and Pacific, and Mauritius.

12 J. Ruby, 'Harald Lechenperg, photojournalist', *Studies in Visual Communication*, 11:2 (1985), p. 65.

13 See H. M. Kirchner, 'Der Markt der Illustrierten: Gestern und Heute', *Publizistik*, 3:6 (November–December 1958), p. 332.

14 K. Korff, 'Die illustrierte Zeitschrift', *Fünfzig Jahre Ullstein 1877-1927* (Berlin, 1927), pp. 279-303, cited in A. Kaes, M. Jay and E. Dimendberg, *The Weimar Republic Sourcebook* (Berkeley, 1994), pp. 646-7.

15 For a fuller discussion of *Neue Sachlichkeit* photography see D. Mellor (ed.), *Germany, The New Photography 1927-33* (London, 1978).

16 See the following photo-essays in *BIZ*, for example: 'Vom Naturwunder zum Kulturwunder - die Industrialisierung der Niagara-Fälle', 3 (20 January 1924), pp. 43-4; 'Der Zeppelin flug nach Amerika', 35 (31 August 1924), pp. 995-6; 'Neue amerikanische Wolkenkratzerformen', 26 (30 June 1925), p. 804; 'Der höchste Turm Deutschlands', 43 (24 October 1925), pp. 1,381-2; and 'Der Erste der von New York nach Paris flog', 23 (5 June 1927), pp. 906-7.

17 A. Renger-Patzsch, 'Die Freude am Gegenstand', *Das Kunstblatt*, 12:1 (January 1928), p. 19, cited in Kaes, Jay and Dimendberg, *The Weimar Republic Sourcebook*, p. 647.

18 'Unser neues Druckerei Gebaüde in Tempelhof bei Berlin', *BIZ*, 24 (12 June 1927), pp. 979-82. The photographs were by Emil Leitner.

19 The period between 1924 and 1930 is usually regarded as the golden age of the Weimar Republic, witnessing economic, political and social stability. Along with the Dawes Plan, the Reichsmark was introduced in 1925 to help stabilise the economy, and industry also began to vindicate itself during this period. Two useful, analytical histories of the art and culture of the Weimar Republic are P. Gay, *Weimar Culture: The Outsider As Insider* (New York, 1968) and J. Willett, *The New Sobriety: Art and Politics in the Weimar Period 1917-33* (London, 1978).

20 By 1932, there were fifty-five German cities with populations of more than 50,000 people and ten with populations over 500,000. Berlin itself was

exceptional, with 4. 3 million inhabitants, by far the largest metropolis in the early 1930s. See Kaes, Jay and Dimendberg, *The Weimar Republic Sourcebook*, p. 412.

21 Sander, *Geschichte des deutschen Stadtwesens* (Bonn 1922), pp. 5-6, 18; Brecht's poems *The Crushing Weight of the Cities* (1925) and *Concerning The Cities* (1926) express this point of view. In 1922, Oswald Spengler published the second volume of his *Der Untergang des Abendlandes* in Munich, in which he inverted Sander's equation and contended that the rise of urbanism implied the decay of culture and civilisation.

22 See the following issues of *BIZ*: 16 (20 April) and 17 (27 April), 'Moskau in März 1924', pp. 387-90; 18 (3 May 1924) 'Die Stadt unter der Erde', pp. 477-8; 21 (24 May 1924) 'Eine Weltstadt der Zukunft', pp. 549-50.

23 *Ullstein Berichte*, 7 (January 1931), pp. 10-11.

24 M. Lavin, *Cut with the Kitchen Knife: the Weimar Photomontages of Hannah Höch* (New Haven, 1993), p. 55.

25 *MIP*, 11:46 (1932), pp. 1,282-3. This photo-essay and that from *AIZ* (note 22) are also included in K. E. Becker's 'Forming a profession: ethical implications of photojournalistic practice on German picture magazines, 1926-33', *Studies In Visual Communication*, 11:2 (Spring 1985), pp. 46-60.

26 *AIZ*, 11:50, 1932, pp. 1,164-5.

27 K. J. Sembach, *Style* (New York [1930] 1971), p. 19. Criticism of Renger-Patzsch's work and the New Objectivity can also be found in W. Benjamin, 'The author as producer', in P. Demetz (ed.), *Reflections* (New York, 1978).

28 M. Lavin, 'Ringl + Pit: the representation of women in German advertising, 1929-33', *The Print Collector's Newsletter* 16:3 (July/August 1985), pp. 89-93.

29 By 1934, over 1,500 newspapers and by 1938 over 5,000 magazines had been forced to cease publication by the Nazis. The two official periodicals of the Party were *Der völkischer Beobachter* (founded 1923) and *Die völkischer Kunst*.

30 See S. Lorant, *I Was Hitler's Prisoner* (Harmondsworth, 1935).

31 See C. Osman, '*Weekly Illustrated* photographers', *Creative Camera* (July-August 1982), p. 584, and I. Jeffrey, *Bill Brandt Photographs 1928-83* (London, 1993), pp. 176-8.

32 See Jeffrey, *Bill Brandt Photographs 1928-83*, pp. 178-87.

33 For a critical account of documentary photography and the FSA in America see B. W. Brannan and G. Fleischhauer, *Documenting America 1935-43* (California, 1988) and J. Hurley, 'The Farm Security Administration file', *History of Photography* 17:3 (Autumn 1993). For Mass Observation see T. Jeffrey, *Mass Observation - A Short History* (Birmingham, 1978) and H. Spender, *Worktown people* (London, 1985).

34 In a sense, all photographs tended to be regarded as 'documents' in the nineteenth century, in so far as they were generally believed literally to record the real world. Both Baudelaire in France and Ruskin in England, for example, subscribed to this view - see M. Harvey, 'Ruskin and photography', *Oxford Art Journal*, 7:2 (1984), pp. 25-33; C. Baudelaire, 'The modern public and photography' [1859], in J. Mayne (ed.), *Art in Paris 1845-62* (London, 1981), pp. 149-55; and M. Haworth-Booth (ed.), *The Golden Age of British Photography* (London, 1983). For Grierson see F. Hardy (ed.) *Grierson on Documentary* (London, 1947), and for Vertov see A. Michelson, *Kino-Eye: The Writings of Dziga Vertov* (London, 1984).

35 W. Stott, *Documentary Expression in Thirties America* (New York and London, 1973), p. 9.

36 Hardy (ed.), *Grierson On Documentary*, pp. 80 and 84.

37 T. Hopkinson (ed.), *Picture Post 1938-50* (London, 1984), p. 11. From mid-1942 until August 1951 the price per copy was raised to 4*d*, and then to 5*d* until 1957, except for the period December 1951-August 1952, when it cost 6*d* (*Ibid.*, p. 20).

38 S. Hall, 'The social eye of *Picture Post*', *Working Papers in Cultural Studies*, 2 (Spring 1972, CCCS, Birmingham), p. 90.

39 *Ibid.*, p. 74.

40 *Ibid.*, p. 73.

41 *Picture Post* (15 October 1938), p. 9.

42 Felix Man and Kurt Hutton worked for *Picture Post* between 1938 and 1950. Tim Gidal (Ignatz Gidalewitsch) had emigrated to Palestine in 1936 and as a freelance photographer contributed to *Lilliput*, *Life*, *Parade* and *Picture Post* (1938-50). Bert Hardy was one of the first photographers to receive a byline before 1945, for his photographs of firefighters in *Picture Post* (1 February 1941).

43 See, for example, 'The German Army today', *Picture Post* (4 March 1939). Tom Hopkinson in an interview with Harold Evans mentions that *Picture Post* sometimes bought stories from overseas, and mentions Lorant's links with Germany - see National Museum of Photography, Film and Television, Bradford, *Makers of Photographic History* (1989).

44 Hopkinson, *Picture Post 1938-50*, p. 22.

45 *Picture Post* (26 November 1938), pp. 14-19. The Jews pictured include Einstein, Freud, Luise Rainer, Ernst Lubitsch, Stefan Zweig and Max Reinhardt.

46 'International Brigade dismiss!', *Picture Post* (12 November 1938), pp. 34-7 and 'This is war', *Picture Post* (3 December 1938), pp. 14-24. Capa was one of the first photographers whose work was actually credited before this time, and was even proclaimed as 'The greatest war-photographer in the world' (he had also provided photographs for a feature on the Sino-Japanese War, 'Construction, destruction', in the first issue of *Picture Post*).

47 In an article entitled 'Should we stop criticising?', *Picture Post* (31 January 1942), assessed the extent of government censorship and revealed that owing to its criticism of the handling of the campaign in North Africa the subsidy that the government paid to export houses for the distribution of the magazine to troops in Libya, Egypt, Palestine, Iraq and Iran was to be halted. In March 1942, *The Daily Mirror* was similarly threatened with suspension under Section 2D of the defence regulations.

48 'Diary of the war: no. 6 - the fourth week', *Picture Post* (14 October 1939), p. 13; 'Blitzkrieg', *Picture Post* (8 June 1940), p. 25.

49 Starting on 7 September 1940, London was raided for 76 consecutive nights, suffering 430 civilian losses and 1,600 seriously injured. See A. Calder, *The Myth of the Blitz* (London, 1991).

50 E. McHardy, 'Hitler's days are numbered', *Londoners Remember Living Through the Blitz* (London, 1991), pp. 10-11.

51 Bill Brandt is not credited in this instance but we know that in September 1940 he had been commissioned by Hugh Francis, the Director of the Photograph Division of the Ministry of Information, to photograph life in London's underground shelters. see J. Buggins, 'An appreciation of the shelter photographs taken by Bill Brandt in November 1940', *Imperial War Museum Review*, 4 (1989), p. 36.

52 Calder, *The Myth of The Blitz*, is exemplary in its re-examination of the idea of the Blitz in the consciousness of the British public and the way that the meaning of it was generated by official reports and the media.

53 'Britain will ride out storms of war: "Never surrender"', *Daily Telegraph* (5 June 1940). The report cites Churchill as saying: 'I have myself full confidence that if all do their duty and nothing is neglected and if the best arrangements are made, we shall prove ourselves once again able to defend our island home, ride out the storms of war, and outlive the menace of tyranny if necessary for years, if necessary alone.'

54 *Picture Post*, 19 November 1938 and 13 May 1938. Within the WVS, women were eligible to apply for a whole range of duties including nursing, driving an ambulance, rolling bandages, delivering official messages, acting as an air-raid warden, preparing food and looking after evacuated children. Such activities were also referred to as 'passive defence'. ('Women sign on for home defence', *Picture Post* (14 February 1942), pp. 7-9). During the Second World War, women had been able to enter the armed forces by serving in the Women's Auxiliary Air Force, the Women's Royal Naval Service or the Auxiliary Territorial Service. Following the National Services (No. 2) Act of December 1941 compulsory conscription to the armed forces for all women aged between 20 and 30 years was introduced. Under the Act, however, mothers of children under 14 years of age were exempt, as were certain women taking care of other war workers.

55 'Nippy', *Picture Post* (4 March 1939), pp. 29-34; 'A barmaid's day', *Picture Post* (8 April 1939), pp. 19-23; 'The perfect parlourmaid', *Picture Post* (29 July 1939), pp. 43-7.

56 'Should women wear trousers?', *Picture Post* (1 November 1941), p. 22.

57 'Tyneside', *Picture Post* (17 December 1938), pp. 23-31; 'Enough of all this!', *Picture Post* (1 April 1939).

58 We have converted the original sums cited in *Picture Post* into decimal currency. Thus Mr Smith's unemployment benefit was £2 7s 6d per week and his wage as a trench-digger £3 9s 9d.

59 See, for example, the following photo-essays on reconstruction in *Picture Post*: 'Changing Britain' (2 January 1943, special issue); readers reply to 'Changing Britain' (16 January 1943), pp. 24-5; 'The Beveridge fight' (6 March 1943), pp. 7-11; 'Aged people and the war' (29 May 1943), pp. 22-4; 'Kitchens of tomorrow' (30 October 1943), p. 24; 'What would you like in your post-war kitchen?' (10 June 1944), p. 18; 'Planning post-war Britain: the example of Birkenhead' (8 July 1944), pp. 16-20; 'Problems of 1945' (6 January 1945, special issue); 'Bertrand Russell on the problems of peace' (21 April 1945), pp. 16-18.

60 'Readers work on the Plan For Britain', *Picture Post* (8 March 1941), pp. 14-18.

61 'Foreword', *Picture Post* (4 January 1941), p. 4.

62 Hopkinson, *Picture Post 1938-50*. Net profits in 1949 had been £209,097 and by 1957 had fallen to £11,383.

63 'The best and worst of Britain (3)', *Picture Post* (19 December 1953).

64 The founding members of Magnum were Robert Capa, George Rodger, David Seymour (Chim) and Henri Cartier-Bresson.

65 15,000 photographs were also submitted and the contest was split into two categories - the picture story division and the individual picture division. There were some $15,000 in prizes and the judges' decision was based on choosing the most consistent photographers rather than the best photographs.

66 *Life* (26 November 1951), p. 96. The other judges were Roy Stryker (who had been in charge of the Photographic Division of the FSA between 1936 and 1942); Edward K. Thompson (managing editor of *Life*); Frank Scherschel

(assistant picture-editor); and the photographers Peter Stackpole and James Wong Howe.

Suggestions for further reading

Arts Council of Great Britain, *Thirties: British art and design before the war* (1980).

Barbican Art Gallery, *All Human Life: Great Photographs from the Hulton–Deutsch Collection* (London, 1994).

K. E. Becker, 'Forming a profession: ethical implications of journalistic practice in German picture magazines 1926-33', *Studies in Visual Communication*, 11:2 (Spring 1985), pp. 44-60.

A. Calder, *The Myth of the Blitz* (London, Jonathan Cape, 1991).

Creative Camera (July–August 1982), special issue on picture magazines.

D. Evans, *John Heartfield: AIZ/VI 1930-38* (New York, Kent Fine Art, 1992).

C. Fleischhauer and B. W. Brannan (eds), *Documenting America 1935-43* (University of California Press, 1988).

M. Fulton, *Eyes of Time: Photojournalism in America* (New York Graphic Society, 1988).

T. Gidal, *Modern Photojournalism: Origin and Evolution 1910-33* (New York, Macmillan 1973).

D. Green, 'Did documentary die?', *Creative Camera* (April/May 1990), pp. 20-3.

S. Hall, 'The social eye of *Picture Post*', *Working Papers in Cultural Studies*, 2 (Spring 1972), CCCS, University of Birmingham.

B. Hardy, *Bert Hardy: My Life* (London, Gordon Fraser, 1985).

F. Hardy, *Grierson On Documentary* (London, Collins, 1947).

T. Hopkinson, *Picture Post 1938-50* (London, Chatto and Windus, 1986).

K. Hutton, *Speaking Likeness* (London, Focal Press, 1947).

M. Lavin, *Cut With the Kitchen Knife: the Weimar Photomontages of Hannah Höch* (Yale University Press, 1993).

M. Lavin, 'Ringl + Pit: the representation of women in German advertising, 1929-33', *Print Collector's Newsletter*, 16:3 (July/August 1985), pp. 89-93.

S. Lorant, *I Was Hitler's Prisoner* (Harmondsworth, Penguin, 1935).

D. Mellor (ed.), *Germany, the New Photography 1927-33* (Arts Council of Great Britain, 1978).

T. T. Minh-Ha, 'Documentary is/not a name', *October*, 52 (Spring 1990), pp. 76-98.

National Museum of Photography, Film and Television, *Makers of Photographic History* (Bradford, 1989).

C. Osman (ed.), *George Rodger: Magnum Opus, Fifty Years in Photojournalism* (London, Nishen, 1987).

P. Pachnicke and K. Honnef, *John Heartfield* (New York, Harry N. Abrams Inc., 1992).

P. Petro, *Joyless Streets: Women and Melodramatic Representation in Weimar, Germany* (Princeton University Press, 1989).

C. Phillips (ed.), *Photography and the Modern-Era: European Documents and Critical Writings 1913-40* (New York, Metropolitan Museum of Art, 1989).

J. Rogers Puckett, *Five Photo-Textual Documentaries from the Great Depression* (Michigan, Bowker Publishing, 1984).

H. Spender, *Lensman: Humphrey Spender* (London, Chatto and Windus, 1987).

W. Stott, *Documentary Expression and Thirties America* (Oxford University Press, 1973).

J. Taylor, 'Picturing the past – documentary realism in the 1930s', *TEN*. *8*, 11 (1983).

H. Ullstein, *The Rise and Fall of the House of Ullstein* (New York, Simon and Schuster, 1943).

H. Willman, *Geschichte der Arbeiter-Illustrierten Zeitung 1921-1938* (Berlin, Dietz, 1974).

G. G. Willumson, *W. Eugene Smith and the Photographic Essay* (Cambridge University Press, 1992).

7　From pop to protest: graphic design and youth culture in Britain in the 1960s

Industrial, metropolitan England, with Generation X moving rapidly from the dark, satanic mills of the greedy past towards that New Jerusalem fashioned by the dreamers and the poets of the ad. agencies, and manipulated by the Brian Epsteins, the Ned Sherrins, the Hugh Cudlipps, the J. Arthur Ranks and the Sidney Bernsteins. Moving via pop records, *Fabulous*, David Frost, Jane Asher, Italian suitings and the tantalising images on the small screen towards the new egalitarian society struggling hard to establish itself in the most class-conscious country in the world (Charles Hamblett and Jane Deverson, *Generation X*, 1964).

In 1959 *Vogue* noted that the word 'young' was appearing everywhere 'as the persuasive adjective for all fashions, hairstyles, ways of life', whilst in the same year, the anonymous anti-hero of Colin MacInnes's novel *Absolute Beginners* struck a more cautionary note remarking, 'This teenage thing is getting out of hand.'[1] Both these comments refer to the burgeoning youth culture which had evolved in the mid-1950s during the first wave of post-war affluence and which had begun to challenge the hegemony of conventional lifestyles and values. In 1955, 15- to 19-year-olds constituted 6½ per cent of the population, which grew to 8 per cent in 1963–64, and during this time, with unemployment and inflation almost non-existent in Britain, the wages of British teenagers rose twice as fast as those of other employees.[2] As a corollary, this new, youth-cultural movement forged a social identity of its own, having its own economic, political and moral agenda that postulated more pluralist patterns of production and consumption. The intervention of youth in the market-place and design was manifest in two separate, although complementary, waves of activity beginning in the 1950s. First, in the cluster of distinctive *sub-cultures* which, unfettered by convention and the economic constraints of pre-war generations,[3] openly embraced and arguably transformed consumer culture. The most self-consciously visible appearance of this phenomenon were the 'mods', who emerged in Britain in 1962. And second, in the form of a more politicised *counter-culture*

which rejected the out-and-out affluence and consumerism of its contemporaries. In either case, however, youth culture had a huge repercussion on design and appearance, and style had a large part to play in codifying group identities. This impact was evident not just in dress and fashion but also in the other visual accoutrements of the sub- and counter-cultures. Graphic design was of particular significance within this context, since it was both an affordable and an extremely versatile means of self-expression – visibly ubiquitous as posters, record sleeves, packaging, printed ephemera and magazines. This chapter explores the interrelationship of graphic design and youth culture during the 1960s through two main strands: the first concentrates on the pop aesthetic – the style of the mods – by examining the pin-up magazine, *Fabulous*, and its relationship to the music industry; whilst the second assesses the symbolism of the counter-culture (often known at the time as the 'underground') of the late 1960s and the voice of protest in terms of graphic design by focusing on another magazine, *OZ*. In addition, youth culture and the new consumerism greatly affected social mobility between different classes, and we shall address the insidious cross-fertilisation and incorporation that occurred between the mainstream and the various subcultures by considering both ideology and style during a period when, as Mary Quant aptly put it, 'Everyone wanted to look as though they were young whether they were or weren't.'[4]

Mod culture and consumerism

The novel 'visibility' of young people was a source of contemporary fascination. This interest was twofold: first, in the way that they seemed to transgress the limits of conventional behaviour; and second, in the way that they spent their income and their leisure time. Newspaper reports of the mods, the fashion-obsessed and hedonistic cult of the hyper-cool which emerged in the early 1960s, for example, almost invariably referred to the financial investment spelled out in pounds, shilling and pence that they made in clothes and the other accoutrements of style. An underlying tone of disapproval ran throughout these articles which, though recognising young people as skilled and knowing consumers, also characterised them as obsessive: the *Daily Mail* in 1964 recorded that one mod interviewed 'used to go without food to buy clothes'.[5] According to both Dick Hebdige and George Melly,[6] mod culture was defined not only as being essentially metropolitan, revolving around young people who lived mainly in London and the new towns of the south, but was also circumscribed initially by working-class male dandies who were acutely preoccupied with having the latest

in style and fashion: 'The mod lived now and certainly paid later . . . the game was limited by time and . . . there were never any re-plays.'[7] This obsession with contemporaneity formed the basis of an article in the *Sunday Times Magazine* in April 1964 which focused on the hedonistic lifestyle of 17-year-old Denzil, represented as the archetypal London mod on the scene, flitting every night of the week from club to club and spending Saturday afternoons shop-ping for clothes and records. Yet, as Hebdige attests, the article traded more on the mythology of mod culture, and Denzil was allowed to play to the gallery. Whilst there were certainly some teenagers like Denzil who could afford to pursue a similar lifestyle, the majority of mods had neither the stamina nor the wherewithal to do so, and were employed in semi-skilled jobs on a nine-to-five basis, earning no more than £11 per week. Youth had to be more cautious in the number of nights it spent on the scene and to strike a balance between the type of purchases it made. Most mods sought release from the humdrum of daily existence through fashion and pop music, which were the two interdependent commodity staples of youth culture, a point already identified by Mark Abrams in his 1959 study for the London Press Exchange, *The Teenage Consumer*. But the mod who, according to Dick Hebdige, may have exempli-fied 'pure, unadulterated STYLE, the essence of style', was never just 'a passive consumer' nor someone who merely absorbed his stylis-tic sources unquestioningly.[8] Rather, the pastiche of mod style was both self-conscious and self-effacing, and it transformed the origi-nal object of desire 'at every level of the mod experience'.[9] Thus the Union Jack became one of the floating signifiers in the context of pop design, at one extreme being used by Pete Townshend of The Who as fabric for a jacket, and at the other as a motif on mugs and tea towels. This customising of existing styles, symbols and artefacts became the hallmark of youth culture during the 1960s, a way both of ascribing a personal signature to something and of asserting creative autonomy as a consumer. Consequently, mod style was prone to continuous reinvention (and, as such, it was an analogue of the visual eclecticism of Pop Art that had emerged in the mid 1950s.) Pluralist and expendable, mod style 'came to refer to several distinct styles, being essentially an umbrella term used to cover everything which contributed to the myth of "Swinging London"'.[10]

Graphics in fashion and pop music

Writing in *1966 and All That*, Nigel Whiteley contended that it was the graphic design of the 1960s which codified 'the *meaning* of youthfulness' more successfully than anything else.[11] Certainly,

graphics occupied a singular place within the discourse of youth culture, cropping up generically in the context of posters, corporate identity systems, advertising, magazines and printed ephemera, as well as invading and transforming other spheres of design practice such as home furnishings. One thinks here, for example, of Peter Murdoch's reinforced paper chairs, decorated with a bold, graphic polka-dot motif, or the Vymura range of wallpapers launched in 1966 with their op art, monochrome patterns. Design took on what might be described as a graphic quality: flat, boldly coloured and linear. More specifically, graphics had a large part to play in the retailing of fashion, which in itself had become symbolic of the expendable and playful nature of pop culture, with the rise of the boutique. By 1970, the *Daily Mail* estimated that there were around 15,000 boutiques scattered across the British Isles, most of them catering for people under 25 years old.[12] The first of these new, informal outlets, in effect run more like parties with piped music and free gifts, was Mary Quant's Bazaar, opened in Kings Road, Chelsea in 1955, followed shortly afterwards by John Stephen's boutique for men in Carnaby Street in 1957.[13] Stephen had largely been responsible for popularising the 'Italian look' and by the mid-1960s he owned half of the boutiques in Carnaby Street which at the same time had achieved a mythical status of its own for being the fulcrum of an international mod culture; witness Ken and Kate Baynes's comment in 1966 that, 'One day, "Carnaby Street" could rank with "Bauhaus" as a descriptive phrase for a design style and a design legend.'[14] For many of the pop fashion designers, graphic design became an integral and expressive element both in the clothes they produced and in formulating a corporate identity for their boutiques. Marion Foale and Sally Tuffin, who had graduated from the Royal College of Art, for instance, incorporated a capital double-D on the right hip of a shift dress they devised in the mid-1960s, and used a similar asymmetric typographic device for the Foale and Tuffin label that was sewn on to their designs. From the outset, Mary Quant also paid particular attention to the graphic promotion of her merchandise, evident in the crisp, modernist styling of an invitation to the opening of Bazaar in 1955, with its economical and integrated treatment of typographic and photographic forms, as well as in the familiar, stylised daisy motif which was devised for Quant by Tom Wolsey. Other boutiques and designers likewise became instantly recognisable through the deployment of distinctive graphic signifiers, notably Harry Peccinotti's bulls-eye motif for Top Gear, and Anthony Little and John McConnell's Art-Nouveau inspired organic motifs for Biba in 1965–66.

It was the pop music industry, however, which was most

influential in generating and symbolising the fantasies of youth culture, and in which graphic design probably had the most significant and diverse part to play. During the 1950s and early 1960s, American rock-'n-'roll singers like Elvis Presley and Ricky Nelson had dominated the international popular music scene and had spawned home-grown derivatives such as Cliff Richard and Adam Faith. With the advent of The Beatles in 1962 and the concomitant phenomenon of Beatlemania, the tables were turned and British pop music was dominant throughout the world for the next five years or so. The Beatles initiated a veritable design industry of their own, largely orbiting around cheap souvenirs and merchandise ranging from pens to plastic models, from stockings to dresses, and from posters to wallpaper. More notably, The Beatles were an exceptionally successful chart act, attaining twenty-two top twenty hit singles and ten best-selling albums between 1962 and 1970, and as such their manager, Brian Epstein, realised that the marketing of the group in terms of sleeve design was paramount in creating the appropriate image both for the band and for its music. As with their music, therefore, The Beatles began to transform the appearance of album covers at a time when the annual sales of LPs began to double in quantity from 17 million in 1960 to just under 34 million in 1966.

The cover of the first Beatles' album, *Please, Please Me*, issued by Parlophone in April 1963, has been dismissed by historians of the period as being unimaginative and muddled, yet in essence it formed a stark, conceptual contrast to most of the unadventurous album covers which were released either before or after it by other artistes.[15] The majority of album covers, such as The Everly Brothers' *Songs Our Daddy Taught Us* (Cadence, 1958), were produced in a very *ad hoc* manner, featuring straightforward head-and-shoulders portraits or studio photographs which were afterwards elaborated with lettering and other graphic devices. As the pop photographer Gered Mankowitz testifies, this was because few record companies had their own art departments or any concern with promoting their artistes effectively: 'Up until the late 60s few LPs were conceptualised – people did not commission you to take a record cover. They'd commission you to take a picture which *might* be used for a cover.'[16] The image of The Beatles on the cover of *Please, Please Me*, however, had been taken by the well-known surrealist and fashion photographer Angus McBean in a New Objectivity style that deploys a skyscraper perspective – the group are represented from below, looking down from a stairwell at the EMI headquarters. The photograph tends to a strong, diagonal axis which has been offset by the placing of horizontal bands of letter-forms of different dimensions and weights asymmetrically across the design, and

established a trend through which each of the subsequent Beatles album covers was similarly to have a singular identity of its own. Four of The Beatles' album covers featured photographs by another well-known fashion photographer, Robert Freeman (*With The Beatles* (November 1963), *Beatles For Sale* (December 1964), *Help* (August 1965) and *Rubber Soul* (December 1965)). Of these, only two could be regarded as pioneering in terms of their design and symbolism. *With The Beatles* (figure 58) featured a stark, moody monochromatic image befitting the rhythm and blues colouration of the music on the album. Moreover, the way in which the heads of the group emerge from the darkness like some latter-day musical geniuses is redolent of the style and lighting deployed by Julia Margaret Cameron in her mysterious portraits of the astronomer Sir John Herschel and the historian Thomas Carlyle in 1867. *Rubber Soul* combined a distorted photograph, as if the group were seen reflected in the surface of a pool, with complementary ballooning, bulbous typography placed diagonally at the top left of the cover, both elements connoting the hallucinatory or dreamlike quality of songs like 'I'm looking through you' and 'Nowhere man' contained in the album.

The virtuosity of these two Beatles' sleeve designs is evident also in *A Hard Day's Night* (July 1964) and *Revolver* (July 1966). The former was the sound-track of the Beatles movie of the same name,

58] *With The Beatles*, album cover, photographed by Robert Freeman, 1963.

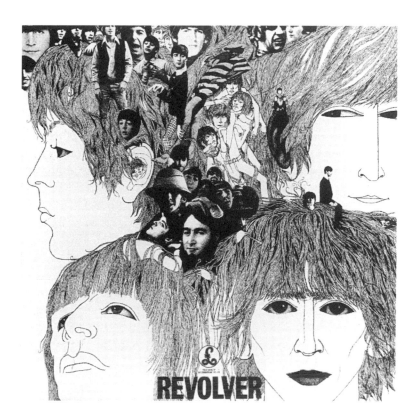

59] *Revolver*, album cover, designed by Klaus Voorman, 1966.

directed by Richard Lester and traded both on its filmic associa-
tion, through the strip format of the twenty black and white
portraits, as well as the serial portraiture of Andy Warhol's screen
prints. The latter was designed by Klaus Voorman and intermeshes
four mask-like drawings of The Beatles, executed in the graphic
style of Aubrey Beardsley but appearing to have 'real' eyes, with
smaller photographic portraits of the group in various poses (figure
59). As such, the design appears to play on a more ambiguous
signification that questions the identity of The Beatles and
whether they could ever be more than the images constructed of
them in the mass media. This masquerade was, in turn, to be trans-
ported into the 1967 design for *Sergeant Pepper's Lonely Hearts Club
Band*, which was devised by the pop artists Peter Blake and Jan
Haworth, and for which the group posed in satin bandstand
regalia, surrounded on the cover by a pantheon of the good and
the great from the past and the present. The album also included
a sheet of cut-out figures and was the first gatefold sleeve of its
kind, replete with a somewhat retrogressive pin-up of the group
on the inside and with the lyrics to the songs printed on the back.
In terms of record-sleeve design this was a turning-point, and after
1967 the album covers of many best-selling groups and singers
attempted to match the inventiveness of *Sergeant Pepper*. In 1968,

for instance, *The Sandie Shaw Supplement* (Pye), which was the sound-track to her BBC television series, featured a set of photographs arranged to look like a fashion spread from the pages of *Vogue*, whilst The Small Faces' *Ogden's Nut Gone Flake* (Immediate, 1968) with its fold-out, circular cover symbolising a tin of tobacco, received a Council of Industrial Design award. The Beatles could, therefore, be said to have completely transformed the visual appeal and symbolism of the record sleeve during the 1960s. But the impact of Beatlemania on graphic design did not just generate a more inventive and thoughtful approach to record covers; it can also be seen to have contributed to the development of new types of pop photojournals such as *Rave* (1964-) and *Fabulous* (1964–80).

Fabulous, pop pin-up photography and stardom in the 1960s

Fabulous, published by Fleetway, was initially edited by Unity Hall, with Sheena MacDonald as picture editor and John Fearn as art editor. The first issue appeared on 18 January 1964 and the last on 27 September 1980; from 4 June 1966 it became known as *Fabulous 208*, after it had joined forces with Radio Luxembourg.[17] In its fourth birthday issue on 13 January 1968, the opening editorial stated: 'FABULOUS came into the pop world on the tail-end of the dying trad jazz craze. It was a completely new paper - big, colourful, Today - and it arrived at the birth of a another phenomenon which became big, colourful and Today. That amazing infection we called Merseymania.' Here we see expressed several of the key-words associated with the 1960s - new, big, colourful, Today - signifiers of the dynamic impulse of post-war youth culture which also find currency in other texts from the period, including John D. Green's *Birds of Britain*, Christopher Booker's *The Neophiliacs* and George Melly's *Revolt into Style* in which he contested (that in the country of 'Now'): 'The words "Do you remember" are the filthiest in its language.'[18] Its unequivocal espousal of the contemporary was a major factor contributing to the success of *Fabulous*: in its heyday circulation figures were in excess of 250,000 copies every week in Britain, before gradually decreasing to an average of 180,000 copies between 1965 and 1969, and the magazine was widely syndicated across the British Commonwealth and within Europe.[19] But the magazine's initial popularity was also predicated by several other cogent factors. First, *Fabulous* initially offered twelve full-colour pin-ups every week for the price of one shilling (down to an average of eight by 1965) and by the last issue of 1969 it had published some 2,350 in total. Second, at least one pin-up of The Beatles appeared in every issue between 1964 and 1966 and

there were also special numbers devoted entirely to Beatlemania in 1964.[20] And finally, in its typologising of stardom, *Fabulous* established a feeling of complete intimacy and rapport with the singers and groups of the time who were connoted as being, more or less, one and the same kind as their fans. As Richard Dyer contends, 'Stars are ... representations of people ... However, unlike characters in stories, stars are also real people.' [21]

In the context of youth culture, this ideology of 'stars are like us' oscillated between what Andrew Tudor would call self-identification and imitation, and was manifest on different levels.[22] In some instances *Fabulous* would appear to act as a mediator between stars and fans, often being privy in its editorial to the innermost thoughts and secrets of the stars and in its photofeatures having access to their homes – see, for example, 'Billy J. Kramer has no secrets from FAB' (11 February 1964) and 'Sonny and Cher: palace of pop' (5 February 1966). At the same time, both stars and readers were incorporated as producers or editors of the magazine itself, thus The Kinks were guest editors on 14 August 1965 and readers edited 'Written by you' on 8 January 1966.[23] Through such strategies *Fabulous* could, therefore, be seen to function within the context of two of the forms of the fan economy outlined by Jon Fiske – that is, the *enunciative productivity*, where fans are encouraged to talk about or express their feelings for stars, and *textual productivity*, whereby readers are given not only a voice but also an agency for circulating and exchanging their ideas with one another.[24] Yet more consistently, it also democratised the *semiotic productivity* of the same system[25] by enabling its readers to form a feasible symbolic association or identification between themselves and their favourite pop stars. In this way, stars and fans intermingled in fashion spreads. The Dave Clark Five, Cilla Black and Marianne Faithfull, for example, were seen wearing expendable, mod outfits in recognisable, mundane *milieux* such as bowling alleys and Regent's Park.[26]

This kind of accessibility was underscored in a feature on the 'vital statistics' of The Beatles and another on four female singers, Cilla Black, Sandie Shaw, Dusty Springfield and Lulu (figure 60). In both cases, the stars represented were mostly average in height, weight and other measurements. The Beatles, for instance, were stereotypically of the same, slender stature, their hair and body profile the complete antithesis of the Charles Atlas beefcake culture of Hollywood. And whilst there was more variation between the female singers with regard to hairstyles, height and image, only Sandie Shaw, standing at five feet and eight inches tall, with her rangy, model-girl figure, defined bone structure and bohemian penchant for singing barefoot, could perhaps be regarded as

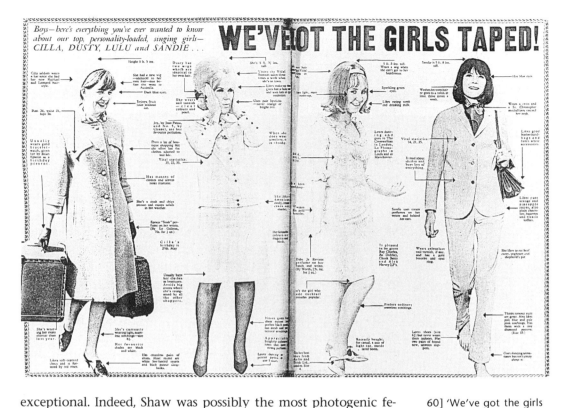

exceptional. Indeed, Shaw was possibly the most photogenic female singer of her generation, a point expressed in a curious piece of hagiography by the journalist Quentin Crewe, entitled 'The girl I love ... who keeps falling off the wall', which was written in the fawning spirit of the fan who has formed a close and adoring affinity with the object of her or his desire: 'Of course she is a pretty face. I know that because I have looked at her face every day for four years. But no one could say it was just a pretty face ... I can only think of one face that has just that depth of quality – the face of Greta Garbo.'[27]

In common with many periodicals of the 1960s, *Fabulous* also became a spawning ground for young and innovative photographic talent. It was at this time, for instance, that David Bailey, Brian Duffy and Terence Donovan were working for *Vogue* and the *Sunday Times Colour Section* (later *Magazine*); John Hedgecoe, David Montgomery and David Steen for *Queen*; Lewis Morley for *She* and *Tatler*; and Don McCullin for the *Observer*. Writing in *Revolt Into Style*, George Melly claimed canonical status for the 1960s photographer in the following unstinting terms:

> It is not an accident that the photographer should have played so vital a role in pop cultural development. For a start he is in the position to move between two worlds, that of high fashion and the pop world, carrying the ideas and rage for the new from one to

60] 'We've got the girls taped!', *Fabulous* (31 July 1965).

the other ... Into an age increasingly obsessed with sexual voyeur-
ism he seemed the ultimate eye ... Like a bee with fertilizing pollen
on his bottom he flew from Cable Street to Chelsea, engaged in an
act of visual cross-pollination.[28]

Somewhat predictably, Melly elected David Bailey as the indubit-
able personification of the new photographic pop hero – as a star
in his own right. But Bailey can hardly be regarded as an accurate
paradigm for the majority of photographers of the period, many
of whom were working under much humbler conditions as the
unsung heroes of the music industry. In recent years several ex-
hibitions and books have rehabilitated the contribution of some
of them into the history of photography, for example, Gered
Mankowitz, Robert Whitaker, Lewis Morley and Bryan Whar-
ton.[29] These figures all had their work published in *Fabulous* and
were among a roll-call of 144 photographers whose names are cited
in the magazine's picture credits between 1964 and 1969. Other
well-known photographers who contributed pin-ups sporadically
to the magazine included Robert Freeman, Dezo Hoffman, David
Hicks and Terry O'Neill, and many images were also supplied by
big picture agencies such as Camera Press, Pictorial Press and Key-
stone, or from film companies such as MGM and Paramount.
While few of the images that these photographers produced were
intended to achieve the status of art, their work certainly illumi-
nates the centrality of the pop industry to photography during
the 1960s and its significance as an entrée into photojournalism.

Although most of the photographers who provided images to
Fabulous did so on an irregular basis, between 1964 and 1970, there
were nine photographers who each supplied more than fifty pin-
ups (see table 7.1). There are several interesting points to emerge
from the information included in this table. First, this small group
of photographers produced more images (*c.* 54 per cent) than the

Table 7.1] Pin-ups
contributed by
photographers to
Fabulous (1964–66) and
Fabulous 208 (1966–69)

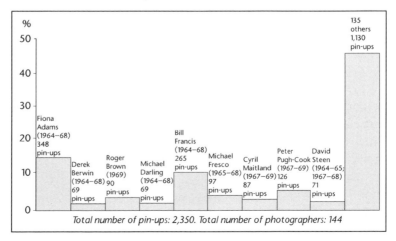

Total number of pin-ups: 2,350. Total number of photographers: 144

remaining 135 put together (c. 46 per cent); second, they appear to
fall into two generations, between 1964 and 1968 (Adams, Berwin,
Darling, Francis, Fresco and Steen) and between 1967 and 1969
(Maitland, Pugh-Cook and Brown). This watershed also divides the
period when pin-ups were of central concern to youth culture
(1964-67) from that when they became less so (1967 onwards), and
seems to overlap with a broader development in the pop industry
itself, away from the blatant fandom instituted by Beatlemania
towards an incipient rock or underground movement. And finally,
whilst there is only one female photographer included in the fig-
ures, Fiona Adams, her contribution far outstrips that of anyone
else working for the magazine. Indeed, Adams was one of a handful
of female photographers who produced pin-ups for *Fabulous* at this
time, the others being Beryl Bryden (1966), Zoe Dominic (1966), Ann
Ivel (1966), Rosemary Mathew (1964-65), Sylvia Pitcher (1967) and
Gloria Stavers (1967), each of whom contributed no more than two
images. Little or nothing has been written about any of these
women, nor has it has been possible to trace them or to find any
other photographers who recall their work, but nevertheless their
presence, particularly that of Adams, is testimony to the fact that
pin-up photography was an important entrée for women into
professional practice and photojournalism. As such, these photo-
graphers can be placed in a wider context of portrait production
which began in the 1840s, when women like Ann Cook, working
in Leeds, turned to portraiture as a way of keeping their families
after they were widowed, and continued well into the twentieth
century in the independent studio practices of Dorothy Wilding
and Vivienne (Florence Entwhistle).[30]

These female photographers, however, more often than not
were regarded as inferior to their male counterparts and their work
as feminine or frivolous – in 1924 Molly Durelle, for example, com-
mented that 'quite a good income can be made by a season on the
Riviera or some fashionable resort' – whereas Adams must be seen
as equal to any of her male contemporaries who were working in
the music industry.[31] Not only was she extremely prolific, photo-
graphing all the biggest stars of the sixties, including The Beatles,
The Rolling Stones, Cliff Richard and The Walker Brothers, but she
was also the subject of several features in *Fabulous* such as 'The
stars turn the lens on Fiona' (24 October 1964), which portrayed
her as a star photographer in her own right. Furthermore, Adams
appears from her working patterns to have been one of a few
permanently salaried photographers working either for *Fabulous*
or its publisher, Fleetway. Derek Berwin was another, and in a
questionnaire return to the authors revealed that he was paid
£1,560 per annum plus car mileage, but that copyright of his work

was owned by Fleetway. The whereabouts of Adams are sadly unknown, but we may deduce that similar conditions of service applied to her.[32] The earnings of other photographers who were working on assignment were more variable, and could be determined on either a page or space–rate basis. David Steen, for example, remembers being paid anything in the region of £20–£50 for the pin-ups he contributed to *Fabulous*, and that copyright sometimes was his and sometimes belonged to Fleetway.[33] At any rate, the earnings of the pin-up photographer in the 1960s were considerably better than that of the average 21-year-old male, who was earning £960 in 1966, but clearly a far cry from the huge amounts being paid to revered fashion photographers like David Bailey, Terence Donovan, Brian Duffy and John French.[34] In an article for *Queen* in 1965, Anthony Haden-Guest stated, for example, that French was earning over £100,000 per annum and that Bailey, Donovan and Duffy 'would all bemoan the year their turnovers slipped below £35,000'.[35] Photography may have been transformed by the 'youthquake' of the 1960s - formal training or qualifications were not a prerequisite for making one's way - but as Lewis Morley concluded, a professional hierarchy was still very much in evidence: 'Fashion was the apex, reportage a sort of halfway house, depending on the magazine one's work appeared in, and press photographers were relegated to the bottom of the league.'[36]

The majority of the pin-ups which appeared in *Fabulous* were straightforward and somewhat formulaic head-and-shoulders shots which were sometimes jazzed-up by strong colour backgrounds and/or the inclusion of incongruous props. Dusty Springfield, for example, was photographed by Barry Markham with a carriage clock against a crimson background (23 May 1964). Only a handful of photographers attempted more imaginative work by representing stars from interesting angles or in unusual settings and configurations. These include Robert Whitaker's kaleidoscopic montage of The Beatles (21 May 1966) in which he has posed the group lying head-to-head in the formation of flower petals (figure 61).[37] Nevertheless, *Fabulous*'s imagery does offer us some worthwhile perspectives on the meaning of gender in a youth–cultural context.

In its representation of stardom the magazine did maintain some of the gender polarities associated with the Hollywood studio portrait. Thus female stars gaze directly at us and are objectified as passive or sexually available, in comparison to male stars who direct their gaze downward or to the side and are depicted in more aggressive or active poses: Marianne Faithfull in a photograph by Max Steiner, for instance, is seen pouting as she unwraps her

61] Pin-up of The Beatles, photographed by Robert Whitaker, *Fabulous* (21 May 1966).

Christmas nightie (12 December 1964); Tony Hicks, in contrast, is photographed by Bill Francis with his arms resolutely folded and his legs crossed (5 February 1966). In the main, however, *Fabulous* appears to have subverted such stereotypical codes, particularly in its representation of male singers, who were connoted as being ambiguously active and passive at one and the sametime. This is evident in Bill Francis's pin-up of Mark Wynter who, like Tony Hicks, is seen with his arms folded, but who also looks at us directly, affecting a coy and alluring expression (25 January 1964), or in Fiona Adams's image of Dave Berry with his freshly-washed hair wrapped up in a towel (6 November 1965), as well as in David Steen's subtle twist on the passive 'girly-car' pose in which he has photographed a pouting Cliff Richard leaning back on the bonnet of his sports convertible (8 August 1964). These more ambiguous masculine prototypes of the 1960s can be seen to be a clear response to the fluid sexual dynamics of both pop and mod culture which had emasculated the rampant chauvinism and sexuality of 1950s rockers like Jerry Lee Lewis and Chuck Berry to the extent that 'neat haircuts, mohair suits, sweet faces and sweet songs were the order of the day'.[38] It would be erroneous to suggest that either society or the pop industry were suddenly divested of patriarchal values during the 1960s, but the mod aesthetic had certainly challenged normative stereotypes and had resulted in some blurring at the edges of strict gender positioning. These were still very much the days when gay pop stars did not come out and any overt suggestion of homosexuality would have been taboo. Nevertheless, the pop industry had a gay presence - Brian Epstein's interest in The Beatles was, after all, not exclusively profit and loss - and it knowingly exploited the affluence of young gay people by embracing male and female stars who appealed simultaneously to straights and gays. As Mark Bolan himself commented at the time: 'I'd say that Mod was mentally a very homosexual thing, though not in any physical sense.'[39]

Whilst *Fabulous* was paradigmatic of a new kind of periodical in British popular culture in so far as it was the first to feature full colour pin-ups of pop stars rather than film stars, it did, in essence, emulate the more tried and tested formulae of earlier prototypes such as the Hollywood-inspired fanzines, *Picture Goer* and *Photoplay*, and the more improvised air of music papers like *Hit Parade*. Furthermore, in its design and page layout it drew upon the new typographic forms and ideas which had become common throughout the 1950s. These included the cool sobriety of the international style of Swiss School typography and the more exuberantly eclectic free forms of American graphic design as expressed by practitioners known as the New York School, including Alexey

please turn to page 8

62] 'Fab's week with the Beatles', *Fabulous* (18 January 1964).

Brodovitch and Paul Rand. In turn, a new ethos in graphic design began to transform periodical publishing; the art direction of Tom Wolsey, for example, had done much to aestheticise the design of *Queen* between 1963 and 1964, and the colour supplements of the *Sunday Times*, the *Sunday Telegraph*, and the *Observer* also featured more innovative layouts. Likewise, new printing technologies such as high-speed web offset lithography became available in Britain during the 1960s and replaced both letterpress printing, which inhibited the combination of type and pictures, and photogravure, which was softer in edge and tone. Consequently, in the page layouts of *Fabulous* we can discern a lively and playful eclecticism which appeared to synthesise the then fashionable modernist Swiss style and the expressive plasticism of 1960s typography. This was achieved through combining letter-forms of different weights and sizes with illustrations and photographs into asymmetric configurations such as the layout for 'Fab's week with The Beatles' (18 January 1964, figure 62) and 'Cinderella Sandie' (9 January 1965), and also in the more metaphorical codes of layouts such as 'Emergency Ward 8. 5' (21 November 1964, figure 63), whose televisual sequences were based on a popular television series of the period. Such acts of stylistic incorporation are revealing of a kind of cross-pollination which existed between the mainstream and the subculture through which the ideas of one could be absorbed, yet modified, by the other. The first issue of the *Sunday Times Colour Section*, for example, not only posed the question,

63] 'Emergency Ward 8.5', *Fabulous* (21 November 1964).

'What do you need to be of the 1960s?' but also gave a firm riposte, 'Primarily under 30 years old.' This interaction, however, was often complex and could also tend towards circularity. Sometimes the ideas could go from mainstream to subculture and back to the mainstream, or vice versa, and as Dick Hebdige has suggested: 'This new economy - an economy of consumption, of the signifier, of endless replacement, supersession, drift and play - in turn engendered a new language of dissent.'[40] Graphic design was particularly prone to such transition and as the expendability of pop began to invade the sphere of mainstream publishing, so it was rejected by the subculture who had originally embraced it. But the complex relationship between the mainstream and subculture, or more accurately, counter-culture, was much more self-consciously tested and probed by a new wave of publications that emerged in the second half of the 1960s.

The counter-culture

In the summer of 1967 the *Observer Magazine* announced the demise of the mod movement ('Ready, steady, gone') and primed its readers with the key signifiers of a new, surfacing style, that of the 'flower children' or hippies.[41] A distinct and new aesthetic was emerging in Britain and in the USA which linked disparate phenomena such as the kaleidoscopic effects developed by the graphic designers Martin Sharp and Hapshash and the Coloured Coat; the multi-layered and electronic forms of experimental rock music pioneered by The Beatles and bands like The Soft Machine; and the vividly patterned, colourful and eclectic fashions of dress then on sale at boutiques like Granny Takes a Trip on the King's Road in London.

All of these forms of expression were dubbed 'psychedelic', a term which described the perceptual effects of hallucinogenic drugs like lysergic acid diethylamide (LSD). Hapshash and the Coloured Coat, a partnership formed by Michael English and Nigel Waymouth in 1967, frequently working for the imminent rock culture (and, in fact, recording their own LP), produced striking images which made reference to *fin-de-siècle* graphic designers like Aubrey Beardsley and Alphonse Mucha, then in vogue, as well to the psychedelic effects of hallucinogens.[42] Their poster for the newly formed Island record label advertising an album by Art in 1967 combined an image of the band with a floating sphere populated with 1920s flappers and a Beardsleyesque belly-dancer dissolving into amorphous, fluid shapes under the gaze of an Art Nouveau mask. The colours of this design were screen-printed in plum, azure and a rainbow effect flooding from fuchsia into bright yellow (figure 64). In 1967 and 1968 Hapshash and the Coloured Coat were much lauded for their brand of psychedelic graphics. This work redirected the convention of the pop pin-up away from the kinds of photographic portrayals of smiling or sultry stars that had been central to *Fabulous*'s success to more experimental and impressionistic images which matched the overtly intellectual and philosophical aspirations of this new culture. The *Observer* article (which, coincidentally, included a photograph of 'flower child' Nigel Waymouth), in characteristic fashion, undertook the task of discovering this 'new look', codifying the elusive and shifting markers of fashion. This 1967 article was illustrated with a drawing of an androgynous cut-out doll which the reader was invited to dress in an Indian shirt or a racoon coat, a gangster hat or a hippie necklace adorned with a bell. Viewed through the frame of earlier subcultures, this Sunday supplement predicted that the hippies, with their 'credo of love and beauty and LSD', would prove to be less troublesome than the mods with their pitched battles on the beaches of Brighton and Margate and antipathy to the older generation. 'Kids now are too smug, too safe to go ape for anything and they find it too much effort to care.'[43] The hippies were to be nothing more than just another turn on the roundabout of youth style. This author was, in fact, a purblind prophet: the hippies were the most 'visible' section of the broader counter-culture which was beginning to shape an indictment of the prevailing values and lifestyles in Britain. Identifying the origins of the underground, however, was not as simple as spotting new styles of dress and music. An intellectual or ideological current can be traced back at least to the Beatnik movement of the 1950s as well as to the New Left.

Though originating in America and much mythologised in the lone figure of poets like Jack Kerouac or the hipster in Norman

64] Advertising for 'Art,' 1967, screen-printed poster designed by Hapshash and the Coloured Coat (Nigel Waymouth and Michael English).

Mailer's celebrated essay, *The White Negro* (1957), by the late 1950s Beatniks could also be found in British art colleges and universities, and grouped around poetry magazines like *New Departures* edited by Michael Horovitz (founded 1959) and in shops like Better Books in London's Charing Cross Road, which sold imported volumes from the USA. These largely white, middle-class, non-conformists were indifferent to property and stood in opposition to self-righteous social mores and the bureaucratic and technocratic organisation of society. They were often fans of jazz, the absurdist theatre of dramatists like Albert Jarry, and abstract art, which they viewed as forms of unrestrained, spontaneous, 'pure' expression. Politically, another root of the radical face of the counter-culture can be traced to the New Left. After the Soviet invasion of Hungary in 1956 as well as Khrushchev's revelations about the brutality and criminality of Stalin's rule, emerging from Moscow at the Twentieth Party Congress of the Communist Party of the Soviet Union, the authority of orthodox Marxism collapsed amongst left-wing intellectuals. New issues became the focus of left-wing dissent: civil rights for ethnic minorities and women, Atomic Weapons and, from the mid 1960s, the war in Indo-China. The New Left adopted different campaigning strategies to match its new libertarianism. Direct action, 'sit-ins' and demonstrations shifted responsibility away from the autocratic and centrally-structured political organisations of the 'Old Left' to the individual. Many were galvanised by the marches from London to the Atomic Weapons Research Establishment at Aldermaston, organised by the Campaign for Nuclear Disarmament (CND), which was founded in February 1958.[44] Protest against the Bomb took a variety of forms from simply wearing a CND badge to demonstrations where protesters took to lying down in the street outside the Ministry of Defence. The direct approach to political activism was extolled by sections of the counter-culture in the later 1960s who sought to politicise all aspects of everyday life: 'The personal is the political', as was claimed in a much-used slogan. Important issues could not be left to professional politicians or shirked because they were too dramatic. The philosophy of the American Digger movement (a name borrowed from a seventeenth-century English libertarian fellowship) – promoted in counter-cultural papers like *OZ* and *Hapt* – stressed the importance of working for the benefit of the community ('dig where you stand') and was a major influence on the communalism advocated by some sections of the counter-culture. Direct action, at its most extreme and sometimes most romanticised, motivated terrorist groups frustrated with ineffectual peaceful methods of protest, like the Angry Brigade, which started a minor bombing campaign attacking the Employment Minister's

flat and a Biba boutique in 1971. A somewhat less grave and self-righteous form of direct action was also found in the playful situationism of the counter-culture. Pranks, happenings and hoaxes were not only a means of puncturing the 'hypocrisy' of mainstream lifestyles and prevailing values, but could restore – through pleasure and excitement – a sense of self to people alienated by joyless work and materialism. Following the lead of the American Yippie movement, John Hoyland suggested various public scams and carnivalesque actions like trying to cash a 30 ft long cheque bearing the rather pretentious slogan 'Banks are the temples of sick religion', or stripping naked in Carnaby Street.[45]

From such roots the underground became home to a loose and disparate alliance of interests and lifestyles. The hippies' advocacy of travel, hallucinogenic drugs, freely expressed sexuality, Eastern spiritualism (symbolically originating in what were regarded to be 'simple' and 'organic' societies) and anti-materialism was claimed as a way of achieving self-understanding and exploring subjective experience. Altering one's consciousness of both the material and immaterial world – perhaps through psychedelics or by taking the trail to India – was viewed as the first step in a process of liberation from 'straight' life. Others advocated escape from capitalist society and its fixed social relations (the nuclear family, patriarchy and so on) by setting up communes. Alternative communities – variously based on anarchism, arcadianism, craft technologies or vegetarianism – were set up with their own land and means of production. The year 1968 was very much a watershed with regard to international political crises – the Tet offensive of the Vietnam War in January; the murder of Martin Luther King in April; the general strike and student demonstrations in Paris in May; the invasion of Czechoslovakia by Warsaw Pact forces in August; and the Yippie disruption of the National Democratic Convention in Chicago.[46] Militant political activism became increasingly prominent within the counter-culture; feminists, Maoists and Trotskyites, Gay Liberationists and Black Rights activists became forceful voices of protest. And whilst smouldering tensions and sometimes explosive disagreements could be found between these various interests – bohemian voices rejecting ideology as unnecessarily dogmatic ('it's a brain disease')[47] and the 'politicos' upbraiding the ruralist romanticism of 'drop-outs' living in communes as 'retreatism' – a shared anger over American involvement in the war in Vietnam and antipathy to capitalism was the cement which held the counter-culture together. Notwithstanding their obvious differences, the Black Power activist, Michael X, for example, envisaged an alliance with the 'Flower Children'.[48] Whether belonging to what Mike Brake has characterised as either the 'bohemian' or

'radical' traditions within the counter-culture,[49] most sections regarded their views and lifestyles to be oppositional. And particular bywords became common property: 'revolution', the theme of the Rolling Stones' 1968 'Street fighting man' and the title of The Beatles' somewhat more sceptical song written in the same year, was the magic incantation both of the stoned bohemian dreaming of revolutionary change in people's consciousness and of the seditious Marxist plotting world revolution.

Like the earlier youth subcultures, the counter-culture (not itself an exclusively youthful phenomenon) was the product of post-war affluence. Higher education and the Welfare State provided the financial means and the opportunity for many to 'drop out'. Accordingly, the hippies could enjoy an extended period outside the constraints of the family in which to explore new lifestyles and identities. In this respect they were unlike working-class subcultures such as the mods, who tended to succumb to adult responsibilities like employment and marriage at a younger age. In fact, 'doing your own thing' was a way of 'stretching' the experiments of adolescence. 'Dropping out' of society was also often marked by a symbolic disavowal of materialism: 'Many of us do not believe in the unalienable right of property, to the extent that we own little or nothing, and do not complain when it is carried off by others.'[50] The material poverty of people living in the Third World was mythologised as nourishing a great sensitivity to nature and as a kind of Rousseauesque cultural and spiritual nobility. The commodification of the underground's sacred mantras of 'love' and 'revolution' in sloganeering posters and rock music records frequently provoked ire. Nevertheless, a new wave of businesses – head shops, wholefood restaurants, underground magazines and psychedelic light shows – were quickly established to cater for this new market. But the position of the entrepreneurs ('breadheads') within the counter-culture and, more generally, the status of hippies as consumers, was ambiguous and even self-deceiving. Non-Western styles of dress and musical instruments may, for example, have been a way of identifying symbolically with the poverty of the Third World, yet this identification was achieved through consumption of goods in a capitalist system.

One important distinction with earlier subcultures, however, can be found in the ways that the counter-culture articulated its opposition to the mainstream. As Hebdige has noted 'opposition in subculture is ... displaced into symbolic forms of resistance, [whereas] the revolt of the middle-class youth tends to be more articulate, more confidently, more directly expressed'.[51] The underground had the means to promote its counter-ideologies and to contest antagonistic coverage of its adherents' activities in the

mass media. Reports on the lifestyle of the hippies in popular British newspapers oscillated between two poles: the kind of fascinated discovery of a new style found in the *Observer Magazine* described above, and often malevolent, alarmist stories claiming to inform 'decent' readers worried about the fate of 'their children'. The *News of the World* in 1969 claimed to investigate the 'sordid truth' of hippie lifestyle in a London Street Commune squat: 'Drug-taking, couples making love while others look on, a heavy mob armed with armed bars, filth and stench, foul language, that is the scene inside the hippies' fortress in London's Piccadilly.'[52] The most important voice to counter such hostile representations of the hippies was the underground press.

The underground press

By the turn of the decade a plethora of magazines were produced for various constituencies within the counter-culture. The Bohemian tradition was catered to by *Gandalf's Garden*, 'a mystical mish-mash of madness and megalomania' at the height of its success in 1968. This magazine, written in an acid haze and edited by Muz Murray, tended to dwell on UFOs, transcendentalism and communalism. Other more politically aggressive publications like the Trotskyite *Black Dwarf*, launched in June 1968, and the *Hustler*, a black rights paper, spoke for different sections of the political underground. A handful of more enduring, familiar titles owe their genesis to the counter-culture, such as *Time Out*, the London listings magazine, which published its first issue in August 1968, and *Spare Rib*, the influential feminist magazine, was founded in 1972 by active figures in the underground. There were also numerous local publications often espousing a digger philosophy. In 1972 *Frendz* magazine published a list of 114 publications spread throughout the British Isles.[53] Although the underground press was as diverse as the culture which spawned it, there were a number of attempts to find common ground. Some magazines, for example, were members of the Underground Press Syndicate, a syndicating network originating in America which allowed articles to be shared without cost. Some of these underground publications were under police vigilance (particularly the Obscene Publications Squad) and consequently lost a number of printers who were fearful of prosecution. Distribution was also a thorny issue, resolved only by networks of 'street sellers' working on commission, and hippie shops. Consequently circulation figures were never as high as they might otherwise have been. *OZ* and *it*, the best selling magazines, occasionally touched 50,000 sales per issue (usually when a rock star graced the cover), but such figures were

65] Cover of *it*
(19 November–
3 December 1970).

exceptional. Nevertheless, in the size of their readerships, their breadth of coverage and their relatively long runs, *OZ* (1967-73) and *International Times / it* (1966-72) were the two most important underground magazines. *International Times* (renamed *it* after legal action for breach of copyright by *The Times*) is usually acknowledged as the first British underground magazine (figure 65). It was first published by a small editorial group associated with a London book shop, Indica, in October 1966.[54] The rather earnest content and unglossy style of early issues of this magazine betray its Beatnik and New Left origins. In contrast, *OZ* - the subject of the case study below - was a much more pluralist and eclectic publication, characteristics which describe its inventive graphic style as well as its editorial stance.

OZ

OZ was launched in Britain in January 1967 by Richard Neville, an Australian who had published a student magazine in Sydney under the same name in 1963.[55] Published in an irregular monthly edition with an initial circulation of 15,000 copies, *OZ*'s sales settled to an average of 30,000 copies until its closure in the winter of 1973. The editorial views and content of *OZ* were in permanent flux throughout its short life. In fact, it was a sensitive barometer of the counter-culture, producing, for example, psychedelic issues (3 and 4) in 1967 as the hippie movement surfaced, and an 'Angry *OZ*' (37)

in the aftermath of the Angry Brigade's bombing campaigns of 1971. Whilst political manifestos and passionate incitements to action appeared in a great number of issues – particularly after 1968 – the editors often took an irreverent and self-disparaging approach to such material. Following a rather verbose article on the significance of the inevitability of revolution, they added an ironic coda: 'If the revolution means prose like this, let's LOSE!'[56] Consequently, articles on flying saucers ran alongside pieces on 'How to commit revolution in corporate America', and on the sex lives of groupies before an issue celebrating situationist attacks on the 'mercantile society'. This pluralism was formalised by Neville and his colleagues in invitations to other interest groups and individuals to edit the magazines for special one-off issues. *OZ* 6 was a collaborative issue with *Other Scenes*, an itinerant underground magazine edited by John Wilcock; and, more notoriously, *OZ* 28, the 'School kids issue', was edited by teenagers and 'Female Energy' *OZ* (29) was given over to the feminist writer, Germaine Greer.

After a rather sober start, *OZ* became famous – even notorious – for its graphic invention. A regular set of contributors under the art direction of Jonathan Goodchild, a designer who had worked in advertising (from 1971 his role was filled by Richard Adams, who was working for Decca Records), included the artist Martin Sharp and the photographer Robert Whitaker, one of the more inventive contributors to *Fabulous*. The format of the magazine constantly changed; sometimes appearing as a fold-out poster ('Plant a Flower Child', *OZ* 5) and other times as a long, thin publication printed on glossy paper or in a larger square format on newsprint. The masthead changed with every issue, thereby breaking with the convention which maintained that a fixed, easily identifiable logo should occupy a set position on a magazine cover. The name of the magazine almost disappeared in Martin Sharp's design for the cover of *OZ* 3 in fluid, decorative effects, and for the cover of 'The beautiful freaks' issue of *OZ* (24), Goodchild arranged the title in tiny Letraset lettering on the tongue of the 'cover star', Lee Heater. The layout of the pages was often as inventive and changeable as its covers. The text, printed in one vivid colour, was often overprinted with an image or a dense pattern in another day-glo hue (figure 66). In a spirit of playfulness, the layout broke with convention by laying columns of text diagonally, by running single articles in narrow horizontal bands across a number of pages or by stretching and distorting type and hand-drawn lettering. Goodchild and Sharp's visual inventions drew fire from irate readers who found the magazine difficult to read. The editors were fond of reproducing their letters: 'Agit OZ. Why? Because there is a clash of colours and it strains one's eyes to read. Finding it so I passed

on an article which I most likely should have enjoyed.'[57] But Neville's rejoinder was to claim that the magazine's appearance provoked a new kind of reading which prized visual sensuality and ocular pleasure more than the mundane and anonymous column of easily read text.

Whilst Neville may have overstated his case, *OZ* certainly sought to redefine the nature of magazines. The 'Magic theatre' issue of *OZ* (16) designed by Martin Sharp, an Australian compatriot of Neville, was extraordinary even by the magazine's own standards. This issue, containing no articles or copy, was an extended collage of drawings, scribbled text and graphic elements culled from underground comics, advertising, art books and other visual sources, a practice described by *OZ* at the time as 'snare-art'. The intoxicating claims of advertising were pasted over skulls; headlines from the newspapers ('jail break') captioned quasi-biblical passages (the expulsion from 'paradise'); and politician's speeches on the 'dignity of man' contrasted with images of emaciated victims of famine. Matching the underground's avowed contempt for property, Sharp disregarded the laws of copyright by using 'plundered' images. Familiar icons and slogans, often taken from advertising or the mass media, were subverted by juxtaposition or the addition of speech balloons. Sharp's approach opened an imaginative space for the reader to connote the meaning of these often

66] Double page spread from 'Cunt power', *OZ*, 19 (July 1970), printed by a four colour lithographic process (the underprinting on the left-hand page is an image of a starving Biafran woman photographed by Don McCullin in 1968).

ambiguous combinations of images. The production of this visual issue suggests that the editors of *OZ* regarded its graphic effect as being as important as its textual content. 'At last', announced Robert Hughes, the art critic, after reading 'Magic theatre' *OZ*, 'a magazine has broken the mould in a lyrical and decisive way.'[58] Furthermore, the magazine's approach was equally novel in its attitude to professionalism. *OZ*, like many underground magazines, was designed in defiance of 'professional standards'. Exploiting recent technical inventions in offset lithography, the magazine could be designed with simple tools; a typewriter and Letraset and a reservoir of drawn and photographic images to plunder. Also, experimentation with split-fountain inking - a technique which divides the supply of ink on to the page so that two colours can be printed - produced richly coloured rainbow effects. Design itself became a game, stimulated by accident, inventive by necessity and fuelled by a spirit of playfulness.

This challenge to professionalism also influenced *OZ*'s attitudes to its readership. Not only did it offer its readers extended reproduction of their letters and frequently invited them to send in artwork and cartoons, but the editorship itself was offered to different groups. Most famously, in 1970 *OZ* published this invitation: 'Some of us at OZ are feeling old and boring, so we invite any of our readers who are under the age of eighteen to come and edit the April issue.'[59] Of course, *Fabulous*, a few years earlier, had invited reader participation, but *OZ*'s approach was a more self-conscious response to critiques of the mass media which were in circulation amongst the New Left. In the same year Hans Magnus Enzenberger argued in *New Left Review* that the mass media, rather than serving communication, inhibits it, because it 'allows no reciprocal action between transmitter and receiver'.[60] Enzenberger rejected *manipulation theses* - that is resigned views which saw the media as a monolithic mechanism for controlling opinion - as self-defeating. In contrast, new media, he argued, can be decentralised and socialised to encourage anyone to become a broadcaster, writer or publisher. In becoming engaged with the production of meaning in society, one would learn from the process itself and become a more critical and politically conscious citizen. Following the logic of such critiques, a magazine which sought to be politically radical was not simply required to change the message contained on its pages but also to overthrow the conservative social relations of production and consumption; in other words, readers of underground magazines should be encouraged to become writers. As a result of *OZ*'s appeal, the 'School kids issue' (28) contained articles and artwork by twenty teenage readers. These were for the most part rather uninspired pieces about conditions

and prejudice at their schools. A few images and articles prepared by these teenagers, however, took on the theme of sex: notoriously, a montaged image which combined Rupert Bear's head with a sexually-graphic cartoon strip originally drawn by the American illustrator, Robert Crumb, a drawing of a sexually-aroused schoolmaster abusing a boy entitled 'School atrocities' and a photographic image of a doe-eyed 15-year-old contributor to the issue entitled 'Jail bait' (again a reference to Crumb's work). It was largely this material and the caption 'School kids issue' on the cover which prompted the prosecution of the magazine's editors for obscenity and for corrupting public morals; the culmination of what they regarded as a campaign of harassment by the authorities. The resulting court case in 1971 initially led to convictions of Neville and his 'conspirators' on the charge of publishing an obscene article, which were only quashed on appeal.[61]

Sexuality – or rather its representation – was a thorny issue which *OZ* dealt with in a rather ambiguous fashion. Throughout its run, the magazine featured numerous images of nudity and sexual activity as well as championing a liberated, 'free' approach to sexuality. At the outset, underground ideology claimed that attitudes to sex in Britain were still repressed under a shadow of ignorance and prurience. The exposure and celebration of sexuality would, it was argued, have a liberating effect. Consequently, the rather coy and subliminal sexuality of *Fabulous* was usurped by a very graphic and even pornographic explicitness. Moreover, the reproduction of sexually provocative material was implicitly claimed as an index of the underground's own emancipation from conventional morality. *OZ* set out to test the tolerance of the so-called 'permissive society' which had been officially acknowledged in progressive legislation dealing with contraception (The National Health Service (Family Planning) Act 1967), abortion (The Abortion Act, 1967), Homosexuality (The Sexual Offences Act, 1967) and definitions of obscenity (The Obscene Publications Act 1959, amended 1964). However, a contemporary feminist critique was also emerging even in the pages of *OZ*. With its sharp ability to catch the ascending currents within the underground, the magazine gave over the editor's role to Germaine Greer for the 'Female power' (also known as 'Cunt power') issue in 1970. The Pop Art-inspired image on the cover commented to the harnessing of 'female energy' by consumerism. The content of the issue was a mix of vaginal imagery, celebrations of female sexuality and calls for equal rights and responsibilities (figure 66). Although largely absent from the pages of this issue, feminism was increasingly developing a critique of the ideological effects of the ways in which women were represented in the mass media and advertising, and, in particular, in

pornography. Despite its apparent engagement with gender politics, the treatment of sexuality in this and similar magazines tended to be naive and hedonistic. In retrospect, *OZ* stands indicted, like much of the counter-culture in the late 1960s, with the failure to fully understand feminist concepts of liberation: 'sexual freedom ... frequently turned out to mean freedom for men at the expense of women'.[62]

Some commentators - including David Widgery from within the *OZ* 'camp' - have suggested that the sexism of the underground press and *OZ* in particular (dubbed the '*Playboy*' of the underground'), was one of a number of factors which brought about its collapse in the early 1970s (*it* ceased publishing in 1972 and *OZ* in the following year).[63] More generally, the recession in the British economy - which came into pronounced crisis in 1973 when oil prices rose dramatically - had an adverse effect, hitting the underground press directly by reducing the purchasing power of its readership and its revenue from advertising, and by increasing paper prices. Optimistic attempts by the *OZ* team to produce a weekly newspaper, *Ink*, which would combine 'professionalism' and solid financial backing with a radical agenda floundered in financial crisis, internal squabbles over workers' democracy and competition from other magazines, a year after its launch in 1971. But even before the slump hit, the radical impulse which had fuelled these magazines in the late 1960s was being *incorporated* as entrepreneurs seized opportunities to profit from a burgeoning culture. This process and the ways in which the counter-culture responded to it reveal a significant difference from earlier subcultures and had a marked effect on the kind of graphic forms that magazines like *OZ* developed.

OZ and incorporation

Incorporation has been a widely explored concept used by academics and other cultural commentators to explain the diffusion and ultimately the dissolution of subcultures. Alternative cultures like the underground which stand in opposition to socially sanctioned lifestyles are drawn into an approved sphere by being commodified and, as such, take on recognisable forms, or they are rendered meaningful by processes which divest them of any kind of significant dissidence. Hebdige has characterised this 'process of recuperation' as having two guises: the *ideological form* and the *commodity form*.[64] In its first guise, the underground was frequently represented in the tabloid press in ways that characterised it as *other*, that is outside any kind of 'normal' behaviour and therefore as trivial or antisocial; or in ways that domesticated it, that is by

showing how the members of the underground are really 'just like us' (notably through stylish studio portraits of hippie *families* taken by the photographer Irving Penn which appeared in *Look* magazine in America in 1967 and in the *Daily Telegraph Magazine* in 1970). In its second guise, the very signs which the counter-culture used to signal its disaffection with mainstream values and lifestyles ordered by capitalism were turned into commodities by businesses seeking to 'cash in' on the fashionability of the new. In either instance, the underground was measured by standards from without, by those which it sought to overturn.

Although earlier subcultures like the mods recognised their vulnerability to incorporation – often objecting to the 'commercialisation' of their style – the counter-culture of the late 1960s was in a uniquely better position to refute its insidious encroachment on its project.[65] The underground was, after all, aware of the rise and fall of the subcultures which had preceded it (as well as much earlier movements like Dada in the 1910s). Moreover, it was a skilled plunderer of the 'overground' itself. Many early commentaries anticipated the inevitable commercialisation of the hippie culture: George Melly, for example, reporting Hapshash and the Coloured Coat's poster designs, noted that 'as the influence of Hapshash spreads into commercial advertising, the inevitable law of pop culture has begun to operate: that which spreads becomes thinner'.[66] The underground press offered a forum to warn its readers about processes of incorporation and to probe the prejudices of the mainstream media. However, these magazines were scored with ambiguity; the vicissitudes of working in a commercial environment conflicted with their anti-capitalist ideologies.

OZ offers many examples of such awareness of the processes of incorporation. When the magazine was approached by the *People* newspaper for an interview with its editor, Lee Heater, a 'dreadlocked' and unwashed 'freak' was presented to the paper's journalist and photographer. When the *People* published its report on *OZ*, with Heater's portrait, in September 1967 under the title 'Can YOUR kid buy this?' Neville and his colleagues made much capital from the gullibility of tabloids. But *OZ* tended to be more concerned with the commodification of the underground. The photographic cover of 'Yippie' *OZ* (31) by David Nutter, for example, showed a gun-toting family of urban guerrillas in the style of Penn's 1967 photograph, captioned with the legend: 'He drives a Maserati / She's a professional model / The boy is the son of the art editor of *Time* magazine / Some revolution!' (figure 67). The ambiguous signifiers of the radical politics seemed to be sliding into mere fashionability. Writers in *OZ* were particularly antipathetic to *Rolling Stone* magazine which was launched in London in March 1969

by Jann Wenner (with financial support from Mick Jagger) following the success of his San Francisco title.[67] Whilst *Rolling Stone* shared a little of *OZ*'s graphic style (not least by employing its designer, Jon Goodchild, to work on its American edition), it strove to maintain an apolitical stance in the pursuit of the profits that could be made from fans of the new rock culture which had taken hold in Britain. Germaine Greer, writing in *OZ*, was particularly irked by its timidity regarding provocative material and its disavowal of ideology.[68] Nevertheless the rising popularity of rock music evident at festivals like 'Phun city' in Sussex and the Isle of White Festival, where Jimi Hendrix and Bob Dylan performed in 1970, brought mixed blessings to *OZ*, which had itself championed the same musicians. As a consequence, from 1969 it increasingly enjoyed the 'venal patronage' of advertisements placed by record companies. Although welcoming the novel financial stability that these ads brought, the editors were uncomfortable with the presence of commerce on the pages of the magazine. In fact, they dubbed the page which advertised back copies and merchandising as the 'rip-off section'.

OZ's anxieties about its incorporation had a particular effect on its innovatory graphic format. Raymond Williams, in his assessment of the process of incorporation, suggests that it is difficult for a dominant culture to absorb the 'emergent' forms of an oppositional culture.[69] New meanings and practices which have yet to be normalised seem totally incomprehensible to a value system which lacks a gauge by which to measure them. As we have seen, *OZ*'s editors were particularly keen to celebrate and even to overestimate the illegibility of the magazine's layout. In the light of

67] Cover of 'Yippie' *OZ*, 31 (1970) photographed by David Nutter.

Williams's notion, the magazine's graphic restlessness can be interpreted as an attempt to sustain its impenetrable, 'illegible' character and to hold off the moment of assimilation. *OZ* linked its graphic form to its pluralist political agenda. In 1968 the 'Flying saucer' issue congratulated itself with these words: 'People get very annoyed because *OZ* is not laid out like the *New Statesman*. "You publish some extraordinary articles," they say, "but no one can take them seriously when they're painted upside down in circles in purple ink." Yes, they can. That is why *OZ* is banned in Parkhurst Prison. Their library committee take *OZ* very seriously.'[70]

Graphic design working in the 'service' of youth culture in Britain in this period operated in a dynamic and modish climate, though not one predicated on fashionability alone, and the process of commercialisation - or the 'conventionalisation' of these forms - was not a 'one-way street' in which business profited from the invention and creativity of a new wave of young photographers and designers working in this expanding sphere; their work often plundered images and symbols already circulating in the mass media. These forms, appearing in magazines like *Fabulous* and *OZ*, were highly fluid, unstable signifiers which could be valorised by the underground or legitimated by the mainstream. Graphic design was, in this sense, a contested space. Whilst this was by no means a unique phenomenon, the equivocal 'space' between subculture/underground and the 'mainstream' in which these designers and photographers worked, and the increased velocity of the turns of fashion during the 1950s and the 1960s, presented opportunities for designers to probe self-consciously the limits of the shifting boundaries of accepted social conventions - notably in the relaxation of sexual mores - as well as the limits of magazine design.

Notes

1 See, for example, the April 1959 issue of *Vogue* which was dedicated to the 'Young idea'; C. MacInnes, *Absolute MacInnes: the Best of Colin MacInnes*, edited by T. Gould (London, 1985), p. 69.

2 See A. Marwick, *British Society Since 1945* (Harmondsworth, 1982), pp. 117-18.

3 It should be noted that 'youth' as a distinct category had been the subject of many sociological surveys before the 1950s. See D. Hebdige 'Hiding in the light: youth surveillance and display', in *Hiding in the Light* (London, 1988), pp. 19-26.

4 M. Quant, 'A design for personal living', *The Listener* (December 1974), p. 816.

5 'It's a mod, mod, mod, mod world', *Daily Mail* (15 September 1964), pp. 14-15.

6 D. Hebdige, *The Style of the Mods* (Birmingham, 1974); G. Melly, *Revolt into Style* (Harmondsworth, 1972).

7 Hebdige, *The Style of the Mods*, p. 8.

8 *Ibid*, p. 9.

9 *Ibid.*

10 *Ibid.*, p. 4. Following the lenient Gaming Laws of 1963, London had attained a notorious cachet for being the centre of night-life in Britain. The dynamic pace of the London scene was reinforced in an article by J. Crosby, 'London - the most exciting city', *The Daily Telegraph* (30 April 1965).

11 N. Whiteley, 'Shaping the Sixties', in J. Harris, S. Hyde and G. Smith (eds), *1966 And All That - Design and the Consumer in Britain 1960-69* (London, 1986), p. 26.

12 E. Ewing, *History of Twentieth-Century Fashion* (London, 1975), p. 186.

13 See M. Quant, *Quant by Quant* (London, 1966), p. 45 where she describes the atmosphere in Bazaar as 'a sort of permanently running cocktail party. '

14 K. Baynes and K. Baynes, 'Behind the scene', *Design*, 212 (August 1966), p. 28.

15 See, for example, N. Whiteley, *Pop Design: Modernism To Mod* (London, 1987), p. 108, and Harris, Hyde and Smith, *1966 and All That*, pp. 135-6.

16 H. Hammond and G. Mankowitz, *Pop Star Portraits of the 50s, 60s, 70s and 80s* (London, 1984), p. 9.

17 By the time of its closure, the magazine was called *Fab Hits*. Somewhat ironically, it was incorporated into *Oh Boy!*, a girls' periodical that had taken its name from Jack Good's 1950s pop programme and was the antithesis of the 'Swinging 60s' syndrome into which *Fabulous* was launched.

18 Melly, *Revolt into Style*, p. 8; J. D. Green, *Birds of Britain* (London, 1966); C. Booker spoke of a collective image grounded in 'youth', 'vitality', 'creativity', 'originality', 'life' and 'excitement', in which 'all that was new was instantaneously and unquestioningly embraced'.

19 See *Benns Newspaper Press Directory* (London, 1965 and subsequent years). *Fabulous*'s nearest rivals were *NME* which averaged *c.*250,000 copies weekly; *Rave*, 140,000 copies monthly, and *Valentine*, 190,000 copies weekly. But it was never as popular as *Jackie* which also featured colour pin-ups and had an increasing circulation throughout the 1960s - 350,000 in 1964 and 504,000 in 1969. Within Europe, *Fabulous* was available in Sweden, Norway, Germany and Holland from 1964, and Denmark and Finland from 1965.

20 See '*Fabulous* goes all Beatles', 5 (15 February 1964); and '*Fabulous* goes Beatling off to Paris', 11 (28 March 1964).

21 R. Dyer, *Stars* (London, 1979), p. 22.

22 A. Tudor, *Image and Influence* (London, 1974), p. 81.

23 Other guest star editors were Gerry Marsden (18 April 1964); Billy J. Kramer (22 August 1964); Gene Pitney (24 April 1965); Donovan (13 November 1965); The Walker Brothers (18 December 1965); The Hollies (5 November 1966); and Cat Stevens (8 July 1967).

24 J. Fiske, 'The cultural economy of fandom' in L. A. Lewis (ed.), *The Adoring Audience - Fan Culture and Popular Media* (London, 1992), pp. 37-42.

25 *Ibid.*

26 See, 'Oi'll give 'em foive' (25 January 1964); 'Anyone who had a heart' (18 April 1964), and 'Sugar sweets' (12 September 1964).

27 Q. Crewe, 'The girl I love ... who keeps falling off the wall', in the *Sunday Mirror* (13 October 1968).

28 Melly, *Revolt into Style*, p. 144.

29 Hammond and Mankowitz, *Pop Star Portraits*. Their work was also the subject of an exhibition, 'Pop people' that started at the Photographer's Gallery in 1981 and which afterwards was toured extensively across Britain; R. Whitaker, *The Unseen Beatles* (London, 1991) – Whitaker was also the subject of a retrospective exhibition at Brighton Museum and Art Gallery entitled 'Underground London', between September and November 1994; L. Morley, *Black and White Lies* (London, 1992); and B. Wharton, exhibition at The Gallery, 74 Audley Street, London, 6-10 October 1992.

30 B. V. P. F. Heathcote, 'The feminine influence: aspects of the role of women in the evolution of photography in the British Isles', *History of Photography*, 12:3 (July/September 1988); and V. Williams, *The other observers, 1900 to the present* (London, 1986), chapter 7.

31 M. Durelle, *Women's Employment* (London, 1924).

32 Derek Berwin, questionnaire return (7 September 1994). (A questionnaire was sent in July 1994 to ten of the photographers who had worked for *Fabulous*; of these, Derek Berwin, David Steen and Roger Brown replied.)

33 David Steen, questionnaire return (15 September 1994).

34 A. Marwick, *British Society Since 1945*, p. 118. See also L. McCartney, *Sixties: Portrait of an Era* (London, 1992), who recalling her career in 1966 comments, 'It gave me the independence I needed, it provided me with an exciting life, and although I didn't make a fortune, it enabled me to pay the rent, buy food and look after my little daughter.'

35 A. Haden-Guest, 'The new class - a post-mortem', *Queen* (November 1965).

36 D. Berwin, for example, had taken photography at evening classes when he was 14 and began work in a press agency one year later; see L. Morley, *Black and White Lies*, p. 123.

37 Whitaker took seven pin-ups of The Beatles in total for *Fabulous* between 1965–67 and had been working with the group since 1964.

38 Hammond and Mankowitz, *Pop Star Portraits*, p. 7.

39 M. Bolan quoted by N. Cohn, 'Ready, steady, gone', the *Observer Magazine* (27 August 1967), p. 12.

40 D. Hebdige, 'Towards a cartography of taste 1935-62', in *Hiding In The Light*, p. 71.

41 Cohn, 'Ready, steady, gone', p. 19.

42 See G. Melly, 'Poster power', in the *Observer Magazine* (3 December 1967), pp. 13-17; for an early view of the contemporary fascination with Art Nouveau see P. Barker, 'Art Nouveau riche', *New Society* (2 July 1964), pp. 24-6.

43 Cohn, 'Ready, steady, gone', p. 19.

44 The CND campaigns established a deeper link with a long-established tradition of pacifist non-conformism. Leading British thinkers such as Bertrand Russell were active campaigners against the bomb.

45 J. Hoyland, 'Right! Now that summer's here and the heat is on', in *it*, 57 (23 May-June 5 1969), p. 3.

46 See N. Young, *An Infantile Disorder? The Crisis and Decline of the New Left* (London, 1977), pp. 205-22.

47 R. Neville, *Play Power* (London, 1971), p. 14.

48 Anon., 'Michael X and the Flower Children', *OZ*, 7 (October / November 1967), p. 14.

49 Mike Brake, *The Sociology of Youth Culture and Youth Subcultures* (London, 1980), pp. 86-114.

50 G. Greer, 'Flip-top legal pot', *OZ*, 15 (October 1968), unpaginated.

51 D. Hebdige, *Subculture* (London, 1981), p. 148, note 6.

52 *News of the World*, 21 September 1969, cited in Brake, *The Sociology of Youth Culture*, p. 98.

53 *Frendz*, 27 (12 May 1972), pp. 20-1.

54 *Private Eye*, published from 1961 to satirise the political establishment in Britain, might be described as an underground magazine. But its independence from and even disdain for the underground scene marks it out as an early exception.

55 Although Richard Neville was the main force behind the magazine throughout its life, many other figures were involved in *OZ*'s editorial decision-making processes. See R. Neville, *Hippie Hippie Shake* (London, 1995).

56 *OZ*, 19 (n. d. 1969), p. 23.

57 Letter printed in *OZ*, 14 (n. d. 1968), p. 2 .

58 Robert Hughes in *OZ*, 17 (n. d. 1968), unpaginated.

59 *OZ*, 26 (February 1970), p. 46.

60 H. M. Enzenberger, 'Constituents of a theory of the media', *New Left Review*, 64 (November/December 1970), p. 15.

61 See T. Palmer, *The Trials of OZ* (London, 1971).

62 S. Laing, 'The politics of culture: institutional change', in B. Moore-Gilbert and J. Seed (eds), *Cultural Revolution? The Challenge of the Arts in the 1960s* (London, 1992), p. 93.

63 D. Widgery, 'What went wrong?' in *OZ*, 48 (Winter 1973), pp. 8-9, 66. See also E. Nelson, *The British Counter-Culture, 1966-1973* (London, 1989), pp. 138-40.

64 Hebdige, *Subculture*, pp. 92-9.

65 Melly has suggested that the mods' overt effeminacy was an attempt to stave off the commercialisation of the style. See Melly, *Revolt into Style*, p. 152.

66 *Ibid.*, p. 137.

67 *Rolling Stone* was first published in San Francisco in November 1967.

68 G. Greer, 'The million-dollar underground,' *OZ*, 22 (July 1969), p. 4.

69 R. Williams, 'Base and superstructure in Marxist theory', in *Problems in Materialism and Culture* (London, 1980), pp. 40-1.

70 *Flying Saucer OZ*, 9 (February 1968), p. 7.

Suggestions for further reading

C. Booker, *The Neophiliacs* (London, Collins, 1969).

I. Chambers, *Popular Culture: The Metropolitan Experience* (London, Methuen, 1986).

N. Fountain, *Underground: The London Alternative Press 1966-1974* (London, Comedia/Routledge, 1988).

J. Green, *Days in the Life: Voices from the English Underground 1961-1971* (London, Heinemann, 1988).

J. Harris, S. Hyde and G. Smith, *1966 and All That: Design and the Consumer in Britain 1960-1969* (London, Trefoil, 1986).

Harvester Collection of the Underground and Alternative Press in Britain, 1966-1973 (Brighton, Sussex, Harvester, 1978).

D. Hebdige, *Subculture: the Meaning of Style* (London, Methuen, 1979).

D. Hebdige, *Hiding in the Light* (London, Routledge, 1988).

H. Jones, 'Don't overlook the underground press', *Penrose Annual*, 66 (1973), pp. 49-62.

L. A. Lewis, *The Adoring Audience: Fan Culture and Popular Media* (London, Routledge, 1992).

N. Lewis, *Outlaws of America: the Underground Press and its Context. Notes on a Cultural Revolution* (Harmondsworth, Pelican, 1972).

G. Melly, *Revolt into Style: the Pop Arts in Britain* (Harmondsworth, Penguin, 1972).

E. Nelson, *The British Counter-Culture 1966-1973* (London, Macmillan, 1989).

R. Neville, *Play Power* (London, Paladin, 1971).

T. Palmer, *The Trials of OZ* (London, Blond and Briggs, 1971).

W. Owen, *Magazine Design* (London, Laurence King, 1991).

T. Roszak, *The Making of a Counter Culture: Reflections on the Technocratic Society and Its Youthful Opposition* (London, Faber & Faber, 1970).

P. Stansill and D. Z. Mairowitz, *BAMN: Outlaw Manifestos and Ephemera 1965-1970* (Harmondsworth, Penguin, 1971).

N. Whiteley, *Pop Design: Modernism to Mod* (London, The Design Council, 1987).

8 In the empire of signs: ideology, mythology and pleasure in advertising

> The essence of advertising consists of one will using every means of suggestion available to persuade the greatest possible number of other wills to act in determined ways ... good design organizes all the necessary parts into a balanced and harmonious unity (Max Burchartz, *Die Form*, 1925).

Of all the graphic systems addressed in this book, advertising is certainly the most abundant, channelled to us via magazines, posters, radio, cinema and television, and the discourse which, moreover, potentially wields enormous ideological power and influence on our lives. For better or for worse, advertising has come to occupy a unique cultural space in the economic, social, political and aesthetic spheres of everyday life and in the twentieth century has become, according to Mason Griff, *the* central institution of mass society:

> It has the connotations of omnipotence and omnipresence in a sense comparable to the Church in the Middle Ages or industry during the nineteenth century. It is central in containing greater social power over the institutional arrangement than any of the basic institutions of a society ... Advertising has as its goal the deliberate breaking down of the rational process both directly through persuasion and indirectly through the use of techniques to circumvent the conscious rational process.[1]

The persuasive tactics and the ways in which advertisements work on our consciousness alluded to here by Griff have been one of the chief concerns of both protagonists (mostly the advertising profession itself) and opponents of advertising (mostly left-wing critics such as Hoggart, Williams and Berger).[2] In comparison to most of the material included in this book, the literature on the subject is immense, though not always critical. The most worthwhile writing is that which has attempted to examine it from diverse ideological or methodological perspectives, as the above-mentioned authors have done. Judith Williamson's *Decoding Advertisements* (1978) has been, however, probably the key text in this kind of enquiry, and in it she contextualises advertising in a

Marxist-feminist framework, with resort to semiological analysis. Most authors writing in her wake have admitted a huge intellectual debt to Williamson's endeavour – Robert Goldman's *Reading Ads Socially*, for instance, which is a more recent attempt to assess the ideological signification of advertisements, but which also essays to square the semiological circle somewhat by questioning the hegemony of bourgeois commodity culture with reference to a more pluralist market and the challenge faced by advertisers from a more knowing spectatorship after 1980.

This chapter functions with similar aims and objectives in mind. We do not intend, therefore, to synthesise the entire history of advertising (although there is 'history' included here by way of necessary context), but rather to explore how and what advertisements signify by considering both the codes which govern their production and the symbolism with which they work. Given that there are literally thousands of new campaigns produced and circulated every year in Britain alone, the first part of this chapter addresses the role of semiology and mythology in helping us to decode the ideological impact of advertisements with reference to various campaigns, whilst the second part elaborates these themes further by concentrating more specifically on the signification of pleasure in tobacco advertising and the influence of Surrealism on Benson and Hedges since 1976.

The evolution of modern mass-media advertising

Small-scale, classified advertisements for products such as soap, tobacco and alcohol were found in cheap papers during the eighteenth century, but illustrated campaigns as we understand and expect them to appear today did not become common until the abolition of advertising duty in 1853 and stamp duty on periodicals in 1855. After this point, most popular illustrated weeklies carried a certain number of half- and full-page advertisements which helped them to keep circulation costs down (see chapter 1), and poster advertising was common by the 1890s (see chapter 3).[3] The nineteenth century also witnessed the beginning of intense competition between different manufacturers of similar products to become market leaders, and the realisation that advertising would have a major role to play in attaining this control. As Guy Debord has argued, 'EACH INDIVIDUAL COMMUNITY fights for itself, cannot acknowledge the others and aspires to impose its presence everywhere as though it were alone.'[4] The so-called 'soap war' of the 1880s between A. and F. Pears and Lever Brothers is testimony to the fact that, in a capitalist economy, being brand leader was quintessential. In 1865, for example, Pears's annual bill for

advertising was £80, but this rose to between £100,000 and £130,000 after T. J. Barratt took control of the company in the 1870s, and both companies combined were spending in the region of half a million pounds on promotional campaigns by the start of the twentieth century.[5] The chief reason for the marked increase in advertising expenditure by these companies can be attributed to their concern to find a visually symbolic association for their products with works of 'high art'. Lord Lever, for instance, issued reproductions of well-known Victorian paintings in exchange for soap wrappers, and from 1891 onwards Pears issued Christmas Annuals containing chromolithographs and heliographs of popular art works.[6] Possibly the most notorious example of this kind of practice was the linking of Pears with Sir John Everett Millais's *Bubbles*, the copyright of which Barratt had purchased from the editor of the *Illustrated London News*, William Ingram, in order to reproduce it as an advertising poster.[7]

It was from such origins that commercial art and advertising were to become an increasingly important economic and cultural phenomenon during the twentieth century – in 1910, £13. 5 million was spent on press and poster advertising (accounting for 0.5 per cent of the gross national product) whilst in 1990 approximately £7 billion pounds was spent on advertising in the mass media (the equivalent of 2 per cent of GNP).[8] The nineteenth century also witnessed the evolution of the first advertising agencies – J. Walter Thompson, for example, had been formed in the 1870s – but it was not until the 1920s that professional practice was consolidated with the foundation of agencies like Charles Higham, William Crawford and Young and Rubicam. From this time until the 1950s, the advertising scene was dominated by Madison Avenue, New York, but most American agencies had satellite organisations in Britain and in Europe. America was likewise the birthplace of a new form of advertising in the 1920s which was based on modernist visual aesthetics and which prioritised the use of the hard-edged, straight photographic images. One of the first apologists for the application of art to commerce was the Photo-Secessionist Clarence White, who was invited by Arthur Wesley Dow to teach photography classes at Columbia Teachers' College, New York in 1907. Under Dow's influence, White also began to realise the potential of photography as a mass medium, eventually producing work for *Vanity Fair* and *Vogue* and showcasing commercial exhibits at the Art Center which he had founded in 1921 for this purpose. The first Art Center catalogue in 1921 drew particular attention to the scope of photography in advertising, declaring that:

The visitors will be interested in the recent developments in artistic

photography as applied to modern advertising shown in these
galleries. It is not impossible to make a beautiful composition of
objects which are illustrations in an advertising page of our popular
magazines, or in other printed matter, and the American advertiser
is becoming more and more aware of this fact.[9]

The modern style alluded to here was manifest in many photo-
graphs advertising commodities, such as Paul Outerbridge jun.'s
'Ide shirt collar' for *Vanity Fair* in 1922, and owed much to the
example of Paul Strand, whose work had been featured in *Camera-
work* in June 1917. Strand had also disavowed the soft tonalism of
the Photo-Secessionists, who had applied gum bichromate to their
images with brushes in an attempt to authenticate them as one-off
art works, proclaiming instead that 'Objectivity is the very essence
of photography.'[10] By the late 1920s a similar style became com-
mon in Europe amongst practitioners of the *ring neue werbegestal-
ter* (see chapter 5), and with André Kertész, who produced New
Objectivity photographs to advertise cutlery in *Die Dame* in Nov-
ember 1929. At the same time, photomontage became a common
way of objectifying products in more metaphorical and allusive
terms – the dreamlike quality of the Pixavon Shampoo advertise-
ment published in *Berliner Illustrirte Zeitung* in 1928 (figure 47), for
example, or a piece of self-promotion by Young and Rubicam from
1940 entitled 'Wrong place for a padlock', portraying a large head
in profile with a padlocked mind.[11]

It was this new photographic approach to advertising which,
according to John Tennant, would 'awaken a keen sense of posses-
sion' in the potential purchaser[12] and whose consumerist ethos
would, by the late 1920s, in turn be compounded by the rise of
instinct psychology. Through such strategies, the general public
was led to believe that it could consume itself out of any trouble
or misfortune, and even during the era of the Great Depression this
ideology was somewhat cynically deployed to help keep the econ-
omy buoyant. Thus in 1931 *Advertising Weekly* could declare:
'instead of neglecting the unemployed, we visualise them as a pro-
spective market of two and a half million people'. From this point
onwards, advertising and the role of consumer behaviour became
strictly interrelated and as such were regarded as instrumental in
determining the success or failure of any product or service. In 1929
the advertising agency Young and Rubicam, which had been
founded in 1923, invited Gallup to set up the first formal research
department, and ten years later J. Walter Thompson formed its first
Consumer Purchase Panel. It was not until after the Second World
War, however, that advertisers began to test more systematically the
ways in which advertisements were being received and how an
information industry had, in effect, become a persuasion industry.

In this, they relied heavily on the concept of motivational research that the Viennese psychologist Dr Ernst Dichter and Louis Cheskin, the director of the Color Research Institute, had begun to promulgate in America in order to analyse the role of the unconscious or subconscious mind in forming preferences and in making decisions about different goods.[13] As post-war affluence began to be consolidated in the 1950s and 1960s, finding the ideal target audience became a *sine qua non* for advertising agencies, and various classification systems were evolved to break the population down into professional or social groupings. These include the National Readership Survey, which categorises society into five broad economic groups ranging from group A, the top earners who constitute just over 3 per cent of the population, to group C, the middle earners (54 per cent), to Group E, pensioners, casual workers and the unemployed (11 per cent), and more recently the Values and Lifestyles System (VALS) launched by the Stanford Research Institute, California in 1978, and Viewpoint (1992) which typologise consumers in terms of motivation as well as income, age and habitat.[14]

Signification, mythology and advertisements

Whilst motivational research and the concomitant stereotyping of the population into social or economic groups may help advertisers to determine more closely the market for a particular product or service, the success of any advertising campaign relies much more on the effective deployment and affective impact of the symbolism or signs it contains. As Judith Williamson insists: 'Ads must take into account not only the inherent qualities and attributes of the products they are trying to sell, but also the way in which they can make those properties mean something to us.'[15] Consequently, in attempting to unpack the latent meanings that advertisements have, we are implicated as consumers or spectators in proactively decoding their semiological or sign structures: 'meaning is always negotiated in the semiotic process, never simply imposed inexorably from above by an omnipotent author through an absolute code'.[16]

We have already seen how Pears and Lever were quick to realise the association of soap with high art as a neat economic ploy, enabling them to keep ahead of their market competitors. Yet this kind of association was not necessarily a logical or a natural one and rather, in connoting the intended class status of the product advertised, was also based on the fundamental ideological precept of social superiority. Pears's 'Bubbles' is paradigmatic of the crucial paradox of the advertising system which ostensibly sets out to assuage us, to entertain us, indeed to be like us, but which does

so by masking the ideologies it contains with signs. As a semiological system, therefore, advertising has at its disposal a myriad of symbols or tropes through which it is able to signify similar ideological perspectives or beliefs with reference to totally different products. The signification of class in the context of 'high art' and Pears soap is, after all, only one way of encoding the purported values of the product as well as the meaning of class itself. In contrast to Pears, for example, Burroughs resorted to 'low art' in promoting their Mixed Doubles alcoholic drinks in 1986, humorously subverting the British class system in the style of a cartoon strip. Entitled 'Role-playing situations: the interview', the advertisement is set in the staff room of a boy's public school and connotes peer-group initiation and the hegemony of the upper classes in terms of having the 'right attitude', the 'right look', the 'right answer'. Furthermore, the advertisement is testimony to the fact that not only can individual ideologies be represented in a multitude of ways but that they may even be simultaneously intermeshed with others. Consequently, in addition to class, the Burroughs ad invokes an imputedly superior gender position through the symbolisation of the product as a gentleman's drink. The cartoon itself depicts an exclusively male domain and seems anachronistically patriarchal, as if it were set in the 1950s; the headmaster wears a mortarboard and Mr Sprote, the interviewee, a striped house tie and jacket; between them there are shelves decked with sporting trophies and another, older teacher wearing a plaid jacket sits in an armchair. Whilst appearing to send up the chauvinism and elitism of public school decorum by framing it as a cartoon, the advertisement ironically serves to bolster the authority of the class types portrayed – *they* know what a *good* drink is – and represents, as most advertisements for alcohol tend to do, the timeless ideal of homo-social activity in a world untainted by women.

The role of semiology is clearly instrumental in helping us to decode the ideological meanings of advertisements, but as Barthes warns us in his essay 'Myth today', signs in themselves are not hermetic entities but part of a wider signifying chain and, as such, prone to distortion and ambiguity. According to Barthes, therefore, every sign is not only polysemous or open to multiple readings, but may also form the basis of a second sign system which he calls myth or *metalanguage*:

> Mythical speech is made of material which has *already* been worked on so as to make it suitable for communication ... it is a peculiar system, in that it is constructed from a semiological chain which existed before it: *it is a second-order semiological system* ... It can be seen that in myth there are two semiological systems, one of which is staggered in relation to the other: a linguistic system, the language

(or the modes of representation which are assimilated to it), which I shall call the *language-object*, because it is the language which myth gets hold of in order to build its own system; and myth itself, which I shall call *metalanguage*, because it is a second language, *in which* one speaks about the first.[17]

Thus, '*myth is speech stolen and restored*';[18] its purpose is not to make the original symbol disappear but to distort it, and in this way the *language-object* or meaning and the *metalanguage* or myth can be seen to coexist in one and the same text or image. This is achieved through an elision or slippage between the sign of the language system which Barthes calls 'meaning' and the signifier of the mythical system which he calls 'form': 'It is this constant game of hide and seek between the meaning and the form which defines myth.'[19] Furthermore, myth is invested with a potent motivational or persuasional force because its predilection is 'to work with poor, incomplete images'.[20] The motivational power of myth, however, is also one of degree and, in achieving a double or secondary signification, Barthes suggests that myth functions on three different levels of complexity which he classifies as the empty signifier, the full signifier and ambiguous signification, contending: 'I can produce three different types of reading by focusing on the one, or the other, or both at the same time.'[21]

With the empty signifier the meaning or original sign is taken over, usually by the producer, in a literal or unambiguous way as the basis of the form, in order to legitimise the new signified, that is the mythical concept. With the full signifier the intended symbolism is again unambiguous but, in contrast, the form and sign are not so readily or easily confused by the reader or mythologist who is able to detect the imposition and recognise the mythical concept as a distortion, as an alibi or excuse. Finally, with ambiguous signification the meaning and form appear to be inextricably linked into a unitary sign which we find confusing in so far as we can fully believe in and doubt its mythology at one and the same time. Accordingly, Barthes sees that 'the first two types of focusing are static, analytical; they destroy the myth, either by making its intention obvious, or by masking it', whereas 'The third type of focusing is dynamic . . . the reader lives the myth as a story at once true and unreal.'[22] In his analysis of this tripartite system in 'Myth today', Barthes invokes a photograph of a saluting black soldier which he had observed on the cover of *Paris-Match* as a paradigm of French Imperialism, but he also casts his net wide in other essays, turning his attention to the mythologies of various products and advertising campaigns. For instance, he writes about the militaristic discourse of soap-powder advertisements which speak of 'killing' dirt and germs and concludes: 'To say that Omo cleans in

depth is to assume that linen is deep, which no one had previously thought.'[23]

Let us explore Barthes's methodology for unveiling myth further with reference to an advertisement for Calvin Klein's Obsession For Men (1989), which represents a photograph by the cult American fashion photographer Bruce Weber that ostensibly appears to celebrate masculine desire and strength (figure 68). Here the two intertwining, naked bodies appear as smooth and muscular as a classical bronze sculpture. The male figure transports his passive and ostensibly willing female victim over his shoulder like a hunter carrying off his captive prey in a manner which is redolent of Giambologna's sculpture *Hercules and the Erymanthian Boar* (1576–89) or Rodin's sensuous, 'I am beautiful', from the *Gates of Hell* (1882–84). On the level of the empty signifier we can recognise the association as a kind of literal symbolism in which the image has been chosen to 'fit' the product, and we understand how, if not why, the producer has linked them together. It is immaterial here whether we are able to associate exactly with the sculpture of Giambologna or of Rodin (our reading of the image will be more deeply coloured if we do; if not, we may merely regard the forms in more general terms as statuesque or monumental), but what does matter is that we recognise that the naked bodies are symbols of sexual desire that correlate with the wearing of Obsession. In contrast, with the full signifier we recognise the objectification as heavy-handed and are not convinced by the equation; the wearing of Obsession will not of necessity result in such an act of sexual subordination, even if we wear it to 'smell nice' or to feel attractive to another person. Its symbolisation in the form of idealised, 'sculpted' human bodies is an alibi for sexual desire which, on this level, could be read instead as a licence for sexism and possibly for

68] Calvin Klein advertisement, 'Obsession for men', 1989.

rape. Finally, with ambiguous signification we acknowledge simultaneously that the naked bodies are neither just an appropriate symbol for the product nor an alibi for sexual domination, that is, we appreciate that their symbolism is neither too obscure nor too obvious to believe. Rather, in this lost and found, any scepticism or equivocation concerning the truth of the advertisement seems to be suspended, and we succumb fully to myth's motivational force – that is, the naked bodies are not just a representation but the actual personification of what we expect or desire Obsession/obsession to be. In this context, 'myth is neither a lie nor a confession: it is an inflexion', and 'driven to having either to unveil or to liquidate the concept, it will *naturalize* it'.[24] Any connotations of potential barbarism or subordination in the Obsession advertisement have, therefore, been rectified by the nature of the product in question, as well as by the aesthetic monumentality of the figures represented, each of which signifies 'sex' rather than 'sexism'. Here masculine desire and power have been transmuted into a kind of primordial or instinctual sexuality that appeals, either consciously or subconsciously, both to men and women – we might just as well argue that the female figure has merely been overwhelmed by the musk of the scent he wears.

The Janus-like scope of ambiguous signification presents us, therefore, with a persistent textual dilemma, but one that resolves itself in our ineluctable embracing of mythology. This compulsion to believe in myth occurs because its ultimate objective, as Barthes contests, is to transform history into nature: 'everything happens as if the picture naturally conjured up the concept, as if the signifier gave a foundation to the signified'.[25] The deployment of nostalgia and the synchronisation of different historical periods as portrayed in an atavistic 1990 advertisement for Homefire Smokeless Fuel, 'Keep the homefire burning' (figure 69) are key strategies in this kind of transformation. Here not only the *mise-en-scène* appears to be located in the 1950s; the sepia-tinted advertisement itself with its discoloured edges actually seems to have been produced during that period as well. The product, however, is distinctly modern and represented as being ecologically sound; the caption states: 'Capture the mood. Create the glow. Re-kindle your yesterdays With the fuel of today. With clean smokeless HOMEFIRE. For maximum heat. And minimum waste.' The suffused cosy tonalism of the living-room and the happy family represented at leisure around the fire (who are depicted as the only nuclear unit that can be regarded as natural in a nuclear age, and who by extension symbolise the 'naturalness' of smokeless fuel) convey, therefore, timeless, eternal values. Yet within such a naturalising framework myth also functions as a political tool, upholding the

KEEP THE HOMEFIRE BURNING

Capture the mood. Create the glow. Re-kindle your yesterdays. With the fuel of today. Look out for the pink and black bags at petrol stations, garden centres and corner shops. Or order HOMEFIRE direct from your Coal Merchant.
With clean smokeless HOMEFIRE. For maximum heat. And minimum waste.
For longer burning. On cold winter nights. Brings people together. Drives the cold away.

Homefire – all our yesterdays from today's fuel

69] Homefire Smokeless Fuel advertisement, 'Keep the homefire burning', 1990.

hegemony of bourgeois capitalism by rendering it inescapable. Accordingly, Barthes insists: 'Statistically myth is on the right . . . The oppressed is nothing, he has only one language, that of emancipation; the oppressor is everything, his language is rich, multiform, supple, with all the possible degrees of dignity at its disposal.'[26] Certainly, Barthes admits that myth may also exist on the Left (the mobilisation of a 'poor, incomplete image' like the red rose by the Labour Party to symbolise socialism is a good recent example), although he regards this as inessential or otiose.[27] Consequently, within the realm of myth the political or ideological content of an advertisement for smokeless fuel is sublimated, and conversely we could say that politics may be sold like smokeless fuel. Thus myth is accepted as fact rather than being read as semiology; it sequesters ideology, naturalises it, and in so doing transforms politics into a kind of depoliticised speech – the nuclear family *is* the natural family just as fossil fuel *is* naturally superior to nuclear energy. We may claim that we are not completely fooled or taken in by the symbolism or the rhetoric of such advertising, yet this does not always inhibit us from purchasing the shampoo that alleges to fix our hair or the car that promises to keep us ahead of the Joneses: 'Myth has an imperative buttonholing character . . . It is *I* whom it has come to seek. It is turned towards me, I am

subjected to its intentional force, it summons me to receive its expansive ambiguity.'[28]

The process of ideological naturalisation is, therefore, immanent in the discourse of advertising which operates, in most cases, as the servant of capitalism by playing cynically on our inadequacies, fears and desires. From perfume to party politics, from cars to clothing, there is probably not one product or organisation that does not rely on some form of mythical concept in promoting itself. At the same time, however, such a process of naturalisation is not always subtle, and history can be incorporated into advertising to portray either positive values or negative ones to differing effect. In the case of the campaigns produced by Oliviero Toscani for Benetton since 1984 under the 'United Colors' banner, for instance, history was initially used with reference to positive national or racial stereotypes. Between 1985 and 1991, Benetton advertisements attempted to represent the world as a harmonious place unified in politics and culture by deliberately juxtaposing young people of disparate ethnic origins and ideological backgrounds (much as Coca-Cola had done with their campaign of the early 1970s – 'I'd like to teach the world to sing'). Sometimes this was realised through uniting young people from the same country – America represented by a white girl posing as Madonna and a black boy as Michael Jackson – but more often by drawing together young people from different continents – France signified by a girl wearing a Bonapartist cap, and China in the guise of Chairman Mao. In such instances, the mere wearing of Benetton clothing is seen magically to 'cure' the world of all types of prejudice, and any traces of racial or political tension have been somehow transcended or glossed over. Consequently, black and white Americans are seen to coexist peacefully on equal terms, despite the socially and politically marginal status of the former in modern-day America, and French Imperialism can embrace Maoist Communism even though the two political orders are manifestly incompatible. By the summer of 1991, however, Toscani's campaigns for Benetton became the centre of controversy for the way in which they manipulated existing news photographs – a man shot dead by the Mafia – or for their references to human suffering – a man with AIDS on his death-bed, and the war in the former Yugoslavia (figure 70). Such events clearly had little or nothing to do with Benetton clothing *per se*, but Toscani claimed that this was the point. As discussed in more detail in chapter 9, these images were not intended to be straightforward advertisements, but were deliberately used to make the public more aware of the events that were unfolding in their own time: 'We touch on themes that unite the whole world . . . Advertising is the richest and most powerful form of communication in the world.

70] Benetton advertisement depicting the clothes of a dead soldier from the war in Yugoslavia captioned in Serbo-Croat ('I, Gojko Gagro, father of Marinko Gagro born 1963, wish that all is left of my son is used for peace and against war'), 1994, photographed by Oliviero Toscani.

We need to have images that will make people think and discuss'.[29] In light of the fact that the images were used in conjunction with the 'United Colors' logo, nonetheless, many have questioned his disavowal as being *faux-naïf* and regard Benetton's shock tactics not just as an act of historical consciousness-raising but more as a ploy for attracting attention to the company itself.[30]

Cigarette advertising and Surrealism: a case study in the symbolisation of gender and pleasure

Probably the most successful type of mythology in advertising is concerned with the achievement of pleasure. In this respect, every cultural material from alcohol (as discussed in chapter 3) to zit lotion can be signified as having the potential to gratify human senses and desires and to increase pleasure. Indeed, since 1991 advertising campaigns for Häagen-Dazs ice-cream have persistently proclaimed that they are 'Dedicated to pleasure'. It is paramount, therefore, that advertisements appear to offer up fulfilment by filtering out any hint of unpleasurable feelings or experiences, and as such they appear to deal with Freudian concepts of pleasure. Writing in the 'Formulations of two principles of mental functioning' (1911), for instance, Freud addressed the way in which the ego's quest for pleasure is continuously mediated by external reality, the 'reality principle', which teaches the ego to delay gratification so as to attain satisfaction more responsively and knowingly: 'the substitution of the reality principle for the pleasure principle implies no deposing of the pleasure principle, but only a safeguarding of it'.[31] These ideas are expounded further in 'Beyond the pleasure principle', first published in 1920,[32] where Freud describes the overwhelming tendency of the mind to preserve the delicate balance between tranquillity and agitation by emphasising pleasure:

The dominating tendency of mental life, and perhaps of nervous life in general, is the effort to reduce, to keep constant or to remove internal tension due to stimuli ... a tendency which finds expression in the pleasure principle ...

The pleasure principle, then, is a tendency operating in the service of a function whose business is to free the mental apparatus entirely from excitation or to keep the amount of excitation in it constant or to keep it as low as possible.[33]

While most advertisements seem to offer up an unbridled hedonism or sense of fulfilment, for some products or services the promise of pleasure is vitiated somewhat by a possible threat of loss, disappointment or pain. These include the 'I want to be ...' campaign for Prudential Insurance which was launched on television in August 1989. In this, various impediments to pleasure or personal achievement ranging from the imaginary (a young boy declares 'I want to be a slug'), to the possible (a female sculptor who wants 'to be discovered'), to the actual (a woman returns home to find that she has been burgled) can all be overcome by having the right insurance policy: 'Whoever you want to be, you want to be with the Prudential.' But it is products which can damage our health that have had to objectify pleasure in more entropic ways and, in particular, advertisements for some brands of cigarettes such as Benson and Hedges have achieved this through surrealist symbolism.

The first cigarette advertising originated in the late nineteenth century: during the 1880s, James Buchanan Duke of North Carolina spent 800,000 dollars on advertising his tobacco products and in 1898 Players adopted the bearded sailor emblem which still appears on their cigarette packets today.[34] Since then, cigarette advertising has become one of the world's largest economic categories – in 1987 Gallaher, manufacturer of Benson and Hedges and Silk Cut and the eighth largest advertiser in the United Kingdom, spent £25 million on press advertising alone. Although most people object to tobacco advertising (in 1991, a survey by Mintel revealed that 61 per cent of all those consulted opposed it) and there have been various unsuccessful initiatives to ban it outright, the most recent by the European Association of Advertising Agencies in 1992, without the revenue accrued from it most periodicals would be in dire economic straits.[35] In 1991, the Periodical Press Association revealed that some 2,000 titles would face closure if there was a total ban on cigarette advertising.[36] Nonetheless, there have been several restrictions placed on cigarette manufacturers since the 1962 report by the Royal College of Physicians in Britain and the 1964 report by the Surgeon-General in America revealed smoking to be a huge social and health scourge. In 1965 cigarette advertising was outlawed on

British television, and in 1986 banished from the the cinema as well as from all periodicals aimed at women between 15 and 24 years old or with circulations in excess of 200,000. These prohibitions do not, however, necessarily inhibit the consumption of tobacco or encourage people to smoke more responsibly, and the correlation between tobacco advertising and the incidence of smoking is notoriously difficult to prove. A survey held in Italy in 1980, where all forms of cigarette advertising have been totally banned since 1965, revealed that cigarette consumption had actually increased by 76 per cent during the same fifteen-year period, and research by Lehmann Brothers Kuhn Research, New York in 1982 revealed that in countries where cigarette advertising has not been totally forbidden most smokers buy low-tar types – in Germany, 88 per cent of people who smoke, and in Britain 58 per cent.[37]

Consequently, advertisers have used various strategies to invest tobacco products with a distinctive identity and in particular smoking has been represented as a gendered activity. Most agencies work on the premise that cigarettes, along with alcohol, should be targeted especially at males, because they are most likely to be the only two products that the majority of married men would think of purchasing for themselves on a daily basis. An advertising copywriter working in the 1960s, for example, revealed that when he was working on a campaign for cigarettes he would be expected to masculinise smoking in one of four chief ways – (i) as an initiation symbol through which independent manhood is achieved; (ii) as a nipple substitute; (iii) as proof of sociability; and (iv) as a symbol of phallic power.[38] A good example of this kind of stereotyping occured when Marlboro, the world leader in cigarette sales, changed its identity during the 1950s from being a woman's brand to a man's by association with various masculine figure-heads including the Marlboro cowboy.[39] Ever since, the analogy has stuck and Marlboro have been promoted as an uncompromisingly rugged and macho brand of cigarettes; an advertisement in 1989, for instance, was set in a barber's shop, and more recently the red logo of the packet has been symbolised as a red-necked farmer. Achieving the right form of association for products like cigarettes is a particular imperative since they are consumed both in public and in private and as such, 'they make personal statements about their user that are closely connected with the imagery associated with the brand'.[40]

In 1976, new restrictions were enforced in Britain which resulted in manufacturers having to warn consumers, both on the packet and in promotional campaigns, about the deleterious effects that smoking could have on a person's health. With regard to advertising this clearly meant that any overt claims either to sociability

or to social status were no longer possible, and instead producers began to promote such ideals by mobilising a more oblique form of symbolism. One of the best-known campaigns to have evolved from this change is the Benson and Hedges 'Pure gold' surrealist campaign which has been masterminded by Collett Dickenson Pearce since 1977. The first wave of advertisements invoked the illusionistic art of Réné Magritte, who had been affiliated with the Surrealists since 1925 and who regarded the ostensible link between reality and representation as a paradox: 'An image should not be confused with something tangible: the image of a pipe is not a pipe. The desire to interpret an image of likeness . . . may lead to an endless series of superfluous interpretations.' [41] Moreover, it can be no small coincidence that Collett Dickenson Pearce chose at the outset to emulate the one surrealist artist who himself had worked, albeit grudgingly, within advertising – between 1932 and 1936, Magritte produced several images advertising tobacco and fashion.[42] In turn, the anacoluthic language-form of paintings such as *Elective Affinities* (1936) and *Le Chant de l'orage* (1937) were plundered by Benson and Hedges to form visual puns of their own in which the caged egg of the former is transformed into a cigarette packet which paradoxically cast the shadow of a bird (figure 71), and the raindrops of the latter became a shower of cigarettes. Both in Magritte's paintings and the Benson and Hedges ads there is a deliberate disruption or dislocation of form and ideas, and nothing appears as it should be. The unsettling imagery of the early surrealistic campaigns, however, was extremely successful and in 1978 they won the Design Council award for best advertisements, being heralded as 'a milestone in poster advertising' in which 'the brilliant use of Surrealism arouses curiosity and has created a talking point'.[43] Indeed, this was the avowed aim of Alan Waldie, the art director at Collett Dickenson Pearce responsible for introducing the symbolism, who stated at the time: 'Let's make it visually interesting, we want people to question what's going on. Let's educate people to expect more subtle visual ideas.' [44]

Since 1978, the surrealist symbolism of Benson and Hedges has become increasingly more complex and has embraced the work and ideas of other practitioners such as Salvador Dalí, Man Ray and André Breton. For Breton, writing in the first *Surrealist Manifesto* (1924), Surrealism was defined as:

> Psychic automatism in its pure state . . . by which it is intended to express verbally, in writing or in any other way, the true process of thought . . . Surrealism is based on the belief in the superior reality of certain forms of association previously neglected, in the omnipotence of the dream and in the disinterested play of thought.[45]

71] Benson and Hedges advertisement, *Birdcage*, 1978.

Breton had been employed as a military psychiatrist between 1916 and 1917, and through this he became aware of the clinical use of Freudian theories of free association, even if he had not read Freud's *The Interpretation of Dreams* (1900), which was not published in a French translation in its entirety until 1926. The overriding concern of Freud's thesis was the distinction he observed between primary process, which he linked to our unconscious thought and to dreams, and secondary process, of which we are fully conscious as waking or rational beings. It was primary process, however, which he claimed to be the most revealing barometer of human thought and desires, since in dreaming our minds had free play and the logical chain of events could be short-circuited. The dissolution of all tight boundaries implied by such consciousness lay at the heart of Breton's ideal of psychic automatism, which would result in the expression of spontaneous thoughts and ideas, unmediated by reason or anxiety: 'Occupied at that time as I was by Freud, and familiar with his methods of examination . . . I resolved to obtain for myself what I had tried to obtain from them . . . which would be as close as possible to spoken thought.'[46] As a poet, his initial concern was with the way in which language could articulate primary process, but Breton also came to realise that the visual arts could be equally effective in representing the unconscious and subconscious workings of the mind.

The chief aesthetic propounded by Breton that underpinned surrealist practice was the idea that 'beauty should be convulsive', by which he meant that every being or idea had the propensity for being transformed into something else through representation.[47] There were, moreover, three separate ways of representing convulsive beauty, namely the *érotique voilée* (veiled erotic); the *explosante-fixe* (fixed explosion) and *magique circonstantielle* (circumstantial magic). The first of these describes a kind of superimposition through which two distinct objects may be signified in the same form, one becoming a metaphor for the other. Man Ray's photograph the *Violon d'Ingres* (1924) exemplifies this approach. Here, a woman wearing a turban has been represented from behind so that she appears like a nude odalisque from a painting by Ingres; at the same time the serpentine outline of her back resembles closely the shape of a violin, and this signification has been underlined by the marking of two symmetrical f-holes on her skin. The second term deals with the capturing of an arrested motion or second of time through which the person or object represented takes on the aspect of another form, as with Man Ray's photograph *Explosante-fixe* (1934) in which we discern a woman dancing suddenly being transfixed into the shape of an exotic flower. The final term is perhaps the most complex of the

MIDDLE TAR As defined by H.M. Government
DANGER: Government Health WARNING:
CIGARETTES CAN SERIOUSLY DAMAGE YOUR HEALTH

MIDDLE TAR As defined by H.M. Government
Warning: SMOKING CAN CAUSE FATAL DISEASES
Health Departments' Chief Medical Officers

72] Benson and Hedges advertisement, *Snakeskin*, 1984.

73] Benson and Hedges advertisement, *Tap*, 1986.

three, since to a certain extent it is based on a more subjective interpretation which can involve the manipulation of an object not only through visual representation – the strangely paranoic world in Dalí's painting *The Persistence of Memory* (1931), for example, where solid masses appear to liquify into soft forms – but also through totemic hallucination – the chance encounter with a found object such as the wooden spoon with an intriguing tiny shoe at the tip of its handle, which triggered Breton to suggest, 'it symbolized for me a woman *unique* and *unknown*'.[48] On either level, however, the association takes on a personal significance, since the forms which appear to be in a state of transubstantiation do so precisely in order to become obscure or fetishistic objects of desire.

It is clearly a huge philosophical and mental leap from the intricate theorising of the original surrealist movement to the commercial image-making of advertising, but we may still detect convulsive beauty at play in many Benson and Hedges campaigns. Thus the *érotique voilée* is manifest in advertisements depicting the gold Benson and Hedges packet as a newly-shed snakeskin (figure 72, 1984) or as a packet of washing powder (1988), whilst another ad from 1989 has affinities with Man Ray's *Violon d'Ingres*, only this time the f-hole marks on the musical instrument form the initials B & H. Examples of the *explosante-fixe* are less frequent, but include the 1986 'Tap' campaign in which the arrested motion of the water

dripping from the tap (the handle of which puns 'gold' for 'cold') contains the jumbled letters of the words Benson and Hedges (figure 73). But the most abundant form of convulsive beauty to be found in Benson and Hedges advertising is *magique circonstantielle*: a shaft of golden light coming through the doorway of a hotel takes on the image of the Benson and Hedges packet (1979); a mollified cigarette packet appears to slide off the page as if in homage to Dalí (1982); an advertisement for Benson and Hedges in a magazine seen hanging off the edge of a coffee table magically spills its imaginary contents from the page on to the floor (1989); and a snail's slimy trail is magically transformed into liquid gold after it has traversed the Benson and Hedges packet (figure 74, 1990). In all of these instances, the use of surrealist devices transcends any suggestion of displeasure or the harm that smoking can cause; rather the pleasure of spectatorship is underscored through the symbolic deliverance of the spectator's undoubted object of desire – gold in the form of cigarettes.

In addition, we need to question the extent to which the pleasure which is objectified in the 'Pure gold' campaigns could be regarded as sexually-oriented as surrealist iconography. Freud himself had contended that 'The more one is concerned with the solution of dreams, the more one is driven to recognise that the majority of the dreams of adults deal with sexual material and give expression to erotic wishes', and it was precisely his avowal of the erotic and the sexual which appealed to Breton.[49] Likewise, the act of smoking has been linked to sexual desire, the consumption of cigarettes often serving either as an invitation or a chaser to sexual intercourse, or even as a substitute for the sex act itself; we have already mentioned the example of the copywriter who envisaged cigarettes in Freudian terms as a nipple substitute. Given

MIDDLE TAR
Warning: SMOKING CAN CAUSE LUNG CANCER, BRONCHITIS AND OTHER CHEST DISEASES
Health Departments' Chief Medical Officers

74] Benson and Hedges advertisement,. *Snail*, 1990.

75] Benson and Hedges
advertisement, *Tailor's
Dummies*, 1989.

that this is the case, we may also argue that advertisements for
Benson and Hedges connote not just the pleasure of smoking but
sexual bliss or *jouissance* (to use the French term), as well. Thus the
shedding of skin in the snake campaign, the dripping taps and
the snail slime are all invested with erotic undertones, while the
nut and bolt symbol from 1989 contains a more overt reference to
penetration. A more subliminal and disturbing signification of
jouissance, however, can be ascribed to the 'Tailor's dummies' ad-
vertisement which also appears to trade on the patriarchal sexism
of both Freud and the Surrealists themselves (figure 75). In this
image, there is a stark contrast between light and dark; a group of
white, 'undressed' female dummies of differing dimensions loom
out of the darkness, and one of them has been convulsed into the
rectangular shape of an unidentified cigarette packet. On the cut-
ting table in front of them lies a piece of gold material embroidered
with the Benson and Hedges logo. There are also two disquieting
elements in the advertisement. Standing behind the female dum-
mies in the background of the picture we can discern another
dummy, wearing a man's jacket, while one of the female dummies
casts an elliptical shadow on to the naked cigarette packet. This
shadow, moreover, takes on the indexical appearance of a woman's
breast and in turn connotes that the cigarette packet has been
feminised. Overall, the image conveys a sense of dystopian claus-
trophobia, the space is shallow and the light tenebrous, as if
something sinister is about to take place or has just taken place.

These visual effects seem to have much in common with a
photograph by Maurice Tabard entitled 'Hand and woman' (1929),

which similarly represents an imminent threat. Here, a male figure with a sweater pulled over his face looms in the darkness behind a woman dressed in her incandescent underwear and gazing at herself in a hand-mirror which obliterates her face. The man's left hand is just about to grab hold of her waist, but as we cannot see the expression on her face we do not know whether she beholds herself or the shady character who is about to threaten her. There is the implication of some impending catastrophe in Tabard's photograph which is not answered. Is the woman going to be raped? Is she going to be killed? The photograph, therefore, deals both with a play on reflection and a sense of menace which, as Rosalind Krauss suggests, invokes another of Freud's essays which the Surrealists held dear, 'The uncanny'.[50] In this essay, written in 1919, Freud discusses the idea of 'doubling', which he sees as having both a positive and a negative register; on the one hand, we seek in our dreams or subconscious to compensate for a threatened or impending loss by creating a benign alter-ego or double, while on the other, the same double can turn out to be a primitive, destructive being who, 'From having been an assurance of immortality ... becomes the harbinger of death.'[51] The arrangement of the figures in 'Tailor's dummies' appears to work on a similar level of association – it is the male presence who appears to introduce an element of destruction or unease and whose function, we may assume, is to seize the 'female' cigarette packet. This is perhaps the most entropic advertisement to have been produced for Benson and Hedges, although it would be stretching a point to insist that Collett Dickenson Pearce intended it to be Freudian in the same sense that Tabard's image was meant to be. Whilst Alan Waldie has openly admitted the agency's debt to Magritte and Surrealism, Keith Connor, head of the Benson and Hedges account in 1990, admitted that 'weird would be a better way of describing the adverts rather than surreal'.[52] Here we come to the crux of Benson and Hedge's reliance on Surrealism, which we may regard as no more than gratuitous, postmodern style-raiding – 'Surrealism without the subconscious', as Frederic Jameson might put it.[53] Nevertheless, we need to make the distinction between campaigns for Benson and Hedges which are intentionally modelled on surrealist art and the ideal of *magique circonstantielle* and the many other advertisements that we may call 'surreal' and which codify magic in more general or literal terms. These include campaigns which rely on photomontage to achieve a shock impact, such as an advertisement for Ferguson in which a Lilliputian orchestra emerges from a compact disc player (1984), or the 'Well, they said anything could happen' promotion by Brian Duffy for Smirnoff vodka during the 1970s. What would seem to be of more

importance, therefore, is the knowledge that we as spectators either have or do not have of surrealist art and theory which determines our response to such symbolism and which enables us to anchor the meanings of these advertisements more specifically. As Judith Williamson has argued with reference to Benson and Hedges: 'The ads are visual puzzles, they imply meanings one doesn't have access to. This suggests "High Art" and thereby exclusivity. A product for the discerning, the tasteful, the few.' [54]

Within the culture of capitalism, advertising is the unavoidable spectacle that assails us from the pages of magazines and from street hoardings, in the cinema and on television and radio, representing a world replete with unbounded material pleasures through a procession of delectable images. It is scarcely surprising, therefore, that advertisements can be seen to function at the level of 'harmless' entertainment, offering us limitless potential for personal expression and freedom of choice. But as we have also observed, the pleasure of these texts is controlled, and the power of the advertising industry often means that we have neither choice in the campaigns we see nor in the identities or freedom they purport to offer us. In this regard, we might seriously question why we need advertising at all (as Raymond Williams and others have done)[55] since what we seem to be dealing with superficially is *image*. More cogently, however, in the context of advertising, image and pleasure are vehicles for ideology and mythology, the latent meanings of which are framed in symbolism that is sometimes obvious, yet more frequently subliminal or entropic. It is instructive to take note of Williamson's contention in reference to Benson and Hedges, since her comments adumbrate the dualism of the advertising discourse which, as we have argued in this chapter, may be regarded as a two-way process. For advertisements contain not just the intentional signification of their producers but have meanings negotiated for them in the interaction that takes place between different target groups or social classes – a theme to which we shall return in the next chapter. Advertising agencies themselves are well aware of spectators' willingness to share in such a process of decoding, as campaigns for Glenfiddich whisky in 1993, 'This is a competition about symbolism. But what do we mean by that?' and 'Solve the enigma' for Guinness in 1995 attest.

Furthermore, in their reliance on the visual language of Surrealism and on Dalí in particular, both campaigns are testimony to advertising's voracious capacity for recuperating well-known visual codes. Consequently, just when we feel that a particular sign system has been exhausted, it is cannibalised and regenerated for

new purpose and effect. At the time of writing this chapter, for instance, it is interesting to note Smirnoff vodka's satirical rehabilitation of Benson and Hedge's 1978 flying ducks campaign and British Airways' 1995 twist on Benetton's ideal of inter-racial harmony with their 'There are more things that bring us together than keep us apart' promotion.[56] The self-referentiality of advertising in this context and the way in which it simulates or short-circuits reality by creating images which are based on previous sign-systems is just one of several important issues which have become deeply bound up with debates on postmodern culture and representation since the 1970s. Consequently, in our final chapter we evaluate the impact of graphic design on postmodern culture and vice versa, and interrogate just how meaningful it is to speak of the transformation in the production and consumption of images which this has allegedly brought about.

Notes

1 M. Griff, 'Advertising – the central institution of mass society', *Diogenes*, 68 (Winter 1969), p. 121.

2 See R. Hoggart, 'The case against advertising', in *Speaking to Each Other* (London, 1970); R. Williams, 'Advertising: the magic system', in *Problems in Materialism and Culture* (London, 1980); and J. Berger, *Ways of Seeing* (London, 1972).

3 See T. Richards, *The Commodity Culture of Victorian England* (London, 1990) for an exemplary investigation of the ideological purpose of nineteenth-century advertising.

4 G. Debord, *The Society of the Spectacle* (1967), translated by P. Nicholson-Smith (Massachusetts and London, 1994), thesis 66, p. 43.

5 T. Bennett and J. Donald, 'The image and mass reproduction', The Open University's *U203, Popular Culture*, Block 6, Unit 25 (Milton Keynes, 1982), p. 68.

6 *Ibid.*, p. 69.

7 A reproduction of the painting had been issued with the *Illustrated London News* Christmas number, December 1887. See R. Treble, *Great Victorian Pictures* (London, 1978), p. 60.

8 'Spending heads for record', the *Sunday Times* (6 November 1988).

9 Cited by B. Yochelson, in 'Clarence H. White reconsidered: an alternative to the modernist aesthetic of straight photography', *Studies In Visual Communication*, 9 (Fall 1983), p. 33.

10 P. Strand, *Seven Arts* (August 1917), pp. 524–5. The objectivity to which Strand refers became known as 'straight photography' in America.

11 This advertisement appeared in America in *Fortune* (April 1940), p. 93. For an illuminating account of photomontage in American advertising see S. Stein, '*Good Fences Make Good Neighbors* – American resistance to photomontage between the wars', in M. Teitelbaum (ed.), *Montage and Modern Life: 1919–1942* (New York, 1992), pp. 128–89.

12 Yochelson, 'Clarence H. White reconsidered', p. 33.

13 See V. Packard, *The Hidden Persuaders* (Harmondworth, [1957] 1981), p. 29.

14 For a fuller account of the different categories constituting VALS, see E. Clark, *The Want Makers* (London, 1988), pp. 236–41.

15 J. Williamson, *Decoding Advertisements* (London, 1978), p. 12.

16 R. Hodge and G. Kress, *Social Semiotics* (Ithaca, 1988), p. 12.

17 R. Barthes, 'Myth today', in *Mythologies* (London [1957] 1973), pp. 119, 123 and 124.

18 *Ibid.*, p. 136.

19 *Ibid.*, p. 128.

20 *Ibid.*, p. 137.

21 *Ibid.*, p. 138.

22 *Ibid.*, p. 139.

23 R. Barthes, 'Soap powders and detergents', in *Mythologies*, p. 41.

24 R. Barthes, 'Myth today', p. 140.

25 *Ibid.*

26 *Ibid.*, p. 162.

27 *Ibid.*, pp. 158–62.

28 *Ibid.*, p. 134.

29 L. Baker, 'Taking advertising to its limit', the *Guardian* (22 July 1991), p. 29.

30 According to Benetton's *United Colors of Benetton, P. R. United Kingdom* (1991) issued by Marysia Woroniecka Publicity, London, in 1991 Benetton was based in 100 countries across the world with around 6,500 outlets in total.

31 See *The Standard Edition of the Complete Psychological Works of Sigmund Freud*, edited by J. Strachey, vol. 12 (London 1953), p. 223.

32 S. Freud, 'Beyond the pleasure principle', in *On Metapsychology* (Harmondsworth, 1991), pp. 329 and 336. The first German edition was published in Leipzig, Vienna and Zurich under the original title 'Jenseits des Lustprinzips', and the first English translation appeared in 1922. The translation used here is based on *The Standard Edition*, vol. 18, 1955.

33 *Ibid.*, pp. 329 and 336.

34 Clark, *The Want Makers*, p. 336.

35 Mintel, *Advertising in Europe – An Agency Perspective* (London, August 1991).

36 The PPA survey revealed that most national newspaper colour supplements would lose between £3 and £4 million in advertising revenue per annum.

37 See also M. J. Waterson, *Advertising and Cigarette Consumption* (London, 1981).

38 Clark, *The Want Makers*, p. 342.

39 *Ibid.*, pp. 348–9.

40 *Ibid.*, p. 349, quoting the agency Batten, Barton, Durstine and Osborn.

41 Cited in J. C. Welchman, *The Dada-Surrealist Word Image* (London, 1989), p. 46.

42 See G. Rogue, 'The advertising of Magritte/The Magritte in advertising', *Print* (March/April 1985), p. 70.

43 J. Walker, *Art in the Age of the Mass Media* (London, 1983) p. 59.

44 *HotShoe International*, 19, p. 28.

45 A. Breton, 'Manifeste du Surréalisme' (1924), cited in C. Harrison and P. Wood (eds), *Art In Theory 1900-1990: an Anthology Of Changing Ideas* (Oxford, 1992), p. 438.

46 Breton, cited in P. Waldberg, *Surrealism* (London, 1965), p. 71.

47 Breton first wrote of compulsive beauty in his novel *Nadja* (1928) and afterwards in *Minotaure* (1934) and *L'Amour fou* (1937).

48 A. Breton, *Mad Love* (1937), translated by M. A. Caws (Lincoln and London, 1987), p. 37. A photograph by Man Ray entitled 'From a little shoe that was part of it' accompanied Breton's ideas.

49 S. Freud, *The Interpretation of Dreams* (London, 1961), p. 396.

50 R. Krauss, 'Corpus delicti', in R. Krauss and J. Livingstone, *L'Amour fou: Photography and Surrealism* (London, 1986), p. 82.

51 *Ibid.*

52 Keith Connor, in an interview with the authors, 27 March 1990.

53 This is the title of chapter 3 of F. Jameson, *Postmodernism; or, The Cultural Logic of Late Capitalism* (London, 1991) pp. 67–96.

54 Williamson, *Decoding Advertisements*, p. 69.

55 R. Williams, 'Advertising: the magic system', in *Problems in Materialism and Culture* (London, 1980) states: 'If we were sensibly materialist, in that part of our living in which we use things, we should regard advertising to be of an insane intolerance', p. 185.

56 The British Airways ads depict people from different nationalities and professions encountering each other with happy smiles on their faces, for example, Richard Bacon (deep sea diver, London, England) and Ebrahim Abdulaziz R. Al Bangi (pearl diver, Bahrain) published in the *Observer Life* (21 May 1995), p. 4.

Suggestions for further reading

In addition to the titles listed below, readers who wish to keep abreast of recent developments in advertising are advised to consult *Campaign* (for Britain) and *Advertising Age* (for the USA). Other useful periodical sources which feature advertising on a regular basis include: the *Observer*; the *Sunday Times*; the *Guardian* ('Creative and media' on Mondays); the *Independent*; *XYZ Direction*; *HotShoe International*; *HotAds International*; and *Creative Review*.

Advertising Standards Authority, *Code of Advertising Practice* (London, 1981).

S. Baker, 'The hell of connotation', *Word and Image*, 1 (1985), pp. 164–75.

R. Barthes, 'Myth today', in *Mythologies* (London, Paladin, 1973).

R. Barthes, *The Pleasure of the Text* (Oxford, Basil Blackwell, 1990).

D. Bellamy, 'On billboards and cigarette advertisements, *Photography/Politics 2* (London, 1986).

J. Bird, 'The politics of advertising', in *Design History: Fad or Function?* (London, Design Council, 1978).

J. Bullmore, *Behind the Scenes in Advertising* (London, NTC, 1991).

R. Chapman and J. Rutherford, *Male Order: Unwrapping Masculinity* (London, Lawrence and Wishart, 1988).

S. Chapman, *Great Expectorations: Advertising and the Tobacco Industry* (London, Comedia, 1986).

E. Clark, *The Want Makers* (London, Hodder and Stoughton, 1988).

G. Cook, *The Discourse of Advertising* (London, 1992).

M. P. Davidson, *The Consumerist Manifesto – Advertising in Postmodern Times* (London, Routledge, 1992).

G. Dyer, *Advertising As Communication* (London, Methuen and Co., 1982).

J. Evans, 'The imagined referent: photographic constructions of the handicap', *Block*, 12 (1986-87), pp. 71-82.

S. Freud, 'Beyond the pleasure principle', in J. Strachey (ed.), *On Metapsychology* (Harmondsworth, Penguin, 1991).

E. Goffman, *Gender Advertising* (London, Macmillan Press, 1979).

R. Goldman, *Reading Ads Socially* (London, Routledge, 1992).

P. Hanson, *Advertising and Socialism: the Nature and Extent of Consumer Advertising* (London, Macmillan, 1974).

D. Hebdige, 'A report on the Western Front: Postmodernism and the "politics" of style', *Block*, 12 (1986-87), pp. 4-26.

R. Hoggart, 'The case against advertising', in R. Hoggart (ed.), *Speaking to Each Other* (London, Chatto and Windus, 1970).

N. Ind, *Great Advertising Campaigns* (London, Kogan Page, 1993).

S. Jhally, *The Codes of Advertising* (London, Routledge, 1991).

P. Jobling, 'Keeping Mrs. Dawson busy – safe sex, gender and pleasure in advertising condoms since 1985', in M. Nava and B. Richards (eds), *Buy This Book! Advertising and Consumption Since 1950* (London, Routledge, 1996).

P. Jobling, 'Playing safe – the politics of pleasure and gender in the promotion of condoms 1970-82', in the *Journal of Design History*, forthcoming 1997.

W. Leiss, S. Kline and S. Jhally (eds), *Social Communication in Advertising: Persons, Products and Images of Well-Being* (Toronto, Methuen, 1991).

R. Millum, *Images of Women: Advertising in Women's Magazines* (London, Chatto and Windus, 1975).

K. Myers, *Understains* (London, Comedia, 1987).

R. McGrath, 'Dangerous liaisons', in T. Boffin and S. Gupta (eds), *Ecstatic Antibodies: Resisting the AIDS Mythology* (London, Rivers Oram Press, 1990).

M. Nava and O. Nava, 'Discriminating or duped? Young people as consumers of advertising art', *Magazine of Cultural Studies*, 1 (March 1990).

T. Nevett, *Advertising in Britain: a History* (London, Heinemann, 1982).

D. Ogilvy, *Ogilvy on Advertising* (London, Orbis, 1983).

T. Richards, *The Commodity Culture Of Victorian England* (London, Verso, 1990).

J. Sinclair, *Images Incorporated: Advertising As Industry and Ideology* (London, Routledge, 1987).

TEN. 8, 26 (1988) – special issue containing articles on political advertising and advertising for AIDS awareness.

T. Vestergaarde and K. Schrøder, *The Language of Advertising* (Oxford, Basil Blackwell, 1985).

A. Warnick, *Promotional Culture: Advertising, Ideology and Symbolic Expression* (London, Sage, 1991).

R. Williams, 'Advertising: the magic system', in *Problems in Materialism and Culture* (London, Verso, 1980).

J. Williamson, *Decoding Advertisements* (London, Marion Boyars, 1978).

J. Williamson, 'The history that photographs mislaid', *Photography/Politics 1* (London, 1979).

J. Winship, *Advertising in Women's Magazines 1956-74* (University of Birmingham, 1981).

J. Winship, 'Back to the future', *New Socialist* (Summer 1986).

R. D. Zakia, 'Adverteasement', *Semiotica*, 59 (1986).

9 Graphic design in a postmodern context: the beginning *and* the end?

This is not a just image. This is just an image (Jean-Luc Godard).

Since the 1970s Postmodernism has come to dominate discussion in many spheres of culture.[1] An exponentially increasing number of academic tomes as well as countless newspaper and magazine reports and television programmes have put Postmodernism under scrutiny. Although Andreas Huyssen warns that it 'appears on one level as the latest fad, advertising pitch and hollow spectacle', he stresses nevertheless that our age is undergoing 'a change in sensibility': 'there is a noticeable shift in sensibility, practices and discourse formations which distinguishes a post-modern set of assumptions, experiences and propositions from that of a preceding period'.[2] And though there is much discussion and disagreement as to what constitutes Postmodernism, when it first emerged and, more contentiously, what the effects of living in a postmodern age are, few areas of culture have been exempt from its seductive embrace. Graphic design in its many forms is no exception. Postmodernism in this field is usually identified as the rejection of modernist precepts of design which seemed – from the perspective of the 1970s and 1980s – to have petrified in the systematic work of the Swiss School in the 1960s. Key transitionary figures like Wolfgang Weingart working in Basle, the *Heimat* of Swiss orthodoxy, are now lionised as early mavericks who broke with modernist hegemony (itself an overestimation, since the penetration of formal Modernism into most of the ephemeral fields of graphic design in reality was slight).[3] Since the 1980s the repertoire of stylistic devices introduced by Weingart and others have become *the* signifiers of postmodernity in graphic design: for example, emphatically 'bitmapped' or expressively skewed type and multi-layered, 'stepped' and often confusing compositions. Distinctly postmodernist work in this style was produced in the 1980s and early 1990s by a cabal of American designers 'spotlighted' by the San Francisco-based magazine, *Émigré* (founded 1982), by prominent British practitioners like Why Not Associates (founded

1987) and by Dutch designers associated with Studio Dumbar in The Hague (founded 1977).[4] The entry of this new wave into history can be charted, it seems, as a relatively straightforward succession corresponding to the simple axiomatic definition advocated by Jürgen Habermas to describe Postmodernism itself: 'Postmodernity definitely presents itself as Antimodernity.'[5] The singular avowal of clarity and simplicity in modernist design has been overturned by a postmodern fascination with complexity and contradiction, decoration and ornament. Postmodernism is, it seems, Modernism's nemesis.

But the widespread adoption of the term to describe a new 'period style', as well as the acceptance of the more consequential idea that a epistemological shift has occurred *within* graphic design, is problematic for a number of reasons; two illustrations will suffice here. First, many of the underlying relations and conditions which, for example, fuelled graphic design's development in the period covered by this study are precisely those which many commentators claim to be at the heart of postmodern culture since its emergence in the 1950s. Frederic Jameson, for example, tells us that a major feature of Postmodernism is the 'effacement in it of some key boundaries or separations, most notably the erosion of the older distinction between high culture and so-called mass or popular culture'.[6] 'High culture', as Andy Warhol notoriously showed, could include images of soup cans and washing powder packaging on the walls of the world's eminent museums. Moreover, the collapse of older distinctions that Jameson identifies as a central characteristic of Postmodernism is a difficult concept to utilise in the history of graphic design. It has always been positioned *between* 'high' and 'low' culture. As we have seen, Toulouse-Lautrec in France in the 1890s and the *ring* designers in the 1920s and 1930s consciously took the opportunity to work with mass-reproducible forms of print precisely because in this way they would reach a wider audience.

Second, in the opinion of many critics Postmodernism is intrinsically tied to the emergence of particular technical, social and economic conditions which now prevail throughout much of the world (encapsulated in terms like the 'consumer society', the 'media society', the 'post-industrial society', and so on). The implications of these changes are wide-ranging, but one frequently invoked issue is the domination of the 'image'. Christopher Booker, charting the impact of commercial television, advertising and the glossy, illuminated world of consumerism in the late 1950s, recalled that 'the word "image" floated into the general consciousness' in Britain.[7] He unintentionally identified the beginnings of a shift away from an industrial economy based on the manufacture of

three-dimensional goods produced by large work-forces to a new age dominated by computer technology, financial investment houses, multinationals and media corporations which pursue profit through the production, organisation and careful manipulation of information. A business, for example, is not valued by the things that its workers produce but by the way it is *represented* on the stock exchange and the confidence that shareholders have in its *image*. For the French philosopher, Jean Baudrillard, our age is one of 'simulation' where the real has taken flight into images.[8] The world seems increasingly to be experienced as a series of images which are more important than the 'real' which they purport to represent. A Japanese tourist, for instance, no longer needs to travel to see architectural sites such as Buckingham Palace in London and St Basil's Cathedral in Moscow, but can see scale models of them and numerous other landmarks at home in 'Tobu World'. Moreover, when we take the trouble to visit real places, our experience can often be eclipsed by the images of them we have already consumed. When Baudrillard visits Los Angeles, he experiences it as a film: 'Where is the cinema? It is all around you outside, all over the city, that marvellous, continuous performance of films and scenarios.'[9] Graphic design can, like television and the cinema, be claimed to play an important role within the domination of the image in postmodernist culture. In an era when the image prevails, graphic design, at least in the form of advertisements, posters and magazine spreads, has a heightened significance in the measureless circulation of representations that we encounter in ordinary life. In this sense too graphic design seems to have been, if not an 'anticipatory' practice, then certainly one which has been instrumental in accelerating the advent of the postmodern condition. But this is not necessarily a distinctly new feature of graphic design's enterprise, nor are such celebrations of the hegemony of the image entirely new. As we have seen in chapter 2, contemporary opinion characterised the 1850s as a 'bustling' age in which the captioned image, found on the pages of illustrated magazines like *Le Charivari*, usurped the autonomous word as the significant conveyor of meaning.

Consequently, any evaluation of a distinctly novel postmodern character in graphic design is a difficult task. Indeed, many commentators are keen to warn that the advent of postmodernist culture does not necessarily mark an absolute break with Modernism. David Harvey, however, warns that we should not treat Postmodernism as 'simply a version of Modernism', but that 'real revolutions in sensibility can occur when latent and dominated ideas in one period become explicit and dominant in another'.[10] Consequently within Modernism we can find works which also

achieved the postmodern 'effacement' of distinctions between high and low that Jameson identifies; around 1910 'analytic' cubist collages by Pablo Picasso and Georges Braque, for example, included borrowed elements from the popular press and music scores. Similarly, many modernist graphic works seem to display traits which are now dubbed postmodern; the fractured style of the Dadaist Kurt Schwitters in the early 1920s seems to look forward to designs recently produced by Max Kisman and Studio Dumbar in the Netherlands, which display a kind of postmodern fascination with typographic disjunctures and ruptures. Despite these problems of definition, we do not mean to suggest that the term 'Postmodernism' is redundant, or that the insights offered by those who have speculated on its impact on our lives are inapplicable to graphic design. Certain important points of technical change and shifts in culture (Huyssen's 'changes in sensibility') *can* be identified which have significance for contemporary graphic design and, in the opinion of some observers, may even signal its end. Four themes warrant brief attention here: postmodern style, postmodern oppositions, postmodern theory and postmodern technologies.

Postmodern style

'Style' was an ugly word for the most principled, orthodox practitioners of graphic Modernism. It implied fashion, transience and even whimsicality that contrasted with their aspirations to produce enduring values of 'good design'. In their preference for 'objectivity' and 'authentic values', designers like Jan Tschichold in the 1920s or Max Bill in the 1950s revealed their faith in the relatively unproblematic and simple process of communication. Meaning, if sufficiently clear, would be lifted off the page as easily as printing ink was deposited there. With the advent and diffusion of post-structuralist thinking - a wide field of critical thought which encompasses the work of figures like Roland Barthes, Jean Baudrillard, Jacques Derrida and Michel Foucault - this view of graphic communication has come to seem untenable. Meaning - produced through any form of 'language', whether literary, graphic or sartorial - has increasingly come to be viewed as relative and dependent on the social or cultural context in which it operates and the subjectivity of the reader. Moreover, graphic forms are now understood as ambiguous signifiers which can be revalorised by their insertion into new contexts. The Swiss School principles of *Neue Grafik* became, on the pages of *Fabulous*, for example, no more than a style to be deployed whilst fashionable and to be discarded when *passé*. Of course, graphic design has rarely been a

76] Cover of *Octavo*, 5
(1988), designed by 8vo
design group.

self-conscious exploration of Post-structuralism (though since the 1980s designers have displayed a greater awareness of 'theory'): it is more accurate to say that a common shift in sensibility can be found throughout what are ostensibly different spheres of culture.

As a corollary, in the postmodern age even high Modernism itself can be replayed as style. Between 1986 and 1992 the London-based graphic design consultancy, 8vo, for instance, designed and published their own magazine, *Octavo*, in a run of eight issues (figure 76). Early issues of this publication, a journal of typography set in Helvetica and composed asymmetrically according to functionalist principles, were dedicated to marginalia of Modernism such as lower-case Dutch typography. Modernism, however, was no longer a project but a pastiche, even if one resulting from a 'love affair' with Modernism on the part of these designers.[11] For Jameson the freeing of style from the responsibility of conviction (think of Moholy-Nagy's 'commitment' to typofoto), allows postmodern pastiche – the detached, cool play of style – to enter the frame of culture:

> Pastiche is, like parody, the imitation of a peculiar or unique style, the wearing of a stylistic mask, speech in a dead language: but it is a neutral practice of such mimicry, without parody's ulterior motive, without the satirical impulse, without laughter, without that still latent feeling that there exists something normal compared to which what is being imitated is rather comic.[12]

Octavo's 'love affair' with Modernism was not driven by a satirical impulse, nor was it just a form of historicism. It was a romance with modernist *style* governed by a kind of nostalgic pleasure in its details.

This kind of 'quotation' of past styles is often driven by a kind of nostalgic impulse – not necessarily for the past as lived but for the past as imagined, as we have already seen in our discussion of the 1990 advertisement for Homefire Smokeless Fuel, 'Keep the homefires burning' (figure 69) and, however paradoxical it might seem, even the 'future' can be consumed in this nostalgic mode. Recent publicity for the pop singer Björk's 1995 album 'Post', for example, a digitally-manipulated image created by Paul White, includes a one-off logo for the singer's name (figure 77). This emerges from a lotus flower and appears to project from the picture plane in three dimensions, conjuring up an echo of futuristic lettering found in science-fiction film titling in the 1970s. White's design evokes a curious nostalgia for this vision of the future in the feel and shape of a graphic style of an older period. In the postmodern image, past and future dissolve into what Jameson calls the 'perpetual present'.[13] The complexities and tensions of

history as lived are drained in pastiche. Like Benetton's advertising campaigns since the mid-1980s (see chapter 8), historically sedimented and deeply-rooted differences within and between cultures seem to dissolve. Similarly, White's design promotes Björk's music by synthesising a traditional symbol of emanation and origination in Chinese culture, with 'sci-fi' lettering. In the world of the *post* (whether Björk's album, *Post*modernism or *Post*-structuralism), no hierarchies of representation or cultural differences stand: it is, as is often noted, a flat terrain where all things *as images* are treated equally, and everything is vulnerable to pastiche. Writing about *The Face* magazine, Dick Hebdige states: 'The past is played and replayed as an amusing range of styles, genres, signifying practices to be combined and recombined at will. The then (and the there) are subsumed in the Now. The only history that exists here is the history of the signifier and that is no history at all.'[14]

For Hebdige, writing in 1985, *The Face* was the epitome of post-modern fascination with pastiche and the kaleidoscope of style. This British monthly, launched by Nick Logan, is the best known of a cluster of publications which appeared in 1980 including *I-D* and *Blitz* that reported on the so-called 'style culture' of the period. *The Face* has been widely celebrated for its graphic inventiveness, and its principal designer between 1981 and 1986, Neville Brody, was awarded the accolade of his own exhibition at the Victoria and Albert Museum in 1988 in large part for his work on this

77] Publicity for Björk's album, 'Post', 1995, designed by Paul White of Me Company.

78] Cover of *The Face*, 29, (September 1982) designed by Neville Brody and photographed by Sheila Rock.

magazine. His designs – widely recorded and discussed elsewhere[15] – are often claimed to have defined the 'look' of magazines of the period, and continue to be a source of influence. Brody's work was at the outset distinguished by a keen understanding of the history of graphic design, with early spreads drawing on the innovations of constructivist designers like Rodchenko and El Lissitzky. *The Face*, in its hybrid mix of articles on music, fashion and film and other forms of popular culture as well as its occasional explorations into technology, philosophy and social reportage, seemed to offer a kind of pluralist graphic environment which could be 'cruised' by the reader.[16] 'Serious' issues came under the magazine's purview in disarmingly diverse ways. Unemployment and poverty, the most pressing social issues when the magazine was launched, might be treated to a journalistic investigation of life in the 'underworld' of 'dole survivors' with shadowy black and white documentary-*style* photographs (January 1986), or they might appear in the guise of pastiche in fashion spreads such as 'Hard times', with images of models dressed in fashionably 'distressed' denim which, in the spirit of nostalgia, owed much to 1950s Hollywood images of Marlon Brando and James Dean (September 1982, figure 78), or be alluded to in 'Workwear' (October 1982), a seductively 'retro' view of work, suggesting the proletarian figures

that populated Soviet propaganda in the 1930s. *The Face*'s cool gaze marks a significant change of sensibility away from the earnest and engaged approach to economic and social inequality taken by *Picture Post* in the 1930s and 1940s (see chapter 6). Knowledge is not put to some 'greater' end, but in this highly visual form it is offered for spectatorship – for the pleasure of looking. In effect, it could be argued that *The Face's* representation of unemployment accurately sums up the meaning of that condition in the 1980s – i.e. young people may not have had much money to spend, but they tended to compensate for this by prioritising style over substance. *The Face*'s self-appointed assignment was to identify, and even to stimulate, the rapid turns and ascending currents of 'style culture'. This was, however, a paradoxical task – one consequence of 'naming', whether in the form of photographic images or quite literally by inventing new descriptive labels, was, in effect, a nullification, a process of arresting and fixing the fluid and elusive signifiers of fashionability. Nevertheless, the continued success of the magazine in the 1990s in a market full of competitors is testimony to its sharp eye and quick-wittedness.

Beyond *The Face*'s evident graphic invention, a question remains about the significance of the kind of culture that it represents. Has there simply been a wholehearted capitulation to the force of consumerism, in which even poverty could be commodified? Or does the emergence of such a culture in the 1980s reflect a new 'knowing' attitude which encourages the spectator to explore different and individual sexual, racial or social identities and non-conformities? These tensions were noted by Brody at the time in the following way. 'Style culture', he claimed, 'was an expression of individualism and an anti-establishment position. *The Face* dealt primarily with a visual culture.' But he stated further: 'This was greatly misread, so that it appeared we were dealing with a superficial culture.'[17] Whilst the issue of individualism is problematic – many commentators have suggested a connection between *The Face*'s espousal of individualism and right-wing politics in Britain under Margaret Thatcher – the claim that the magazine staked out some kind of opposition to convention has also been disputed. Martin Davidson asserts that *The Face*, far from being counter-cultural, was 'about hip consumerism'.[18] The commitment required to be truly oppositional demanded too much of a culture pledged to ephemerality and cool 'knowingness'. However, many of the critiques which emerged in the 1980s seem overstated in the light of the magazine's own development. The oppositional tactics of *The Face* have more recently been manifest in its forays into libertarian politics (see below), in the anti-racist 'Love sees no colour' issue (May 1992), or in the magazine's support

for 'Fax for freedom', a high-tech campaign organised by *Actuel* in France to prompt protest against the repression of the movement for democracy in China in Tianamen Square in 1989, when it challenged its readers with the slogan 'You have the technology to change history' (December 1989).

Nevertheless, *The Face* and, more generally, the kind of postmodern pluralism in graphic design that it seems to advocate, are often characterised as the abandonment of guiding notions which have been central to graphic design in the last two centuries. Highly referential, postmodern practices seem, for example, to put the notion of originality in jeopardy. Reliant on quotation and pastiche, the postmodern designer turns to history as a reservoir of established images which already have currency. Indeed, they make apparent a truism offered by post-structuralist thinking, i.e. that inescapably we speak through languages which are already constructed for us. David Harvey, outlining the post-structuralist strategy of deconstruction, notes that 'writers who create texts or use words do so on the basis of all the other texts and words that they have encountered, while readers deal with them in the same way. Cultural life is then viewed as a series of texts intersecting with other texts and the words that they have encountered.'[19] Postmodern graphic design can be seen in this light as a practice which celebrates the *intertextuality* of the (graphic) text. Nevertheless, one can identify examples of what might be characterised as a 'rearguard' action on the part of some critics and designers who have attempted to distinguish between 'quotation' and 'plagiarism' in graphic design.[20] This is an attempt to shore up individualism or genius, concepts which seem to have lost their importance in the postmodern age, as well as to offer up ethical codes of good practice to 'police' the postmodern culture of appropriation.

In fact, many commentators have found much in postmodern culture about which to be pessimistic; its propensity to reduce all forms of human productivity to commodities and, for some, its incorrigible intertextuality which seems to trivialise the shibboleths of earlier human endeavour and even suggests a kind of promiscuous and apolitical culture (perhaps best exemplified in the writings of Baudrillard, who suggests that the hyperreality of the image has deposed the 'real'). Postmodernism, according to Alan Sinfield, 'depoliticises culture by imagining it as flowing, necessarily with the stream of consumer capitalism. No position is advanced from which to speak that is in advance, or even outside of the general position.'[21] What kind of critiques can graphic images make of our world? How can we use representations – visual or written texts – to confront the very real inequities of our lives when they are likely to be returned to us as style or commodities?

Postmodern oppositions

One strategy, widely explored since the underground of the 1960s, has been to privilege those forms which are ignored or viewed as marginal in our culture. The work of the French philosopher, Michel Foucault, has proven to be important in this respect. His writing has crystallised an influential critique which traces the connections between knowledge and power. For Foucault, power is not simply a matter of state control but is ever-present, scored throughout all locations and situations. He observed through his brilliant studies of the asylum (*Madness and Civilisation*, 1961) and the prison (*Discipline and Punish*, 1975), how a close relationship exists between forms of social domination and systems of knowledge like medical science, in the ways that such discourses 'know' and represent their subjects. Knowledge is equated with repression by Foucault through his emphasis on the 'imprisoning' nature of the categories of thought which organise how and what we can think. Power, in this sense, is not the domination of one class or social group over another, but a matter of the accretion and utilisation of knowledge in particular ways, not least in terms of representation. His work asks us to assess and intervene in the ways in which knowledge about the world is produced and constituted as a matter of resistance. It should come as no surprise, therefore, that his ideas have had marked influence on the various strains of libertarianism which became prominent in the 1960s – gay rights, feminism, black rights and so on.

A parallel can be drawn between Foucault's advocacy of localised resistance to the means and discourses of repression and the streams of designs printed to express opposition to prevailing orthodoxies. One recent survey – spanning a vast array of material (largely small-run posters, magazines and flyers) from punk fanzines of the 1970s to anti-fascist leaflets printed in the newly reunited Germany after 1989 – describes this field as 'agitational graphics.'[22] The product of particular cultures of resistance, these graphic forms circulate outside or even parasitically *on* the mass media. Feminist groups like Women Against Violence Against Women in the 1970s or more recently Saatchi and Someone, an informal alliance operating in Yorkshire, have 'hijacked' public billboards by diverting advertisers' messages with graphic interventions. Their additions – printed captions in the style of the original advertisement, graffiti or stencilled images – ridicule the advertiser's message (or the embedded ideologies that it reproduces). Such practices are, to borrow Umberto Eco's earlier phrase, forms of 'semiological guerrilla warfare'. The roots of many of these and other allied graphic practices can be traced to the

counter-culture of the 1960s. However, today the utopianism of the more romantic elements in the underground has largely been relinquished. 'Micropolitical' movements now concentrate their energy into more focused forms of activism. In fact, utopian and totalising ideologies such as Marxism ('meta-narratives') are increasingly viewed as suspect, stifling the virtues of pluralism and ultimately proving repressive. Paul Virilio, quoted in the 'popular guide to postmodern apostasy', *The Face*, asserts: 'Classless society, social justice – no one believes in them any more. We're in the age of micro-narratives, the art of the fragment.'[23]

The response to the threat of the HIV virus and AIDS has thrown up some of the most interesting graphic activist interventions. Many campaigning groups in North America and throughout Europe have developed sharp critiques of the ways in which societies generate repressive knowledge about the virus and the people that it infects. By producing images which promote AIDS awareness, groups like ACT UP, founded in New York City in March 1987, which has since established 'chapters' in over twenty countries, have politicised the representation of pleasure and sexuality.[24] Although they operate in a space dominated by public prohibition and conservative censorship, many of these campaigners share an attitude held by many in 'high risk groups' who refuse to allow public anxieties about the issue to become the means by which their lifestyles and their sexuality become the object of censure.[25] Whilst early official public health programmes often deployed hackneyed and ambiguous graphic symbols (coffins, skeletons and icebergs) or called for sexual restraint, in contrast many of the graphic works produced *by and for* the communities at most risk (the young, homosexuals and intravenous drug users), critique the ways in which such official and mass-media representations marginalise and morbidly caricature their lifestyles. In the 1980s 'public' knowledge of gay life, for example, was increasingly defined by the HIV virus which infected many homosexual people.[26]

The Terrence Higgins Trust, an organisation founded in London on Valentine's Day in 1983 to promote AIDS awareness and to offer support and counselling to those who have contracted the HIV virus, has produced some of the most interesting graphic images of this kind. The Trust's 1992 poster, for example, 'Wet your appetite for safer sex' (figure 79) – one in a series of six images designed by Big-Active with photographs produced by the Photo Co-op aimed at both heterosexuals and homosexuals – depicts a scene suggesting lesbian sex.[27] Unlike earlier official campaigns, the entreaty made in the poster's title neither calls for abstinence nor reminds the viewer of the mortal risk associated with unsafe sex.

79] 'Wet your appetite for safer sex', AIDS awareness poster designed by Big Active and published by The Terrence Higgins Trust, 1992.

On the contrary, in self-consciously adopting and adapting the seductive and indulgent language of advertising and fashion photography, it renounces the 'invisibility' of gay sexuality in our culture.[28] In fact, the captions imitate the appeals to consume found throughout contemporary advertising ('Wet your appetite'; 'It's that condom moment'; etc.) and the grainy, slightly blurred photographic style it made fashionable. In celebrating pleasure, these Terrence Higgins Trust images reject the representation of gay sexuality as deviant, or safe sex as dull sex. In reminding their viewers about the importance of preventing the spread of disease, these images crucially refuse to represent that audience as *diseased*. In this case, the self-conscious referentiality and intertextuality of the postmodern image is put to critical purpose.

Postmodern theory

The prevailing professional relations of graphic design, largely organised today in consultancies commissioned by commercial clients or by salaried designers working within firms like publishers, offer relatively few opportunities for the kind of critical practice sponsored by the Terrence Higgins Trust. However, since

the late 1980s there has been animated discussion of one field of postmodern theory – Deconstruction – that has affected the course of graphic design and which can be detected in some commercial spheres. Deconstruction was initially triggered by the work of the French philosopher Jacques Derrida in the 1960s and found its first exposition in his book *Of Grammatology* (1967), published in English in 1976.[29] The deconstructive approach to texts recognises their fluid referentiality to other sign systems as well as the pro-active role of the reader in the construction of meaning. Whatever we write, we cannot fix the meanings our words convey. In fact, texts often inadvertently reveal deep-seated assumptions in the things that are not expressed. The task of Deconstruction is to reveal these contradictions and oppositions within the text through close, critical readings. According to Derrida the idea of *différance* (an intentional pun based on the French verb *différer* meaning both to differ and to defer) is particularly illuminating in the way in which it encourages the reader to ponder on the 'spaces' which exist between normative concepts. As he would put it, for example, it is no longer useful or acceptable simply to speak of masculinity and femininity as oppositional or polarised entities; rather we need to negotiate one in terms of or with reference to the other and accordingly recognise the potential for more diffuse and indeterminate gender positions.

The label 'Deconstruction', has been widely applied to the work of a number of prominent and relatively young graphic designers including Why Not Associates, the London-based consultancy who designed a comprehensive compendium of graphic works in this style from Europe and North America, *Typography Now* (1991). Deconstructive graphics is used to describe designs which deploy compositional complexity, the layering of signs and playful confusion, as a strategy to force the spectator to deconstruct 'hidden' meanings. 'The aim' of this work, according to Rick Poynor in his introduction to *Typography Now*, 'is to promote multiple rather than fixed readings, to provoke the reader into becoming an active participant in the construction of the message'.[30] There is a kind of literalism which underscores such intentions, as if many of these designs set out to 'illustrate' post-structuralist theory. But as Paul Stiff points out, 'reading' has always been 'a highly complex set of activities, working on many levels – from the relatively automatic one of eye movements to the intentional level of navigating, monitoring, sampling and selecting'.[31] What is clear, however, is that for many designers – and the audiences that they cater for – 'reading' the postmodern graphic text should be a pleasurable experience which stimulates the senses rather than simply a matter of absorbing concise information.

Yet Deconstruction as literary theory is an inherently paracritical, questioning approach to reading and writing: 'To "deconstruct" a text is to draw out conflicting logics of sense and implication, with the object of showing that the text never means what it says or says what it means.'[32] It is possible, at least in the abstract, to see how one might extend this approach to graphic design: for the interpretative impulse of Deconstruction is ostensibly shared by all designers who, by definition, engage in first deciphering and then realising the briefs that they are set. But it is difficult to see how many of the more mundane tasks to which graphic design is put can utilise deconstructive approaches. Neither the layout of cooking instructions nor even the more expressive combinations of brand identity and attractive image on food packaging which attracts the supermarket shopper, are susceptible to an approach which seeks to underscore and problematise the complexity of communication (particularly when commercial interest lies in its easy, seductive exchange).

Whilst many designers might celebrate ambiguity and polysemy as a kind of democratisation of design, few corporate clients seem likely to look at the thoroughly speculative and even philosophical nature of many of these trials favourably (except in their diluted forms as traces of a fashionable 'period style'). And, in fact, for the most part deconstructive design has been conducted in the kind of laboratory atmosphere of graphic design departments in various colleges around the world (notably at the Cranbrook School in Michigan[33] and at Britain's Royal College of Art under Gert Dumbar in the 1980s) or has been produced for highly design-literate audiences, for example, in the form of posters promoting contemporary art exhibitions and other high cultural events. In such works the designer's role transcends that usually ordained by commerce, and he/she becomes a kind of author or editor. In 1992 Jonathan Barnbrook, whilst still a postgraduate student at the Royal College, for example, worked on a typeface which he entitled 'Burroughs' (figure 80). Words generated on a computer screen are randomly turned into a kind of nonsense poem as the typeface is used. This experiment not only makes explicit reference to the literary technique of the writer William Burroughs, who 'cut up' his sentences to achieve random effects, but also seems to testify to the 'arbitrary nature of the sign', a truism of semiotic theory already explored in chapter 8.

Nevertheless, exceptions within the corporate sphere *can* be found. The advertising strategy developed by Oliviero Toscani for Benetton, the Italian fashion company, has produced some of the most controversial images of recent years.[34] Images of a new-born baby, an AIDS sufferer on his death-bed, the blood-soaked uniform

80] 'Burroughs' typeface,
1991, designed by Jonathan
Barnbrook.

of a dead soldier from the war in Yugoslavia and other highly topical photographs to promote 'The United Colors of Benetton', have been widely exposed throughout the world on billboards and the pages of glossy magazines (figure 70). Much of this controversy centres on the fact that these images seem troublingly 'out of place', thereby confusing the kind of compartmentalised and specialised organisation of graphic communications. One editor of a British fashion magazine refused to accept Benetton's depiction of David Kirby, a young American dying of AIDS, precisely because it was not in the 'right context'.[35] These representations, making no claims about the merits of Benetton's products, seem to reflect on the condition of the world – or more accurately, they make space for the viewer to speculate on the knowledge that they contain. Benetton's advertisements are spectacularly 'open' texts. That is, they encourage the spectator 'to produce a signification which could be neither univocal nor stable'.[36] In this sense, Toscani's images for Benetton seem to celebrate the fundamental instability of all texts that Deconstruction takes as a matter of fact.

Whilst deconstructive graphic design and the kind of experimentation promoted by Benetton can justifiably be considered a form of critical practice, it cannot be described as avant-garde, at least in the sense defined by Modernism. It neither seeks to prompt nor to prefigure social change, like the works produced by modernists like El Lissitzky, who allied their graphic inventions to a political project, nor does it seek to antagonise conventional mores, like the dadaists of the 1910s. And whilst, for example, the aspirations of practitioners of deconstructive graphics like Barnbrook lie beyond

the pursuit of stylistic novelty for its own sake, they are primarily concerned with redirecting the practice of design itself. As such, their work seems to confirm the conservatism of much post-modernist culture and the disavowal of 'totalising' projects.

Postmodern technology

Nevertheless, a strong current of optimism continues to gather pace within postmodern graphic design. Digital technologies such as video and computers have an unassailable place in postmodern culture as the principal media of the 'post-industrial age'. The wholesale adoption of computer technologies in design studios and the printing industry since the 1980s has had a dramatic effect not only on the formal languages of graphic design but, perhaps more importantly, on the technocratic specialisms that define this professional activity. The Apple Macintosh computer, launched in 1984, with its 'user-friendly' interface, and a number of software packages aimed directly at the communications industry, have become the ubiquitous tools of the graphic designer and have triggered a wave of enthusiasm for digital technologies (perhaps more notably in the design press than in the industry). There are two major effects of computerisation. First, the digital storage and manipulation of photographic images through the use of a scanner, a computer and software.[37] In this way 'seamless' montages can be made from different negatives or existing photographs can be subtly or dramatically enhanced or modified. In fact, new photographs can be produced without a camera or without a subject in the traditional sense. Second, with the aid of relatively inexpensive software and computer technology, a designer can now easily produce his or her own letter-forms. This has marked a dramatic departure from tradition, for in the past designers were reliant on a limited repertoire of faces available from the major type-foundries like the Monotype Corporation (unless, like Brody in the early years of *The Face*, they were prepared to undertake the arduous task of hand-drawing their own letter-forms). As a consequence, in recent years there has been an explosion of new and highly inventive typefaces. In the era of metal type the lengthy process of research and development, as well as the craftsmanship required, acted as a kind of conservative brake on the design of type fonts, whereas today type designs are as subject to the rapid turns of fashion as any other aspect of postmodern culture. Letter-forms have shifted from the autarkic realm of the type foundry to become virtually the autographic marks of the designer who invents them.[38]

But the effects of computerisation on design are not likely to be

just a matter of providing new tools for old chores. The potential of the computer to shape new ways of communicating information throws traditional forms of print into jeopardy. Although today computers are widely used to design and prepare an advertisement, magazine or other graphic form for print, the actual processes of printing still rely on the application of ink to paper. It seems, however, that the future lies in new electronic formats which will be accessed on screen. These new formats will inevitably change the face of graphic design and the ways in which we consume information. We are presented with the potential of 'multimedia' which, in dealing with the vast amounts of information that can be stored in digital form, will offer new ways of 'reading'. Unlike the linear format of the traditional directory or the conventional sequential layout of the magazine, multimedia operate with matrix-like formats like the CD-ROM, which allow information to be presented, layered and cross-referenced in different ways. Unlike static print-based media, for example, the electronic magazine can combine video animation, sound and text.[39] Utilising the CD's capacity to store large amounts of graphic information, a growing number of multimedia products are now being released each month, including magazine titles and books in electronic formats, such as Douglas Adams's *Hitchhiker's Guide to the Galaxy* and *The Guinness Book of Records*. Some graphic designers have been particularly active advocates of the electronic magazine. In fact, the final issue of the journal *Octavo* was produced as a CD-ROM (somewhat ironically, given the magazine's title, which refers to a traditional size of a book or magazine page achieved by folding a standard paper size into eight pages).[40]

The rapid and seemingly dramatic arrival of these computer technologies has prompted many excited and some might say exaggerated claims about their effects on our culture. One common theme featured in many portentous and polemical predictions is that we are witnessing 'The death of the book'. Malcolm Garrett writes:

> The question I find myself addressing is whether the notion of intelligence will forever be inextricably linked with the need (or ability) to store information as words on paper, and here I'm using the term information in the broadest sense: pictures, sounds, symbols are all forms of information. In a world increasingly geared towards producing and deciphering visual stimuli of all kinds ... It is wilfully anachronistic to expect tomorrow's populace to put up with such an expensive to produce and maintain, tedious to access, space demanding system of storage as the conventional library.[41]

Others have claimed that we are on the threshold of a new democratisation of knowledge; 'a *social* revolution in communications'.[42] In fact, postmodern graphic design is marked by a kind of

euphoric futurism about the potential of new digital multimedia technologies to empower 'ordinary' users. Rick Poynor records that 'Evangelists enthuse about a soon to be realised digital paradise in which everyone will compose letters in personally configured typefaces as idiosyncratic as their own handwriting.'[43] And the potential for users to order and select the information that they need from the array of sources available – 'interactivity' – threatens to make the profession of the graphic designer, as it is currently practised, redundant. The aim of producing an immutable, ideal design is terminally threatened by the possibility that the user may completely change it. Paul Stiff warns that 'traditional graphic design has probably had its day, and is unlikely to survive – except perhaps as a heritage craft'.[44] 'Graphical user interfaces' may be a buzzword of the electronic age, but it is, nevertheless, one which demands *graphic* invention just as much as the print explosion of the nineteenth century. Reports of the 'death' of graphic design, like the famous and apocryphal notice of Mark Twain's demise, have, it seems, been 'greatly exaggerated', for many of the long-standing and often mundane tasks that this profession has to perfor, will remain. Moreover, designers, as some of the most enthusiastic advocates of multimedia, will continue to determine the appearance of graphic communications, in whatever guise we consume them. Although the computer may very well come to replace all other means of reproduction, with regard to representation the role of the designer *as a generator of ideas and images* will be as essential in the future as it was in Daumier's time.

Notes

1 For a history of the concept see H. Bertens, *The Idea of the Postmodern* (London, 1995).

2 A. Huyssen, 'Mapping the post-modern', *New German Critique*, 33 (Fall 1984), p. 8.

3 Y. Schwemmer-Scheddin, 'Reputations - Wolfgang Weingart', *Eye*, 4 (1991), pp. 4-16.

4 See R. Poynor and E. Booth-Clibborn (eds), *Typography Now: The Next Wave* (London, 1991).

5 Habermas quotes an unnamed critic writing in *Frankfurter Allgemeine Zeitung*. See J. Habermas, 'Modernity - an incomplete project', in H. Foster (ed.), *Postmodern Culture* (London, 1985), p. 3.

6 F. Jameson, 'Postmodernism and consumer society', in E. A. Kaplan, *Postmodernism and its Discontents* (London, 1988), p. 14.

7 C. Booker, *The Neophiliacs* (London, 1969), p. 42.

8 G. Debord, *The Society of the Spectacle*, translated by D. Nicholson-Smith (New York, 1994), thesis 18, p. 17; J. Baudrillard, 'Simulacra and simulations', in M. Poster (ed.), *Jean Baudrillard: Selected Writings* (Cambridge, 1988), pp. 166-84.

9 J. Baudrillard, *America*, translated by Chris Turner (London, Verso, 1988), p. 56.

10 D. Harvey, *The Condition of Post-modernity* (Oxford, 1989), p. 44.

11 M. Brent, '8vo', *Communication Arts*, 34:5 (September 1992), p. 136.

12 Jameson, 'Postmodernism and consumer society', in Kaplan, *Postmodernism and its Discontents*, p. 16.

13 *Ibid.*, p. 28.

14 D. Hebdige, 'The bottom line on Planet One', *TEN. 8*, 19 (1985), p. 47.

15 J. Wozencroft, *The Graphic Language of Neville Brody* (London, 1988).

16 Hebdige, 'The bottom line on Planet One', p. 43.

17 N. Brody, in the *Guardian* (1 August 1988).

18 M. Davidson, *The Consumerist Manifesto* (London, 1992), p. 189.

19 Harvey, *The Condition of Postmodernity*, p. 49.

20 See T. Kalman, 'Good history, bad history', *Design Review*, 1:1 (Spring 1991), pp. 48-57; and S. Heller and J. Lasky, *Borrowed Design* (New York, 1993).

21 A. Sinfield, *Literature, Culture, and Politics in Postwar Britain* (Oxford, 1989), p. 291.

22 L. McQuiston, *Graphic Agitation: Social and Political Graphics Since the Sixties* (London, 1993).

23 P. Virilio, quoted in 'The end of politics', *The Face*, 61 (May 1985), p. 125.

24 An excellent survey of ACT UP actions in the USA is D. Crimp and A. Rolston, *AIDSDEMOGRAPHICS* (Seattle, 1990).

25 See S. Watney, 'Photography and AIDS', *TEN. 8*, 26 (undated), pp. 14-25.

26 See C. Patton, *Inventing AIDS* (London, 1990).

27 The complete series of posters is reproduced in Chris Boot, 'Get set for safer sex', *TEN. 8*, 2:1 (Spring 1991), pp. 26-33.

28 It should be noted, however, that in recent years there has been a kind of fascination with lesbianism in the mass media. See D. Hamer and B. Budge (eds), *The Good, The Bad and The Gorgeous: Popular Culture's Romance with Lesbianism* (London, 1994).

29 For a discussion of Deconstructionism see J. Culler, *On Deconstruction: Theory and Criticism after Structuralism* (Ithaca, 1982) and C. Norris and A. Benjamin, *What is Deconstruction?* (London, 1988) for an analysis of the application of deconstructive approaches in architecture and the fine arts.

30 Poynor, *Typography Now*, p. 10.

31 P. Stiff, 'Stop sitting around and start looking', *Eye*, 11 (1993), p. 4.

32 Norris and Benjamin, *What is Deconstruction?*, p. 7.

33 See Hugh Aldersey-Williams, *Cranbrook Design: The New Discourse* (New York, 1990).

34 S. Bogan, 'Fashion firm that thrives on controversy', the *Independent* (25 January 1992), p. 3; A. Garrett, 'Benetton's battered baby', the *Observer* (8 September 1991).

35 J. Mullin, 'Journals ban dying AIDS victim advertisement', the *Guardian* (24 January 1992), p. 7.

36 Derrida in Harvey, *The Condition of Postmodernity*, p. 51.

37 There is a large and ever-growing literature on this theme: see F. Ritchin, *In Our Own Image* (New York, Aperture, 1990); W. J. Mitchell, *The Reconfigured Eye: Visual truth in the Post-Photographic Era* (Cambridge, Mass., 1992); 'Digital Dialogues' - a special issue of *TEN. 8*, 2:2 (Autumn 1991).

38 See M. Rock, 'Beyond typography', *Eye*, 15 (1994), pp. 26–35.

39 See W. Owen, *Magazine Design* (London, 1992), pp. 224–30.

40 *Octavo*, 8 (1992).

41 See M. Garrett, 'The book is dead', *Graphics World* ('Hi-Tech' supplement), 90 (February 1991), pp. 22–3.

42 J. Wozencroft, *The Graphic Language of Neville Brody 2* (London, 1994), p. 5.

43 Poynor, *Typography Now*, p. 7.

44 Stiff, 'Stop sitting around and start reading', *Eye*, 5.

Suggestions for further reading

L. Appignanesi (ed.), *Postmodernism: ICA Documents 4 and 5* (London, Institute of Contemporary Arts, 1986).

J. Baudrillard, *Selected Writings* (Oxford, Polity Press/Basil Blackwell, 1988).

B. Cotton and R. Oliver, *The Cyberspace Lexicon* (London, Phaidon, 1994).

G. Debord, *The Society of the Spectacle*, translated by D. Nicholson-Smith (New York, Zone Books, 1994).

H. Foster (ed.), *Postmodern Culture* (London, Pluto, 1985).

D. Harvey, *The Condition of Postmodernity* (Oxford, Basil Blackwell, 1989).

D. Hebdige, *Hiding in the Light* (London, Comedia/Routledge, 1988).

S. Heller and J. Lasky, *Borrowed Design* (New York, Van Nostrand Reinhold, 1993).

F. Jameson, *Postmodernism, or the Cultural Logic of Late Capitalism* (London, Verso, 1991).

C. Jencks (ed.), *The Post-Modern Reader* (London, Academy Editions, 1992).

T. Kalman, 'Good history, bad history', *Design Review*, 1:1 (Spring 1991), pp. 48–57.

E. A. Kaplan, *Postmodernism and Its Discontents* (London, Verso, 1988).

W. Owen, *Magazine Design* (London, Laurence King, 1992).

R. Poynor and E. Booth-Clibborn (eds), *Typography Now: the Next Wave* (London, Internos Books/Edward Booth-Clibborn Editions, 1991).

TEN. 8, 2:2 (Autumn 1991) – special issue on the theme of 'Digital dialogues – photography in the age of cyberspace'.

R. Vanderlans, Z. Licko and M. E. Gray, *Émigré: Graphic Design in the Digital Realm* (New York, Van Nostrand Reinhold, 1993).

K. Varnedoe and A. Gopnik, *High and Low: Modern Art and Popular Culture* (New York, Museum of Modern Art, 1991).

J. Wozencroft, *The Graphic Language of Neville Brody* (London, Thames and Hudson, 1988).

J. Wozencroft, *The Graphic Language of Neville Brody 2* (London, Thames and Hudson, 1994).

Index